# A SURVEY OF MANUSCRIPTS
# ILLUMINATED IN THE BRITISH ISLES
## VOLUME FIVE
# GOTHIC MANUSCRIPTS [I]
### 1285–1385

BY LUCY FREEMAN SANDLER

*Frontispiece:* Illustration to Psalm 97. Ormesby Psalter.
Oxford, Bodleian Library, MS Douce 366, f. 128 (cat. 43)

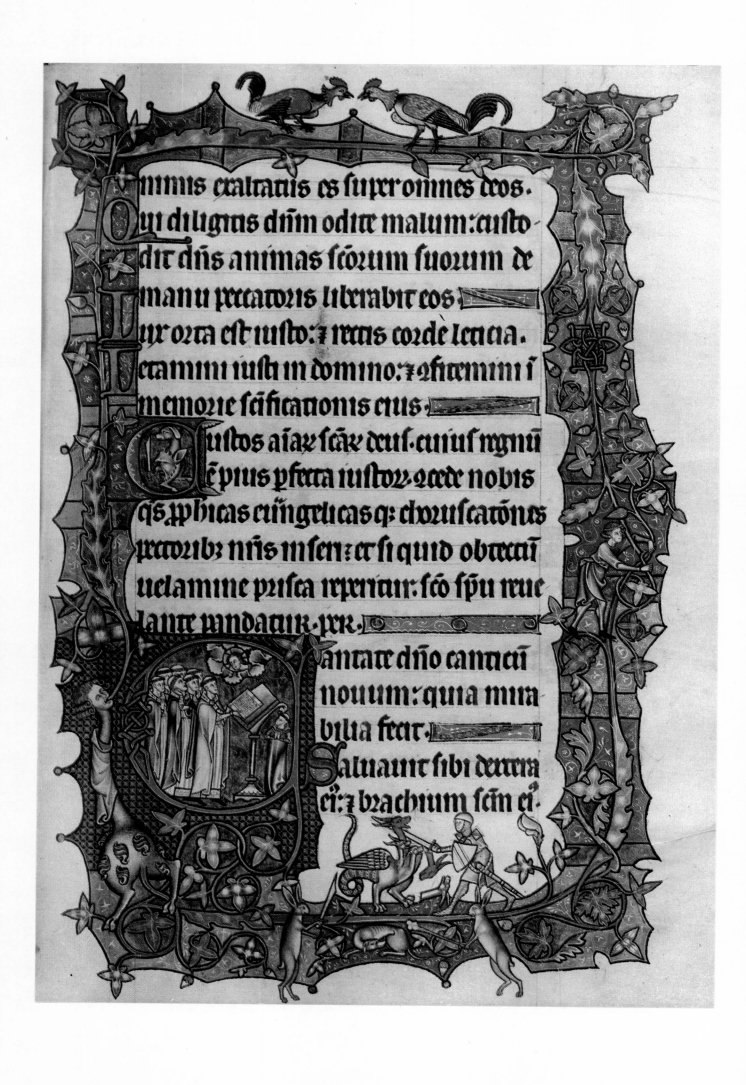

A SURVEY OF MANUSCRIPTS ILLUMINATED IN THE
BRITISH ISLES~GENERAL EDITOR J·J·G·ALEXANDER

# GOTHIC MANUSCRIPTS 1285–1385

## BY LUCY FREEMAN SANDLER

I · TEXT AND ILLUSTRATIONS

 HARVEY MILLER PUBLISHERS
~ OXFORD UNIVERSITY PRESS

# A SURVEY OF MANUSCRIPTS
# ILLUMINATED IN THE BRITISH ISLES

General Editor J. J. G. Alexander

Volume One: INSULAR MANUSCRIPTS FROM THE 6th to the 9TH CENTURY

Volume Two: ANGLO-SAXON MANUSCRIPTS 900–1066

Volume Three: ROMANESQUE MANUSCRIPTS 1066–1190

Volume Four: EARLY GOTHIC MANUSCRIPTS (in two parts) 1190–1285

Volume Five: GOTHIC MANUSCRIPTS 1285–1385

Volume Six: LATER GOTHIC MANUSCRIPTS

Originating Publisher HARVEY MILLER · 20 Marryat Road · London SW19 5BD

Published in conjunction with OXFORD UNIVERSITY PRESS · Walton Street · Oxford OX2 6DP

*London · Glasgow · New York · Toronto · Melbourne · Auckland*
*Kuala Lumpur · Singapore · Hong Kong · Tokyo · Delhi · Bombay · Calcutta · Madras · Karachi*
*Nairobi · Dar es Salaam · Cape Town · and associates in Beirut · Ibadan · Mexico City · Nicosia*

Published in the United States by OXFORD UNIVERSITY PRESS, New York

**British Library Cataloguing in Publication Data**
**Sandler, Lucy Freeman**
　　Gothic manuscripts: 1285–1385.——(A survey of
manuscripts illuminated in the British Isles; v.5)
　　1. Illumination of books and manuscripts, British
　　2. Illumination of books and manuscripts, Gothic
　　——Great Britain
　　I. Title　　II. Series
　　091'.0941　　ND3128

**ISBN 0–19–921037–3**

*Published with the assistance of the J. Paul Getty Trust*

*Publication of this book has been aided by a grant from the*
*Millard Meiss Publication Fund of the College Art Association of America*

MM

Designed by Elly Miller

© 1986 Harvey Miller

Printed in Great Britain
Illustrations originated & printed at the Oxford University Press
Composition by Area Graphics Ltd · Letchworth · Herts
Text printed & bound by Clark Constable (1982) Ltd · Edinburgh

# CONTENTS

## PART I · TEXT & ILLUSTRATIONS

# EDITOR'S PREFACE

THIS VOLUME contains amongst its entries some of the most famous manuscripts illuminated in the British Isles in the Middle Ages, particularly the early fourteenth-century Psalters such as the Gorleston, Arundel, Ormesby, Queen Mary and Luttrell Psalters. But these exceptional manuscripts have to be understood in a wider context of the production of less grand books for an increasingly lay audience. As with the earlier volumes in the series Professor Sandler's book places equal importance on making better known such second rank manuscripts. In many cases she provides accessible descriptions or illustrations of these manuscripts for the first time.

As book illumination becomes more professional, more organized and more commercial from the thirteenth century onwards, it also becomes more specialized. A hierarchy of decoration evolves and specialist craftspersons may execute different parts such as miniatures, borders, initials and pen flourished decoration. It is a merit of Professor Sandler's volume that she has paid attention to these evolving patterns and provided materials for their further examination.

Finally these manuscripts are incredibly rich in imagery. The enormously inventive marginal illustrations showing genre and other scenes whether scurrilous, satirical or fantastic, are rightly famous in such manuscripts as the Luttrell Psalter, even if their raison d'être in general or their interpretation in particular cases is still often a matter of controversy. Professor Sandler's volume in addition includes a number of other still relatively unknown manuscripts with extraordinary pictures, examples being the Glasgow devotional miscellany or James le Palmer's encyclopedia 'Omne bonum'. In fact such is the variety of the texts and the richness of the imagery provided for them in the fourteenth century that it would not be possible within the practical limits of this series to describe either texts or imagery comprehensively. As with other volumes the bibliography, which is selective, will give necessary directions to help the reader to track down the particular additional information required.

*J. J. G. Alexander*

# FOREWORD

IN HIS TWO FUNDAMENTAL STUDIES of English illumination Eric Millar cited 69 manuscripts executed during the period covered by the present volume. I have included all but five of those listed by Millar, and have added some 90 more to make a total of 158. The additions are by no means discoveries of mine; for the most part they are books known through the later work of Millar himself ('Fresh Materials', 1954), or through the research of Margaret Rickert, Francis Wormald and Phyllis Giles, Otto Pächt and Jonathan Alexander, to name those authors who have contributed the largest amounts of collected information; through important exhibitions such as those in Baltimore in 1949, or Norwich and Brussels in 1973; through the extensive collection of manuscript photographs in the Conway Library at the Courtauld Institute (often of books sold at auction); and finally, through the kindness and generosity of other scholars in sharing their own discoveries.

When the series editor proposed this book to me in 1976, it was suggested that the number of manuscripts included should amount to about 140 to provide a survey of the output of the period. I tried to adhere to the numerical limit suggested by the editor and, though tempted to expand this number, concluded in the end that going much beyond that limit, say to 200 manuscripts, would have resulted in a different kind of book – less selective, less focused on the pictorial side of manuscript illumination, and more focused on codicological matters. Still, there may well be objections that such and such a fine manuscript was left out, and there may be questions as to why such and such a book was found of sufficient interest to warrant a place here. There must also be some, perhaps even many, English late 13th and 14th century illuminated manuscripts still to be discovered. Ultimately, my selection was personal – I hope not idiosyncratic – reflecting my evaluation of what is important, interesting and beautiful in English manuscript illumination of the late 13th and 14th centuries. When there was a question of inclusion I asked myself whether the work was of high quality, whether the text or programme of illustration was unusual or unique, whether the illustrations were by an identifiable artist or augmented the number of books of a particular style, whether the book was of known origin, destination or date. Some lesser examples of common types of illustrated books such as Psalters or Bestiaries were rejected, for example, while some unique works illustrated by naïve artists (e.g. nos 19, 124, 125) were included.

I had thought of making a much more inclusive table of manuscripts, a greatly expanded handlist on the order of those in Millar's volumes, but gave up the idea, for two reasons: first, the number of English manuscripts of the period which may be said to be illuminated must extend to the thousands (over 200 listed in Pächt and Alexander's Bodleian handbook alone); and second, the publication in recent years of catalogues or handlists of illuminated books in heretofore uncatalogued or inadequately catalogued collections – Pächt and Alexander's Bodleian handbook, Wormald and Giles' catalogue of post-James additions to the Fitzwilliam Museum collection, Elzbieta Temple's handbook to the illuminated manuscripts in the Oxford colleges – has added greatly to just the kind of information such a table would have provided.

In selecting the books to be included in this volume, some considered decisions had to be

made about manuscripts falling at either end of the study. It was clear to me from the outset that this volume should begin with the Alphonso Psalter as representing a new development heralding the 14th century. And to emphasize the importance of the innovations of the Alphonso Psalter, I wanted to set it off against the more conservative style of the end of the 13th century, illustrated by such books as the New College Apocalypse or the Bird Psalter (nos. 7, 10). Some of these books could conceivably have found a place in Volume IV of this series, and conversely some included in the preceding volume, such as the Huth Psalter (*Survey*, IV, no. 167), could have been included here.

At the end of the 14th century I thought that a natural conclusion was the Litlyngton Missal of 1383–84 rather than the Carmelite Missal of the last decade of the century, because the latter, like the Alphonso Psalter, is marked by stylistic innovation looking forward to the 15th century. I found, however, that a number of books related to the Litlyngton Missal were actually executed between 1380 and 1400 (e.g. nos. 144, 152), and these, which represent the conservative tendency of the late 14th century, and which are relatively unknown, I decided to include in the present volume. For all these decisions I have had the concurrence of my collaborators in the series, Nigel Morgan for the 13th century and Kathleen Scott for the 15th.

The numbered entries for the individual manuscripts were arranged in rough chronological order which also takes into account groups of manuscripts. This resulted in inevitable lapses from strict chronology, since a later manuscript from one group may precede an earlier one from another. Within the several groups of manuscripts I usually placed the most important book first, followed by its relatives, attempting in the case of large groups, such as that of the Queen Mary Psalter, to indicate degrees of relationship by the sequence of the individual manuscripts.

In describing the manuscripts I followed a general format set up for the entire series. The introductory headings include dates and original provenance where known. However, for the 14th century it is no longer certain that the place *where* a manuscript was illuminated and the place *for which* the manuscript was illuminated, were identical. Consequently, the provenance where given in the introductory heading is to be taken as the original destination, either geographical, ecclesiastical or individual, not the place where the book was made.

The manuscript descriptions usually include two sections, the first listing the illustrations of the manuscript and describing their main pictorial or decorative elements, the second describing the text decoration of the book. The descriptions vary considerably in the amount of detail. The pictorial contents of manuscripts which have been reproduced in facsimile or which have previously been described exhaustively, are summarized rather than recited completely.

Each description is followed by a commentary whose first element is usually a presentation of the material for localization and dating of the book. Where unillustrated texts, such as Litanies, have a bearing on these matters they are discussed in this part of the commentary. Then follows a discussion of the pictorial and textual contents and the style of the illumination, in which the relations with other works are considered. The commentary ends with my conclusions about style, date and localization. I have attempted to separate clearly what is hypothesis (mine or others) from what is provable fact.

Finally, the last section of each entry consists of information as to provenance, literature and exhibitions. These sections are intended to be useful but not exhaustive. Under the literature heading, Margaret Rickert's *Painting in Britain: The Middle Ages*, which is probably mentioned more frequently than any other publication, is cited from the first edition of 1954 in order to show her relative position in the development of research (almost no changes pertinent to the late 13th and 14th centuries were made in the text of the second edition of 1965).

A study of this kind could not have been completed without the help of a great many individuals and institutions. It would not have been started in the first place without the inducement of the general editor of the *Survey*, Jonathan Alexander, and would not have achieved its final shape without his profoundly knowledgeable and sympathetic review. To him, and to Nigel Morgan and Kathleen Scott, authors of the preceding and following volumes in the series, I am grateful for sharing information – and judgements – with truly collegial generosity. I acknowledge with gratitude and admiration the commitment of the publisher, Elly Miller, to the production of books that are both scholarly and beautiful. I am indebted to Isabel Hariades for painstaking editorial labour on this volume, and I thank Marietta Cambareri for assistance in the preparation of the indices.

I owe thanks to numerous individuals for advice, encouragement, information, and help in obtaining photographs: François Avril, Janet Backhouse, Bruce Barker-Benfield, Adelaide Bennett, Kathleen W.-G. Brandt, Walter Cahn, Joanna Cannon, Kerstin Carlvant, D. Steven Corey, Ruth Dean, Christopher de Hamel, A. C. de la Mare, Paula Gerson, Joan Gibbs, Phyllis Giles, W. O. Hassall, Christopher Hohler, Isabelle Hyman, Robert Ireland, the late H. W. Janson, Carol Krinsky, Charlotte Lacaze, Richard Marks, James Marrow, Ruth Mellinkoff, Michael A. Michael, Kathleen Morand, Kerstin Moreno, Carl Nordenfalk, Judith Oliver, Otto Pächt, Julian Plante, John Plummer, Jean Preston, Lilian Randall, Edward Roesner, Nicholas Rogers, Jane Rosenthal, Amanda T. Simpson, Patricia Danz Stirnemann, Clark Stillman, Alison Stones, Edward Sullivan, Elżbieta Temple, the late D. H. Turner, William Voelkle.

For offering research facilities, enabling me to study books, manuscripts and photographs in their care, or for providing the photographs reproduced here, I wish to thank the following institutions and their staffs: All Souls College, Oxford; Archivio General de Navarra, Pamplona; Bangor Cathedral; Marquess of Bath, Longleat; Bayerische Staatsbibliothek, Munich; Earl Beauchamp, Madresfield Court; Beinecke Rare Book and Manuscript Library, Yale University, New Haven; Biblioteca Apostolica, Vatican; Biblioteca de El Escorial; Biblioteca Queriniana, Brescia; Bibliothèque Mazarine, Paris; Bibliothèque Nationale, Paris; Bibliothèque Publique, Douai; Bibliothèque Royale Albert I, Brussels; Elmer Holmes Bobst Library, New York University; Bodleian Library, Oxford; Boston Public Library; British Library, London; Canterbury Cathedral Library; Castle Museum, Norwich; Chicago Art Institute; Christ Church, Oxford; Columbia University Library, New York; Conway Library, Courtauld Institute of Art, University of London; Corporation of London Record Office; Corpus Christi College, Cambridge; Exeter College, Oxford; Fitzwilliam Museum, Cambridge; Fürstenbergische Bibliothek, Herdringen; General Theological Seminary Library, New York; Huntington Library, San Marino (Calif.); Jesus College, Oxford; St. John's College, Cambridge; St. John's College, Oxford; Keble College, Oxford; Kongelige Bibliotek, Copenhagen; Lambeth Palace Library, London; Earl of Leicester, Holkham; Lilly Library, University of Indiana, Bloomington; Lincoln College, Oxford; Magdalen College, Cambridge; Monastic Manuscript Microfilm Library, St. John's University, Collegeville (Minn.); Monumenta Germaniae Historica, Munich; Musée Calvet, Avignon; National Library of Scotland, Edinburgh; National Library of Wales, Aberystwyth; New College, Oxford; New York Public Library; Newberry Library, Chicago; Österreichische Nationalbibliothek, Vienna; Oriel College, Oxford; Abbey of St. Paul in Lavantthal, Carinthia; Pierpont Morgan Library, New York; Princeton University Library, New Jersey; Public Record Office, London; Marquess of Salisbury, Hatfield; Gräflich Schönbornische Bibliothek, Pommersfelden; Senate House Library, University of London; Sidney Sussex College, Cambridge; Trinity College, Cambridge; Trinity College, Dublin; Trinity College, Oxford; Walters Art Gallery, Baltimore; Westminster Abbey, London; Dr. Williams's Library, London; Union Theological Seminary Library, New York; University

Library, Cambridge; University Library, Glasgow; University of San Francisco Library; University of Toronto Library.

Finally, I am grateful to New York University for granting sabbaticals and research leaves, to the National Endowment for the Humanities for a fellowship which made it possible for me to complete large sections of this study, and to both the Millard Meiss Publication Fund and the J. Paul Getty Trust for their generous assistance towards this publication.

*To Irving*

# ABBREVIATIONS

| | |
|---|---|
| Baltimore, 1949 | Baltimore, The Walters Art Gallery, *Illuminated Books of the Middle Ages and Renaissance*, 1949 |
| Bennett, *Thesis* | A. Bennett, *The Place of Garrett 28 in Thirteenth-Century English Illumination*, Ph.D. Dissertation, Columbia University, 1973 |
| B.F.A.C. | Burlington Fine Arts Club |
| Bodleian Library, *English Illumination* | T. S. R. Boase, intro., *English Illumination of the Thirteenth and Fourteenth Centuries* (Bodleian Library Picture Book, no. 10), Oxford, 1954 |
| Bodleian Library, *Scenes from the Life of Christ* | R. G. Chapman, intro., *Scenes from the Life of Christ in English Manuscripts* (Bodleian Library Picture Book, no. 5), Oxford, 1951 |
| British Museum, *Catalogue* | British Museum, *Catalogue of Additions* |
| British Museum, *Reproductions*, I–V | British Museum, *Reproductions from Illuminated Manuscripts*, Series I–V, London, 1907, 1908, 1928, 1965 |
| British Museum, *Schools of Illumination* | British Museum, *Schools of Illumination*, pts. II–IV, London, 1915, 1922 |
| Brussels, 1973 | Bibliothèque royale, Brussels, *English Illumination 700–1500*, 1973 |
| Cockerell, *Gorleston Psalter* | S. C. Cockerell, *The Gorleston Psalter*, London, 1907 |
| Coxe, *Catalogue* | H. O. Coxe, *Catalogi codicum manuscriptorum bibliothecae Bodleianae*, 3 vols., Oxford, 1853–58 |
| | H. O. Coxe, *Catalogus codicum MSS qui in collegiis aulisque Oxoniensibus hodie adservantur*, Oxford, 1852 |
| Delisle, Meyer, *Apocalypse* | L. Delisle, P. Meyer, *L'Apocalypse en français au XIIIe siècle*, Paris, 1901 |
| De Ricci, *Census* | S. De Ricci, W. J. Wilson, *Census of Medieval and Renaissance Manuscripts in the United States and Canada*, 3 vols., New York, 1935–40, 1961; *Supplement*, C. Faye, W. H. Bond, eds., New York, 1962 |
| Egbert, *Tickhill Psalter* | D. D. Egbert, *The Tickhill Psalter and Related Manuscripts*, New York, 1940 |
| Evans, *English Art* | J. Evans, *English Art 1307–1461* (Oxford History of English Art, V), Oxford, 1949 |
| Harrison, *Treasures of Illumination* | F. Harrison, *English Manuscripts of the Fourteenth Century (c. 1250–c. 1400)*, London, 1937 |
| *H.B.S.* | *Henry Bradshaw Society* |
| Herbert, *Illuminated Manuscripts* | J. A. Herbert, *Illuminated Manuscripts*, London, 1911 |
| James, *Apocalypse* | M. R. James, *The Apocalypse in Art*, London, 1931 |
| James, *Catalogue* | M. R. James, *Descriptive Catalogue of the Manuscripts in the Library of:* |
| | *Corpus Christi College, Cambridge*, 1912 |
| | *Emmanuel College, Cambridge*, 1904 |

James, *Catalogue*      M. R. James, *Descriptive Catalogue of the Manuscripts in the Library of*: *Fitzwilliam Museum, Cambridge, 1895*

*Fitzwilliam Museum (McClean Collection), Cambridge, 1912*

*Lambeth Palace, 1932*

*Magdalen College, Cambridge, 1909*

*St. John's College, Cambridge, 1913*

*Sidney Sussex College, Cambridge, 1895*

*Trinity College, Cambridge, 1900–1904*

James and Millar, *Bohun Manuscripts*      M. R. James, E. G. Millar, *The Bohun Manuscripts*, Roxburghe Club, 1936

*J.W.C.I.*      *Journal of the Warburg and Courtauld Institutes*

Ker, *Medieval Libraries*      N. R. Ker, *Medieval Libraries of Great Britain*, London, 1964

Ker, *Medieval Manuscripts*, I, II, III      N. R. Ker, *Medieval Manuscripts in British Libraries*
I *London*, Oxford, 1969
II *Abbotsford–Keele*, Oxford, 1977
III *Lampeter–Oxford*, Oxford, 1983

London, 1930      Victoria and Albert Museum, London, *Exhibition of English Medieval Art*, 1930

London, 1967      British Museum, London, *Illuminated Manuscripts Exhibited in the Grenville Library*, 1967

Marks and Morgan, *English Manuscript Painting*      R. Marks, N. J. Morgan, *The Golden Age of English Manuscript Painting 1200–1500*, London, 1981

Millar, I      E. G. Millar, *English Illuminated Manuscripts from the Xth to the XIIIth Century*, Paris, 1926

Millar, II      E. G. Millar, *English Illuminated Manuscripts of the XIVth and XVth Centuries*, Paris, 1928

Millar, 'Fresh Materials'      E. G. Millar, 'Fresh Materials for the Study of English Illumination', *Studies in Art and Literature for Belle da Costa Greene*, Princeton, 1954

*New Pal Soc.*, I, II      New Palaeographical Society, *Facsimiles of Ancient Manuscripts*, 1st and 2nd series, London, 1903–30

New York, 1933–34      New York Public Library, *The Pierpont Morgan Library Exhibition of Illuminated Manuscripts*, 1933–1934

Norwich, 1973      Castle Museum, Norwich, *Medieval Art in East Anglia 1300–1520*, P. Lasko and N. J. Morgan, eds., 1973

Ottawa, 1972      National Gallery of Canada, Ottawa, *Art and the Courts*, P. Brieger and P. Verdier, eds., 1972

Pächt, 'Giottesque Episode'      O. Pächt, 'A Giottesque Episode in English Medieval Art', *J.W.C.I.*, VI, 1943, 51–70

Pächt and Alexander, III      O. Pächt, J. J. G. Alexander, *Illuminated Manuscripts in the Bodleian Library*, Oxford, III, British School, Oxford, 1972

*Pal. Soc.*, I, II      Palaeographical Society, *Facsimiles of Manuscripts and Inscriptions*, 1st and 2nd series, London, 1874–94

Paris, 1968      Musée du Louvre, Paris, *L'Europe gothique XIIe XIVe siècles* (Council of Europe Exhibition, no. 12), 1968

Randall, *Images*      L. Randall, *Images in the Margins of Gothic Manuscripts*, Berkeley, 1966

Rickert, *Carmelite Missal*      M. Rickert, *The Reconstructed Carmelite Missal*, London, 1953

Rickert, *Miniatura*, I, II

M. Rickert, *La Miniatura Inglese*. I, *Dalle origine alla fine del secolo XII*, Milan, 1959; II, *Dal XIII al XV secolo*, Milan, 1961

Rickert, *Painting in Britain*

M. Rickert, *Painting in Britain. The Middle Ages* (Pelican History of Art), 1st edn., 1954

Sandler, *Peterborough Psalter in Brussels*

L. F. Sandler, *The Peterborough Psalter in Brussels and Other Fenland Manuscripts*, London, 1974

Saunders, English Illumination I, II

O. E. Saunders, *English Illumination*, 2 vols., Florence and Paris, 1928

Saxl and Meier, III

F. Saxl, H. Meier, *Verzeichnis astrologischer und mythologischer illustrierter Handschriften des lateinischen Mittelalters*, III. *Handschriften in Englischen Bibliotheken*, 2 vols., London, 1953

Simpson, *Thesis*

A. Simpson, *The Connections between English and Bohemian Painting during the Second Half of the Fourteenth Century*, Ph.D. Dissertation, Courtauld Institute of Art, London University, 1978; publ. Garland Series 'Outstanding Theses from the Courtauld Institute of Art', New York and London, 1984

*Survey*, III

C. M. Kauffmann, *Romanesque Manuscripts 1066–1190* (*A Survey of Manuscripts Illuminated in the British Isles*, III), London, 1975

*Survey*, IV, Parts [I] and [II]

N. J. Morgan, *Early Gothic Manuscripts* [I] *1190–1250* (*A Survey of Manuscripts Illuminated in the British Isles*, IV), *Early Gothic Manuscripts* [II] 1250–1285, London, 1982 [I] and in preparation [II]

*Survey*, VI

K. L. Scott, *Later Gothic Manuscripts* (*A Survey of Manuscripts Illuminated in the British Isles*, VI); in preparation

Vienna, 1962

Kunsthistorisches Museum, Vienna, *Europäische Kunst um 1400* (Council of Europe Exhibition, no. 8), 1962

Vitzthum, *Pariser Miniaturmalerei*

G. von Vitzthum, *Die Pariser Miniaturmalerei von der Zeit des hl. Ludwig bis zu Philipp von Valois und ihr Verhältnis zur Malerei in Nordwesteuropa*, Leipzig, 1907

Warner, *Illuminated Manuscripts in the British Museum*

G. Warner, *Illuminated Manuscripts in the British Museum*, London, 1903

Warner and Gilson

G. F. Warner, J. P. Gilson, *Catalogue of Western Manuscripts in the Old Royal and King's Collections*, 4 vols., London, British Museum, 1921

Watson, *Dated Manuscripts*

A. G. Watson, *Catalogue of Dated and Datable Manuscripts c. 700–1600 in the Department of Manuscripts in the British Library*, London, 1979

Wormald, 'Fitzwarin Psalter'

F. Wormald, 'The Fitzwarin Psalter and its Allies', *J.W.C.I.*, VI, 1943, 71–79

Wormald, *Kalendars*, I, II

F. Wormald, *English Benedictine Kalendars after A.D. 1100*, 2 vols. (*H.B.S.*, LXXVII, LXXXI), 1939, 1946

Wormald and Giles, 'Handlist', I, II, III, V

F. Wormald and P. Giles, 'A Handlist of the Additional Manuscripts in the Fitzwilliam Museum Received Since the Publication of the Catalogue by Dr. M. R. James in 1895, Excluding the McClean Bequest', *Transactions of the Cambridge Bibliographical Society*, pt. I, 1951, 197–207; pt. II, 1952, 297–309; pt. III, 1953, 365–75; pt. V, 1966, 173–78

Wormald and Giles, *Catalogue*, I, II

F. Wormald and P. Giles, *A Descriptive Catalogue of the Additional Illuminated Manuscripts in the Fitzwilliam Museum acquired between 1895 and 1979 (excluding the McClean Collection)*, 2 vols. Cambridge, 1982

Yapp, 'Birds'

W. B. Yapp, 'The Birds of English Medieval Manuscripts', *Journal of Medieval History*, V, 1979, 315–48

# INTRODUCTION

## ENGLISH ILLUMINATION AND EUROPE
## IN THE FOURTEENTH CENTURY

SHORTLY BEFORE AUGUST, 1284, a richly illuminated Psalter was begun in England in anticipation of the marriage of Edward I's son Alphonso, who died before it was completed. With this manuscript – the Alphonso Psalter – the present volume of the *Survey of Manuscripts Illuminated in The British Isles* begins. Exactly one hundred years later the elaborately decorated missal given by Abbot Nicholas Litlyngton to Westminster Abbey was completed. With the Litlyngton Missal (no. 150), and its successors during the next decade, the volume ends. Although this study is concerned essentially with 14th-century illumination, it begins with works of the 1280s rather than 1300 because the Alphonso Psalter and its contemporary relative, the Ashridge Petrus Comester (no. 2), seem to be at the beginning rather than the end of a phase of English manuscript painting. The exquisite modulations of surface texture and shape, the acute accuracy of representation of tiny aspects of the natural world, the astounding minuteness of scale and richness of detail are new in English Gothic manuscripts, as if the most refined style of English 13th-century panel painting – surviving only in the Westminster Abbey Retable (fig. 1) – could be translated for the first time to the parchment page.

By and large, the finest English manuscripts of the second half of the 13th century, such as the Douce Apocalypse or the Oscott Psalter (*Survey*, IV, nos. 153, 151), are characterized by severe linearity and grandeur of scale (fig. 2); where their decoration is small in scale and crammed with detail, as in the Bible of William of Devon (*Survey*, IV, no. 159), nuances of surface modulation are absent (fig. 3). Consequently, it may be concluded that the manuscripts with which the volume begins introduce genuine innovations. These features can be traced through most of the 14th century, as for instance in the St. Omer Psalter (no. 104) and the Bohun manuscripts (nos. 133–141); but a rich, elegant, detailed and acutely perceptive miniature style is only one of the strands composing the complex interlace pattern of English manuscript illumination of the period. In fact, the Litlyngton Missal (no. 150), the Westminster *Liber regalis* (no. 155) and the St. Albans Abbey Benefactors' Book (no. 158) – at the end of the volume – all demonstrate the survival of the taste for monumentality and forceful linearity which characterized the Douce Apocalypse and the Oscott Psalter. The next sharp break in the development of English manuscript illumination occurred in the last decade of the 14th century with the works of the artist of the Carmelite Missal named the 'Dutch Master' by Margaret Rickert (fig. 4). This work is miniature in scale, full of appealing and accurate nuances of surface detail and form, but the detail is part of an integrated vision creating an illusion not only of the surfaces but of the spaces of the visual world. The beginning of a new phase of book illustration can be found in the Dutch Master's historiated initials in the Carmelite Missal, and for this reason the manuscript marks a fitting start to the last volume in the series (*Survey*, VI, no. 2).

Between the Alphonso Psalter and the Litlyngton Missal it is apparent that no single line of development occurred. Certainly this could not be the case literally, for the surviving illuminated manuscripts represent no more than a fraction of those once extant; direct

knowledge of one surviving book by the artist of another cannot be assumed but must be proven case by case. Moreover, the area ruled over by the English kings in the 14th century was not a centralized artistic monolith, but rather an artistic 'consortium' with multiple contemporary stylistic variants dependent on factors not only of geography but patronage, type of project, and method of production.

While the complexities of stylistic development are the main subject of inquiry in this introductory essay, the characteristics common to English 14th-century illumination may be outlined first. Most important seems to be a consistent taste for the heterogeneous as opposed to the homogeneous, the multiple as opposed to the unified – resulting in surprising and often anachronistic juxtapositions of linear and plastic, two- and three-dimensional, multi-centred or multi-focused rather than hierarchical and centralized compositional organization; and interaction or interpenetration of the pictorial elements with the picture (or initial) frame rather than clear separation of picture and frame. These characteristics recur throughout the 14th century. They are found in the company of another group of features – a strong sense of visual humour, a taste for the grotesque, even the ugly and brutal, for detailed pictorial narrative, for depiction of the particularities of nature, often made more piquant or dramatic by juxtaposition or intermingling with representations of stylized, non-natural fantasies and hybrids.

The preceding characterization accords with scholarly opinion that English Gothic illumination is inherently earthy, naïve, humorous, and full of acute observations from nature at the same time as it tends to be flat and linear. Most modern writers have differentiated between these English characteristics and those of contemporary illumination on the Continent, particularly in France, noting the uniform, balanced compositions, the suave modelling, the harmony of scale – especially the uniformity of small scale – the general sophistication, elegance and courtliness of French Gothic manuscripts.[1] Terms such as piquant, absurd, grotesque, ambiguous, or violent – common in description of English illumination – are rarely found in discussions of French manuscript painting.

Such sharp distinctions are only partly true, however, or perhaps they are truisms. Not all French manuscripts of the period are courtly, suave and elegant, and certainly not all English manuscripts are earthy, naïve, humorous, nor full of observations of nature. Nevertheless, these ideas have taken such a strong hold that some modern writers on English medieval manuscripts 'explain away' every courtly or sophisticated English work of the period as 'French-influenced'. Vitzthum, writing in 1907 of the French-influenced English court atelier of c.1300, by which he meant the Psalter of Queen Isabella in Munich (no. 27) and related manuscripts, cited Von Schlosser's conclusion of 1895 that 'English court art was under French influence throughout the 13th century'.[2] In his volume on English manuscripts of the 10th to the 13th century, Eric Millar commented on the strong French influence in the Alphonso Psalter and the Ashridge Petrus Comestor (no. 2), adding that these books 'represent all that is most perfect in 13th-century art'.[3] His general distinction between France and England, written for the introduction to his volume on the 14th and 15th centuries, is worth quoting in full:

> In France, from the year 1300 onwards, illuminators continued to work often on a small scale, and with the most marvellous delicacy and refinement. English artists, on the other hand, indulged to the full their taste for splendid and vigorous ornament, and if there is rarely in their work the exquisite finish of the best French production there is ample compensation in its boldness and virility, while they maintained the great tradition of outline drawing that had been handed down to them through three centuries.[4]

In a more recent appraisal, Richard Marks and Nigel Morgan have used the term 'French

manner' in describing the Alphonso Psalter, the Windmill Psalter (no. 4) and the Queen Mary Psalter (no. 56), commenting that the elegant, relaxed and sinuous figure poses and softly drawn heads with sweet faces are close to Parisian art from Master Honoré to Jean Pucelle.[5]

The assumption of the priority of France over England in the development of a refined, softly modelled style, 'sweet' in expression, needs reassessment. The roots of this assumption lie in the demonstrated leadership of the Ile de France in the development of Gothic architecture and in the clear debts of Early English cathedrals such as Canterbury and Westminster to the Early and High Gothic of France. But is French influence really demonstrable by analysis of the relationships among illuminated manuscripts? The case of the Alphonso Psalter and one or another of the works usually attributed to Master Honoré[6] – the Breviary of Philip the Fair in Paris, the *Somme le roi* in London (fig. 5), or the Nuremberg Hours – serves as a test. The French books were probably executed around 1290 to 1295 and the English manuscript in 1284. So far, no earlier French manuscript – including the Canon Law text of Gratian's *Decretum* in Tours, dated in 1288, with one illustration attributed to Honoré[7] – appears to be as close to the Alphonso Psalter in style as the Breviary of Philip the Fair, the London *Somme le roi* and the Nuremberg Hours; there is no certain proof that this particular Parisian style appeared first in France and then was transported to England. In fact, in a dissenting opinion, D. H. Turner claimed in his study of Master Honoré that: 'It is in English painting in the second and third quarter of the 13th century that a new spirit and tradition had emerged, to which we may look for the inspiration of Honoré's later manner'.[8] Turner saw in English art the source of the convincing dramatic gestures and facial expressions which he found particularly impressive in the work of Master Honoré, qualities which distinguished this artist's work from the sweet conventionality of his Parisian contemporaries.

Insofar as the style of the master of the Alphonso Psalter and the chief artist of the Breviary of Philip the Fair are similar, direct influence of one on the other cannot be proven. It might be more appropriate to explain the artistic similarities by considering the parallel circumstances of patronage and production of these books. They were made for royal patrons, and the taste for elegance and luxury, which is demonstrated in contemporary royal and noble wills and inventories with their emphasis on goldsmith's work, jewels, embroideries, silks and *objets de luxe*,[9] is reflected in the exquisite, polished beauty of these manuscripts, whether on one side of the Channel or the other.

However, the more detailed the examination of the Alphonso Psalter, the less close the relationship with Parisian manuscripts appears. Surely the most striking aspect of the completed pages of the Alphonso Psalter is the realization of the marginal subjects, the graphic and convincing depiction of creatures natural and fantastic in 'real world' or *monde renversé* situations. These marginal creatures, shaded, coloured and textured with the same exquisite finesse as the figure of David in the first historiated initial of the Psalter, are found nowhere in the works attributed to Master Honoré. Consequently, while individual aspects of the so-called 'French manner' of the Alphonso Psalter have parallels in contemporary Parisian art, and while these features more consistently characterize French illumination than English, the very similarities are more useful in distinguishing one style – as an entity – from the other than in demonstrating the dependence of one on the other.

The value of comparative study over the search for priority or influences is borne out again by a consideration of the relationship between the mise-en-page of English manuscripts of the late 13th and early 14th centuries and those from Northern and Eastern France and French Flanders. Cockerell, in characterizing the East Anglian School (in which he included most of the important English manuscripts illuminated from c.1250 to 1325), attributed part of its vitality to influences from across the Channel, 'its sympathy with the vigorous schools of

Artois and French Flanders being clearly shown in its fondness for marginal grotesques'.[10] Subsequently, Rickert was uncertain only whether East Anglian illumination displayed 'direct' (or indirect) North French or Flemish influence.[11] Most students have agreed, however, that in the introduction of marginal illustration, especially of the sort unrelated in content to the text, England had the priority,[12] since by the middle of the 13th century marginalia had made a spectacular appearance on almost every page of the Rutland Psalter (*Survey*, IV, no. 112), long before they appeared on the Continent.

A sampling of manuscripts produced on both sides of the Channel during a particular period – for example, around 1300 – would show parallels rather than influences from either side. If, for instance, the elegant Breviary of Reginald of Bar of 1302–04 (fig. 6), made for use in the diocese of Verdun,[13] is compared with the equally fine Tickhill Psalter of 1303–14 (no. 26), the figure style, especially that of the small, agile marginal figures, rather doll-like in proportions and jaunty in pose and gesture, would appear strikingly similar, but the decorative framework of the breviary – its comparatively small-scale historiated initials neatly enclosed in squares, and the rectilinearity of the border bands which is broken regularly at the corners by symmetrical curving foliated shoots – would resemble more closely the Alphonso Psalter of twenty years earlier than the contemporary Tickhill Psalter, with its large figured initials, and asymmetrical, organic borders bursting with varied, natural foliage.

If the Bar Breviary is compared with the contemporary Peterborough Psalter (no. 40), which belongs to a different group of English manuscripts from the Tickhill Psalter, then the points of similarity and difference shift some degrees. The scale of the historiated initial in the Peterborough Psalter is small, as in the Bar Breviary, but the figures within it are comparatively larger, and the marginal motifs are larger still, tending to greater visual importance than the historiation within the initial. The border frame is not a neutral bar with small foliate shoots but an amalgam of human, hybrid, animal, foliate and floral forms in a variety of scales and iconographic relationships or non-relationships.

The characterization of these three contemporary manuscripts has some validity as a more general characterization of the distinction between English and Continental marginal illustration. At least two points seem worth comment: (1) the Tickhill Psalter marginal illustrations are serial, in this case forming an entire Biblical cycle on successive pages; no contemporary French manuscript contains continuous, serial marginalia, yet not only do such illustrations occur in other manuscripts of the Tickhill group (e.g. the Isabella Psalter in Munich, no. 27), but they recur in numerous English volumes of the 14th century – the Queen Mary Psalter (no. 56), Taymouth Hours (no. 98), Smithfield Decretals (no. 101), and Carew-Poyntz Hours (no. 130) – while they are hardly known in France; (2) the components – human, animal, hybrid, foliate, abstract, heraldic – of both the Peterborough and the Tickhill borders are varied in theme, in scale and subject to surprising juxtapositions of a visual as well as literary sort, 'sight gags' based on sheer visual improbability as well as pictorial renditions of entertaining stories or parodies of human situations; these features recur in English manuscripts throughout the 14th century, characterizing not only the East Anglian School, but reappearing in especially inventive form in a number of manuscripts of the Bohun group at a time when they had all but disappeared on the Continent.

Another question that should be raised again is the extent and nature of French influence on the Queen Mary Psalter (no. 56). Modern scholars have usually commented on the profoundly French quality of the Queen Mary Psalter.[14] Some of the most fundamental and consistent characteristics of French Gothic illumination – the qualities of compositional harmony, balance and clarity – permeate the English work. The refined taste demonstrated even by the drolleries, the gentle grace of the figures in pose, gesture and physiognomy, all evoke the French spirit. Yet here, where the Queen Mary Master appears to have shown an appreciation of the fundamentals of Parisian art, not just an appropriation of selected

techniques or motifs, it is surprisingly difficult to cite extant manuscripts either earlier or contemporary that might have provided models, or even parallels. As for models, there is the problem of the uncertainty of the date of execution of the Queen Mary Psalter although, for reasons to be detailed in the catalogue following, a date in the second decade of the 14th century may be proposed. Among the possible sources or parallels of the Queen Mary style are a number of books executed in Paris between *c.* 1315 and 1320, books such as the Wymonduswold *Decretum*, the Life of St. Denis, the Chronicles of the Kings of France in Paris (fig. 7), and Henricus de Segusia's Commentary on the Decretals in Brussels.[15] Related to the Queen Mary Psalter are the tall, willowy figure proportions, the graceful stance and gesture, and the articulated (rather than ovoid) facial structure. The artists of these French books also seem to have shown a preference for line over surface modulation or texture, a taste expressed still more decisively by the Queen Mary Master. Indeed, if all the salient characteristics of the Queen Mary style were enumerated, linearity, or linearism, would be high on the list. Line is not the fine, firm, continuous outline of the French manuscripts, however, but is varied in thickness, bite, length and direction; it is employed with the utmost grace and delicacy but with equal freedom. In the Queen Mary Psalter the colour, too, is often applied as washes with a kind of swift, carefree abandon, perfectly controlled by the artist. The colour in the French manuscripts is more opaque, and more evenly modulated. As a result, the figures – equally readable – are more tangible and substantial than those in the English book.

It remains a question whether these particular French illuminations were the transmitters of the French manner to the Queen Mary Psalter. In fact, the Wymonduswold *Decretum* and the Brussels Decretals Commentary were considered to be English works by Vitzthum, and both he and Erwin Panofsky thought that the Chronicle of the French Kings was influenced by English art.[16] Their conclusion is given some support by the fact that the scribe of the Chronicle was William the Scot (the scribe of the Wymonduswold *Decretum*, Thomas Wymonduswold, was also from the British Isles), but recently François Avril has shown convincingly that the artists themselves were French and that both they and the British scribes did their work in Paris.[17] Paris was an international centre of book production; as English scribes worked with French illuminators, so did English illuminators work with French scribes; for instance, in an Aristotle in the Bibliothèque Nationale (no. 70), in which the painted decoration was executed in the Queen Mary style, the text was flourished with penwork by an Anglo-French team, and written throughout by a French scribe.[18]

For the second half of the 14th century, the accepted view is that illuminated manuscripts produced in England first fell under the influence of Flanders, and then of Bohemia, all the while borrowing here and there aspects of Italian art, ranging from isolated motifs of daring foreshortening, or techniques of modelling, to entire compositions.[19] Indeed, artistic debts to Italy were accrued throughout the 14th century, but the impact or successive impacts of Italian art are more easily defined than the exact nature of the relationship of English illumination to that of Flanders or Bohemia.

The question of Bohemian influence has recently been fully dealt with by Amanda Simpson.[20] At the beginning of the present century J. W. Bradley put forward the idea that Anne of Bohemia brought the Bohemian manner to England at the time of her marriage in 1382 to Richard II, and he was the first to suggest that the *Liber regalis*, made, he thought, for Anne's coronation in 1382, was influenced by the Bohemian style.[21] This hypothesis has been accepted as fact ever since, although one of its chief proponents, Margaret Rickert, introduced a certain doubtful note when she admitted that she could not find close stylistic parallels to the *Liber regalis* in either of the two chief groups of Bohemian manuscripts of the second half of the 14th century.[22]

Simpson examined the pictorial evidence in greater detail than previous scholars and concluded that if comparisons were limited to surviving Bohemian manuscripts known to have been executed before Anne's arrival in England, the results were negative. Indeed, Bohemian art during the 14th century underwent a splendid renaissance under the successive monarchs Charles IV, the Holy Roman Emperor, and his son (Anne's half-brother) Wenceslas, whose names are associated with a number of lavish books. These contain miniatures and historiated initials with heavily modelled figures, brilliant gold grounds, and elaborate borders with lush, fleshy foliage, all showing similarities with the contemporary painting of Naples and Avignon.[23] But the only Bohemian style that parallels that of the *Liber regalis* did not develop until the last decade of the century (fig. 8),[24] by which time Anne of Bohemia had died (1394) and Richard II had married Isabelle of Valois (1396). Consequently, the 'Bohemian manner' in English illumination appears to be misnamed. If foreign precedents or exactly contemporary parallels are to be identified, they are as likely to be French, Flemish, or even Italian, as Bohemian.

The idea that Flemish illumination influenced England in the second half of the 14th century was put forward tentatively by Margaret Rickert, who commented without explanation that some of the Bohun manuscripts were illuminated in 'some version of French or possibly Flemish style'.[25] This was taken up by Amanda Simpson in her recent dissertation; she proposed that a group of Flemish manuscripts associated with Louis de Male, Count of Flanders, and made *c*. 1360, was connected with the dominant Bohun style, pointing out that the Bodleian Psalter-Hours (no. 138), the Fitzwilliam Psalter (no. 139), much of the Egerton Psalter (no. 135) and these Flemish books, all have similar figures characterized by 'curly hair and coarse featured faces' and 'raffish expressions', and all employ similar 'ponderous' architectural canopies.[26] Simpson discussed the relation of the particular Bohun style and the Louis de Male style not so much in terms of the influence of Flanders on England but rather to differentiate the 'Flemish' from the 'Italian' Bohun manners. Nevertheless, she seems to have assumed that the Flemish connection was not simply a parallel but an influence transmitted across the Channel to the Bohun workshop. This view has recently appeared in print in the remark of Marks and Morgan that both Flemish and Italian elements appear in the Bohun manuscripts, apparently referring to the same Louis de Male books as Simpson.[27] It is worthy of note that Gaspar and Lyna, the first modern commentators on the Flemish manuscripts, took the opposite point of view, observing English influence on the Flemish works (and describing the drawing as 'correct' but hard and without life, the modelling with only slight accents of white, and the 'tasteless' juxtaposition of colours);[28] and this line was taken up by Delaissé in his discussion of the same manuscripts in 1959 and 1967, when he commented that the 'very linear style' and the 'rich marginal decoration and the amusing grotesques recall the illustration of English 14th-century liturgical books'.[29]

The mutually exclusive conclusions about the sources of these English and Flemish manuscripts suggest that while modern scholars on both sides of the Channel are willing to view the artistic styles of their own nations as receptive to outside influences, there is too ready a willingness to ascribe every striking artistic change to a foreign influence. Ample evidence exists in English manuscripts that the 'Flemish' manner, in both its figural and its decorative aspects, was an indigenous development from the style of mid-century books such as the Psalter of Simon de Montacute (no. 112) and that the roots of this style can be traced back to manuscripts such as the St. Omer Psalter (no. 104) and Douce 131 (no. 106) in the 1320s. Interestingly enough, the figures of the Flemish manuscripts (fig. 9) – small-scale, wasp-waisted, thin-armed and thin-legged, often with squinting eyes and open mouths with red lips – seem closer to those in mid-century English manuscripts – not only the Psalter of Simon de Montacute but the Fitzwarin Psalter (no. 120) and the Bodleian Psalter, Liturg. 198 (no. 121) – than to the main style of the Bohun volumes. Elements of decoration, especially the initial

frames composed of profile faces and jaw-to-jaw monster heads appear, however, in English illumination only with the Bohun manuscripts, not earlier,[30] while the particular kind of neat, thin foliate spiral in the Flemish borders is similar to motifs in later rather than earlier books of the Bohun group, above all, the Bodleian Psalter and Hours (no. 138) and the Psalter in Cambridge (no. 139), both probably executed *c*. 1380.

Thus, individual aspects of the Flemish manuscripts have diverse relationships with English manuscripts of the half century roughly beginning at 1320. These relationships are neither so concentrated nor consistent as to constitute an influence. Moreover, the Flemish manuscripts which have been proposed as sources of influence – a Breviary, two Missals, an Antiphonal, and a Book of Hours[31] – are devoid of the abundant narrative imagery which is a hallmark of the Bohun manuscripts. Their programmes of illustration are conventional and reduced in comparison to the Bohun manuscripts. What attractive features then would these books have offered to English artists that their own tradition could not have provided? The answer seems to be none.

If the question is reversed, that is, reverting to Gaspar and Lyna's assertion of English influence on Flemish manuscripts, the answer is likely to be the same. Flanders, too, had an artistic tradition that could account for many of the features found in the Louis de Male volumes. Figures with similar types of body structure – sloping-shouldered, narrow-torsoed, thin-armed, bow-legged – and similar facial types – squinting-eyed and 'cruel'-mouthed – painted in rather anachronistic combinations of shaded drapery, outlined and uncoloured faces and coloured linear-patterned hair, had occurred in earlier Flemish manuscripts such as the Romance of Alexander in the Bodleian Library, of which the illustrations were completed in 1344 (fig. 10).[32] This manuscript, too, is characterized by elaborate architectural tower-frames and canopies, rendered in perspective and often illusionistically shaded, as in the Louis de Male books. Moreover, the drolleries of the Romance of Alexander form a link between the marginalia of the Louis de Male manuscripts – the bas-de-page subjects of the Breviary and Antiphonal and the marginal birds of the Hours in the Bodleian Library – and Franco-Flemish Psalters and Hours of the late 13th and early 14th centuries, in which such marginal elements abound.

Once again it seems to be more accurate or adequate to think in terms of parallels between English and Continental art than to draw conclusions about influence in either direction. Once again, too, the observation of parallels throws into relief the intrinsic differences between these groups of manuscripts and produces a clearer picture of the English work – the antic fantasy world of its marginal illustrations, the boundless loquacity of its pictorial narrative, and the dazzling virtuosity of its infinitesimal detail. Yet to insist on parallel development rather than influence by Flanders on England or vice versa is not to say that there were no artistic contacts or exchanges. The Flemish Antiphonal of *c*. 1360 in Brussels (Bibl. Royale MS 6426) contains two small historiated initials, a Baptism on f. 36 and Christ holding a child's hand on f. 42 (fig. 12), which seem to have been painted by one of the Bohun artists, perhaps one of those in the Exeter College Psalter (no. 134). The Flemish Book of Hours in the Bodleian Library (MS Lat. liturg. f. 3), associated traditionally though incorrectly with Anne of Bohemia,[33] has border decoration (fig. 11) by a Bohun group artist close to the main decorator of Egerton MS 3277 (no. 135), while most of the miniatures (fig. 13) are the work of one of the painters of the Antiphonal in Brussels. Finally, the same style of border decoration – golden foliate streamers projecting perpendicularly into the margin, convincing black-and-white birds in flight, stylized flying insects, along with more typical Bohun motifs such as profile head or jaw-to-jaw monster initial-frames – recurs in the English Psalter-fragment in the British Library, MS Royal 13. D. I* (no. 131) together with large historiated initials and figural borders by two other artists, one of the Bohun group, working in the manner of the major decorated pages of

the Exeter College Psalter (no. 134) and the other possibly Flemish, working in the style of the miniaturist of the Brussels Antiphonal.

It would be as useful to compare the Bohun manuscripts with those produced in Paris as with those of Flemish origin. Such a comparison would reveal yet other aspects of the English books. While the number of Flemish manuscripts contemporary with the Bohun group is small, the number of French – Parisian – manuscripts of the period is relatively large. The French counterparts of the Bohun volumes are associated with the name Mâitre aux Boqueteaux, given to the artist who started the Bible of Jean de Sy in 1356 for Jean le Bon.[34] Work in the Boqueteaux style (fig. 14) is marked by shaded, often grisaille figures of wasp-waisted, large-headed, thin-armed proportions, clothed in soft and swirling robes or skin-tight tunics and wearing fashionably pointed shoes, figures whose faces have high, sloping brows, deep-set eyes, prominent noses and plump lips. Boqueteaux compositions are often dramatic, the figures clustered together or widely separated in a tense, highly-strung manner, their passionate gestures either cutting across each other, or silhouetted against the patterned grounds. Despite the dynamic movement of pose and gesture, the Boqueteaux compositions are legible and rational. The frame, for instance, is unbroken by projecting figures, indeed, it usually cuts them off, and all the figures are placed in the same single, uniform ground area; the artist confidently and convincingly sets figures at oblique angles to the picture-plane and the flat background, in this way emphasizing the sense of a stage on which the action takes place.

The superb technique, the soft and refined surface detail, and the dramatic pictorial narrative – as well as the general figural types – of the Boqueteaux Master are linked to the Bohun artists. Yet these similarities serve to dramatize the differences between the English and the French masters, for the Boqueteaux paintings are far more convincingly anchored in a 'real' world in which figures move in space, in which figures – in smoothly shaded grisaille – are of one substance, and background – patterned in gold and colour – is of another, and in which narrative accessories – furniture, curtains, trees, even the famous *boqueteaux* – are purely symbolic and never vie for attention with the more important aspects of the narrative, as they do so frequently in the Bohun works.

In a magisterial article of 1943, Otto Pächt defined precisely for the first time the impact of the painting of Trecento Italy on English illumination.[35] He saw three waves, or phases, of influence, each qualitatively different from the other. The first – in the first decade of the century – was the borrowing of isolated Italian figural motifs, generally those of classical ancestry, which perhaps held an attraction because of the presentation of the figures in complex, foreshortened poses. The second phase – in the 1320s – Ducciesque in origin, resulted in the borrowing of entire compositions – the Crucifixion of the Gorleston Psalter (no. 50) is an example – and also in the creation of new compositions using Italian techniques of rendering space perspectively – for instance, the Last Judgement of the St. Omer Psalter (no. 104) and representing surfaces and volumes of forms without exterior outlines – as throughout the Douai Psalter (no. 105). The third phase, which Pächt called a 'Giottesque episode', revealed a still more profound absorption of Italian painting, particularly in the creation of volumetric figures displacing space in a manner echoing that of the Florentine master, albeit on a small scale. Pächt saw the greatest impact of the Giottesque in a small group of manuscripts of the 1360s, centred on the Egerton Genesis (no. 129).

To Pächt's waves of Italian influence Margaret Rickert and others since have added one more in noting the Italian features of the Bohun manuscripts,[36] no longer Giottesque but perhaps more akin to Italian painting in the second half of the century – the post-Black-Death styles characterized by Millard Meiss.[37] The bland, pastel colour, the floating figures with the broad, uninflected surfaces that occur in central Italian painting after the Black Death, seem to have found a sympathetic echo in the work of some Bohun artists, the master of the full-page

miniatures of the Bodleian Psalter-Hours (no. 138) above all; and the attraction of Italian art is proven again by the appearance of Italianate motifs such as the Man of Sorrows (fig. 15) in the Egerton Psalter (no. 135), probably before 1373 (fig. 16).

Most of the Italian sources were Tuscan, not surprising since Tuscany was the most vital artistic centre in Italy during much of the 14th century. The contributions of other regions of Italy have also been mentioned. Pächt, for example, compared the decorative mise-en-page of Bolognese Bibles and legal treatises to the marginal decor of English manuscripts,[38] and Jonathan Alexander has recently discussed a number of Decretals written and partly illustrated in Italy with added English illustrations imitating Bolognese work.[39] Pächt also suggested the well-known Paduan Picture Bible in the British Library (fig. 18) as a stylistic as well as iconographic source of the Egerton Genesis,[40] but in this he seems to have discounted the heavy, sculptural plasticity of the Italian work, which differs considerably from the light, sharp, almost metallic cutting of the shaded drawings in the English book.

Indeed, the source of the indubitably Italianate style of the Egerton Genesis remains to be specified. Naples or Avignon may be put forward as possibilities. During the 14th century the Sienese style, which was brought to Naples by Simone Martini, encountered the Northern Gothic style of the French artists employed by the Angevin rulers of the kingdom. Although hardly any of the monumental painting of this period survives in Naples, a considerable number of manuscripts remains. Some of these books contain long cycles of coloured or tinted drawings, the figures and other compositional components painted in shaded, translucent tones on natural parchment grounds (fig. 18).[41] There are obvious technical similarities to the Egerton Genesis, but closer still are the figure proportions, the stances and gestures – and the drapery systems with precisely edged folds, not only falling vertically but cutting across the body in parallel curving lines. The linear refinement of the Neapolitan style was perhaps its attraction to English artists. Certainly the parallels between such a book as the British Library Dante (fig. 17)[42] and the Egerton Genesis are striking. It is interesting also that some of the lesser motifs of the Egerton group – the lopped-off branches of trees, the heart-shaped foliage with spiral 'veins' – have counterparts among Neapolitan manuscripts too.

Naples may also have been the source of sporadic later appearances of Italianate compositions in manuscripts of the Litlyngton Missal group, in particular the Crucifixion of the Litlyngton Missal itself (no. 150). The Neapolitan Missal now in Avignon (fig. 19)[43] offers not only close compositional analogues, and similar virtuoso foreshortened poses but also some of the same exotic details of coiffure and headgear,[44] sharing with the English miniature a taste for elaborate, flat surface decoration which sometimes vies with volumetric figure contours and modelling. It may be that the Neapolitan style was transmitted to England not only directly (some surviving Neapolitan manuscripts have long histories in English collections)[45] but through the intermediary of Avignon. The presence of the papal court in Avignon during much of the 14th century, the employment by French popes of Italian artists, including Simone Martini, led after the middle of the century to the development of a Franco-Italian artistic style with close parallels to that of Naples, a style exemplified by the frescoes of Matteo Giovannetti on the one hand, and the Missal of Clement VII on the other.[46] It may have been in the diplomatic pouches of papal envoys that this style reached the British Isles (and it is certainly known that English artists were employed at the court in Avignon).[47]

## GROUPS OF ENGLISH MANUSCRIPTS OF THE FOURTEENTH CENTURY

As noted above, 'England' during the 14th century was not a monolithic cultural entity, and although 'Englishness' can be recognized, especially in relation to Continental artistic

styles, the variations among English manuscripts of the period, even among those apparently contemporary in date, can be great. Traditionally, at least for the first half of the century, almost all the surviving manuscripts have been considered under one of two headings – Court School or East Anglian. 'Court Style' or 'Court School', originated in classifying manuscripts from the Alphonso Psalter to the Queen Mary Psalter that have royal connections. 'East Anglian', a portmanteau term, has been used for a large number of books with some connection by provenance or destination to the geographical area of East Anglia. This schema is inadequate as a characterization of the material, which rather than being split simply into two broad categories, ought to be divided into a larger number of small segments. Although the conventional terms 'Court School' and 'East Anglian' are used here, they serve primarily as reference points for definition of the distinctive character of a number of small groups of manuscripts situated all along a broad spectrum of style.

(a) *The Court Styles*

The term 'Court School' can be understood in a number of ways; first of all literally, as pertaining to works produced for the court of the sovereign of England. In this usage, the actual centre of production would be understood to be Westminster – both the Palace (now almost entirely lost) and the Abbey, of which, fortunately, significant portions decorated in the late 13th and early 14th century survive. For the period before 1325 only a few manuscripts meet these criteria, namely the Alphonso Psalter (no. 1), the Ashridge Petrus Comestor (no. 2) and the Isabella Psalter in Munich (no. 27), and the last is less sure than the others because although undoubtedly destined for a royal owner, its Calendar was for use in the diocese of York and its closest stylistic relation – the Tickhill Psalter (no. 26) – was also made for use in York diocese. Thus patronage and place of origin alone are insufficient to identify the Court School. In fact, the term is used most often as a shorthand reference to a set of stylistic features, found certainly in the Alphonso Psalter, the Petrus Comestor, and in the Isabella Psalter, and in a number of other volumes, some with indications of provenance or destination in the London area, and some linked only by style to the rest of the group.

The style may be characterized as elegant and refined and, especially around 1300, miniature in scale, sparkling in colour, rich and elaborate in surface texture, and full of wit and sharp observation of details from nature. Among the manuscripts executed in this style *c.* 1300 are the Windmill and Mostyn Psalters (nos. 4 and 5) of the 1290s. Adelaide Bennett has suggested that the Windmill Psalter was made for Edward I and that it bears his cypher 'E' in the enlarged second letter of the first psalm, 'BEatus vir';[48] the Mostyn Psalter, whose main psalm initials were historiated by an artist close to the Windmill Psalter master, has a Calendar for the diocese of London. Both these books are marked by the characteristic refinement of surface and scale of the Court Style, although the figure handling lacks the disarming grace of the Alphonso Psalter, being more sharp, linear and intense in expression.

If these books have some geographical connections with London–Westminster, then the following group in the Court Style is more problematic. The central figure would be the first artist of the Peterborough Psalter in Brussels (no. 40), who may have planned the whole enterprise. He was the artistic heir of the master of the Alphonso Psalter. His work combines finesse and gusto in a way that epitomizes the Court Style, yet the destined owner (and the provenance of the manuscript) was the Benedictine Abbey of Peterborough, on the borders of East Anglia, geographically and ecclesiastically distant from the Court. Closely related to the work of the first artist of the Peterborough Psalter are the illustrations of the Bestiary attached to the Psalter of Hugh of Stukeley, prior of

Peterborough (no. 23), a manuscript whose origins are unknown in spite of its attachment to the Psalter (no. 66), which itself came to Peterborough from the diocese of Norwich. An artist very close to the Bestiary miniaturist did the illustrations of the Psalter in Jesus College, Oxford (no. 24), and the Calendar of this Psalter contains some slight hints pointing toward London, though it is not by any means an orthodox London Calendar. However, the Jesus College Psalter artist participated, probably before 1310, in the decoration of the Bible in the Mazarine Library (no. 25) that seems to have been made for Anthony Bek, sometime Bishop of Durham and Chancellor of Edward I, a provenance again pointing back to Court circles. Not all the books listed above were completed entirely in the Court Style, however. The Alphonso Psalter, the Peterborough Psalter in Brussels and the Mazarine Bible all contain considerable amounts of decoration in a bold, larger-scaled manner that falls in a general way into the 'East Anglian' category. The juxtaposition of 'Court' with 'East Anglian' suggests at least some question as to the validity of either of these terms as accurate descriptions of the actual place of origin of these books.[49]

The term 'Court Style' may also be employed to characterize manuscripts resembling works of art in other media found in royal palaces and churches. The Court Style in manuscript illumination would then be the counterpart of the Decorated Style in architecture and more particularly its elegant, restrained London–Westminster variant.[50] During the late 13th and early 14th century, London saw the completion of Old St. Paul's, the beginning of Greyfriars,[51] among large-scale projects, and among components of interior furnishing, the construction and painting of the throne of Edward I and the sedilia of Westminster Abbey (fig. 20), the building of the tombs of Edmund Crouchback and Aymer de Valence.[52] It may be, however, that these various projects, a number of which included large-scale painting, had only rare reflections in manuscript illumination, of which the Psalter of Robert de Lisle of c. 1310 (no. 38) is practically the only survivor.

Another possible manifestation of the Court Style is the group of manuscripts around the Queen Mary Psalter. George Warner proposed that this manuscript – of unparalleled pictorial abundance and highest artistic quality – had been made for Edward I or Edward II, putting this view forward on the basis of the calendrical emphasis on St. Edward the Confessor.[53] While no further evidence can be adduced to substantiate this proposal, a number of the manuscripts in the Queen Mary group are of London area provenance, and it is widely accepted at the present time that London was the centre in which they were produced, possibly during the second decade of the century. If this is the case, then it is important to observe that the previous characterization of the Court Style as miniature in scale and rich in surface detail, no longer accommodates the manuscripts of the Queen Mary group, in which, in fact, a number of innovative features occur. One of the major developments is the creation of new figure types, tall and pliant rather than *petite*, and new facial types, with articulated facial planes, not undifferentiated ovals. However, if the figures and faces are marked by a more precise and convincing sense of bodily definition, the elaboration of the surfaces of forms by rich, complex and often accurate depiction of details of pattern and texture – characteristic of the Court Style around 1300 – is reduced. Surfaces are unaccented, homogeneous, rather than scintillating and broken. In sum, the Queen Mary style might be called the 'New Court Style'. It certainly broke sharply with the Old Court Style.

(b) *The Tickhill Styles*

The Isabella Psalter (no. 27), classified by Vitzthum in 1907 among the Court School manuscripts on account of its ownership,[54] was reclassified in 1940 by D. D. Egbert as a member of a group of books clustered round the Tickhill Psalter (no. 26), a manuscript

written and gilded by John Tickhill, Augustinian prior of Worksop, Nottinghamshire (diocese of York), and left unfinished, probably at his removal from office in 1314. Egbert linked seven manuscripts together: the Tickhill and Isabella Psalters, the Grey-Fitzpayn Hours (no. 31), the Vaux Psalter (no. 30), the Welles Apocalypse (no. 34), the Guisborough Breviary (Woolhampton, Douai Abbey MS 8), the Brewes–Norwich Commentaries (no. 113), and in addition claimed the added Beatus page and other sections of the Ormesby Psalter (no. 43) for the group.[55] The links he observed were partly stylistic, partly liturgical, and partly based on the family connections (sometimes hypothetical) of the owners of the books. However, the cohesiveness of the group is unequal, each of the factors mentioned carrying a different weight in relation to the several manuscripts.

It is clear by now that the Tickhill Psalter itself contains work in two different successive styles. That of the first artist could well be characterized as Court Style, similar in manner to the Bestiary of the Psalter of Hugh of Stukeley (no. 23). This first Tickhill painter was the artist of the Isabella Psalter and two further books unknown to Egbert – a cutting from a Psalter now in the Bodleian (no. 28) and a fragmentary Sarum Hours in University Library, Cambridge (no. 29). The second Tickhill artist's work is closely related to that of the Vaux Psalter and the Grey-Fitzpayn Hours and more distantly connected with the Welles Apocalypse – and in addition, to two quite important manuscripts also unknown to Egbert, the McClean Bible (no. 32) and the Aristotle *Metaphysica* in Paris (no. 33). This second Tickhill style is large in scale, and is characterized by that bold outline, heavy, opaque colour and prominent marginal motifs of figures and animals common to 'East Anglian' work generally.

The juxtaposition of 'Court' and 'East Anglian' styles in the Tickhill Psalter parallels the sequence of styles in the Peterborough Psalter in Brussels (no. 40) and the Mazarine Bible in Paris (no. 25), and even in the Gorleston Psalter (no. 50). Yet some books included by Egbert in his Tickhill group do not seem to fit stylistically with either Tickhill manner – in particular, the Brewes–Norwich Commentaries (no. 113). Those remaining, the number now augmented by the four additions mentioned above, form a group on the basis of stylistic affinity, with the Tickhill Psalter as the pivotal manuscript. The indications of provenance, destination and origin are more varied, however. Egbert thought that the artists of the group worked for patrons in houses of Augustinian Canons in the diocese of York, possibly in the county of Nottingham.[56] This proposal applies accurately only to the Tickhill Psalter; the Isabella Psalter, while Augustinian in Calendar and Litany, was made for the use of the Queen of England, not a cleric, and insofar as its York diocese provenance can be specified more precisely, the indications point toward Staffordshire or Shropshire rather than Nottinghamshire. All three counties lie, of course, in the southern part of the diocese of York; on the other hand, the Guisborough Breviary was used at a house of Augustinian Canons in the northern part of the diocese, in Yorkshire. The Vaux Psalter, liturgically of York diocese, and geographically pointing back to the Midlands, has a Calendar rather more characteristic of the Augustinian Friars than the Augustinian Canons, and was in any case made for secular use. Other manuscripts in the group point away from York diocese entirely: the Grey-Fitzpayn Hours, for instance, are of Sarum Use, as are the Hours in the University Library, Cambridge. On the whole, then, the constitution of the group suggests more varied patronage, ownership and destination than Egbert acknowledged, even though the geographical centre of gravity was perhaps the Midlands rather than London–Westminster or the Eastern Counties. Where, if anywhere, in the Midlands such a varied group of books might have been produced, remains an open question.

## (c) *East Anglian Groups*

As recently as 1954, Margaret Rickert, in the first edition of *Painting in Britain*, included the Queen Mary Psalter and related manuscripts in the East Anglian, not the Court School.[57] In fact, for much of the twentieth century almost every important English illuminated manuscript of the first forty years of the 14th century has been called 'East Anglian'. Even manuscripts whose earliest known provenance or place of origin itself is known to be outside East Anglia – from the Alphonso Psalter to the Milemete Treatise to the Luttrell Psalter – have been considered East Anglian.[58] What underlies such an indiscriminate use of the term seems to be a sense of a broad stylistic current which in some ways is the antithesis of the Court Style in being bold rather than miniature in scale, energetic rather than elegant and earthy, even uncouth, rather than witty in attitude toward nature. Cockerell, who was certainly instrumental in the broadest application of the term, first employed 'East Anglian' in his book on the Gorleston Psalter (no. 50), which no doubt to him epitomized the style, whose main features he described as 'stateliness of the writing and lavishness of the ornament, which is gay in colour and virile, if somewhat irresponsible in design'.[59] He listed eighteen manuscripts as East Anglian. Some would now have to be eliminated from the group on the grounds of chronology or affiliation, both stylistic and by known origin, to other schools. For example, the Rutland Psalter (*Survey*, IV, no. 112) is a mid 13th-century book. Although its multiplicity of marginalia heralds a typical East Anglian mode of illustration, in style it is clearly allied with contemporary 13th-century volumes which have nothing directly to do with any group of English 14th-century books. The Alphonso Psalter, the Ashridge Petrus Comestor and the Isabella Psalter, also mentioned by Cockerell, are Court Style manuscripts; at least two were produced in London–Westminster with some certainty; the third, while it has no documented affiliation with the capital, does not point in its origin to East Anglia either, but rather toward the diocese of York. The Grey-Fitzpayn Hours (no. 31), also included by Cockerell in his East Anglian group, are linked in style with a number of other manuscripts including parts of the Tickhill Psalter (no. 26) and the Vaux Psalter (no. 30), both of which were likewise destined for the diocese of York.

The manuscripts that remain from Cockerell's East Anglian group, in addition to the Gorleston Psalter, are the Peterborough Psalter in Brussels (no. 40), the Barlow Psalter (no. 91), the Howard Psalter (no. 51), the Stowe Breviary (no. 79), the Tiptoft Missal (no. 78), the Ormesby Psalter (no. 43), the Emmanuel College Gregory *Moralia* (no. 45), the Ramsey Psalter (no. 41), the Douai Psalter (no. 105), the St. Omer Psalter (no. 104) and the Luttrell Psalter (no. 107) – to retain Cockerell's order. All these books have some heraldic, documentary or liturgical connection with East Anglia (Norfolk, Suffolk, parts of Cambridgeshire, the Isle of Ely and the fenlands of Northamptonshire and Lincolnshire), and all conform to Cockerell's characterization of the East Anglian style.

Using the same criteria, a number of manuscripts unknown to Cockerell can be added to the core list; the Gough Psalter (no. 42), the Bromholm Psalter (no. 44), the Dublin Apocalypse (no. 46), the Norwich Castle Museum Hours (no. 47), the Longleat Breviary (no. 52), the Escorial Psalter (no. 80), the All Souls College Psalter (no. 82), the Schloss Herdringen Psalter (no. 81), the Psalter in the Bodleian, Douce 131 (no. 106), and the Cluniac Psalter at Yale (no. 108), to name the most prominent. This now-enlarged East Anglian group lends itself to a number of subdivisions, constituted primarily on the basis of specific rather than general stylistic features. In fact, as many as six sub-groups emerge, each containing three or more manuscripts. First is the Fenland group, consisting of the Peterborough Psalter in Brussels (no. 40), the Ramsey Psalter (no. 41) and the Gough Psalter leaves (no. 42), all of which contain work by two of the same artists and are linked in patronage to the Fenland abbeys of Peterborough and Ramsey, at least

where their destinations are known. These are the earliest East Anglian manuscripts, apparently datable to the first decade of the 14th century.

The second group is centred on the powerful artistic personality of the chief artist of the Ormesby Psalter (no. 43), and includes not only the Gregory *Moralia* (no. 45), already mentioned by Cockerell, but the Bromholm Psalter (no. 44) and the Dublin Apocalypse (no. 46) added by M. R. James;[60] to these should be added the Norwich Castle Museum Hours (no. 47, recognized in 1973 as an East Anglian manuscript.)[61] the London Martinus Polonus (no. 48) and the Fitzwilliam Bestiary (no. 49), which contain work in the Ormesby style,[62] although not by the Ormesby master. The Ormesby master appears to have been active in the second decade of the century, but the last two manuscripts on this list were probably earlier, the Martinus Polonus, for example, dated between 1295 and 1303. Most of them have direct or indirect links in destination or early ownership to Norwich, the diocesan centre of much of East Anglia.

A third group, centred on the Gorleston Psalter (no. 50), includes the Howard Psalter (no. 51) – of all the East Anglian manuscripts listed by Cockerell the closest to the Gorleston Psalter in details of style – and the Longleat Breviary (no. 52), painted by the Howard Psalter artist. Although Cockerell reluctantly dated the Gorleston Psalter before 1306 on the basis of heraldic evidence,[63] a later dating is permitted by a reinterpretation of the heraldry; the date between 1316 and 1322 for the Longleat Breviary suggests that the Howard Psalter was contemporary. All three manuscripts may well have been executed between 1310 and 1320, during the same decade as the Ormesby group. Their destinations, however, are more diverse than those of the Ormesby volumes, for the Gorleston Psalter bears the dedication of a parish church in Suffolk (Norwich diocese), the Howard Psalter was probably intended to be used by a chaplain of the Fitton family at Wiggenhall St. Germans, Norfolk, and the Longleat Breviary was ordered by the Bohun family for the rector or vicar of Kimbolton, Huntingdonshire (Lincoln diocese).[64] Nevertheless, the three books appear to have been destined for the secular rather than monastic clergy, and it seems possible that they were to be used by priests or chaplains in the service of the families that paid for their production.

The Stowe Breviary (no. 79) is the focus of a group of East Anglian manuscripts of the 1320s. Cockerell commented on the similarities between the decoration of the Stowe Breviary and the Gorleston Psalter,[65] but he was unaware of several books with much more striking connections to the Breviary than those demonstrated by the Psalter. These include the Escorial Psalter (no. 80) which contains work by the chief Stowe artist, the Schloss Herdringen Psalter (no. 81), noted by Nigel Morgan,[66] the Psalter in All Souls College, MS 7 (no. 82) – both with work by another Stowe hand – and the Dublin Bible (no. 83), till now unpublished, but with historiated initials by the main artist of the All Souls Psalter. The Stowe Breviary, a Sarum (i.e. secular) Breviary of the diocese of Norwich, is the only member of this group with a certain East Anglian destination. The Escorial Psalter, with a unique English 14th-century Calendar of the Use of the Austin Friars, probably belonged not to a cleric but to a laywoman, a member of a Lincolnshire family. Although the destination of the All Souls Psalter is geographically East Anglian, the calendrical evidence leading to this conclusion points about equally to the dioceses of Ely on the one hand and Norwich on the other. The early history of the Schloss Herdringen Psalter and the Dublin Bible are completely unknown.

To this complex group, with its interlocking artists, should be attached three of the artists of the Tiptoft Missal (no. 78), the painter of the 'Te igitur' initial, who executed the Schloss Herdringen Psalter and the Beatus page of the All Souls Psalter, one of the border artists (ff. 91, 92, 97$^v$, 98), who also painted some of the smaller historiated initials in the Stowe Breviary (e.g. ff. 308$^v$, 332), and the figure painter of two historiated initials (ff. 216, 267), who appears to have been close to the main artist of the All Souls Psalter. Like the All Souls Psalter, the Tiptoft Missal has been attributed to Ely; it has been claimed indeed that the volume was

intended for use in Ely Cathedral Priory,[67] a claim disputed in the catalogue which follows. In any case, in spite of the participation of three artists known to have worked on the Stowe Breviary and related manuscripts, the general format of the Tiptoft Missal, with its more than six hundred broad, rectilinear borders, resembles more closely the Milemete manuscripts (nos. 84 and 85), probably produced in London, than any of the East Anglian books.

It should be noted too, that the Stowe Breviary group contrasts strongly with the East Anglian manuscripts of the preceding decade in the comparative paucity of marginal figural elements of human, animal or hybrid kind, much as the border frameworks themselves resemble those of earlier date, particularly those of the Gorleston Psalter. If these manuscripts were made in East Anglia – and if they were made by artists working consciously in the tradition of the Gorleston Psalter (or some similar now-lost manuscript) – it becomes clear that the East Anglian style had lost by the 1320s one of the most characteristic features identified by Cockerell, the fondness for marginal grotesques.

An exactly parallel change can be seen in the difference between the Barlow Psalter of 1321 to 1338 (no. 91, listed by Cockerell), which was owned by Walter de Rouceby, prior of Peterborough Abbey, and its apparent model of the first decade of the century, the Ramsey Psalter (no. 41). Two Apocalypses, one from Crowland, and a few cuttings from a now-lost Psalter (nos. 92 and 93), are closely connected with the Barlow Psalter, for the most part sharing the same artists and even, in the case of the Apocalypses, the same scribes and text decorators. The group is completed by a manuscript from Bury St. Edmunds (no. 95) – a volume of prophecies concerning the popes, with pen drawings closely resembling those in the Barlow group, not only in figure conception but in the details of graphic technique.[68] The earliest provenances of the Barlow group manuscripts, Peterborough, Crowland, Bury St. Edmunds – where those provenances are known – suggest the possibility that the books in this group were actually made in East Anglia. Again, as with the earlier Fenland group (to which the Barlow group is related through the Ramsey Psalter), the known owners were all monastic rather than secular. This does not necessarily warrant a conclusion that one or another of the East Anglian Benedictine monasteries maintained a scriptorium for the production of elaborate illuminated manuscripts. Rather it suggests that a certain group of scribes and artists made a specialty of working for East Anglian monasteries, or in other words, that through an ecclesiastical information network a particular group of artists came to the notice of potential monastic patrons. Logic suggests that these artists worked in East Anglia, perhaps in its diocesan capital and largest city, Norwich, but this cannot be proven for certain.

Still another group of East Anglian manuscripts is made up of those in which innovative Italianate techniques and compositions in the spirit of Duccio are found in the midst of, or overlaid on decoration of the most typical East Anglian character. In addition to the Douai and St. Omer Psalters (nos. 105, 104), both mentioned by Cockerell, this group includes the Luttrell Psalter (no. 107), which Cockerell saw only as exemplifying East Anglian illumination in its decline, the Psalter in the Bodleian, MS Douce 131 (no. 106), the Cluniac Psalter at Yale (no. 108), and additions to the Ormesby and Gorleston Psalters (nos. 43, 50). The dating of these manuscripts is based upon that of the Douai Psalter (1322–25), the only one for which documentation is precise, and this suggests the second part of the third decade or between 1325 and 1330. The Douai Psalter, like the Gorleston Psalter before it, has calendrical entries for the dedication of Gorleston parish church, and in addition, a slightly later inscription identifying the volume as a gift of Thomas, vicar of Gorleston, to one Abbot John – the abbey unnamed. The manuscript is, of course, of secular, not monastic use, as is the St. Omer Psalter, named after the family of Mulbarton, Norfolk, one of whose male members is represented in St. Omer arms on the Beatus page. The Psalter at Yale, while of East Anglian destination according to its Calendar and Litany, was intended for a Cluniac priory rather than secular use; the Luttrell Psalter, on the other hand, while secular, was made for Geoffrey Luttrell of Irnham, Lincoln-

shire, and differs considerably in Calendar and Litany from Psalters of the diocese of Norwich or Ely. When the Italianate additions were made to the Ormesby Psalter, a Norwich Cathedral Priory Calendar was added. Finally, as to Douce 131, the original owner is uncertain, and both Calendar and Litany are lost. No clear picture of the constitution of this group emerges from this list of manuscripts other than one based on stylistic affinities.

Cockerell's list of East Anglian manuscripts ends with the Italian-influenced group, but unknown to him some rather later books with threads of connection to East Anglia remain – the Brescia Psalter of *c.* 1330 (no. 109), with an Ely Calendar, and the Psalter of Simon de Montacute, Bishop of Ely, 1337–1345 (no. 112). In style, too, these volumes echo the subdued shading, delicate scale and profuse though miniature foliage of the borders of such manuscripts as the St. Omer Psalter, though without any overt Italianisms and without prolific marginalia. The same style occurs, however, in the Psalter of Queen Philippa, of Court destination (no. 110), and the Hours and Psalter probably given by Elizabeth de Bohun to the Dominicans of Shrewsbury (no. 111), so that not all the manuscripts in this group were clearly destined for the diocese of Ely.

To which of all the books mentioned above should the term 'East Anglian' be applied? So strong is the traditional conception of East Anglian as a style of decoration marked by exuberance, largeness of scale, parody and caprice, that the term cannot be used for manuscripts utterly lacking these qualities, even if they are of known East Anglian provenance. On the other hand, the early appearance of the East Anglian style in manuscripts connected by origin or destination with East Anglia in a geographical sense, suggests that the term should be used only for manuscripts of actual East Anglian provenance as well as style. Once a core group (or groups) of these books is identified, however, it becomes clear that enough manuscripts related in style, but of provenance outside East Anglia, exist to determine that the patronage of East Anglian illumination was not confined to the Eastern counties but extended into the Midlands, especially Lincolnshire and Nottinghamshire. But still the geographical locus of most of these books was East Anglia; consequently, it seems reasonable to suppose that they were actually produced at one or more centres in the region. One likely possibility would be Norwich, in which, as we know from records of the Cathedral Priory, various kinds of work on manuscripts were done in the town as well as in the cloister.[69]

### (d) *London Manuscripts*

The height of activity in the production of East Anglian manuscripts was reached during the same years that saw an equal vitality in production of volumes associated with the cities of London and Westminster. Unlike East Anglian manuscripts, however, no general 'London–Westminster' style typifies these books. They fall into two differing stylistic categories, which represent partly overlapping phases of development. The first London group is centred on the Queen Mary Psalter and the work of its single artist. The most recent listing of the constituent members of the Queen Mary group was Jonathan Alexander's.[70] The basis of the group is stylistic affinity, and the style is immediately recognizable for delicate, precise, yet free linearity, for slender, tall figures, swaying poses, elegant gestures and articulated facial features, a preference for tinted rather than body colour in the figures, and gold or small-scale rose or blue neutral diapered backgrounds. Primary emphasis is placed on figure compositions; decoration of margins and borders – where these are not filled with figures – while of characteristic refinement, is of lesser visual or thematic interest. About twenty surviving manuscripts (or sections of manuscripts) fulfil these criteria of style (nos. 56–77). The work of the Queen Mary Master himself appears in six of them – the Queen Mary Psalter (no. 56), the Psalter of Richard of Canterbury (no. 57), the Paris Instructions for the Mass (no. 58), the Douce Passion fragment (no. 59), the St. John's College *Somme le roi* (no. 60) and the British Library MS Royal 19. B. XV Apocalypse (no. 61) – in the last two joined with that of a total of

four other artists. Some other artists of the Queen Mary group worked in more than one surviving manuscript, for example, the decorator of the *Somme le roi* may have done some of the borders of the Chertsey Breviary (no. 62); of these, the most active was the miniaturist-decorator team of the Sherbrooke Missal (no. 65). As a team they also executed the illumination of the Bangor Pontifical (no. 69) and worked on both the London *Liber legum antiquorum* (no. 68) and the Paris Aristotle *Physics* (no. 70) together with other artists. In addition, the miniaturist painted the prefatory subjects of the Hours of Alice de Reydon (no. 67) and possibly the pictures of seated saints inserted in the Alphonso Psalter (no. 1), while the decorator probably did the borders of the Psalter of Hugh of Stukeley (no. 66). Finally, the work of a number of masters of the Queen Mary style survives in single manuscripts – the two individuals who painted the prefatory miniatures of the Psalter of Hugh of Stukeley (no. 66), the second hand of the Royal Collection Apocalypse (no. 61), and the painter of the Lincoln College Apocalypse (no. 72), to name the most distinctive.

If all the manuscripts containing work in the Queen Mary style are put together, some consistency in dating emerges but considerable disparity in provenance remains. No manuscript with painting by the master himself can be dated precisely, and only the provenance of his Psalter for Richard of Canterbury – a monk of St. Augustine's – is known. As for the rest of the Queen Mary group, the range of dates is from after 1304 (no. 66), after 1307 (no. 62), after 1309 (no. 69), after 1320 (no. 67) and after 1328 (no. 74), to before 1321 (no. 66), before 1324 (no. 67), before 1328 (no. 69), and before 1340 (no. 74). The most precisely dated book is the London *Liber legum antiquorum* (no. 68), which Neil Ker showed to have been written in 1321,[71] and after this, the Hours of Alice de Reydon (no. 67), which in all likelihood was executed between 1320 and 1324. Both of these contain work by the same miniaturist, as does the Bangor Pontifical (no. 69) of 1309–28. Together, the three offer the comparatively strong support for a general dating of the activity of the group to the second and third decades of the century. Where exactly the leading artist of the group – the Queen Mary Master himself – fits chronologically in this scheme is uncertain, but it could well be that he was active throughout the period, as his personal style seems to have undergone an Italianate development (no. 59) which was probably contemporary with the appearance of Italianisms in East Anglian manuscripts around 1325.

Where were the Queen Mary manuscripts made? They exhibit a wide variety of both provenance and patronage – southern Benedictine establishments in Canterbury (no. 57), Hyde (no. 64) and Chertsey (no. 62); the Cathedral of Bangor, Wales (no. 69); secular clergy in Norwich diocese (no. 66), individual lay owners (nos. 67, 73), the Queen of England (no. 74), the Corporation of London (no. 68), and even the Collège de Navarre of the University of Paris (no. 70). The types of texts are also wide-ranging – biblical and service books for private and public use (nos. 56–57, 61–62, 64–67, 69, 72–74), vernacular devotional and moral treatises (nos. 58–60, 63, 71), the Latin translation of Aristotle's *Physics* (no. 70) and a legal compilation (no. 68). Some of the texts are unique (e.g. no. 58), or unusual in having illustrations (no. 70), or having unusual cycles of illustrations (no. 60), although most representations of any given standard subject adhere faithfully to a single compositional type. The number of texts written in the French vernacular is striking (nos. 58–61, 71–72).

Amidst all this diversity the fact that four Queen Mary manuscripts are associated in various ways with London and Westminster may be taken as a sign pointing to the actual place of origin of the entire group. These are the Breviary of Chertsey, Surrey, the *Liber legum antiquorum* of the Corporation of London, the Psalter of Queen Philippa of Hainault (no. 74) and the inserted miniatures of saints in the much earlier Alphonso Psalter (a Court manuscript of 1284). Two of the hands in these books appeared in other manuscripts of known destinations as diverse as the dioceses of Bangor and Norwich, suggesting either that the artists were peripatetic or that the wide-ranging commissions of the group were all executed in a single place, which from

the prominence of London among the known destinations may well have been the chief city of the realm.

A second group of manuscripts associated with London–Westminster is centred on the pair of volumes intended for presentation to Edward III in 1326 or 1327 by Master Walter de Milemete, king's clerk, who was himself the author of the treatise on the 'kingly office' contained in one of them (nos. 84–85). Both the commissioner and the recipient suggest a London–Westminster origin as well as destination. The organization of the decoration of the two volumes shows that a large number of artists worked side by side on the projects, also pointing to an origin in a place where plenty of artistic labour was available. Six contemporary artists, at least, were employed on the two Milemete volumes, of whom three took part in the decoration of both books. Five of these six artists also worked on other surviving manuscripts (nos. 82–83, 86–90), in some of which (e.g. no. 83) a pair of Milemete hands appeared together. The basis of the group is stylistic in a rather narrow sense, that is, the reappearance of the same individuals in a considerable number of manuscripts; there are general affinities in the work of these artists, but there is no single leading figure of the stature of the Queen Mary Master, whose own style was stamped strongly on an entire group of books.

In other ways, however, the Milemete group resembles the Queen Mary group, particularly in the variety of types of manuscripts – Milemete's own Treatise, its companion Pseudo-Aristotle *De secretis secretorum* (nos. 84–85), several Canon Law volumes (including Oxford, Bodl. Lib. MS lat. misc. b. 16, MS e Mus. 60, and Cambridge, Gonville and Caius Coll. MS 257–662),[72] some contemporary theology (no. 90), and three Books of Hours and a Psalter (nos. 86–89). Insofar as the destinations of these books are known or suggested, they are also diverse. The Psalter was almost certainly made for use in Exeter diocese (no. 86); one of the Hours (no. 88) was made for a Hawisia DuBois, perhaps of Buckinghamshire, another (no. 87), which contains work of a DuBois artist, has liturgical indications pointing toward the diocese of Lincoln; the Gonville and Caius *Liber sext* belonged to a Richard de Norton of Oxford as early as 1333, the Duns Scotus (no. 90), which was written by a French scribe perhaps in Paris, bears the arms of Warenne and Fitzalan. This diversity of destination again suggests that if there was a primary place of origin it was likely to be a metropolitan centre, London more likely than any other.

As observed previously, the stylistic features of the Milemete manuscripts have some relationship with those of the East Anglian sub-group round the Tiptoft Missal, Stowe Breviary and All Souls Psalter (nos. 78, 79, 82). Indeed, one of the numerous artists of the Milemete books was the main painter of the Stowe Breviary, another was the main artist of the All Souls Psalter, a third did a few of the historiated initials at the end of the Dublin Bible (no. 83), most of which was painted by yet another Milemete hand. The rich border decoration of the Milemete books most closely resembles the various schemes in the Tiptoft Missal, but none of the Milemete borders was designed by any of the individuals who worked on the East Anglian manuscripts mentioned above. What implications this has for the place of origin or movements of the artists of the East Anglian Stowe group remain to be studied.

Another group of manuscripts with some London connection consists of four stylistically related books, probably made between 1325 and 1335, one of which (no. 99) was compiled by and written for Roger Waltham, Canon of St. Paul's in 1309, possibly a keeper of the wardrobe of Edward II, and still alive in 1332. Roger's compilation of writings attributed to Aristotle and Seneca as well as Augustine, Bernard and Hugh of St. Victor was illustrated by the same artist as the Taymouth Hours in the British Library (no. 98), whose original owners are represented therein as crowned, but otherwise unidentified. In addition, the Taymouth Hours has some slight liturgical indications of a London destination. Completing this group – although not by

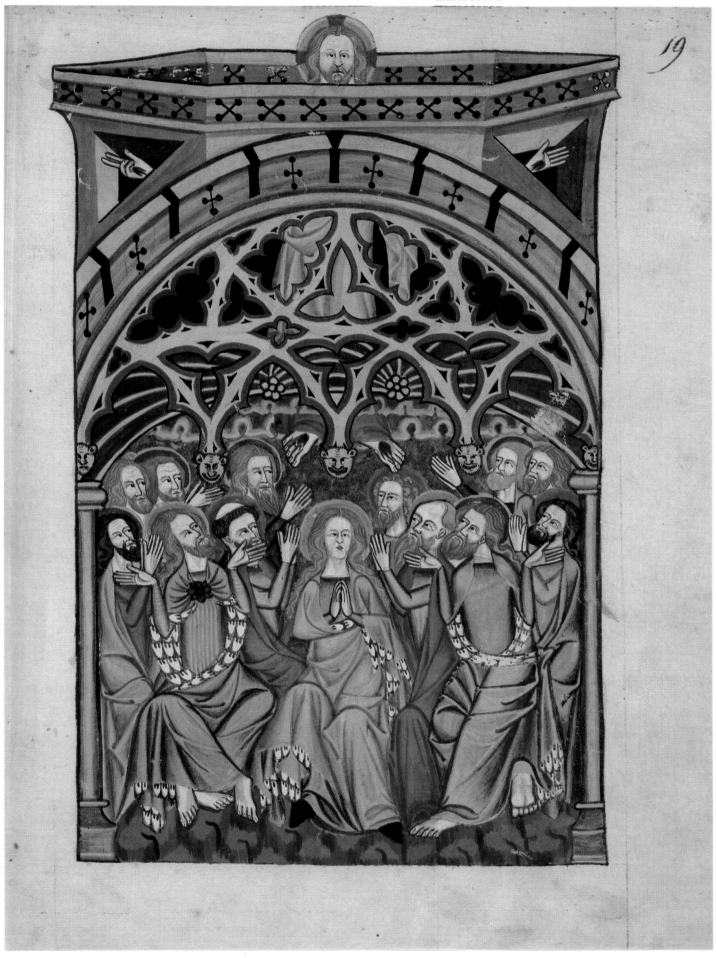

Ascension. Paris, Bibl. Nat., lat. 765, f. 19 (cat. 120)

the same artist – are the Smithfield Decretals (no. 101), whose London provenance can be traced to the 15th century, and the Corpus Christi Apocalypse and Coronation Order (no. 103), whose first owner seems to have been Baron Henry de Cobham (d. 1339). The style of all four manuscripts may be characterized as vernacular, with an emphasis on figural representation and dramatic narrative rather than border decoration; in this it resembles the Queen Mary manuscripts and differs greatly from the Milemete manuscripts. The figure style is linear and awkward, very different from the graceful fluidity of the Queen Mary style at its purest, and points toward the characteristic manner of the mid 14th century found in such examples as Exeter College MS 46 (no. 102), London, British Lib. MS Royal 1. E. IV (no. 100), Egerton MS 2781 (no. 115), Vatican MS Pal. lat. 537 (no. 116), Baltimore, Walters MS W. 105 (no. 117), Dublin, Trinity College MS F. 5. 21 (no. 118), and Oxford, Bodl. Lib. MS Lat. liturg. e. 41 (no. 119). Little is known of the destination, provenance or origin of these mid century books. The Walters Hours were made for the barons of Wem, Salop, the Zouche Hours (no. 119) for the Zouche family of Northamptonshire (diocese of Lincoln), but with an Ely Calendar, the Vatican Hours (no. 116) were illustrated by an artist apparently familiar with the less common compositions of the Queen Mary Psalter.

Equally diverse is the documentation of destination, provenance and place of origin of a series of manuscripts loosely linked in a stylistic sequence extending from *c.* 1350 to *c.* 1375. This series includes the Fitzwarin Psalter (no. 120), made for owners in Somerset, with a Midlands Calendar, and the Psalter painted by the same artist, Bodleian Lib. MS. liturg. 198 (no. 121), possibly Northern and Augustinian on the basis of its Litany. A similar linear, awkward style, if less powerfully expressionist, characterizes the only manuscripts of this group of known origin – the *Omne bonum* (no. 124) and the Gospel Commentary of William of Nottingham (no. 125) – which were written by and for the London exchequer clerk James le Palmer, before 1375. A London origin was clearly no guarantee of sophistication, elegance or refinement of style. Conversely, some of the most forward-looking and internationally attuned manuscripts of the third quarter of the century were destined for use far away from the capital, the James Memorial Psalter (no. 127) for a Northern owner and the Psalter of Stephen of Derby (no. 128), by the same artist, for a prior of the Cathedral of Dublin. Unfortunately, identification of these destinations sheds little light on the ultimate origin of the manuscripts, a question particularly tantalizing because of the mysteries of destination, provenance and origin surrounding the most important work of this small group, the Egerton Genesis (no. 129).

### (e) *The Bohun Group*

A large group of manuscripts of the second half of the century is associated with the Bohun family, Earls of Northampton, Essex and Hereford, and twice married in the same generation into the royal house (see Table of Bohun Family Genealogy, p. 60). No other English family of the 14th century appears to have taken such an active or personal interest in illuminated manuscripts. The first 'Bohun' manuscript is the Longleat Breviary of 1316–22 (no. 52), made for use in the church of Kimbolton, Huntingdonshire, of which Humphrey de Bohun, fourth Earl of Hereford, was the patron;[73] for Elizabeth, the wife of Humphrey's nephew William, Earl of Northampton, an Hours and Psalter now owned by Lord Astor (no. 111) was made between 1338 and 1355. Then, from the years between 1360 and *c.* 1380, a group of five manuscripts, all with heraldic, and most with textual references to Humphrey de Bohun – perhaps the sixth, but more likely the seventh Earl of Hereford – survives. These manuscripts, together with two others associated with Humphrey's daughter Mary and her husband, the future Henry IV, form the core of a still larger group of books closely related not only in pictorial style but similar in format, pictorial programme, types of texts, and particular textual features (nos. 131–141). These books offer an unparalleled opportunity for assessment of stylistic continuity and change over a period of time from *c.* 1360 almost to the end of the

century, an investigation scarcely begun in M. R. James' careful description of five of the volumes in 1936.[74]

The Bohun style was characterized by Millar as reminiscent of East Anglian illumination of the first half of the century. He was especially struck by the revival of the tradition of prolific marginal decoration, much of it irreverent in character;[75] also reminiscent of East Anglian work, or rather of the group of East Anglian manuscripts centred on the Douai and St. Omer Psalters (nos. 104 and 105), is the treatment of the figures, small in scale, carefully shaded although lacking in substance or gravity, agile and expressive in movement and gesture, and crowded into sometimes tumultuous multifigured compositions. Others since have identified what Millar had considered as an extension of the East Anglian tradition with the contemporary art of Flanders on the one hand, and on the other hand have observed in certain Bohun artists a contact with the more plastic and less frenetic art of Trecento Italy.[76]

This characterization sees the Bohun style from a static point of view, but the basis now exists for an examination of the development of the style as well. Such an analysis would not result in a linear succession of Bohun manuscripts, although an attempt to sort them out by weighing factors of style, textual, heraldic and iconographic documentation has produced a rough sequence of books which is reflected in the order in which nos. 131–141 in the catalogue following are arranged. The earliest manuscript could well have been begun before 1360 and the latest was apparently begun after 1380. Several however, including the Vienna Psalter (no. 133), which has some of the earliest illumination, also contain work considerably later in character. Moreover, in one case, the paired manuscripts in the Bodleian and the Fitzwilliam (nos. 138 and 139), which are nearly identical from a stylistic point of view, have textual features on the one hand suggesting a date between 1361 and 1373 and heraldic features on the other suggesting a date between 1380 and 1394. From a consideration of the various kinds of evidence for dating of the Bohun books, it seems that the least reliable is the textual evidence in the form of invocations of the Deity and the Saints on the part of Humphrey de Bohun (seventh earl, 1361–73, or possibly sixth earl, 1337–61), because this name occurs in texts of manuscripts with features of style, heraldry or iconography leading to conclusions of dates extending considerably past the lifetime of either Humphrey. Consequently, the textual mentions of Humphrey are valuable for demonstrating the cohesiveness of the group, and the reliance – in all likelihood – on a single text model. Moreover, the inclusion of prayers on the part of Humphrey, even after his death, in manuscripts made for his descendants, certainly shows a strongly dynastic feeling which is supported by the extensive and careful heraldry in the books.[77]

Indirect evidence of the lengthy career of at least one of the artists who worked for the Bohun family is provided by historical documents. In his will, Humphrey the sixth earl (d. 1361) left £10 to 'frere Johan de Teye nostre luminour . . . a prier pur nous', plus 40s. as an additional gift.[78] Fr. John de Teye was still alive in 1384 when he received permission from the provincial of the Austin Friars to train Fr. Henry Hood in the art of illumination, and the latter was still alive in 1389 when he received permission to go to Rome for the Jubilee of 1390.[79] These men may well have formed the nucleus of the group of artists who created the 'Bohun' style and continued its practice into the 1390s, and in this context Henry Hood's trip to Rome might be especially significant since it provides confirmation of the possibility of direct experience of contemporary Italian art.

Elaborately illuminated manuscripts, produced for one of the great families of England during the second half of the 14th century, would suggest attribution to artists working in the capital of the realm, but there is no documentary evidence for this conclusion. Nor is there any persuasive stylistic affinity with surviving contemporary London or Westminster wall- or panel-painting. The fragmentary paintings of St. Stephen's Chapel (fig. 23), though small in scale, and accompanied by inscriptions, like pictures in books, are executed in a manner

comparable neither with the 'Flemish' nor the 'Italian' Bohun styles, although they have been linked with the latter by Margaret Rickert. Rickert, in seeking the most precise Italian analogies for the wall paintings, pointed to Lombardy, to the work of Avanzi and Altichiero.[80] The Italianate features of the Bohun manuscript style seem, however, to point toward Central rather than Northern Italy, and in any case away from the monumental conception of the Lombard successors of Giotto.

In fact, if John de Teye was one of the artists whose work is found in surviving Bohun Manuscripts, then it is possible that he practised his art in the Bohun castle at Pleshey, Essex, and not in London. In the will of Humphrey the sixth earl, John – whose name suggests that he came from Great Tey, Essex – was treated as a family retainer. Like Humphrey's confessor William of Monklane, another Austin friar, John may have lived – not in a convent of Austin Friars – but in the residence of the earl, as William certainly did; Humphrey's will requested the provincial of the Austin Friars to allow the earl's confessor to live in 'sa chaumbre bele et honete' in the castle of Pleshey.[81] John de Teye's own request in 1384 for permission to 'call and retain' Fr. Henry Hood would not have been required had not both friars been living apart from the Austin Friars community.[82] Again, it is conceivable that their centre of artistic activity continued to be the Bohun castle.

The male line of the Bohuns died in 1373 with Humphrey, the seventh earl. He left two daughters, however, each of whom married after his death: the younger, Mary (1370–94), mentioned above, was the first wife (1380) of Henry Bolingbroke, grandson of Edward III and later Henry IV; the elder, Eleanor (1366–99), married (1374) Thomas of Woodstock (1356–97), Duke of Gloucester and youngest son of Edward III. Three manuscripts associated with Eleanor and Thomas constitute an addendum to the main Bohun group. First is the Hours and Psalter made for Eleanor and now in Edinburgh (no. 142), datable between 1382 and probably 1396, and characterized by Millar as a 'much less fine' member of the Bohun group.[83] In fact, the Edinburgh volume reflects not so much a reduction in quality as a change in style toward a more robust, substantial representation of the human figure and a much larger, bolder scale of border design – which at the same time shows a greater standardization of foliate motifs and the near disappearance of marginal figures. Another book, the two-volume Wycliffite Bible in the British Library (Egerton MSS 617–618), with border decoration by the Edinburgh Psalter artist, bears the arms of Thomas Duke of Gloucester and very possibly once also bore the Bohun arms; a third volume, Higden's *Polychronicon*, of 1394 to 1397 (Bodley MS 316), with decoration in a related large-scale manner, was given by Thomas to the College of the Holy Trinity at Pleshey, Essex, founded by himself and Eleanor. A fourth manuscript decorated – more elaborately – by the *Polychronicon* artist, is the Ramsey Abbey Psalter at Holkham (no. 143). There is some evidence that these last two volumes were actually executed in Norwich. It may be noted that while the main group of 'Bohun' manuscripts contains no Bohun style books without heraldic, iconographic and/or textual references to the Bohun family, these last 'Bohun' manuscripts were not all in fact made for related individuals. The artists employed by Thomas of Woodstock and Eleanor de Bohun apparently worked for other patrons as well.

### (f) The Litlyngton Group

Contemporary with the Bohun manuscripts of the 1380s is the Litlyngton Missal of 1383–84, the pivotal manuscript of a group (nos. 144–157) whose dates of execution range from c. 1380 to the end of the century. The Litlyngton style is more vernacular than aristocratic. The patronage of the group is mixed, and indeed unknown in many cases. The Litlyngton Missal itself (no. 150) is the best documented surviving English manuscript of the 14th century. Made in 1383–84 for the Abbot of Westminster, Nicholas Litlyngton, every aspect of its production is inscribed in the records of the Abbey. Other manuscripts of the group also have a connection with Westminster – the Apocalypse in Trinity College (no. 153), the Westminster *Liber regalis*

(no. 155) and the *Liber regalis* in Pamplona (no. 157). But these are linked to the Abbey by pictorial or textual ties rather than by known patronage. The Westminster and Pamplona Coronation Orders could have had a royal or court destination and the *Libellus geomancie* (no. 152) bears a dedication to Richard II. Both the historical compilation in London (no. 151) and the statutes of England in Cambridge (no. 156) have textual and pictorial contents pointing toward London–Westminster. But neither these nor any other manuscripts linked stylistically with the Litlyngton group offer clues to the names of their original owners, and the abundant heraldic documentation so characteristic of the Bohun group is completely absent, except in the Litlyngton Missal itself.

The Litlyngton style is characterized first of all by a different conception of page design from that of the Bohun manuscripts. Decorative borders are of paramount visual importance; in many cases they are broad and intricately composed; even where the borders are narrow they are designed symmetrically; the resulting effect is of a static frame. As in the manuscripts made for Eleanor de Bohun and Thomas of Gloucester, the figures are stabilized in stance and proportions and larger in scale than those of the main Bohun group manuscripts. A Litlyngton sub-group (nos. 151–154), taking its lead from one of the Missal artists, presents figures as polygonally faceted columnar forms, while the ordinary Litlyngton style shows figures with ovoid heads, shaded to give a volumetric appearance, chunky bodies draped in simple broad-folded or form-fitting shaded garments. Compositions are simple, with few background or accessory components and the compositional organization is planar and unified, although without depth. The inventive iconography of the Bohun manuscripts has disappeared; on the whole, these are much less ambitious projects than the Bohun books, and even the Litlyngton Missal, in spite of its imposing size and rich border decoration, is not extravagantly endowed with pictorial imagery. While the Litlyngton style recurs in the Carmelite Missal (*Survey*, VI, no. 2) as one component, the Whitefriars volume represents a new beginning, enormous in size, ambitious in pictorial programme, and abounding with stylistic and iconographic innovations. Like the Alphonso Psalter of 1284, which looks ahead to the 14th century, the Carmelite Missal of the 1390s marks the real beginning of the 15th century in English illumination, and thus falls outside the confines of this study.

TEXT TYPES AND PROGRAMMES OF ILLUSTRATION

Two-thirds of the manuscripts selected for this study are biblical or service books. As in the 13th century, the Psalter continues to be the most common type of illuminated manuscript (forty-six Psalters and nine Psalter-and-Hours), but it is clear that independent Books of Hours were gaining in popularity (twenty-three examples as opposed to four discussed in *Survey*, IV). Breviaries (four) and Missals (five) do not survive in large numbers, while the number of Bibles (six) and Apocalypses (eleven) is far smaller than in the preceding century (twenty-six and twenty respectively in *Survey*, IV). The only other type of standard text that occurred in significant numbers is the Bestiary (four examples). Because Apocalypses and Bestiaries are illustrated profusely, subject tables are included (see Part II). For Bestiaries in particular, there appear to be no departures from 13th-century pictorial cycles analyzed by M. R. James.[84] As for Apocalypses, they too fall into traditional categories, except that most examples are of the type with miniatures interspersed in a French text while the most important 13th-century Apocalypses had Latin text, and the illustrations were set in the upper half of each page.

A striking feature of 13th-century Psalter illustration was the series of miniatures preceding the biblical text; in programmes of Psalter decoration such prefatory cycles were far more prominent than the historiated and decorated initials that marked the main divisions of the text, except for the often full-page Beatus initials. Although some Psalters (eleven examples)

discussed in this volume contain prefatory cycles, and indeed some of extraordinary length (Queen Mary Psalter, no. 56) or choice of subjects (De Lisle Psalter, no. 38), most 14th-century Psalters are illustrated only with historiated initials and decorative borders at the text divisions. Marginal decoration, with or without figural components, became the characteristic visual feature of these manuscripts.

One of the most interesting aspects of 14th-century Psalter illustration was the introduction of cycles of narrative illustrations interspersed with text or incorporated into text pages. Many 13th-century prefatory cycles at the beginning of the Psalter text were narrative, but most often their subjects were drawn from the New Testament and consequently related indirectly – exegitically or typologically – to the Old Testament text. During the 14th century the relation of pictorial imagery to the Psalter text was often closer, at least in the sense that cycles of Old Testament subjects became common, and these themes occurred on the text pages themselves. Of course, the Psalms are non-narrative by nature; so much narrative illustration had at most a historical, not a literal, reference to the text, as for example a cycle of illustrations from the Life of David (e.g. Tickhill Psalter, no. 26, marginal cycle, or Egerton MS 3277, no. 135).

A variety of physical relationships to the text marks these narrative cycles. They may consist solely of historiated initials or miniatures at the standard Psalter divisions (e.g. Exeter College MS 46, no. 102, with miniatures from the Life of David); long cycles consisting of large as well as ordinary psalm initials (e.g. Exeter College MS 47, no. 134, with subjects from Genesis to Numbers); or cycles in the lower margin of every page of the Psalter text (e.g. the Tickhill Psalter, no. 26, in which a continuous Life of David fills the major historiated initials and every bas-de-page). Some of the most complex arrangements involve different narrative series, as for instance in the Isabella Psalter (no. 27), where one Old Testament cycle is confined to the main historiated initials and their respective bas-de-pages, and another to all the ordinary psalm initials and their respective bas-de-pages, and an unrelated Bestiary cycle fills the lower margins of alternate pages of the book, those which contain the text of the psalms in French. With the exception of the Queen Mary Psalter (no. 56), the Tickhill Psalter (no. 26) and the Isabella Psalter (no. 27), the Psalters with the most prolific narrative illustrations belong to the Bohun group (nos. 133–135, 138–139), whose artists seemed to have an inexhaustible enthusiasm for this mode of illustration and seldom repeated themselves compositionally, even in representing identical subjects.

English 14th-century Books of Hours present a bewildering variety. None has exactly the same textual components as any other, and many of the surviving volumes contain texts, often quite rare, in addition to the nearly standard Hours of the Virgin, Penitential Psalms and Office of the Dead. Some of the less usual components were more common across the Channel, for example, the Hours of the Passion (nos. 51, 53 and 88) and the Joys of the Virgin (nos. 80, 88), and one element quite common in England, the Short Office of the Cross, was less frequent in France, and there, unlike Britain, illustrated only rarely.[85]

If the Books of Hours catalogued in this volume vary considerably in the selection of their components, they vary at least equally in the programme of illustration of their most common element – the Hours of the Virgin. Slightly under half the Hours of the Virgin are illustrated with narrative cycles consisting of subjects drawn from the Infancy and Public Life of Christ. These cycles usually start with the Annunciation, but they differ widely in the rest of the subjects. They can end with the Presentation in the Temple (DuBois Hours, no. 86, and British Library MS Add. 16968, no. 145), the Massacre of the Innocents (Carew-Poyntz Hours, no. 130), or Infancy Miracles of Christ (Egerton MS 2781, no. 115), or His Temptation (Taymouth Hours, no. 98). One cycle that begins with Infancy subjects ends with the Obsequies (Vespers) and Coronation (Compline) of the Virgin (Percy Psalter-Hours, no. 11); this is the only English pictorial cycle that stresses the Virgin to such a degree, an emphasis that

was much more common in France, where the majority of late 13th- and 14th-century Hours of the Virgin were illustrated with Infancy cycles culminating in the Coronation of the Virgin. Indeed, there are numerous French Books of Hours with identical cycles for the Hours of the Virgin (especially those of Paris Use, which by the middle of the century had the standard sequence Annunciation, Visitation, Nativity, Annunciation to the Shepherds, Adoration of the Magi, Presentation in the Temple, Flight into Egypt and Coronation of the Virgin).[86]

More than half of the late 13th- and 14th-century English Books of Hours contain mixed Infancy and Passion cycles.[87] Again, most of these begin with the Annunciation, continue with one or two further Infancy subjects and then begin again at various places in the Passion narrative – the Last Supper, Betrayal, Christ before Pilate, the Crucifixion, or even the Resurrection. On the whole, French Books of Hours show no such narrative jumps, although some, as for example, the Hours of Jeanne d'Evreux (New York, Metropolitan Museum of Art, The Cloisters), have parallel series of Passion and Infancy illustrations.

Why devotions in honour of the Virgin should be illustrated so frequently with scenes of the Passion of Christ has not been determined. In discussing the cycle of miniatures preceding the Psalter of Hugh of Stukeley (no. 66), similar to the 'mixed' cycles of English Hours of the Virgin, M. R. James suggested that the subjects might represent the Joys and the Sorrows of the Virgin,[88] although no surviving text of the Joys or the Sorrows appears to include the same subjects; Leroquais suggested that such mixed schemes simply represented the transfer of the prefatory cycles of Psalters to new locations in the Hours of the Virgin.[89] Late 13th- and early 14th-century Franco-Flemish Psalter-Hours offer some support for this proposal, as for example Stowe MS 17 (London, British Library), an Hours of Maastricht, in which a series of full-page miniatures, starting with the Infancy of Christ, precedes Matins and the remaining Canonical Hours are illustrated with a Passion cycle. Since the text of the Hours of the Virgin offers no specific guidelines for illustrations, artists presumably turned to the pictorial cycles already developed for Psalters.

In England, however, the emphasis on Passion subjects as illustrations of the Hours of the Virgin may have some connection with the popularity of the illustrated Short Office of the Cross. A number of manuscripts attribute this Office to Pope John XXII (1316–34).[90] Thirteen manuscripts included in this volume contain the text; in two – the Vernon Psalter (no. 53) and the Escorial Psalter (no. 80) – it is the chief devotion attached to the main contents. In the rest, the Office precedes or follows the Hours of the Virgin, and in seven cases the individual Hours of the Cross alternate with those of the Virgin.[91] Unlike the components of the Office of the Virgin, those of the Short Office of the Cross refer specifically to the last events of the Life of Christ, thus forming a guide to the subjects of the illustrations, which consequently are the same in every manuscript. These subjects – the Betrayal or Arrest of Christ, Christ before Pilate, Christ bearing the Cross, Crucifixion between Thieves, Crucifixion with Longinus and Stephaton, Deposition, and Entombment – are among those which occur most frequently in 'mixed' cycles illustrating the Hours of the Virgin, even in manuscripts without the text of the Office of the Cross (nos. 29, 47, 138, 140). Most interesting, however, are those manuscripts in which the alternating texts of the Hours of the Virgin and the Office of the Cross are illustrated with a single pictorial cycle (nos. 117, 118, 142, 145, 146) placed at the beginning of each Hour of the Virgin and consisting of one or two Infancy subjects and six or seven Passion subjects, the Passion subjects closely linked in choice and order with those illustrating separate Offices of the Cross. These manuscripts, of the mid 14th century and later, take up a system of English Hours illustration initiated as early as the time of W. de Brailes, whose Hours of the Virgin in the British Library, Add. MS 49999 (*Survey*, IV, no. 73) had a miniature of the Passion at the beginning of each Hour and a continuous narrative cycle of small historiated initials of the Life of the Virgin and the Infancy of Christ for all the subdivisions of the text.

In the illustration of 13th-century Books of Hours the elaborate scheme of the de Brailes manuscript stands out as unique, but its narrative richness forecasts similar developments in the 14th century. Like contemporary Psalters, a significant number of the Books of Hours in this volume are illustrated with lengthy narrative cycles. Some are entire marginal biblical cycles – Old and New Testament – unrelated to the text above. The Taymouth Hours (no. 98) has such a series below the Hours of the Holy Spirit and Hours of the Trinity. Some are unusual, occurring rarely as pictorial narrative in any context, and equally rare though relevant as illustrations for the particular texts they accompany as, for instance, the eight historiated initials with scenes from the Legend of the True Cross for the Hours of the Passion in the DuBois Hours, no. 88 (in addition to full cycles of historiated initials for the Hours of the Virgin, the Hours of the Holy Spirit and the Short Office of the Cross). A relatively large number of Hours contain series of Miracles of the Virgin as marginal illustrations (Taymouth Hours, no. 98) unrelated to the text (Office of the Dead), as historiated initials in prayers (Egerton MS 2781, no. 115), as large miniatures (Madresfield Hours, no. 37, Bodl. Lib. Auct. D. 4. 4, no. 138) for the Hours of the Virgin, and as bas-de-page vignettes (Copenhagen Hours, no. 140). Some narrative cycles are notable for their relative length, the fifteen miniatures in the Escorial Psalter (no. 80) illustrating the Joys of the Virgin, a text not known to have been illustrated previously, the twenty-three miniatures in the Egerton Hours (no. 115) with scenes from the Life of the Virgin illustrating the Salutations of the Virgin, a devotional text of fifty sections (some lost), and the same text illustrated with both miniatures and bas-de-page scenes – ninety-eight in all – in the Carew-Poyntz Hours (no. 130).

Finally, several manuscripts contain narrative cycles that continue throughout the text, with pictorial material on every page. In the Taymouth Hours (no. 98), for example, the illustrations of the Hours of the Virgin and the Short Office of the Cross are arranged so that standard subjects are represented in large initials or miniatures at the main subdivisions, and the lower margins of the pages between the beginning of each Hour contain representations of the intermediate events in the Life of Christ. The whole is a continuum, a remarkable *tour de force* of pictorial narrative in which traditional cycles are respected and ingeniously enriched by marginal material. A similar system underlies the cycles consisting of hundreds of large (at the main divisions) and small (at all lesser divisions) historiated initials of the Hours portion of Egerton MS 3277 (no. 135), the Bohun manuscript whose Psalter is illustrated according to the same principles. Characteristically, the Psalter illustrations of the Egerton Bohun manuscript are drawn from the Old Testament Life of David while those of the Hours are drawn from the Life of Christ and the Virgin. The manuscript represents the culmination of the pictorial narrative in English 14th-century illumination; in the illustration of standard texts, the 15th century saw a retreat from such pictorial abundance in favour of representation of individual rather than serial narrative themes.

## ILLUSTRATIONS 'HORS TEXTE'

Figural illustrations in the margins of the page outside the text both physically and thematically began to appear in the 13th century, although throughout the Middle Ages there was always an artistic current which appeared to delight in anachronistic or disjunctive relationships between image and text, as in initial letters composed of 'irrelevant' figural components – animal, human, hybrid – found in manuscripts as early as the sixth and seventh centuries. The first half of the 14th century in general, and particularly in England, was noted for prolific and varied marginal illustration. The range of visual and thematic relationships – to text, to initials, and among the marginal components themselves – is almost infinite, and indeed, the governing

principle of marginal illustration sometimes appears to be the unexpected, the expression of the spirit of unbridled freedom.

Nevertheless, several broad categories of marginalia may be enumerated. First of all, in physical form, marginal material may consist of isolated images, often in the lower margin, not tied to any other visual elements on a page. Such isolated marginalia are rare, but their effect is usually startling in that figures – human, animal, hybrid – singly or in groups existing in the totally blank space below the text, seem literally to come from nowhere (see the Luttrell Psalter, no. 107, and the Queen Mary Psalter, no. 56, for the largest number of examples). The opposite of isolated, unframed marginalia are those that are literally encapsulated within a broad, regular frame that runs around the entire page, as throughout the Tiptoft Missal (no. 78), the Milemete Treatises (nos. 84, 85), and on the exceptionally splendid Beatus pages of the Peterborough, Gorleston and St. Omer Psalters (nos. 40, 50, 104). These images are provided with gilded or patterned backgrounds comparable to those of large historiated initials and miniatures.

The most common form of marginal illustration, however, is tied more loosely to a framing device of some kind. Often the frame consists of an extension of the tail or finial of an initial letter, an extension which usually takes on an organic vegetal and foliated substance as it 'grows' down the vertical margin and across the top or bottom margins of the page. The relationship of marginal figural elements to the marginal framework is similar to that between the figural components of initial fields and the initial letter form, except for the absence of a coloured background: in the bottom margin particularly, the framework was treated as a ground line; but there, and in the other margins as well, figures also manipulate the framework as a substance more malleable than the fixed frame of the initial letter.

Finally, marginal illustrations may be placed in the bas-de-page. This is a special space or field, created in the area between the bottom line of text and the marginal framework, especially the sort of framework that completely circles the page. The generally rectangular shape of this area is comparable to that of a framed miniature, and encouraged a similar treatment, that is, the filling of the space with cohesive scenes rather than images unrelated to each other. Unlike miniatures, however, these bas-de-page 'pictures' were painted against natural parchment backgrounds devoid of colour, pattern or gilding. Only in the 15th century did the final transformation of the marginal vignette into a framed miniature occur (see, for example, the Carew-Poyntz Hours, no. 130, for graphic evidence of the several stages).

The physical or formal relationship of the marginal figural components to each other is marked by diversity. In the make-up of any single page, for instance, the figural elements may be both physically independent of each other – occurring as multiple but separate motifs – and physically tied to each other – grouped coherently to perform actions or represent situations, or tell stories. More complex actions tend to take place in upper and lower margins; more isolated images tend to occur along the sides. On any single page, too, there is likely to be a diversity of scale, not just typically medieval anachronisms such as large human figures and small buildings and trees, but scale inversions particularly characteristic of marginal illustration, especially in the size of human beings, hybrids and four-legged animals in relation to foliage, flowers, fruit, insects and birds, the latter often represented as if seen through a magnifying glass. Finally, there is enormous diversity in the make-up of individual figural entities, in which composite construction, truncation, inversion of viewpoint, and multiplication, misplacement, and misproportion of parts are all found as principles of representation, far more frequently than in historiated initials or framed miniatures.

The thematic range of Gothic marginal illustration has been described extensively, yet the subject is of inexhaustible interest because of the variety and richness of iconography. Much inquiry, particularly that of Lilian Randall, has been focused on the identification of individual

multi-figured subjects and the disclosure of their literary counterparts in proverbs, fabliaux and exempla.[92] Yet many areas of meaning of marginal figural illustration remain open for investigation. Just as there are various kinds of physical and formal relationships between marginalia and other material on any single manuscript page (or double opening), so also are there various kinds of thematic relationships, and perhaps nowhere more than in English illumination.

Only infrequently is the text illustrated directly by marginal figures (e.g. the Longleat Breviary, no. 52); rather more often the marginal illustrations are related thematically to framed miniatures or historiated initials on the same page (e.g. the Taymouth Hours, no. 98) as amplification, commentary or even parody of the main pictorial subjects. Most frequently, however, the marginal figural illustration has no discernible thematic relation to the text or other images of a particular folio. Instead, the meaningful context – if any – is supplied by the grouping and interrelationship of the marginal components themselves, or by the succession of marginal images from one page to the next.

Consecutive marginal illustrations may form narrative cycles (e.g. the Tickhill Psalter, no. 26, for a religious series, the Luttrell Psalter, no. 107, for domestic activities, or the Walters Hours, MS 102, no. 15, for a secular fabliau) or they may form a series of representations of visual categories (e.g. the Bestiary subjects of the Isabella Psalter, no. 27, the sports and games of the Smithfield Decretals, no. 101). In some such series, which are characteristically English, there is an implied textual reference, even though these texts – the detailed Life of David, the Miracles of the Virgin, fabliaux, for instance – appear in the 14th century to be illustrated more frequently in the margins of unrelated texts than in their 'proper' settings. Some serial marginalia, however, illustrate no known text; they are variants on visual rather than literary themes, or images based directly on life activities. Such, for instance, are the hybrids in the Luttrell Psalter (no. 107) and the Harley Hours (no. 89), the domestic activities of the Luttrell Psalter and the depiction of sports and games of the Queen Mary Psalter (no. 56), the Taymouth Hours (no. 98) and the Smithfield Decretals (no. 101).

The vast majority of marginal illustrations – serial or not – are 'hors texte'. Bypassing the usual or expected (especially for a book) reference to the written word, they are drawn from the visual world, copying, but also parodying, perverting and distorting its components, or even inventing a meta-world composed of creatures never seen in reality. For this last, English artists seem to have shown a particular propensity.

THE MISE-EN-PAGE

Codicologists customarily think in terms of the archeology of the book, analyzing the material components of a manuscript – written text, scribal decoration, painted decoration and miniatures – in the sequence in which they were executed. This approach has produced a new appreciation of the complexities, and indeed, the unique character of manuscript illumination, and an awareness of the vast range of possibilities of organization of visual material – text and image – in the manuscript book. A current tendency exists to stress those aspects of manuscript execution which formerly were overlooked – that is, what may be called minor decoration, or scribal decoration.[93] These would comprise the first elements added to the page after the text. For the manuscripts included in this volume, such additions are likely to be small initial letters, either monochromatic red, blue, or gold, flourished in contrasting colours with penwork often foliate in character, or painted in gold or body colour usually with rose or blue field and background panel of gold or contrasting colours, the field often patterned or filled in turn with painted foliage or simple geometric, animal or heraldic motifs.

Ordinarily the line fillers (see p. 58), which are especially prevalent in Psalters on account of the alternation of long and short text lines, are treated as parallel or counterpoint to the first level of decoration. The popularity of Psalters in the 14th century assured the continued emphasis on initial letters one-line high, since these letters were usually aligned at the left-hand side of the text block in a prominent columnar arrangement. Frequently the letters, at the beginning of alternate text-lines, were linked by penwork bars (Type D), or by patterned vertical bands (Type C) creating a background panel. But with the increase in the number of illuminated Hours in the 14th century, alignment of one-line initials became relatively less frequent, because the texts of Books of Hours were not written in verses; 'line' initials occurred anywhere in a line. A significant number of Psalters of the second half of the century also followed this practice, which resulted in a compact text block, punctuated irregularly by initials, and without line fillers.[94] 'Ordinary' text pages of such manuscripts could be very plain indeed, or they could be framed by simple borders entirely dissociated from initial letters.

For most of the manuscripts included in this volume, notes describing the minor decoration are included in the catalogue entries. Both in penwork and painted decoration noticeable changes occurred in the 14th century. Penwork flourishing (Type B) and filling of initials, often very elaborate in the 13th century, was increasingly characterized by foliate rather than abstract motifs in the 14th. Elaborate naturalistic foliate penwork is typically English (see the interesting juxtaposition of French and English scribes in the Paris Aristotle, Bibl. Nat. MS lat. 17155, no. 70).[95]

The long foliated extensions of flourished initials often accommodate marginal figures – animal, human, hybrid – linear echoes of the fully painted marginal motifs accompanying larger painted initials and their painted marginal extensions. The fields of initials decorated with penwork flourishing were often worked in patterns – foliate or animal – in reserve against linear cross-hatching, and occasionally this technique was employed to create an irregular net-like background panel, like a small lace doily (e.g. Luttrell Psalter, no. 107). To the chief colours of late 13th-century penwork flourishing – red and blue – were added lavender, especially after 1325, and occasionally green.

If penwork-flourished initials (p. 58, Type D) were in the province of the scribe rather than the painter, entirely painted line initials – the smallest size of painted initial in a manuscript (Type A) – were often also the work of a specialist, not the same as the artist of major initials, borders or miniatures in a particular book. During most of the 14th century such initials were gold on background panels of rose or blue. The background panels were occasionally squared (e.g. the Alphonso Psalter, no. 1) but more often shaped in approximation of the form of the initial letter. Usually the background panel was patterned in white linear motifs, echoing penwork, and often the colour of the field within the initial was counterchanged with that of the background panel; in some elaborate variants the colours of the background panel and initial field were counterchanged quarterly (St. Omer Psalter, no. 104, Douai Psalter, no. 105). In a few luxury East Anglian manuscripts (Ormesby Psalter, no. 43, Gorleston Psalter, no. 50) the line initials were linked by painted and patterned vertical bars with foliated extensions curving into the lower margin.

In a departure from earlier 14th-century practice, the line initials of the Bohun manuscripts are not gold but rose or blue shaded in white, while it is the backgrounds that are tooled and gilded. The fields within these initials are filled with painted foliate motifs. These initials, whether painted by a specialist, or by an artist who did other – larger – initials in the same manuscript, are more closely linked in form and technique to the major historiated initials than was customary in 14th-century English manuscripts. Outside the Bohun group the smallest initials almost always formed a category apart, and the borderline between 'scribe' and 'artist', or 'decorator' and 'figure painter', or 'assistant' and 'master', occurred on the next level of the initial hierarchy, that of the two- or three-line initials at the beginning of

psalms, lessons and other similar text units. Most two- and three-line initials (Types B and C) are painted rather than penwork-flourished, so the assessment of their position within the range of initials in any manuscript is limited to the distinction between minor and major decoration, or assistant and master. How these initials were treated in a particular book depended on a number of factors: the organization of the programme of illustration – vertically (i.e. all decoration in any gathering or series of gatherings), or horizontally (i.e. all decoration of a certain sort throughout a manuscript); the type of text (i.e. Psalters have two-line initials dispersed evenly throughout the text while those in a Book of Hours are concentrated in particular sections, such as the Memoriae in Lauds); and the amount of work to be done (the more initials of one size the greater the tendency to treat them 'horizontally' and consign them to one or more specialists).

Wherever two- or three-line initials fall in the hierarchy, they usually differ in form both from those of larger and smaller size. The chief difference from smaller initials is in the treatment of the initial form itself. Not only is it almost invariably pink, rose or blue (or occasionally tan) rather than gold, but it is patterned either with linear or shaded motifs; once in a while it is treated as an open wiry frame or composed of plant, animal or human elements. The most elaborate examples have marginal extensions from the initial finials like those of major initials. Also characteristic of the middle level of initial is the differentiation between the initial field – usually gold – and the background panel, usually rose or blue and also patterned, but differently from the initial form itself. These features are again like those of the largest initials in the hierarchy, but on the whole the typical two- or three-line initial differs from major initials in the motifs filling the field enclosed by the letter form. By and large these are purely decorative – foliate, animal (usually fantastic) or combinations of the two, geometric or other abstract patterns, heraldic, and occasionally human heads. A corresponding repertory of motifs is found in elaborate line fillers (see p. 58). Only rarely are such initials historiated, the Bohun manuscripts again providing almost the only significant examples.

The widest variety of treatments of initial frame, field, background panel and marginal extensions is to be found among the largest initials, generally four or more text lines in height. The initial forms may be shaded or patterned, they may be animate or foliate in substance, or they may be composed of wiry strands. Almost always in the largest initials the spiralling finials of the letter produce marginal offshoots, these unrolling down the length of the side margin from additional spiral nodules, or from elongated wedges or from animal forms locked to the initial frame, usually by snapping jaws or grasping claws.

The frames of the large initials are treated much as miniature frames enclosing pictorial compositions, although the position of the pictorial components in relation to the initial frame is perhaps freer than in rectangular miniatures. This is because the initial frame is always set against a contrasting background panel which is frequently framed itself. Consequently, the possibilities for placement of figural elements in front of, in between, behind one or both frames, are endless. Indeed, 14th-century English historiated initials are marked even more than miniatures by a spirit of experimentation with spatial composition, with spatial incongruity and inconsistency dominant. Only toward the end of the century in a few of the Bohun manuscripts is a sense of spatial order introduced into the treatment of the large historiated initial, this by the unification of initial field and background panel as a single textured golden backdrop, before which the figures play their roles on a stage whose limits are marked by the 'proscenium arch' of the letter frame.

In the 14th century the largest initials rarely achieved the full-page size so characteristic of the first initial letters of 13th-century illuminated manuscripts, especially Psalters. The only books included in this study that begin with full-page initials are the Windmill Psalter (no. 4), the Vescy Psalter (no. 12) and the Ormesby Psalter (no. 43), whose Beatus initial is an

insertion from another manuscript. Although a number of 14th-century manuscripts contain exceptionally large historiated initials (e.g. Gorleston, no. 50, Tickhill, no. 26, De la Twyere, no. 36, Vaux, no. 30), most are neither the full width nor height of the text block. Furthermore, the custom of adding to the width or height of the area occupied by the largest initials by writing the rest of the first word or phrase of the text in capital letters in an adjacent vertical or horizontal panel was gradually abandoned in the 14 century. Instead, the major initials were tied to increasingly elaborate marginal extensions, which often formed complete frames around the text block. Such borders, even when complete, were rarely regular in width or symmetrical in arrangement of their components. Their genesis, so to speak, or their originating impulse, was from the frame of the initial letter, and they were usually more solid, continuous and rectilinear in the vertical margin closest to the initial letter and more open, broken and curvilinear in the lower margin and on the right-hand side of the page.

A number of important 14th-century manuscripts do have broad, even rectilinear borders on pages with large historiated initials, for instance, the Tiptoft Missal, no. 78 (see in contrast the Milemete Treatise, no. 84, with rectilinear borders on pages without historiated initials and asymmetrical borders on the one initial page), the Bohun Psalter in Exeter College (no. 134), and the Litlyngton Missal (no. 150), and thin rectilinear borders enclose the text block of the pages with half-page miniatures above small historiated initials in a number of other Bohun manuscripts (Bodleian, no. 138, Fitzwilliam, no. 139, Copenhagen, no. 140). The last twenty years of the century are marked by an increasing regularity in the construction of borders, which tend to consist of a limited number of components – foliate spirals, foliate sprigs, interlace knots, shields, masks – arranged in predictable patterns of alternation (especially nos. 142–157).

## PICTORIAL COMPOSITION, FIGURAL MOTIFS AND DECORATIVE VOCABULARY

In the broad terms of 'Period Style' there was little development in English manuscript illumination during the 14th century, nothing comparable to the great shift from Romanesque to Gothic that took place at the beginning of the 13th century. The term Gothic applies equally well to the beginning and to the end of the century. Nevertheless, distinct changes occurred in many aspects of English illumination during the 14th century, although they should not be viewed as inevitable steps in progressive development toward a proto-Renaissance style. For example, the features of pictorial representation that have the greatest potential for creating an illusion of the third dimension are the modelling of solid forms, the depiction of deep space, and the arrangement of forms at oblique angles to the picture plane. These characteristics, scarcely evident at the end of the 13th century in English manuscripts, were introduced separately in the course of the 14th century. At the end of the 13th century, modelling – the gradation of tones to create volume – was inconsistent, often used, for example, on the body or drapery of a human figure but not on the face, hands or feet, and employed also more in connection with certain colours, particularly blue, than others, such as rose or orange. Shading was always reinforced by outline. Because of the prevalence of polished and tooled gold or diaper patterned backgrounds and narrow ground strips, spatial illusion was at most like that of a relief, or on occasion a shadow-box, but because of the placement of figures in relation to each other or to the frame of the miniature or initial letter, the effect of relief or shallow depth was usually ambiguous (for example, in the Peterborough Psalter in Brussels, no. 40).

In a few manuscripts of the first quarter of the 14th century, those of the Queen Mary Psalter group in particular, the ambiguous relation between figure and ground was disentangled, the figures, although rather insubstantial, nevertheless being clearly and logically positioned in relation to each other and to the frame, and the background treated as a plane different from that of the figures. Figure groupings, however, continued to be planar, as they had been in the 13th century, and the viewer's viewpoint was directly at or into the picture. But around 1325, along with Italianate compositions, an Italianate technique of modelling appeared in a small group of East Anglian manuscripts. The striking feature of this system of modelling was the elimination of separate outline, the shading of forms to their edges without further strengthening or definition, consequently a stress on the surfaces of forms more than the edges. The new technique of shading was applied consistently in several manuscripts (e.g. the Douai, St. Omer and Luttrell Psalters, nos. 105, 104, 107), not just to bodies and garments but to heads and faces as well – hair, for example, being treated as a fuzzy aureole rather than a series of linear waves – but for the most part the backgrounds and ground planes against or on which figures were grouped were no different from those at the beginning of the century. Only when a whole composition was borrowed from an Italian source – the Crucifixion of the Gorleston Psalter (no. 50) for example – did the ground strip become a ground plane receding into depth as in Trecento panel paintings. It should be stressed that this phenomenon was limited to one group of manuscripts of the third decade of the century, and that other contemporary manuscripts – those of the Milemete group for instance – were completely unaffected by the development.

Around the middle of the century a number of books – the Fitzwarin Psalter (no. 120) and the Zouche Hours (no. 119) for instance – show the use of techniques of modelling and spatial representation not as tools of illusion but of dramatic expression. Over-inflated forms jostling each other, exaggeratedly heavy shading of faces, strained, fantastic perspectival effects, suggest a sophisticated 'misuse' of techniques generally associated with the objective representation of the visual world.

During the last third of the century, consistent shading of forms to emphasize their volume became the norm, and the spatial relationships between one form and another, or figures and frames, were governed by visual logic; more significant changes, however, took place in the representation of the setting, now conceived of as a deeper space, one often capable of containing figures placed at an oblique angle to the picture plane. Some manuscripts of the Bohun group (see also the Missal in Oxford, Trinity College, no. 144) are marked by this new freedom of composition. However, the majority of manuscripts of the last two decades of the century, including those of the Litlyngton group, are considerably more conservative, and the successors to these spatial experiments did not appear until the work of the 'Dutch Master' of the Carmelite Missal.

At the end of the 13th and beginning of the 14th century the human head was represented as an oval, often unpainted (p. 57, Type A), with an ovoid facial plane on whose surface the outlines of the features were drawn (De Lisle Psalter, no. 38); by the second decade of the century the head was given a more defined bone structure, with a jutting brow, eye-sockets, cheekbones, chin and jaw, as in the Queen Mary Psalter group (Type B). But in the last third of the century the head was again ovoid, although richer shading and colour gave the form more substance and the configuration of features – especially the heavy-lidded black eyes typical of the Bohun manuscripts – was considerably different from the beginning of the century (Type C).

Figures, too, changed in stance and proportions from the beginning to the end of the period, starting out as tall, slender, long-legged, and graceful, and ending up as short, large-headed, long-torsoed, thin-legged and active rather than languid in pose. The treatment of clothing also went through several stages in the course of the 14th century,

46

beginning as 'drapery' and ending as 'costume' (see p. 57). Early in the period, drapery hung in straight or curving folds that paralleled the vertical, columnar form of the body (as in the De Lisle Psalter, Type A); later the folds were drawn diagonally across the torso, creating a richer, more substantial effect (as in the Gorleston Psalter Crucifixion, Type B), then the garment was wrapped round and round the body with cascades of folds at the hem (as in the work of the Majesty Master of the De Lisle Psalter, Type C), and finally, in the second half of the century, garments became increasingly form-fitting and accurate as depictions of actual clothing (as in the Fitzwarin Psalter, Type D).

Like the human figure and its clothing, decorative motifs underwent morphological changes during the 14th century. These are most apparent in the representation of foliage (see p. 59), which plays such an important role in the mise-en-page of English manuscripts. English illumination is noted in the early 14th century for the naturalistic representation of a wide variety of leaves and fruit of nameable plants and trees – vine, oak, rose and strawberry, along with their grapes, acorns, wild roses and berries, are among the most frequent. Fifty varieties of foliage were identified in the Tickhill Psalter (no. 26), for example. Nevertheless, while such depictions of vegetation may testify that art was the mirror – or magnifying glass – of nature, they should not be taken as scientific illustrations, 'better' or 'worse' depending on their accuracy.[96] Indeed, from a scientific point of view nearly all these representations are inaccurate, both in colour, which is often arbitrary and schematic, and in scale, whether it is a question of the relative size of leaves of different plants on the same page, or leaves in relation to their fruit or flowers, or to other components of the natural world, human or animal. Moreover, recognizable leaves, fruit and flowers are only one element of the vegetation vocabulary of the early 14th century. Standard, ordinary foliage is of a number of un-nameable types – five-pointed, three-pointed, trilobed, heart-shaped, and frontal or profile serrated (Types A, B, C, D), and the standard, ubiquitous, flower is the so-called daisy-bud, Type E (open daisies do not occur) which is merely a conventional name for a pink and/or white brushlike blossom, represented without appropriate foliage and looking more like a clover than a closed daisy).

Around the middle of the century the vocabulary of the conventional foliate forms was enriched by the addition of spoon- or kidney-shaped (Type F), and ball-shaped leaves, and by the proliferation of 'currants' on curving stems, 'thorns' tipping pointed-leaf foliage, and small gold balls with black penwork 'squiggles' (Type G or in the Psalter of Simon de Montacute, no. 112). From about 1360 on, the interstices between the sharp tips of profile serrated leaves were frequently filled with golden 'shadows' (Type H) and the axis of these leaves was more frequently curved, with the pointed segments more and more widely separated from each other (especially in the Bohun manuscripts). Still further conventional foliage became common after 1360 and increasingly prominent toward the end of the century, in particular, kite-shaped leaves (Type I) attached to diagonal shoots arranged in diverging pairs and bell-and-clapper or lobe-and-tongue leaves (Type K) on feathery black penwork stems (typical of the Litlyngton group). Such foliage, arranged in regular repeated patterns, almost entirely superseded the less programmatic and more naturalistic forms of the beginning of the century and coincided with a definite shift of English interest in the representation of the visible world from the margins of the manuscript page to the confines of the framed miniature or historiated initial.

## MANUSCRIPT ILLUMINATION AND THE OTHER ARTS

It is beyond the scope of this study to consider in detail the precise position of manuscript illumination in the artistic milieu of 14th-century England. Suffice it to say that the general characteristics of English Gothic as they have been discussed here in relation to illumination, apply equally to the other arts. In numerous particular instances also, there is evidence of close

relationships between manuscript illuminations and individual works of art in other media – carving in stone or wood, metalwork, architectural decoration, as well as other forms of painting; these have been noted, either previously in this Introduction, or in the Catalogue. But although materials for a detailed history of manuscript illumination are relatively rich, those for the other arts of the 14th century – architecture excepted – are much more fragmentary. Consequently, a balanced general history of English 14th-century art, restoring to each aspect of the visual arts its original relative importance, seems almost impossible to achieve.

Especially in wall- and panel-painting and in the related arts of stained glass and *opus anglicanum* does the paucity of remains make it difficult to assess the nature and degree of relationship with manuscript illumination. Illuminated manuscripts must 'stand for' all the lost paintings in other media. Paintings on panel are limited to a few examples from the first third of the century and a few more from the last two decades.[97] While individual works, such as the Sedilia in Westminster Abbey, are related to particular manuscripts, in this case the De Lisle Psalter (no. 38), there are simply not enough surviving panel paintings to sustain conclusions as to whether a consistent pattern of parallels once existed. The Norwich panels of 1380–1400 (fig. 24), for example, were possibly painted in Norwich,[98] and are exactly contemporary with some fine illuminated manuscripts of probable Norwich origin,[99] yet there is little resemblance in style. It seems significant that in written references to painters in England, the activities in which they engaged never seem to include manuscript illumination,[100] and in the development of guilds, the painters and the 'limnours' were in separate organizations, the illuminators with other craftsmen in the book trade.[101]

The situation is comparable when the relation between wall-painting and manuscript illustration is evaluated. The finest surviving, if fragmentary, 14th-century pictorial cycle, the paintings from St. Stephen's Chapel (fig. 23), while similar in format to contemporary miniatures in manuscripts, are not closely related in details of style to any extant book illustrations. But most surviving wall-paintings are of a provincial character and consequently are generally considered to trail stylistic developments in manuscript illumination, even when related in theme.[102] The wall-paintings of Longthorpe Tower near Peterborough (fig. 22), for instance, which offer striking iconographic parallels to some of the diagrams of the De Lisle Psalter, are usually dated in the second quarter of the century,[103] as many as twenty to thirty years later than the miniatures, and show no significant relationship in style.

The richest collections of 14th-century stained glass are in York, Tewkesbury and Gloucester.[104] The handling of details of figure representation – poses, gestures, physiognomic types – resembles that of manuscript illumination, yet few manuscripts of known provenance originated in the places where extensive glass programmes were installed. It should be imagined that images in manuscripts – handy and portable – provided models for stained glass, but the evidence does not favour direct contacts between the artists who designed and executed the glass and those who painted the miniatures. Moreover, the remarkable change in the design of stained glass that came about with the rise of the Perpendicular style – the band window with its rows of tall, single figures, heraldic shields, and painted canopies (fig. 21) – tended to lay stress on the static tableau at the very time when the basic mode of design of manuscript illumination was the dramatic narrative.

*Opus anglicanum*, the brilliant ecclesiastical embroidery exported from England to the distant reaches of the Continent in the 14th century, has often been compared to East Anglian manuscript illumination on account of the elaborate, often fantastic, animal and foliate decoration and the inventive framing motifs of the liturgical vestments (fig. 25).[105] The comparison is focused on stylistic similarities rather than documented connections. Indeed, *opus anglicanum* seems to have been a London, not East Anglian specialty. As is true of so many manuscripts, the dates of the surviving embroideries are conjectural, and the points in the sequence of development are relative, not fixed. Consequently, it is difficult to decide

whether the comparatively few embroideries are contemporary with, precede, or follow the manuscript illuminations they most closely resemble.

## CONCLUSION: A HISTORICAL NOTE

The hundred years of manuscript illumination encompassed by this study differ somewhat from those that would have been identified as a significant chronological unit by historians who focus on political, economic, or social developments. For them it is customary to count in conventional round numbers, 1300–1400; or, more commonly, in regnal years of the British monarchs – 1307–77 (Edward II – Edward III), or 1307–99 (Edward II – Richard II), for instance. The difference underlines the difficulty of reconciling artistic events with the coronations and deaths of the kings of England during the 14th century. Of these rulers, only the last, Richard II, was closely identified personally with cultural developments,[106] even though a Court School existed throughout much of the 14th century. In fact, however, what is called 'Court' art is likely, in the production of illuminated manuscripts at least, to be books made for members of the royal family and the noble circle round the king rather than the sovereign himself.[107] Indeed, the most continuous dynastic patronage of manuscript illumination during the 14th century was that of the Bohun family, noble, but not monarchial. Nevertheless the Bohuns' maintenance of illuminators as personal retainers may well reflect the practice of the *camera regis*, even though the evidence, in the form of illuminated manuscripts themselves, does not survive.

*Manuscript Painting at the Court of France* is a valid title for a recent general study of 14th-century illumination in France;[108] in Britain, however, court sponsorship of manuscript production was only part of the picture of patronage. Innovative and typically English developments in manuscript illumination also occurred in books made not for the higher echelons of the aristocracy but for wealthy, upwardly mobile county families, the Howards, Bardolfs, Tiptofts, Luttrells, St. Omers, Vernons, Fitzwarins, and Zouches, to name some. Hardly country bumpkins, these were armigerous families; their leading members were regularly called to attend parliament and to render judicial and military service to the crown.[109] Nevertheless, the manuscripts associated with their names represent, for the most part, the robust, earthy, expressionistic aspect of English 14th-century illumination rather than the elegant, 'courtly' side. But the lines are not clearly drawn, as some works in 'vulgar', or at least vernacular taste were owned or intended for ownership by the highest ranks of the nobility, even the sovereign, as is the case with the Milemete Treatise and the Taymouth Hours.

If the rise of a new class of secular patron is a distinctive feature of English 14th-century illumination, the strength of the traditional market for manuscripts – the monastic members of the old, established Orders, the Benedictines, Cluniacs, and the Augustinian Canons – is another characteristic. Again unlike France, where Dominican Use frequently went hand-in-hand with royal patronage, in England a significant number of major 14th-century illuminated manuscripts was made for monastic users, including, among others, the Peterborough, Ramsey and Tickhill Psalters, the Psalter of Richard of Canterbury and the Chertsey Breviary, the Bromholm Psalter, the Yale Cluniac Psalter, the Psalter of Stephen of Derby and the Litlyngton Missal. Nevertheless, there is little evidence that such luxury manuscripts were actually produced by monks.[110] On the other hand, the Dominicans and Franciscans, undoubtedly important in the religious and intellectual life of England, played little direct part in the patronage and production of illuminated manuscripts. For instance, very few English liturgical manuscripts can be described as of Franciscan or Dominican Use.[111] It may be that the Mendicant contribution to the development of English manuscript illumination during the 14th century was indirect. The devotional and moral themes on which the friars dwelled in

their ministry to the laity as preachers and confessors found their counterparts in pictorial iconography, as illustrations of devotional texts and Books of Hours.

In spite of the marked institutional growth of Oxford and Cambridge during the 14th century, the practice of illumination played little part in the production of manuscripts for scholars. No illuminated manuscript included in this study has a known English university origin, although a couple of Canon Law texts mentioned in connection with the Milemete manuscripts had medieval Oxford owners.[112] Of course, the information about the actual places of origin of illuminated manuscripts is limited, and where such information exists it cannot usually be tied to extant works. What seems reasonably certain is that illuminated manuscript production had definitively shifted away from monastic or secular religious establishments. The surviving records of the manuscript dealings of Norwich Cathedral Priory during the early 14th century, for instance, show that all aspects of book production were in the hands of outside professionals, some of whom were fed and housed at the priory but most of whom supplied their product or service on commission. Unfortunately, the rolls give only the names of the recipients of payments (and sometimes not even that, as for instance fees paid to 'a certain illuminator'), not where they lived.[113] Toward the end of the century, the production history of both the St. Albans Benefactors Book (no. 158) and the Litlyngton Missal (no. 150) shows that these works, though executed locally, in the abbeys by which they were commissioned, were decorated, and in the case of the Litlyngton Missal, written as well, by lay professionals. The Crucifixion miniature of the Litlyngton Missal was purchased separately and paid for as a product rather than a service, suggesting that it was not painted in Westminster Abbey, but outside the walls, in the surrounding urban milieu.

In the end, however, it is the surviving manuscripts themselves that offer such evidence as there is of centres of book illumination. Groups of manuscripts characterized both by uniform style and identical provenance were probably made in the place at which they were intended to be used. The group of Norwich books around the Ormesby Psalter is one such example, and the Bohun manuscripts may be another. Conversely, groups of manuscripts characterized by uniform style but divergent provenance should – if the group is as large as that around the Queen Mary Psalter – be thought of as originating in a large urban centre, preferably one corresponding with the known provenance of at least some of the individual books, as is the case in the identification of London as the home of this group.

If London and Norwich were two fairly certain centres for the production of illuminated manuscripts during the 14th century, what of the other major cities, York and Bristol, both of which were larger than Norwich?[114] Bristol, the second largest city in England during the 14th century, strategically and commercially important, was not an episcopal see, nor was it often visited by king and court. Perhaps this accounts for the apparent absence of surviving illuminated manuscripts of Bristol provenance, even though the city was in the vanguard of architectural developments as the site of one of the first buildings heralding the Perpendicular style, St. Augustine's Abbey, begun in 1298 and completed in 1341.[115]

In pursuit of the Scottish Wars, the king, the court, and the entire government administration spent considerable parts of the period before the beginning of the war with France, in the city of York, the ecclesiastic capital of the North of England.[116] This situation should have been propitious for the development of York as a centre of production of illuminated manuscripts as well as government documents. In fact, the York diocese provenance of some Court Style manuscripts, such as the Psalter of Queen Isabella (no. 27), the Bodley Roll (no. 16), and even the Tickhill Psalter (no. 26), can be explained by the sojourn of Edward II and Edward III in the North. But once the Hundred Years' War had started and the king and court departed, evidence of the association of York with manuscript illumination disappears almost entirely, even though during the second half of the 14th century intense artistic activity in the area of architecture continued.

To literary historians the 14th century marks the triumphant establishment of an English literature which, by the end of the period, had produced vernacular masterpieces in every category of writing from the lyric to the Wycliffite translation of the Bible.[117] Yet in the sphere of manuscript illumination only two of the volumes included in this study contain even the briefest lines of English (nos. 38 and 147); as for the rest, the vernacular – from rubrics to whole texts – is Anglo-French. Of course, the vast majority of illustrated texts continued to be written in Latin, the universal language of European culture, but the use of French in English books throughout the 14th century is an indication of the continued strength of the ties traditionally binding the two nations.

France indeed was the most important external force in English history during the 14th century, whether it was a question of language, geographical proximity, feudal claims and obligations, dynastic marriages, the Hundred Years' War – or manuscript illumination. Yet the artistic impact of the great events of the century that involved England and France is difficult to evaluate. Specific evidence of the introduction of illuminated manuscripts into the British Isles is sporadic, although sometimes dramatic, as for instance in the capture of a fine Parisian *Bible historiale* and a Pucelle-illustrated Miracles of the Virgin along with Jean le Bon at the Battle of Poitiers in 1356.[118] The *Bible historiale* remained in England, but the Miracles of the Virgin was bought back. Jean le Bon himself spent his captivity in England together with his painter and *valet de chambre* Girart d'Orléans. Whether Girart himself was an illuminator is doubtful. In any case, the books acquired in England by Jean le Bon were purchased from English, not French sources, for instance, a *Roman de Renart*, bought by Jean's tailor, Tassin du Bruil, in Lincoln; a small Psalter, bought from John, 'libraire', also in Lincoln; another Psalter, commissioned but not bought, from Master John Langlois, scribe; a *Roman de Loherenc Garin* and a *Tournoiement d'Anticrist*, bought by Jean's chaplain, Guillaume Racine, from an unidentified source, probably in London.[119] That other contemporary French manuscripts may have arrived in England can only be surmised from the frequency of contacts between the two countries, even at the height of war. And the weight of visual evidence shows that artistic parallels between England and France were closer throughout the 14th century than between England and any other nation.

At the same time, if in a more circumscribed way, the closer political and economic ties established between England and the Low Countries during the 14th century help to explain the parallels between English and Flemish illumination during this period. In the search for anti-French support, England was allied with Flanders militarily and dynastically through the marriage of Edward III to Philippa of Hainault, and economically through the complexities of the wool trade. Again, the artistic impact of these links is difficult to determine. Specific evidence of interchange on both sides of the Channel exists: the Bodleian Library's Flemish Romance of Alexander of 1344 (MS Bodley 264) may have belonged to Thomas, Duke of Gloucester (d. 1397) and may have been brought to London by a Bruges citizen as early as 1374;[120] an English artist who otherwise worked in the Bohun atelier participated fleetingly in the decoration of one of the Flemish manuscripts associated with Louis de Male, Count of Flanders, c. 1360. There are, in fact, broad similarities between certain aspects of English manuscript illumination – marginal drolleries at the beginning of the century, figure style around the middle – and that of Holland, Flanders, Artois and Picardy. In this case, too, while Flanders (if not Artois and Picardy) and England were separated linguistically, they were separated geographically only by the Channel, which served as a bridge rather than a divider.

However, international contacts had to be longstanding, profound and sustained to affect artistic developments. Richard II's marriage to Anne of Bohemia does not appear to have been accompanied by a significant wave of Bohemian or German influence on the art of England. Bohemia and the Empire were too distant, the marriage did not last long enough,

nor was it accompanied by close ties of trade or war. Nor did the missions of papal legates from Avignon, the occupancy of English prebendaries and bishoprics by foreign clerics, or the presence of Italian merchants in London, profoundly affect the course of development of English illumination. Mediterranean art, whether from the south of France, or from Italy, was brought into England frequently, as a conscious import, but seems to have remained in the category of exotic luxury, to be emulated in whole or in part, but not to be absorbed permanently.

In *English Art 1307–1461*, Joan Evans[121] commented at length on the continuous vitality of English architecture in spite of the 'national disasters' of the 14th century – the Black Death, the loss of English possessions in France, the civil conflicts, the Peasants' Revolt – to which could be added the defeats in Scotland and Ireland, and the deposition and murder of two kings. But she adds, 'though building continued, creation in the minor arts was at a low ebb.'[122] She also writes: 'The troubled years of the middle of the 14th century are directly reflected in a dearth of illuminated manuscripts. The break, which can hardly have been complete, is none the less noticeable, and is far more clearly marked in England than in France. Evidently there were fewer trained miniature painters in this country, and the loss of some of them in the plague years must have been more acutely felt. The standard of English manuscripts falls far below that of the French ateliers.'[123]

Evans' view needs some modification. This study has shown that more – and better – illuminated manuscripts were executed after 1348 than she realized. Yet her comments raise a new question: why did architecture thrive and illumination suffer? Evans suggested that the plague had a proportionally greater impact on manuscript illuminators than architectural craftsmen, and this may well have been the case if the illuminators were concentrated in cities badly affected by the disease, such as Norwich and London.[124] Another answer perhaps lies in the character of illuminated manuscript patronage. Buildings were complex team endeavours, both from the point of view of the constructors and the patrons; they were generally communal in inspiration and in use; and they were usually built slowly, often over several human generations. Unlike an earlier time, in the 14th century manuscripts were usually illuminated for or acquired by individuals; single manuscript patrons could suddenly disappear through war, civil disorder or pestilence, while a community could live on. It is an irony of history that of all the portable forms of art of the 14th century in which individual patronage played an important role – painted panels, tapestries, embroideries, ivories, goldsmith's work, jewels – illuminated manuscripts – the least highly valued at the time – are the primary surviving evidence. Precious in themselves as works of art, as any work of art is precious, they are invaluable as clues to the tastes of the rapidly changing society of the 14th century.

Fig. 1. Detail from the Feeding of the
Five Thousand. Retable. London, Westminster Abbey

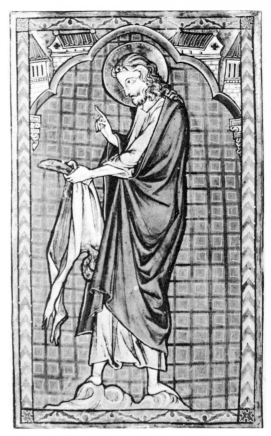

Fig. 2. St. Bartholomew. London, B.L.,
Add. 50000, f.9

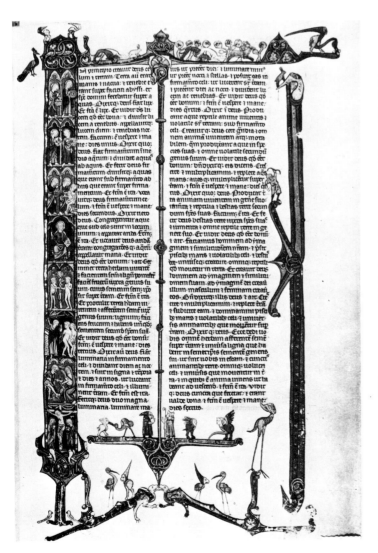

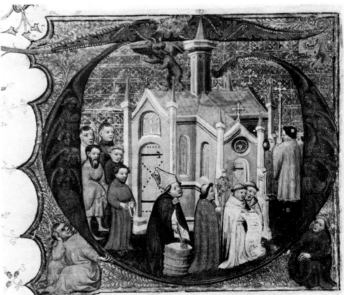

Fig. 4. Dedication of a church.
London, B.L., Add. 29704, f.68�v

Fig. 3. Genesis initial. London, B.L., Royal I.D.I, f.5

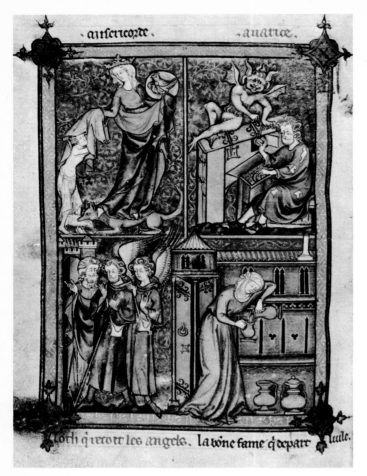

Fig. 5. Mercy and Avarice. London, BL.,
Add. 54180, f.136ᵛ

Fig. 6. Psalm 80. London, B.L.,
Yates Thompson 8, f.45ᵛ

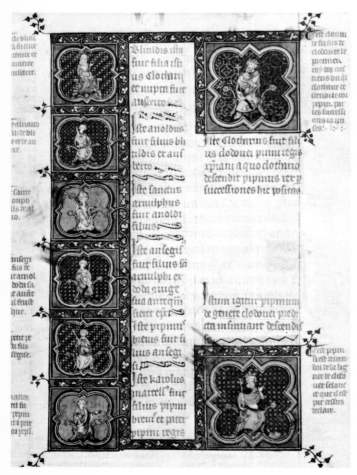

Fig. 7. Detail from the Chronicles of France.
Paris, Bibl. Nat., lat. 13836, f.12

Fig. 8. Detail from the Wenzel Bible.
Vienna, Österreichische Nationalbibl., 2763, Vol.V, f.172

Fig. 9. Ascension. Brussels. Bibl.Royale,
9217, f.33ᵛ

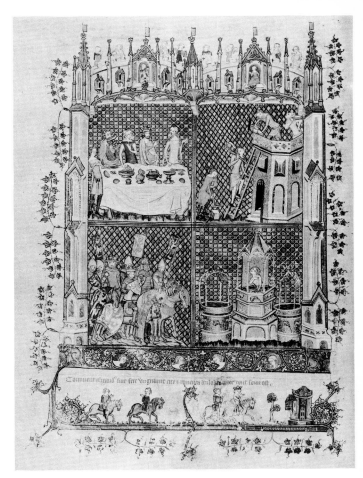

Fig. 10. Romance of Alexander. Oxford,
Bodl.Lib., Bodley 264, f.67ᵛ

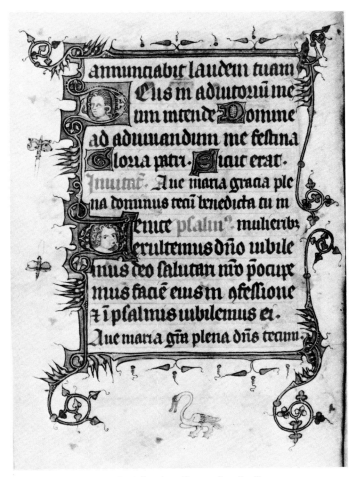

Fig. 11. Oxford, Bodl. Lib., lat. liturg. f.3, f118

Fig. 12. Christ holding
child's hand. Brussels,
Bibl. Royal, 6426, f.42

Fig. 13. Nativity. Oxford, Bodl. Lib.,
lat. liturg. f.3, f.79

Fig. 14. Frontispiece to Proverbs. London, B.L.,
Royal 17.E.VII, f.1

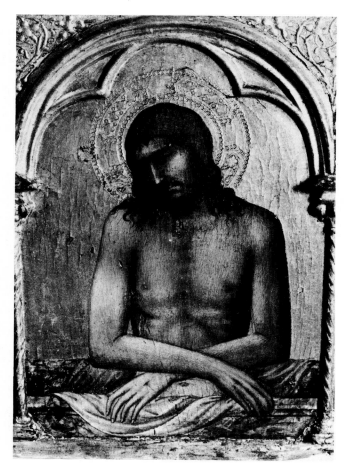

Fig. 15. Simone Martini: Man of Sorrows.
Pisa, Museo Nazionale

Fig. 16. Man of Sorrows.
London, B.L., Egerton 3277,
detail of f.114

la oīre murdīa prima dī partirla.
O ndīo pīū tūo mā penso e dīsceſno
che uī mī ſeqīut 7 īo ſaro tūa gūuda.
e tīraboū dī quī per luogo eterno.
Oue uorrai lī dīſpieeate ſtrīda.
uedrāī gī anācke ſpīrtī dolentū.
che la ſecūda morte aaſeun grīdā.
E uederaī cholor che ſon contentū.
nel fūocho per che ſperan de uenīre.
quando che ſia ale beate gentī.
Alū quaī poī ſe tū uorraī ſallīre.
anīma fīa acīo dī me dēgīna.
con leī tū laſeero nel mūo partīre.

Fig. 17. Illustration to Dante. London, B.L., Add. 19587, f.2

Fig. 18. Scenes from the Life of Moses.
London, B.L., Add. 15277, f.45

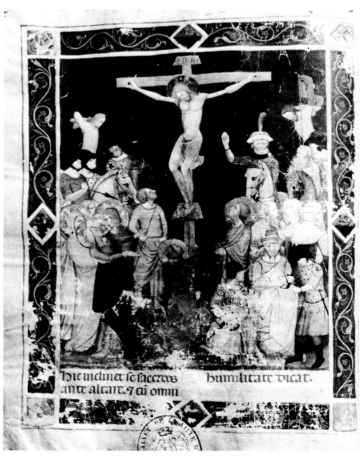

Fig. 19. Cruxifixion from a Neapolitan Missal.
Avignon, Musée Calvet, MS 138.

Fig. 20 Sedilia. London Westminster Abbey

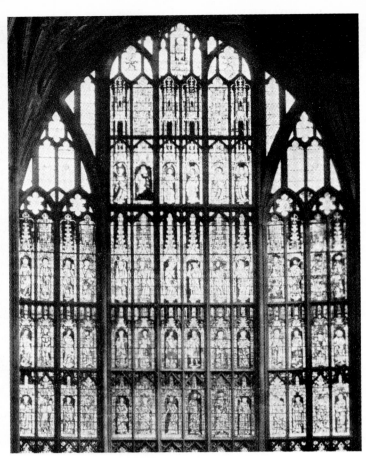

Fig. 21. Detail of Great East Window,
Gloucester Cathedral

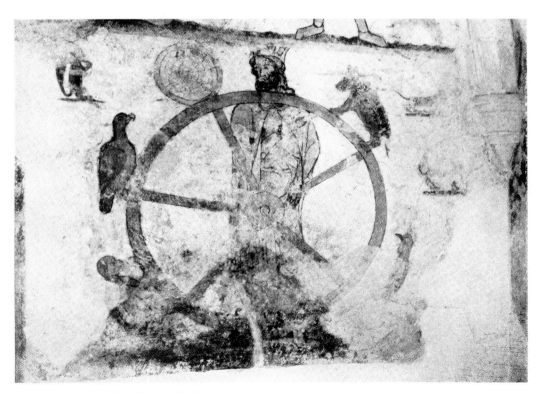

Fig. 22. Wheel of Five Senses. Wall-painting,
Longthorpe Tower, near Peterborough

Fig. 23. Fragments of wall-painting from
St. Stephen's Chapel, Westminister. London, British Museum

Fig. 24. Crucifixion, Resurrection and Ascension.
Retable. Norwich Cathedral

Fig. 25. Nativity. Detail from the Bologna Cope. *Opus Anglicanum,* 1315–35. Bologna, Museo Civico

Fig. 26. Funeral of a king. London, Westminster Abbey, 37, f.224

# NOTES

1. See, for example, A. Haseloff in A. Michel, *Histoire de l'art*, Paris, 1906, II, pt. I, 345–59, passim; Rickert, *Painting in Britain*, 129, 137–50, passim.

2. *Pariserminiaturmalerei*, 70–2, citing J. von Schlosser in *Jahrbuch der kunsthistorischen Sammlungen des allerhöchsten Kaiserhauses*, XVI, 1895, 170ff.

3. Millar, I, 63f.

4. Millar, II, ix.

5. Marks and Morgan, *English Manuscript Painting*, 19. For a differing characterization of the Windmill Psalter style, see catalogue no. 4.

6. For a re-attribution to an anonymous master, see E. Kosmer, 'Master Honoré: A Reconsideration of the Documents', *Gesta*, XIV, 1975, 63–8.

7. Tours, Bibl. Mun. MS 558. See Paris, Bibliothèque Nationale, *Les manuscrits à peintures en France du XIIIe au XVIe siècle*, 1955, no. 30, 21 and E. Millar, *An Illustrated Manuscript of La Somme le Roy Attributed to the Parisian Miniaturist Honoré*, Oxford, 1953, 2, 4ff., pls. XVIII–XIX.

8. 'The Development of Maître Honoré', in London, British Museum, *The Eric George Millar Bequest*, London, 1968, 53–65, esp. 61.

9. For a collection including also numerous mentions of illuminated manuscripts, see M. M. Bigelow, 'The Bohun Wills', *American Historical Review*, I, 1895–96, 414–35, 631–49.

10. *Gorleston Psalter*, I. Cockerell was referring to such Franco-Flemish manuscripts as B.L. Stowe 17, a Book of Hours of *c.* 1300 for use in the diocese of Maastricht.

11. *Painting in Britain*, 139.

12. See Randall, *Images*, 9, n. 38.

13. London, B.L. MS Yates Thompson 8 and Verdun, Bibl. Mun. MS 107. See P. de Winter, 'Une réalisation exceptionelle d'enlumineurs français et anglais vers 1300: le bréviaire de Renaud de Bar, évêque de Metz', *Actes du 103e congrès national de sociétés savantes (1978)*, Paris, 1980, 27–61, where it is proposed that part of the Verdun portion of the manuscript was the work of an English atelier.

14. For the most detailed characterization of the French qualities of the Queen Mary Psalter, see Vitzthum, *Pariserminiaturmalerei*, 78; most recently see Marks and Morgan, *English Manuscript Painting*, 19.

15. Wymonduswold *Decretum*, dated 1314 (Paris, Bibl. Nat. MS lat. 3893); Life of St. Denis, 1317 (Paris, Bibl. Nat. MS fr. 2090–2092); Chronicle of Kings, 1317 (Paris, Bibl. Nat. MS lat. 13836); Henricus de Segusia, 1314 (Brussels, Bibl. Royale MS 7452). See K. Morand, *Jean Pucelle*, Oxford, 1962, 45, Marks and Morgan, *English Manuscript Painting*, 19, and F. Avril, *Painting at the Court of France, The Fourteenth Century*, London, 1978, 12.

16. Vitzthum, *Pariserminiaturmalerei*, 78, 83f., 185 ff.; E. Panofsky, *Early Netherlandish Painting*, Cambridge, Mass., 1958, I, 29.

17. See P. Durrieu, 'Un siècle de l'histoire de la miniature parisienne à partir du regne de Saint Louis', *Journal des savants*, January, 1909; F. Avril in Paris, Grand Palais, *Les fastes du gothique, le siècle de Charles V*, 1981, nos. 232–3, pp. 286–8.

18. See also no. 90, Paris, Bibl. Nat. MS lat. 3114, 3114¹, a Duns Scotus with a French scribe and an English artist related to those of the Milemete group, and another Duns Scotus, Paris, Bibl. Nat. MS lat. 3061, also with a French scribe and English artist, whose work resembles that in the Vaux Psalter and McClean Bible (nos. 30, 32).

19. Graphically illustrated in the diagram in Rickert, *Painting in Britain*, 4–5.

20. *The Connections between English and Bohemian Painting during the Second Half of the Fourteenth Century*, Courtauld Institute, University of London, 1978. Now published in the Garland Series of 'Outstanding Theses from the Courtauld Institute of Art', New York, 1984.

21. *Historical Introduction to the Collection of Illuminated Letters and Borders in the National Art Library, Victoria and Albert Museum*, London, 1901, 127f., 156f.

22. *Carmelite Missal*, 78f.

23. See M. Dvořak, 'Die Illuminatoren des Johann von Neumarkt', *Jahrbuch der Kunsthistorischen Sammlungen des allerhöchsten Kaiserhauses*, XXII, 1901, 6–126; J. von Schlosser, 'Die Bilderhandschriften König Wenzels I', loc. cit., XIV, 1893, 212–317; J. Kràsa, *Die Handschriften König Wenzels I*, Vienna, 1971.

24. E.g. the Wenzel Bible, 1390–1400 (Vienna, Nationalbibl. MSS 2759–2764).

25. *Painting in Britain*, 149.

26. Simpson, *Thesis*, 121–31.

27. *English Manuscript Painting*, 22f.

28. C. Gaspar and F. Lyna, *Les principaux manuscrits à peintures de la Bibliothèque Royale de Belgique*, Paris, 1937, I, 348.

29. L. Delaissé, *Miniatures médiévales de la librairie de Bourgogne au Cabinet des Manuscrits de la Bibliothèque Royale de Belgique*, Geneva, 1959, 68, and Brussels, Bibliothèque Royale de Belgique, *La Librairie de Philippe le Bon*, 1967, 22.

30. The use of such profile faces and jaw-to-jaw monster heads can be traced back to Jean Pucelle, e.g. the Hours of Jeanne d'Evreux (New York, Metropolitan Museum of Art), f. 83.

31. Breviary of Louis de Male, after 1357 (Brussels, Bibl. Royale MS 9427); Missal of 'Louis de Male', *c.* 1360 (Brussels, Bibl. Royale MS 9217); Missal painted by Laurent d'Anvers, 1366 (The Hague, Mus. Meermanno-Westreenianum MS 10 A 14); Antiphonal, *c.* 1360 (Brussels, Bibl. Royale MS 6426); Hours of 'Anne of Bohemia', *c.* 1360, with later insertions (Oxford, Bodl. Lib. MS Lat. liturg. f. 3). See Gaspar and

Lyna, *Bibliothèque Royale de Belgique*, 341–3, 344–6, 346–9, and pls. LXXIIId, LXXIV and LXXV; A. W. Byvanck, *Les principaux manuscrits à peintures de la Bibliothèque Royale des Pays-Bas et du Musée Meermanno-Westreenianum à la Haye*, Paris, 1924, 99–102, pls. LIV–XLV; and Pächt and Alexander, I, no. 299, pl. XXIV.

32. Oxford, Bodl. Lib. MS Bodl. 264. See M. R. James, *The Romance of Alexander*, Oxford, 1933.

33. The source of the attribution (*S.C.* 29742) is the mis-identification of a 19th-century fake showing the marriage of Anne of Bohemia and Richard II (f. 65$^v$) as original. See now Pächt and Alexander, I, no. 299, identifying the fake but still maintaining the association with Anne of Bohemia on the basis of identification of the individual represented in another miniature (f. 118) and the heraldry throughout the book. The arms of Anne of Bohemia as queen were: tierced in pale 1) Edward the Confessor; 2) quarterly France ancient and England; 3) quarterly 1 and 4, or an eagle displayed sable (the Empire) and 2 and 3, gules a lion rampant argent crowned or (Bohemia); see C. R. Humphrey-Smith and M. G. Heenan, 'The Royal Heraldry of England, Part One', *The Coat-of-Arms*, VI, 1960–61, 227. The heraldic charges in the manuscript – fleurs de lis, lions, eagles, etc. – are all painted in white and the fields are all painted in rose and/or blue, so that many of the coats-of-arms are only approximations. There is no complete representation of the arms of Anne of Bohemia and the separate representations of 'Bohemia' and 'The Empire' are inaccurate. The uncrowned woman adoring the Virgin at the beginning of Matins (f. 118) is wearing a garment patterned with the arms of France ancient a bend (?) or, clearly pointing toward France rather than Bohemia or the Empire.

34. Otto Pächt ('Giottesque Episode', 57) first commented that '. . . the Bohun style is ultimately derived from the East Anglian school in much the same way as the style of the Boqueteaux Master, its French parallel, can be traced from Pucelle'. On the Boqueteaux Master, see, most recently, Avril, *Manuscript Painting at the Court of France*, 28. Avril disputes the usual identification of the Boqueteaux Master with Jean Bondol, painter of Charles V (for which see H. Martin, *La miniature française du XIIIe au XVe siècle*, Paris and Brussels, 1923, 37–53).

35. 'A Giottesque Episode in English Medieval Art', *J.W.C.I.*, VI, 1943, 51–70.

36. *Painting in Britain*, 149; Simpson, *Thesis*, 128–31; Marks and Morgan, *English Manuscript Painting*, 22f. Pächt ('Giottesque Episode', 57) discounted Italian influence in the Bohun manuscripts.

37. *Painting in Florence and Siena after the Black Death*, Princeton, 1951.

38. 'Giottesque Episode', 55f.

39. 'An English Illuminator's Work in some Fourteenth-Century Italian Law Books at Durham', *Medieval Art and Architecture at Durham Cathedral* (British Archaeological Association), 1980, 149–53.

40. London, B.L. MS Add. 15277. See Pächt, 'Giottesque Episode', 61.

41. On Neapolitan illumination, see E. von Furstenau, 'Pittura e miniatura a Napoli nel secolo XIV', *L'arte*, VIII, 1905, 1–17, and B. Degenhart and A. Schmitt, *Corpus der italienischen Zeichnungen 1300–1450*, Berlin, 1968, Pt. I, 1, and Suppl., 1980. Among Neapolitan manuscripts of the third quarter of the century, the following may be mentioned: Orosius, *c.* 1350–*c.* 1370 (London, B.L. MS Royal 20. D. I); *Roman du Roy Meliadas*, 1352–62 (London, B.L. MS Add. 12228); *Vitae Patrum*, *c.* 1350–*c.* 1375 (New York, Pierpont Morgan Lib. MS M.626); Dante, *c.* 1370 (London, B.L. MS Add. 19587).

42. London, B.L. MS Add. 19587. See P. Brieger, M. Meiss and C. Singleton, *Illuminated Manuscripts of the Divine Comedy*, London, 1969, I, 258–61 and many pls.

43. Avignon, Mus. Calvet MS 138. See V. Leroquais, *Les Sacramentaires et missels manuscrits des bibliothèques publiques de la France*, Paris, 1924, II, 326f., IV, pl. LXIII, made *c.* 1360 for Nicolas-Jean Ricardi de Ricardinis, Canon of Naples and brought to Avignon by Cardinal Bernard de Bosqueto, Archbishop of Naples and then Cardinal of Avignon.

44. See S. M. Newton, 'Tomaso da Modena, Simone Martini, Hungarians and St. Martin in Fourteenth-Century Italy', *J.W.C.I.*, XLIII, 1980, 234–8.

45. E.g. the Orosius, London, B.L. MS Royal 20. D. I, probably in the Royal Collection in 1535 (see Warner and Gilson, II, 375–77), but *c.* 1400 in Paris (see F. Avril, 'Trois manuscrits napolitains des collections de Charles V et de Jean de Berry', *Bibliothèque de l'École des Chartes*, CCXXVII, 1969, 291–328).

46. Matteo Giovanetti was an important painter in the papal palace at Avignon (see E. Castelnuovo, *Un pittore italiano alla corte di Avignone*, Rome, 1962). For the Missal of Clement VII (Paris, Bibl. Nat. MS lat. 848), see M. Meiss, review of Paris, Bibliothèque Nationale, *Les manuscrits à peintures en France du XIIIe au XVIe siècle*, 1955, in *Art Bulletin*, XXXVIII, 1956, 189. The Crucifixion of this manuscript has also been considered to be of Bohemian workmanship (Simpson, *Thesis*, 159, with further refs.). On the parallels between the painting of Bohemia, Avignon and Naples in the 14th century, see the article by Dvořák, above, n. 23.

47. L.-H. Labande, *Le palais des papes et les monuments d'Avignon au XIVe siècle*, Marseille, 1925, II, 11–13; Castelnuovo, *Un pittore italiano alla corte di Avignone*, 17f.

48. 'The Windmill Psalter: The Historiated Letter E of Psalm One', *J.W.C.I.*, LXIII, 1980, 52–69. I do not accept an 'Edwardian' interpretation of the letter in question.

49. F. Wormald ('Paintings in Westminster Abbey and Contemporary Paintings', *Proceedings of the British Academy*, XXXV, 1949, 176), after observing the presence of artists of East Anglian origin at work in Westminster Abbey in the early 14th century, suggested that the origin of the East Anglian school lay in the training of these artists at court – and presumably their transport of the style back to East Anglia.

50. See M. Hastings, *St. Stephen's Chapel*, Cambridge, 1955, 126–29.

51. See G. Webb, *Architecture in Britain: The Middle Ages*, Harmondsworth, 1956, 133.

52. See W. R. Lethaby, *Westminster Abbey and the King's Craftsmen*, London, 1906, passim.

53. *Queen Mary Psalter*, 7.

54. *Pariserminiaturmalerei*, 70ff.

55. *The Tickhill Psalter and Related Manuscripts*, New York, 1940.

56. Ibid., 3f., 122f.

57. P. 142, repeated in the 2nd ed., 1965, 124. Rickert inaccurately quoted Millar, p. 13, as having written that the Queen Mary Psalter was 'the central manuscript of the East Anglian group', but in fact Millar had differentiated between the East Anglian and the Queen Mary books, calling them 'the two chief groups into which I have divided English manuscripts of the first half of the fourteenth century' (p. 11). He termed the Queen Mary Psalter 'the great masterpiece of the [second] group' (p. 13).

58. E.g. Cockerell, *Gorleston Psalter*, 1–5; Rickert, *Painting in Britain*, 137–54, discussed all English manuscripts of the first half of the century, including these as well as the De Lisle Psalter and the Tickhill Psalter under the rubric 'East Anglian'.

59. *Gorleston Psalter*, 1.

60. For the Bromholm Psalter, see S. C. Cockerell and M. R. James, *Two East Anglian Psalters at the Bodleian Library*, Oxford, 1926; M. R. James, *The Dublin Apocalypse*, Cambridge, 1932.

61. See N. J. Morgan in Norwich, 1973, no. 25, p. 21f.

62. The connection of the Fitzwilliam Bestiary to the Ormesby style was first suggested in Wormald and Giles, 'Handlist', pt. III, no. 379, p. 371f. See now F. Wormald and P. Giles, *A Descriptive Catalogue of the Additional Manuscripts in the Fitzwilliam Museum*, Cambridge, 1982, I, 393.

63. *Gorleston Psalter*, 8.

64. M. Michael ('The Harnhulle Psalter-Hours: An Early Fourteenth-Century English Illuminated Manuscript at Downside Abbey', *Journal of the British Archaeological Association*, CXXXIV, 1981, 81–99) has recently found the hand of the Longleat Breviary artist in a Psalter-Hours associated with the Harnhulle family of Gloucestershire, Hampshire and Suffolk; a destination in any of these counties would still further widen the circle of patronage of this group of artists.

65. *Gorleston Psalter*, 3ff.

66. In Norwich, 1973, no. 19, p. 17f.

67. B. Watson, 'The Artists of the Tiptoft Missal and the Court Style', *Scriptorium*, XXXIII, 1979, 25–39.

68. Jonathan Alexander brought the stylistic connection of the Bury St. Edmunds volume and these Fenland manuscripts to my attention.

69. N. R. Ker, 'Medieval Manuscripts from Norwich Cathedral Priory', *Cambridge Bibliographical Society, Transactions*, I, 1949–53, 1–28.

70. J. J. G. Alexander, 'Early Fourteenth-Century Illumination; Recent Acquisitions', *Bodleian Library Record*, IX, 1974, 72–80.

71. *Medieval Manuscripts*, I, 20f. For further discussion of the *Liber legum antiquorum*, see L. Dennison, ' "Liber Horn", "Liber Custumarum" and other Manuscripts of the Queen Mary Psalter Group', *Medieval Art and Architecture in London* (British Archaeological Conference Transactions for the Year 1984).

72. See Pächt and Alexander, III, nos. 610, 577; Brussels, 1973, no. 64. A number of legal books in addition to those mentioned above were illustrated in Milemete-related styles, e.g. in the British Library a Justinian Codex (Royal MS 10. C. III) and a Decretals Book VII (Royal MS 11. C. IX). Doubtless a fuller picture of the activities of this group would be revealed by further study of the surviving legal codices in British libraries.

73. The Alphonso Psalter (no. 1) also seems to have passed into the hands of Humphrey, fourth Earl of Hereford, or his wife, and their heirs; in the Calendar are the added obits of his wife Elizabeth, daughter of Edward I, her mother and her grandmother, and the inserted miniatures of the life of Christ (ff. 3ᵛ–4ᵛ) were pasted down on leaves painted with the arms of England and Bohun.

74. James and Millar, *Bohun Manuscripts*.

75. Ibid., 3.

76. See above, pp. 12f., 17.

77. The will of Humphrey VI mentions a Missal and an Antiphonal left for use in the chapel of his castle at Pleshey, Essex; these have not survived. The will of Humphrey VII is brief and leaves his entire estate in the hands of his executors, but we know that he owned at least one book which was carefully passed down to his elder daughter Eleanor, as described in her will, and was bequeathed in turn to her son Humphrey (who predeceased his mother). For the Bohun wills, see n. 9 above and J. Nichols, *A Collection of all the wills . . . of the Kings and Queens of England . . .*, London, 1780.

78. See Nichols, *Wills*, 47f.

79. F. Roth, O.S.A., *The English Austin Friars, 1249–1538*, New York, 1961, II, 223, 242, quoting registers of the Priors General of the Austin Friars (Order of the Augustinian Hermits) in the archives of St. Monica, Rome, reg. Dd. 2, f. 17 and reg. Dd. 3, ff. 88–88ᵛ. See also L. F. Sandler, 'A Note on the Illuminators of the Bohun Manuscripts', *Speculum*, LX, 1985, 364–72.

80. *Painting in Britain*, 169.

81. Nichols, *Wills*, 47.

82. Roth, *English Austin Friars*, I, 371, II, 223.

83. James and Millar, *Bohun Manuscripts*, 3.

84. M. R. James, *The Bestiary*, Oxford, 1928, 7–28.

85. On books of hours, particularly French, see V. Leroquais, *Les livres d'heures manuscrits de la Bibliothèque Nationale*, Paris, 1927.

86. E.g. the Hours of Jeanne II de Navarre (Paris, Bibl. Nat. MS nouv. acq. lat. 3145).

87. Cambridge, Univ. Lib. MS Dd. 8. 2 (no. 29); Norwich Hours (no. 47); Walters MS W. 105 (no. 117); Dublin Hours (no. 118); Bodleian, MS Auct. D. 4. 4 (no. 138); Copenhagen Hours (no. 140); Edinburgh Hours (no. 142); Keble Hours (no. 146). In

addition, the historiated initials of an Hours of the Virgin of *c.* 1325–35 in the Boston Public Library, MS q. Med. 124 (formerly MS 1546) constitute such a mixed cycle: Annunciation (f. 1), Nativity (f. 7), Adoration of the Magi (f. 17ᵛ), Presentation (f. 20ᵛ), Coronation (f. 22ᵛ), Crucifixion (f. 24ᵛ), Deposition (f. 26), Entombment (f. 28). See Z. Haraszti, 'Notable Purchases', *Boston Public Library Quarterly*, VII, 1955, 72–74 and M. Michael, 'The Hours of Eleanor de Mohun: A Note on the Coats of Arms found in Boston Public Library MS 1546', *The Coat of Arms*, N.S., V, 1982, 20–23.

88. *A Peterborough Psalter and Bestiary*, Oxford, 1921, 18.

89. *Les livres d'heures*, I, XLIV–XLVI.

90. E.g. Escorial Psalter, no. 80.

91. Short Office of the Cross preceding or following Hours of the Virgin: De Lisle Hours (no. 77, unillustrated); Taymouth Hours (no. 98); Egerton MS 2781 (no. 115); Vatican Hours (no. 116). Individual Hours of the Short Office of the Cross alternating with those of the Virgin: DuBois Hours (no. 88); Walters MS W. 105 (no. 117); Dublin Hours (no. 118); Zouche Hours (no. 119); Edinburgh Hours (no. 142); B.L. MS Add. 16968 (no. 145); Keble Hours (no. 146).

92. *Images in the Margins of Gothic Manuscripts*, Berkeley, 1966.

93. See esp. L. M. J. Delaissé, J. Marrow and J. de Wit, *The James A. De Rothschild Collection at Waddesdon Manor, Illuminated Manuscripts*, Fribourg, 1977.

94. E.g. B.L. MS Royal 13. D. I* (no. 131); Exeter Coll. MS 47 (no. 134); Egerton MS 3277 (no. 135) Edinburgh Psalter and Hours (no. 142); Ramsey Psalter (no. 143); Hatfield Psalter (no. 147).

95. On late 13th- and 14th-century Continental penwork, see: E. Beer, *Beiträge zür oberrheinischen Buchmalerei in der ersten Hälfte des 14. Jahrhunderts unter besonderer Berucksichtigung der Initialornamentik*, Basel and Stuttgart, 1959; F. Avril, 'Un enlumineur ornamentiste parisien de la première moitié du XIVe siècle: Jacobus Mathey (Jacquet Maci?)', *Bulletin Monumental*, 129, 1971, 249–64. With the notable exception of the Windmill Psalter (no. 4), the penwork in manuscripts included in this volume was not used for initials of the largest size, although such manuscripts as the Oxford Bible, MS Auct. D. 3. 2 (no. 13), the Cambridge *Somme le roi* (no. 60), and the Stowe Breviary (no. 79) all have fine penwork initials both one-line and more in height.

96. A recent example of 'scientific' examination is B. Yapp, *Birds in Medieval Manuscripts*, London, 1981.

97. Apart from the Westminster Sedilia, for the first third of the century see the Thornham Parva Retable and the panels in the Cluny Museum, Paris; see Rickert, *Painting in Britain*, 154. For the late 14th century, apart from the Wilton Diptych and the portrait of Richard II in Westminster Abbey, see the Despenser Retable in Norwich Cathedral and the altarpiece from St. Michael-at-Plea, Norwich; see Rickert, 171f., 176f.

98. Rickert, *Painting in Britain*, 176f.; Norwich, 1973, nos. 51, 52, pp. 37f.

99. The Ramsey Abbey Psalter, Holkham MS 26, and the pair of *Polychronicons*, one Oxford, Bodl. Lib. MS Bodl. 316 and London, B.L. MS Harl. 3634, and the other Paris, Bibl. Nat. MS lat. 4922, both with Norwich Cathedral Priory pressmarks; see below, no. 143.

100. See, for example, H. M. Colvin, *The History of the King's Works*, London, 1963, I, 504–27, passim.

101. See H. T. Riley, ed., *Memorials of London and London Life in the XIIIth, XIVth and XVth Centuries*, London, 1858, 557f. for the Ordinances of the writers of text-letters, limners, and others who bind and sell books, dated 1403.

102. See E. W. Tristram, *English Wall Painting of the Fourteenth Century*, London, 1955.

103. Ibid., 219–21.

104. Rickert, *Painting in Britain*, 157–60.

105. See A. G. I. Christie, *English Mediaeval Embroidery*, Oxford, 1938.

106. See G. Mathew, *The Court of Richard II*, New York, 1968, 38–52 and R. F. Green, *Poets and Prince-pleasers, Literature and the English Court in the Late Middle Ages*, Toronto, 1980.

107. See J. J. G. Alexander, 'Painting and Manuscript Illumination at the English Court in the Later Middle Ages', in *English Court Culture in the Later Middle Ages*, V. J. Scattergood and J. W. Sherborne, eds., London, 1983, 141–62.

108. F. Avril, *Manuscript Painting at the Court of France, the Fourteenth Century (1310–1380)*, London and New York, 1978.

109. *Knights of Edward I* (Harleian Society, Vols. 80–83), London, 1929 s.v.; also *Complete Peerage*, London, 1932, under these various baronies.

110. For a possible exception, see the Tickhill Psalter, no. 26.

111. See the Holkham Bible, no. 97, whose production was supervised by a Dominican.

112. See nos. 84–90. The Psalter in Cambridge, Trinity Coll. MS O. 4. 16, has a late 13th-century Calendar and Litany suggesting an Oxford destination (no. 14).

113. See N. R. Ker, 'Medieval Manuscripts from Norwich Cathedral Priory', *Transactions of the Cambridge Bibliographical Society*, I, 1949–53, 1–28.

114. J. C. Russell, *British Medieval Population*, Albuquerque, 1948, 202f.

115. Evans, *English Art*, 66.

116. F. McKisack, *The Fourteenth Century, 1307–1399*, Oxford, 1959, 11, 23, 154.

117. See J. E. Wells, *A Manual of the Writings in Middle English*, New Haven, 1916.

118. See L. Douët D'Arcq, *Comptes de l'argenterie des rois de France au XIV siècle* (Société de l'histoire de France), Paris, 1851, 196–284.

119. At the time of the purchases in Lincoln, Jean le Bon was imprisoned in Somerton Castle, about five miles from the city (1359–60). The last two books on the list were purchased while the king was imprisoned in the Tower of London (1360).

120. See M. R. James, *The Romance of Alexander*, Oxford, 1933, 5.

121. *Oxford History of English Art*, V, London, 1949.

122. Evans, *English Art*, 81.

123. Ibid., 95.

124. Russell, *British Medieval Population*, 228f.

# FIGURAL MOTIFS & DECORATIVE VOCABULARY

## HEAD TYPES

A          B          C

A. London, B.L., Arundel 83, f.131ᵛ

B. Cambridge, University Lib., Dd.4.17, f.2

C. Cambridge, Trinity Coll., B.11.3., f.145ᵛ

## DRAPERY TYPES

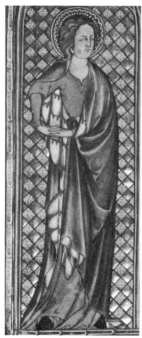 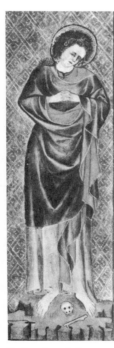 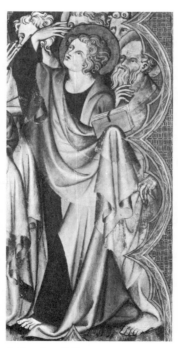 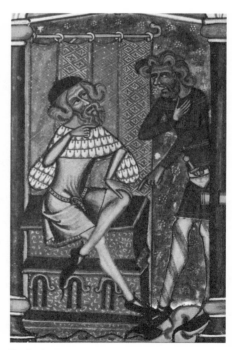

A. London, B.L., Arundel 83, f.132

B. London, B.L., Add. 49622, f.7

C. London, B.L., Arundel 83 f.133ᵛ

D. Paris, Bibl. Nat., lat.765, f.11

# INITIALS

A. One-line initial. London, B.L., Add. 49622, f.198

B. Two-line initial. Oxford, Bodl. Lib., Ashmole 1523, f.127ᵛ

C. Three-line initial. Vatican, Bibl. Apostolica, Pal.Lat.537, f.32

D. Initials with pen flourishes. Baltimore, Walters Art Gallery, W.102, f.76

# LINE FILLERS, VERTICAL BARS & PEN-WORK

A. Line fillers. Oxford, Bodl. Lib., Douce 366, f.63 and
London, B.L., Add. 39810, f.8

B. Pen-work flourishes. Paris, Bibl. Nat., lat. 17155, f.160ᵛ

C. Painted vertical bars. London, B.L., Add. 49622, f.10

D. Pen-work vertical bars. London, B.L., Stowe 12, f.201

Vine-leaves and grapes. Oxford,
Bodl. Lib., Rawlinson G. 185, f.1

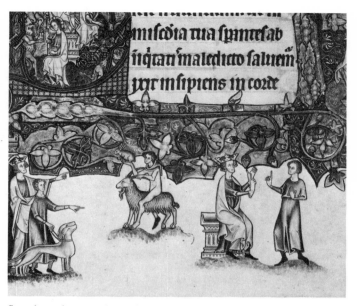

Strawberry leaves and strawberries.
Oxford, Bodl. Lib., Douce 366, f.72

Oak leaves and acorns, Oxford,
Bold. Lib., Astor A. 1, f.10

A

B

C

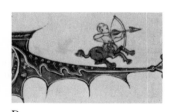

D

E

F

G

H

I

J

K

A,B,C,D. Leaves. London, B.L., Add. 49622, f.10

E,G,H. Daisy-buds, squiggles, segmented leaf.
Cambridge, Trinity Coll., B.11.3, f.123

F. Spoon- or kidney-shaped leaf. Oxford,
Bodl. Lib., Astor A.1, f.10

I,J,K. Kite-shaped, lobe & point, lobe & tongue leaves.
Edinburgh, National Lib., Adv.18.6.5, f.22

# THE BOHUN FAMILY IN THE FOURTEENTH CENTURY

## EARLDOMS OF HEREFORD, ESSEX AND NORTHAMPTON

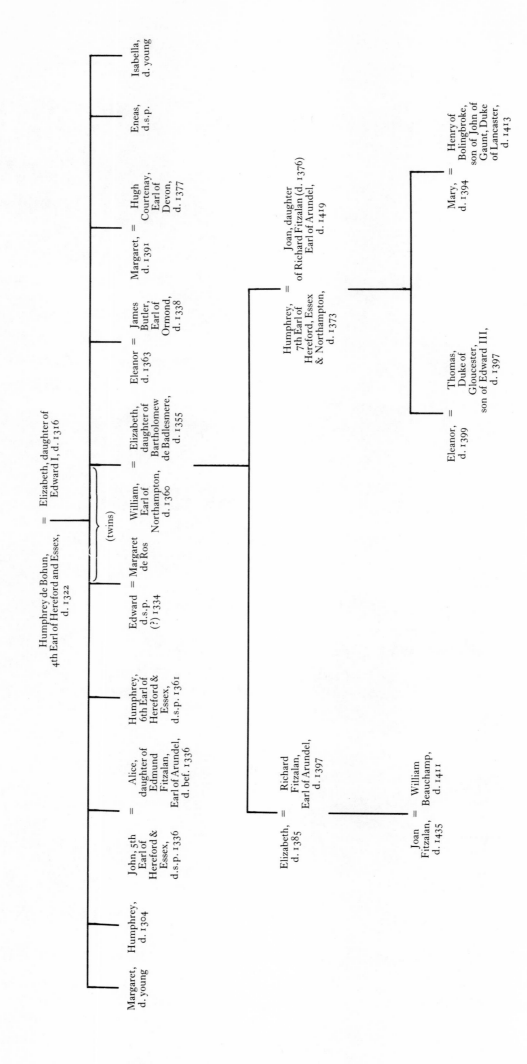

# LIST OF MANUSCRIPTS CATALOGUED IN PART II

1. London, British Library MS Add. 24686, Alphonso Psalter

2. London, British Library MS Royal 3.D.VI, Petrus Comestor, Historia scolastica (Ashridge Petrus Comestor)

3. Cambridge, Fitzwilliam Museum MS BL (Bradfer-Lawrence) 51, Charter of Edward I (Pilkington Charter)

4. New York, Pierpont Morgan Library MS M. 102, Windmill Psalter

5. London, Private Collection, Psalter-Hours (Mostyn Psalter)

6. Paris, Bibliothèque Nationale MS lat. 15472, Bible

7. Oxford, New College MS 65, Apocalypse

8. Cambridge, St. John's College MS 262 (K. 21), Canticles, Hymns and Passion of Christ

9. London, British Library MS Cotton Vitellius A. XIII, Miscellaneous Chronicles

10. Cambridge, Fitzwilliam Museum MS 2–1954, Psalter (Bird Psalter)

11a and b. New York, Clark Stillman and London, Private Collection, Psalter-Hours (Percy Psalter, York Hours)
(a) New York: Calendar, Psalter, Canticles
(b) London: Canticles, Litany, Office of the Dead, Hours

12. New York, Pierpont Morgan Library MS M. 100, Psalter (Clare Psalter, Giffard Psalter, Vescy Psalter)

13. Oxford, Bodleian Library MS Auct. D.3.2, Bible

14. Cambridge, Trinity College MS O. 4. 16, Psalter

15. Baltimore, Walters Art Gallery MS W. 102, Hours

16a. Oxford, Bodleian Library MS Bodley Rolls 3

16b. London, British Library MS Cotton Galba Charter XIV. 4
Genealogy of the Kings of Britain to Edward I and Pedigree of the Kings of England and Scotland

17. Cambridge, Fitzwilliam Museum MS 370, Pictures of Christ, the Virgin and Saints

18. Baltimore, Walters Art Gallery MS W. 51 (Three Living and Three Dead)

19. Oxford, Bodleian Library MS Ashmole 399, Medical and Calendrical Miscellany

20. Canterbury, Cathedral Library MS lit. D. 10, Bestiary

21. Oxford, Bodleian Library MS Rawlinson C. 160, Henry of Bracton, De legibus et consuetudinibus Angliae

22. London, British Library MS Add. 14819, Peter of Poitiers, Genealogy of Christ (roll)

23. Cambridge, Corpus Christi College MS 53, ff. 189–210ᵛ, Bestiary (Peterborough Bestiary)

24. Oxford, Jesus College MS D. 40, Psalter

25. Paris, Bibliothèque Mazarine MS 34, Bible

26. New York Public Library MS Spencer 26, Psalter (Tickhill Psalter)

27. Munich, Bayerische Staatsbibliothek MS gall. 16, Psalter, (Isabella Psalter)

28. Oxford, Bodleian Library MS Lat. liturg. D. 40, Cutting from Psalter

29. Cambridge, University Library MS Dd. 8. 2, Office of the Dead and Hours of the Virgin (fragmentary)

30. London, Lambeth Palace Library MS 233, Psalter (Bardolf-Vaux Psalter, Vaux Psalter)

31. Cambridge, Fitzwilliam Museum MS 242, Sarum Hours (Grey-Fitzpayn Hours)

32. Cambridge, Fitzwilliam Museum MS McClean 15, Bible

33. Paris, Bibliothèque Nationale MS lat. 6299, Aristotle, Metaphysica and Meteora

34. London, British Library MS Royal 15. D. II, La lumiere as lais and Apocalypse (Welles Apocalypse, Greenfield Apocalypse)

35. Princeton, University Library MS Garrett 35, Psalter

36. New York Public Library MS Spencer 2, Psalter (De la Twyere Psalter)

37. Madresfield Court, Earl Beauchamp MS M, Hours (Madresfield Hours)

38. London, British Library MS Arundel 83 II, Calendar and miniatures from a Psalter (Psalter of Robert de Lisle)

39. Oxford, St. John's College MS 178, Bestiary and Scientific Miscellany (Westminster Bestiary)

40. Brussels, Bibliothèque Royale MS 9961–62, Psalter (Peterborough Psalter)

41. St. Paul in Lavantthal (Carinthia), Stiftsbibliothek Cod. XXV/2, 19 and New York, Pierpont Morgan Library MS M. 302, Psalter (Ramsey Psalter)

42. Oxford, Bodleian Library MS Gough liturg. 8, Miniatures from a Psalter (Gough Psalter)

43. Oxford, Bodleian Library MS Douce 366, Psalter (Ormesby Psalter)

44. Oxford, Bodleian Library MS Ashmole 1523, Psalter and Hymnal (Bromholm Psalter)

45. Cambridge, Emmanuel College MS 112, Gregory the Great, Moralia in Job

46. Dublin, Trinity College MS 64 (K. 4. 31), Apocalypse and Meditations of St. Bernard (Dublin Apocalypse)

47. Norwich, Castle Museum MS 158.926. 4f, Hours

48. London, British Library MS Royal 14. C. I, ff. 20–79ᵛ, Martinus Polonus, Chronicles of the Roman Emperors and Popes

49. Cambridge, Fitzwilliam Museum MS 379, Bestiary

50. London, British Library MS Add. 49622, Psalter (Gorleston Psalter)

51. London, British Library MS Arundel 83 I, Psalter and fragmentary Hours of the Passion (Howard Psalter)

52. Longleat House, Marquess of Bath MS 10, Breviary (Longleat Breviary)

53. San Marino, California, Huntington Library MS EL 9. H. 17, Hours and Psalter (Vernon Psalter)

54. Oxford, Bodleian Library MS Selden Supra 38, Gesta infantiae Salvatoris and Apocalypse

55. Brussels, Bibliothèque Royale MS II. 282, Apocalypse and Lumiere as Lais

56. London, British Library MS Royal 2. B. VII, Psalter (Queen Mary Psalter)

57. New York, Pierpont Morgan Library MS G. 53, Psalter (Psalter of Richard of Canterbury)

58. Paris, Bibliothèque Nationale MS français 13342, Devotional Miscellany

59. Oxford, Bodleian Library MS Douce 79, Religious Miscellany

60. Cambridge, St. John's College, MS S. 30 (256), Somme le Roi

61. London, British Library MS Royal 19. B. XV, Apocalypse

62a and b. Oxford, Bodleian Library MSS Latin liturg. d. 42, e. 6, e. 37, e. 39 and San Francisco, University of San Francisco MS BX 2033 A2, Breviary fragments (Chertsey Breviary)

63. Oxford, Bodleian Library MS latin theol. c. 30, Fragment of a Golden Legend

64a and b. Oxford, Bodleian Library MS Gough liturg. 8 and Oxford, Bodleian Library MS Rawlinson liturg. e. 1*, Breviary (Hyde Breviary)

65. Aberystwyth, National Library of Wales MS 15536 E, Noted Sarum Missal (Sherbrooke Missal)

66. Cambridge, Corpus Christi College MS 53, ff. 1–188ᵛ, Psalter and Peterborough Chronicle (Peterborough Psalter, Psalter of Hugh of Stukeley)

67. Cambridge, University Library MS Dd. 4. 17, Hours (Hours of Alice de Reydon)

68. London, British Library MS Cotton Claudius D. II (MS 'C'); London, Corporation of London Record Office Liber Custumarum (MS 'G'); Oxford, Oriel College MS 46 (MS 'O'), Legal Compilation (Liber legum antiquorum regum)

69. Bangor Cathedral, s.n., Pontifical (Liber pontificalis Aniani episcopi)

70. Paris, Bibliothèque Nationale MS lat. 17155, Aristotle, De physica, De anima, De celo et mundo, glossed

71. Baltimore, Walters Art Gallery MS W. 144, Giles de Rome (Aegidius Colonna)

72. Oxford, Lincoln College MS 16, Apocalypse

73. Longleat House, Marquess of Bath MS 11, Psalter

74. London, Dr. Williams's Library MS Anc. 6, Psalter

75. Cambridge, University Library MS Dd. 1. 14, Bible

76. Oxford, Bodleian Library MS Canonici Misc. 248, Computistical Tables

77. New York, Pierpont Morgan Library MS G. 50, Hours of the Virgin (De Lisle Hours)

78. New York, Pierpont Morgan Library MS M. 107, Noted Sarum Missal (Tiptoft Missal)

79. London, British Library MS Stowe 12, Sarum Breviary (Stowe Breviary)

80. Escorial Library MS Q II 6, Psalter

81. Herdringen, Fürstenbergische Bibliothek MS 8, Psalter

82. Oxford, All Souls College MS 7, Psalter

83. Dublin, Trinity College MS 35 (A. 1. 2), Bible

84. Oxford, Christ Church MS 92, Walter of Milemete, De nobilitatibus, sapientiis, et prudentiis regum (Treatise of Walter of Milemete)

85. London, British Library MS Add. 47680, Pseudo-Aristotle, De secretis secretorum

86. Cambridge, Sidney Sussex College MS 76, Psalter

87. Oxford, Bodleian Library MS Douce 231, Sarum Hours

88. New York, Pierpont Morgan Library MS M. 700, Sarum Hours (DuBois Hours)

89. London, British Library MS Harley 6563, Hours

90. Paris, Bibliothèque Nationale MSS lat. 3114¹ and 3114², John Duns Scotus, Commentary on the Sentences

91. Oxford, Bodleian Library MS Barlow 22, Psalter (Barlow Psalter, Psalter of Walter of Rouceby)

92. Oxford, Bodleian Library MS Canonici Biblical 62, Apocalypse

93. Cambridge, Magdalene College MS 5, Apocalypse (Crowland Apocalypse)

94. Oxford, Bodleian Library MS Douce d. 19, f. 3; b. 4, f. 4, Psalter cuttings

95. Cambridge, Corpus Christi College MS 404, Anthology of Joachimist writings

96. Paris, Bibliothèque National MS français 571, Brunetto Latini, Livre du trésor; Pseudo-Aristotle, De Secretis secretorum; Raous le Petiz, Dit de Fauveyn, etc.

97. London, British Library MS Add. 47682, Bible Picture Book (Holkham Bible)

98. London, British Library MS Yates Thompson 13, Book of Hours (Taymouth Hours)

99. Glasgow, University Library MS Hunter 231, Devotional and Philosophical Miscellany

100. London, British Library MS Royal 1. E. IV, Octateuch

101. London, British Library MS Royal 10. E. IV, Decretals of Gregory IX with marginal gloss of Bernard of Parma (Smithfield Decretals)

102. Oxford, Exeter College MS 46, Psalter

103. Cambridge, Corpus Christi College MS 20, Apocalypse and Coronation Order

104. London, British Library MS Yates Thompson 14 (Add. 39810), Psalter (St. Omer Psalter)

105. Douai, Bibliothèque Municipale MS 171, Psalter (Douai Psalter)

106. Oxford, Bodleian Library MS Douce 131, Psalter

107. London, British Library MS Add. 42130, Psalter (Luttrell Psalter)

108. New Haven, Yale University, Beinecke Rare Book and Manuscript Library MS 417, Psalter (Cluniac Psalter, Castle Acre Psalter)

109. Brescia, Biblioteca Queriniana MS A. V. 17, Psalter

110. London, British Library MS Harley 2899, Psalter (Psalter of Queen Philippa)

111. Ginge Manor, Oxon., Viscount Astor, Hours and Psalter (Astor Psalter, Hours and Psalter of Elizabeth de Bohun)
112. Cambridge, St. John's College MS D. 30 (103**), Psalter (Psalter of Simon de Montacute)
113. Cambridge, St. John's College MS A. 4 (4), Boniface VIII, Liber sextus decretalium (Brewes-Norwich Commentaries)
114. London, British Library MS Royal 10. E. VII, 'Hostiensis' (Henricus de Bartholomaeis de Segusia), Lectura hostiensis (Books I–II)
115. London, British Library MS Egerton 2781, Hours of the Virgin
116. Vatican, Biblioteca Apostolica Vaticana MS Pal. lat. 537, Hours
117. Baltimore, Walters Art Gallery MS W. 105 and Stockholm, Nationalmuseum MSS B. 1726, B. 1727, Sarum Hours (Butler Hours)
118. Dublin, Trinity College MS 94 (F. 5. 21), Sarum Hours
119. Oxford, Bodleian Library MS Lat. liturg. e. 41, Hours of the Virgin (Zouche Hours)
120. Paris, Bibliothèque Nationale MS lat. 765, Psalter (Fitzwarin Psalter)
121. Oxford, Bodleian Library MS Liturg. 198, Psalter; Office of the Dead and Hymns
122. Cambridge, Fitzwilliam Museum MS 259, Poem on the Life of Christ
123. Cambridge, Trinity College MS B. 10. 15, Poem on the Life of Christ
124. London, British Library MS Royal 6. E. VI–6. E. VII, Illustrated Encyclopedia (Omne Bonum)
125. Oxford, Bodleian Library MS Laud Misc. 165, William of Nottingham, Commentary on the Gospels
126. Hatfield House, Marquess of Salisbury MS CP 290, Religious Miscellany
127. London, British Library MS Add. 44949, Psalter (M. R. James Memorial Psalter)
128. Oxford, Bodleian Library MS Rawlinson G. 185, Psalter (Psalter of Stephen of Derby)
129. London, British Library MS Egerton 1894, Genesis Picture Book (Egerton Genesis)
130. Cambridge, Fitzwilliam Museum MS 48, Hours of the Virgin (Carew-Poyntz Hours)
131. London, British Library MS Royal 13. D. I*, Psalter fragments
132.    (i) Bloomington, Indiana University, Lilly Library MS Ricketts 15 (4ff)
   (ii) Chicago, Art Institute Acc. no. 31.25 (1f.)
   (iii) Chicago, Newberry Library MS Frag. 62.1–62.4 formerly Ry.1 (4ff)
   (iv) Chicago, University of Chicago Library MS 122 (5ff.)
   (v) New York Pierpont Morgan Library MS M. 741 (2ff.)
   (vi) London, Private Collection (1f.)
   (vii) Oxford, Bodleian Library MS Lat. bib. b.4 (48ff.)
   (viii) Toronto, University Library MS 59–60 (2ff.) Bible Leaves

133. Vienna Österreichische Nationalbibliothek Cod. 1826*, Psalter (Psalter of Humphrey de Bohun)
134. Oxford, Exeter College MS 47, Psalter (Psalter of Humphrey de Bohun)
135. London, British Library MS Egerton 3277, Psalter and Hours of the Virgin (Bohun Psalter)
136. London, British Library MS Royal 20. D. IV, Romance of Lancelot du Lac
137. Pommersfelden, Gräflich Schönbornische Bibliothek MS 2934, Memoriae and Gospel Sequences from a Bohun Book of Hours
138. Oxford, Bodleian Library MS Auct. D. 4. 4
139. Cambridge, Fitzwilliam Museum MS 38–1950, Psalter (Riches Psalter, Psalter of John of Gaunt)
140. Copenhagen, Kongelige Bibliotek MS Thott. 547.4°, Hours of the Virgin (Hours of Mary de Bohun)
141. Copenhagen, Kongelige Bibliotek MS Thott. 517.4°, Lives of the Virgin, St. Margaret and St. Mary Magdalene
142. Edinburgh, National Library of Scotland MS Adv. 18. 6. 5, Hours and Psalter (Hours and Psalter of Eleanor de Bohun)
143. Holkham Hall, Earl of Leicester MS 26, Psalter (Ramsey Abbey Psalter)
144. Oxford, Trinity College MS 8, Sarum Missal
145. London, British Library MS Add. 16968, Hours and Psalter
146. Oxford, Keble College MS 47, Sarum Hours
147. Hatfield, Marquess of Salisbury MS CP 292, Flores psalterii and Psalter
148. Cambridge, Trinity College MS B. 11. 3, Noted Sarum Missal
149. Oxford, Bodleian Library MS Laud Misc. 188, Hours of the Virgin
150. London, Westminster Abbey MS 37, Missal (Litlyngton Missal)
151. London, British Library MS Cotton Nero D. VI, Historical Compilation
152. Oxford, Bodleian Library MS Bodley 581, Libellus geomancie
153. Cambridge, Trinity College MS B. 10. 2, Apocalypse and Scenes from the Life of Edward the Confessor
154. Private Collection, Germany (formerly Major J. R. Abbey), Hours of the Virgin (Belknap Hours)
155. London, Westminster Abbey MS 38, Coronation Order (Liber regalis)
156. Cambridge, St. John's College MS A. 7, Statutes of England, Henry III to Richard II
157. Pamplona, Archivo General de Navarra MS 197, Coronation Order
158. London, British Library MS Cotton Nero D. VII, Catalogue of the Benefactors of St. Albans Abbey

# LIST OF ILLUSTRATIONS

69. Aristotle. Paris, Bibl. Nat., lat. 6299, f. 2 (cat. 33)

70. Aristotle. Paris, Bibl. Nat., lat. 6299, f. 14 (cat. 33)

71. Aristotle. Paris, Bibl. Nat., lat. 6299, f. 23ᵛ (cat. 33)

72. Aristotle. Paris, Bibl. Nat., lat. 6299, f. 66 (cat. 33)

73. Decorative head. Cambridge, Fitzwilliam Museum 242, f. 40ᵛ (cat. 31)

74. Crucifixion. | Cambridge, ı Fitzwilliam Museum 242 f. 55ᵛ (cat. 31)

75. Vision of Christ and the Book. London, B.L., Royal 15.D.II, f. 122ᵛ (cat. 34)

76. Psalm 1, Tree of Jesse. London, Lambeth Palace Lib., 233, f. 15 (cat. 30)

77. Annunciation. Cambridge, Fitzwilliam Museum 242, f. 2ᵛ (cat. 31)

78. Annunciation. Cambridge, University Lib., Dd.8.2, detail of f. 27ᵛ (cat. 29)

79. Annunciation. London, B.L., Royal 15.D.II, f. 3 (cat. 34)

80. Annunciation. Princeton, University Lib., Garrett 35, f. 1ᵛ (cat. 35)

81. Scenes from the Life of Christ. New York Public Lib., Spencer 2, f. 7ᵛ–8 (cat. 36)

82. Nativity, Martyrdom of St. Anastasia; Annunciation to the Shepherds. New York Public Lib., Spencer 2, f. 161ᵛ (cat. 36)

83. Border decoration. Madresfield Court, Earl Beauchamp M, f. 42ᵛ (cat. 37)

84. Three Living and Three Dead. London, B.L., Arundel 83 II, f. 127 (cat. 38)

85. Coronation of the Virgin. London, B.L., Arundel 83 II, f. 134ᵛ (cat. 38)

86. Goat; unicorn. Oxford, St. John's College, 178, f. 166 (cat. 39)

87. Zodiacal Man. Oxford, St. John's College, 178, f. 143 (cat. 39)

88. Typological scenes. Brussels, Bibl. Royale 9961–62, f. 12 (cat. 40)

89. Typological scenes. Brussels, Bibl. Royale 9961–62, f. 25 (cat. 40)

90. Abbot praying. Brussels, Bibl. Royale 9961–62, f. 65 (cat. 40)

91. David rising from his Throne. St. Paul in Lavantthal, Stiftsbibl. Cod. XXV/2, 19, f. 121 (cat. 41)

92. Genesis Scenes. New York, Pierpont Morgan Lib., M. 302, f. 1 (cat. 41)

93. Martyrdom of St. Thomas; Founders of Ramsey Abbey. Pierpont Morgan Lib., M. 302, f. 4ᵛ (cat. 41)

94. St. Benedict; St. John the Evangelist. New York, Pierpont Morgan Lib., M. 302, f. 5 (cat. 41)

95. Deposition. Oxford, Bodl. Lib., Gough liturg. 8, f. 61ᵛ (cat. 42)

96. Tree of Jesse. Oxford, Bodl. Lib., Douce 366, f. 9ᵛ (cat. 43)

97. Initials and border. Oxford, Bodl. Lib., Douce 366, f. 29 (cat. 43)

98. Initial and border. Oxford, Bodl. Lib., Douce 366, f. 63 (cat. 43)

99. A murder. Oxford, Bodl. Lib., Ashmole 1523, f. 65 (cat. 44)

100. Decorated initial. Oxford, Bodl. Lib., Ashmole 1523, f. 127ᵛ (cat. 44)

101. The Creator with adoring animals; David and clerics chanting, Lord above. Oxford, Bodl. Lib., Ashmole 1523, f. 116ᵛ (cat. 44)

102. Gregory and a Benedictine. Cambridge, Emmanuel College, 112, Book IV (cat. 45)

103. Two seated misers. Cambridge, Emmanuel College, 112, Book XV (cat. 45)

104. Christ in Majesty. Cambridge, Emmanuel College, 112, Book XIX (cat. 45)

105. Christ washing the disciples' feet. Cambridge, Emmanuel College, 112, Book XXII (cat. 45)

106. Fall of Man. Cambridge, Emmanuel College, 112, Book XXXI (cat. 45)

107. The Voice of the Eagle and the Fifth Trumpet. Dublin, Trinity College, 64 (K.4.31), p. XXII (cat. 46)

108. Angel and the Book; John takes the Book. Dublin, Trinity College Lib., 64 (K.4.31), p. XXVI (cat. 46)

109. Presentation of Christ. Norwich, Castle Museum, 158.926.4f, f. 53ᵛ (cat. 47)

110. Virgin and Child. Norwich, Castle Museum, 158.926.4f, f. 27 (cat. 47)

111. Coronation of the Virgin. Norwich, Castle Museum, 158.926.4f, f. 76 (cat. 47)

112. Resurrected Christ blessing. Norwich, Castle Museum, 158.926.4f, f. 95 (cat. 47)

113. King saved by dogs. Cambridge, Fitzwilliam Museum, 379, f. 10ᵛ (cat. 49)

114. Border decoration. London, B.L., Royal 14.C.I, f. 20 (cat. 48)

115. Border decoration. London, B.L., Add. 49622, f. 7ᵛ (cat. 50)

116. Grotesque swallowing human head. London, B.L., Add. 49622, f. 198ᵛ (cat. 50)

117. Doeg and the priests. London, B.L., Add. 49622, f. 68ᵛ (cat. 50)

118. King with knights. London, B.L., Add. 49622, f. 69 (cat. 50)

119. Border decoration with heads and foliage. London, B.L., Add. 49622, f. 12ᵛ (cat. 50)

120. Musicians playing, Lord enthroned above. London, B.L., Add. 49622, f. 107ᵛ (cat. 50)

121. Trinity. London, B.L., Add. 49622, f. 146ᵛ (cat. 50)

122. Crucifixion. London, B.L., Add. 49622, f. 7 (cat. 50)

123. Jonah saved from the whale, the Lord above. London, B.L., Arundel 83 I, f. 47 (cat. 51)

124. Christ bearing the Cross. London, B.L., Arundel 83 I, f. 115ᵛ (cat. 51)

125. Trinity. London, B.L., Arundel 83 I, f. 72 (cat. 51)

126. Border decoration. Longleat, Marquess of Bath 10, f. 1 (cat. 52)

127. Dedication of a church. Longleat, Marquess of Bath, 10, f. 105ᵛ (cat. 52)

128. Flagellation and Pentecost. San Marino, Huntington Lib., EL 9.H.17, f. 15ᵛ (cat. 53)

129. David playing the harp. San Marino, Huntington Lib., EL 9.H.17, f. 42 (cat. 53)

130. Betrayal and Descent into Limbo. San Marino, Huntington Lib., EL 9.H.17, f. 14ᵛ (cat. 53)

131. St. Paul. Oxford, Bodl. Lib., Selden Supra 38, f. 39 (cat. 54)

132. Infancy miracles of Christ. Oxford, Bodl. Lib., Selden Supra 38, f. 21ᵛ (cat. 54)

133. Child Jesus straightens a beam. Oxford, Bodl. Lib., Selden Supra 38, f. 28ᵛ (cat. 54)

134. The Two Witnesses. Brussels, Bibl. Royale, II.282, f. 26ᵛ (cat. 55)

135. Third seal: black horse. Brussels, Bibl. Royale, II.282, f. 16 (cat. 55)

136. Fourth seal: pale horse. Brussels, Bibl. Royale, II.282, f. 16ᵛ (cat. 55)

137. Tree of Jesse. London, B.L., Royal 2.B.VII, f. 67ᵛ (cat. 56)

138. The Creator. London, B.L., Royal 2.B.VII, f. 2 (cat. 56)

139. Scenes from the life of Joseph. London, B.L., Royal 2.B.VII, f. 15 (cat. 56)

140. Adoration of the Magi. London, B.L., Royal 2.B.VII, f. 112ᵛ (cat. 56)

141. Entry into Jerusalem. London, B.L., Royal 2.B.VII, f. 233ᵛ (cat. 56)

142. David and a fool. New York, Pierpont Morgan Lib., G. 53, f. 47ᵛ (cat. 57)

143. Trinity. New York, Pierpont Morgan Lib., G. 53, f. 102 (cat. 57)

144. Scholar addressing audience. Paris, Bibl. Nat., fr. 13342, f. 1 (cat. 58)
145. Celebration of the Mass. Paris, Bibl. Nat., fr. 13342, f. 47ᵛ (cat. 58)
146. Nativity. Oxford, Bodl. Lib., Douce 79, f. 2ᵛ (cat. 59)
147. Assumption of the Virgin. Oxford, Bodl. Lib., Douce 79, f. 3 (cat. 59)
148. Ten Commandments. Cambridge, St. John's College, S. 30 (256), p. 1 (cat. 60)
149. St. Augustine lecturing. Cambridge, St. John's College, S. 30 (256), p. 117 (cat. 60)
150. Pentecost. Oxford, Bodl. Lib., Lat. liturg. d. 42, f. 12 (cat. 62a)
151. Jonah and the whale. Oxford, Bodl. Lib., Lat. liturg. d. 42, f. 23 (cat. 62a)
152. St. Edmund. Oxford, Bodl. Lib., Lat. liturg. d. 42, f. 36 (cat. 62a)
153. Bishop preaching. Oxford, Bodl. Lib., Lat. liturg. d. 42, f. 46 (cat. 62a)
154. St. Andrew. Oxford, Bodl. Lib., Lat. liturg. d. 42, f. 38 (cat. 62a)
155. St. Stephen. Oxford, Bodl. Lib., Lat. theol. c. 30, f. 2ᵛ (cat. 63)
156. David and a fool. Oxford, Bodl. Lib., Gough liturg. 8, f. 27 (cat. 64a)
157. Trinity. Oxford, Bodl. Lib., Gough liturg. 8, f. 47 (cat. 64a)
158. Ascension. Aberystwyth, National Lib., 15536 E, f. 164 (cat. 65)
159. Pentecost. Aberystwyth, National Lib., 15536 E, f. 169ᵛ (cat. 65)
160. Presentation in the Temple. Aberystwyth, National Lib., 15536 E, f. 246 (cat. 65)
161. Angel and the Book. London, B.L., Royal 19.B.XV, f. 17 (cat. 61)
162. Lamb on Mount Zion. New Song. London, B.L., Royal 19.B.XV, f. 25 (cat. 61)
163. Angel ordering Letters to Seven Churches. London, B.L., Royal 19.B.XV, f. 3 (cat. 61)
164. John takes the Book. London, B.L., Royal 19.B.XV, f. 17ᵛ (cat. 61)
165. Angel ordering letters to Seven Churches. Oxford, Lincoln College, 16, f. 141 (cat. 72)
166. Prophet Jeremiah and St. Peter. Cambridge, Corpus Christi College, 53, f. 7 (cat. 66)
167. Coronation of the Virgin. Cambridge, Corpus Christi College, 53, f. 11ᵛ (cat. 66)
168. St. Catherine and St. Margaret. Cambridge, University Lib., Dd.4.17, f. 2 (cat. 67)
169. Coronation of the Virgin. Cambridge, University Lib., Dd.4.17, f. 9ᵛ (cat. 67)
170. David playing the harp and Tree of Jesse. Cambridge, Corpus Christi College, 53, f. 19 (cat. 66)
171. Praying woman before an archbishop-saint. Cambridge, University Lib., Dd.4.17, f. 1ᵛ (cat. 67)
172. St. George. Cambridge, University Lib., Dd.4.17, f. 3ᵛ (cat. 67)
173. Henry II and Thomas, Archbishop of Canterbury. London, B.L., Cotton Claudius D.II, f. 73 (cat. 68 MS 'C')
174. Giles de Rome presenting book to Philip the Fair. Baltimore, Walters Art Gallery, W. 144, f. 2 (cat. 71)
175. Seated scholar. Oxford, Oriel College, 46, f. 187 (cat. 68 MS 'O')
176. Queen with two children before king. Baltimore, Walters Art Gallery, W. 144, f. 41ᵛ (cat. 71)
177. Penwork initials. Bangor Cathedral, Pontifical, f. 69ᵛ (cat. 69)
178. Decorated initial. Bangor Cathedral, Pontifical, f. 100ᵛ (cat. 69)
179. Penwork flourishing. Paris, Bibl. Nat., lat. 17155, f. 160ᵛ (cat. 70)

180. Michael Scotus and Stephen of Provins. Paris, Bibl. Nat., lat. 17155, f. 225 (cat. 70)
181. Bishop and attendants at church door. Bangor Cathedral, Pontifical, f. 8ᵛ (cat. 69)
182. Initial and border decoration. London, Corporation Record Office, Liber Custumarum, f. 6 (cat. 68 MS 'G')
183. David playing the harp, David slaying Goliath below. London, Dr. Williams, Anc. 6, f. 20 (cat. 74)
184. Scenes from life of David and Tree of Jesse. Longleat, Marquess of Bath, 11, f. 7 (cat. 73)
185. Clerics chanting. Longleat, Marquess of Bath, 11, f. 126 (cat. 73)
186. Creation cycle. Synagogue and Church below. Cambridge, University Lib., Dd.1.14, f. 5 (cat. 75)
187. Vision of Christ and the Twenty-four Elders. Oxford, Lincoln College, 16, f. 144 (cat. 72)
188. First and Second Seals. Oxford, Lincoln College, 16, f. 148 (cat. 72)
189. Zodiacal Man. Oxford, Bodl. Lib., Canonici Misc. 248, f. 42 (cat. 76)
190. Scenes from life of St. Denis. Oxford, Bodl. Lib., Canonici Misc. 248, f. 45ᵛ (cat. 76)
191. Christ bearing the Cross. New York, Pierpont Morgan Lib., G. 50, f. 63ᵛ (cat. 77)
192. Female questioner and male respondent. New York, Pierpont Morgan Lib., G. 50, f. 64 (cat. 77)
193. The Three Living (kings). New York, Pierpont Morgan Lib., G. 50, f. 6ᵛ (cat. 77)
194. Coronation of the Virgin. New York, Pierpont Morgan Lib., G. 50, f. 163 (cat. 77)
195. Border decoration. New York, Pierpont Morgan Lib., M. 107, f. 48ᵛ (cat. 78)
196. Border decoration. New York, Pierpont Morgan Lib., M. 107, f. 147 (cat. 78)
197. Two men praying, the Lord above. New York, Pierpont Morgan Lib., M. 107, f. 8 (cat. 78)
198. Christ with the Virgin, Saints Peter, Paul and Lawrence. New York, Pierpont Morgan Lib., M. 107, f. 267 (cat. 78)
199. Elevation of the Host. New York, Pierpont Morgan Lib., M. 107, f. 142, (cat. 78)
200. Nativity. London, B.L., Stowe 12, f. 16ᵛ (cat. 79)
201. Ezechiel. London, B.L., Stowe 12, f. 136 (cat. 79)
202. Jonah saved from the whale. London, B.L., Stowe 12, f. 184ᵛ (cat. 79)
203. Initial and border decoration. London, B.L., Stowe 12, f. 332 (cat. 79)
204. Jonah saved from the whale. Escorial Lib., Q II 6, f. 75ᵛ (cat. 80)
205. David pointing to his eyes. Escorial Lib., Q II 6, f. 36 (cat. 80)
206. Adoration of the Magi. Escorial Lib., Q II 6, f. 4ᵛ (cat. 80)
207. Nativity. Escorial Lib., Q II 6, f. 4ᵛ (cat. 80)
208. David playing the harp. Herdringen, Fürstenbergische Bibl., 8, f. 7 (cat. 81)
209. David playing the harp. Oxford, All Souls College, 7, f. 7 (cat. 82)
210. David pointing to his eyes. Oxford, All Souls College, 7, f. 26 (cat. 82)
211. King addressing audience. Dublin, Trinity College, 35 (A.1.2), f. 180ᵛ (cat. 83)
212. David pointing to his mouth. Herdringen, Fürstenbergische Bibl., 8, f. 50ᵛ (cat. 81)
213. David playing bells. Herdringen, Fürstenbergische Bibl., 8, f. 99 (cat. 81)
214. Standing fool. Herdringen, Fürstenbergische Bibl., 8, f. 66 (cat. 81)
215. Jonah saved from the whale. Herdringen, Fürstenbergische Bibl., 8, f. 80ᵛ (cat. 81)
216. King and queen kissing. Dublin, Trinity College, 35 (A.1.2), f. 182ᵛ (cat. 83)

217. St. George and a King of England. Oxford, Christ Church, 92, f. 3 (cat. 84)

218. St. George and Thomas, Earl of Lancaster. Oxford, Bodl. Lib., Douce 231, f. 1 (cat. 87)

219. Aristotle advising Alexander. London, B.L., Add. 47680, f. 28 (cat. 85)

220. Aristotle advising Alexander. London, B.L., Add. 47680, f. 20ᵛ (cat. 85)

221. Aristotle advising Alexander. London, B.L., Add. 47680, f. 21ᵛ (cat. 85)

222. Border decoration. Oxford, Christ Church, 92, f. 68 (cat. 84)

223. Decorated border; Aristotle advising Alexander. London, B.L., Add. 47680, f. 14ᵛ (cat. 85)

224. Border decoration. Cambridge, Sidney Sussex College, 76, unfoliated (cat. 86)

225. Jonah saved from the whale. Cambridge, Sidney Sussex College, 76, unfoliated (cat. 86)

226. Resurrection. Oxford, Bodl. Lib., Douce 231, f. 58 (cat. 87)

227. Resurrection. New York, Pierpont Morgan Lib., M. 700, f. 48ᵛ (cat. 88)

228. John Duns Scotus receiving book from an angel. Paris, Bibl. Nat., lat. 3114¹, f. 1 (cat. 90)

229. Nativity. Paris, Bibl. Nat., lat. 3114¹, f. 149ᵛ (cat. 90)

230–231. Border decoration. London, B.L., Harley 6563, ff. 74ᵛ–75 (cat. 89)

232–233. Border decoration. London, B.L., Harley 6563, ff. 6–6ᵛ (cat. 89)

234. David playing bells. Oxford, Bodl. Lib., Douce, d. 19, f. 3 (cat. 94)

235. Angel playing psaltery. Oxford, Bodl. Lib., Douce, d. 19, f. 3 (cat. 94)

236. Angel playing viol. Oxford, Bodl. Lib., Douce, d. 19, f. 3 (cat. 94)

237. Angel playing portable organ. Bodl. Lib., Douce, d. 19, f. 3 (cat. 94)

238. David playing bells. Oxford, Bodl. Lib., Barlow 22, f. 99 (cat. 91)

239. David and a fool. Oxford, Bodl. Lib., Douce, b. 4, f. 4 (cat. 94)

240. Angel and the Everlasting Gospel. Oxford, Bodl. Lib., Canonici Bibl. 62, f. 22 (cat. 92)

241. Angel and the Everlasting Gospel. Cambridge, Magdalene College, 5, f. 22 (cat. 93)

242. Scenes from the life of Christ. Oxford, Bodl. Lib., Barlow 22, f. 13 (cat. 91)

243. Scenes from the life of Christ. Oxford, Bodl. Lib., Barlow 22, f. 14 (cat. 91)

244. King menaced by a bear. Cambridge, Corpus Christi College, 404, f. 90ᵛ (cat. 95)

245. Pope-saint and two angels. Cambridge, Corpus Christi College, 404, f. 94 (cat. 95)

246. Scenes from Fauveyn. Paris, Bibl. Nat., fr. 571, f. 150ᵛ (cat. 96)

247. Descent into Limbo; Christ saving Nicodemus and Joseph of Arimathaea. London, B.L., Add. 47682, f. 34 (cat. 97)

248. Agony in the Garden. London, B.L., Yates Thompson 13, f. 118ᵛ (cat. 98)

249. Crucifixion. London, B.L., Yates Thompson 13, f. 121ᵛ (cat. 98)

250. Roger adoring the Virgin and Child. Glasgow, University Lib., Hunter 231, p. 62 (cat. 99)

251. Virgin lactans, Mary Magdalene at the feet of Christ, Crucifixion; author addressing a bird. Glasgow, University Lib., Hunter 231, p. 89 (cat. 99)

252. Visions of St. Benedict and St. Paul. Glasgow, University Lib., Hunter 231, p. 85 (cat. 99)

253. Assumption with Roger adoring. Glasgow, University Lib., Hunter 231, p. 36 (cat. 99)

254. Crucifixion with Roger adoring. Glasgow, University Lib., Hunter 231, p. 53 (cat. 99)

255. Genesis Scenes and Crucifixion. London, B.L., Royal 1.E.IV, f. 12ᵛ (cat. 100)

256. Border scene: playing figures. London, B.L., Royal 10.E.IV, f. 94ᵛ (cat. 101)

257. Border scene: playing figures, bird, castle. London, B.L., Royal 10.E.IV, f. 95 (cat. 101)

258. Initials and border decoration. London, B.L., Royal 10.E.IV, f. 3 (cat. 101)

259. Doeg slaying a priest. Oxford, Exeter College, 46, f. 54ᵛ (cat. 102)

260. David and the Ark, Michal on the Ramparts. Oxford, Exeter College, 46, f. 68 (cat. 102)

261. Death of Absalom. Oxford, Exeter College, 46, f. 99ᵛ (cat. 102)

262. Fourth Vial. Cambridge, Corpus Christi College, 20, f. 40ᵛ (cat. 103)

263. Coronation of a king of England. Cambridge, Corpus Christi College, 20, f. 68 (cat. 103)

264–265. Border decoration. London, B.L., Yates Thompson 14 (Add. 39810), ff. 7ᵛ–8 (cat. 104)

266. Anointing and Crowning of David. London, B.L., Yates Thompson 14 (Add. 39810), f. 29ᵛ (cat. 104)

267. David and a fool; scenes from the lives of Moses and Samson. London, B.L., Yates Thompson 14 (Add. 39810), f. 57ᵛ (cat. 104)

268. King-musicians; dwarf, giant, knight and lady. Oxford, Bodl. Lib., Douce 131, f. 68ᵛ (cat. 106)

269. Franciscan hearing confession of a nun. Oxford, Bodl. Lib., Douce 131, f. 126 (cat. 106)

270. Psalm 104, original surface details revealed by show-through from offset on f. 132ᵛ. Douai, Bibl. Mun., 171, f. 132 (cat. 105)

271. Psalm 104, original underdrawing. Douai, Bibl. Mun., 171, f. 133 (cat. 105)

272. David praying (Psalm 119). Douai, Bibl. Mun., 171, f. 163ᵛ (cat. 105)

273. Marcolf and Solomon; Samson and the lion. Douai, Bibl. Mun., 171, f. 124ᵛ (cat. 105)

274. Border decoration. London, B.L., Add. 42130, f. 55ᵛ (cat. 107)

275. Border decoration. London, B.L., Add. 42130, f. 193ᵛ (cat. 107)

276. Border decoration. London, B.L., Add. 42130, f. 194ᵛ (cat. 107)

277. Border decoration. London, B.L., Add. 42130, f. 195 (cat. 107)

278. David playing a psaltery. London, B.L., Add. 42130, f. 149 (cat. 107)

279. David playing the harp. New Haven, Yale University, Beinecke Lib., 417, f. 7 (cat. 108)

280. David pointing to his mouth. Castle of Love. London, B.L., Add. 42130, f. 75ᵛ (cat. 107)

281. Coronation of the Virgin. New Haven, Yale University, Beinecke Lib., 417, f. 64ᵛ (cat. 108)

282. Border decoration. London, B.L., Add. 42130, f. 201ᵛ (cat. 107)

283. David playing the harp in his palace, Virgin and Child. Brescia, Bibl. Queriniana, A.V.17, f. 7 (cat. 109)

284. David and prophets, kings in the border. London, B.L., Harley 2899, f. 8 (cat. 110)

285. David in the water praying, the Lord above. London, B.L., Harley 2899, f. 53 (cat. 110)

286. David in the water praying. Ginge Manor, Oxon., Viscount Astor, f. 101ᵛ (cat. 111)

287. David and a fool committing suicide. Ginge Manor, Oxon., Viscount Astor, f. 91ᵛ (cat. 111)

288. Clerics chanting. Ginge Manor, Oxon., Viscount Astor, f. 127ᵛ (cat. 111)

289. David playing bells. Ginge Manor, Oxon., Viscount Astor, f. 115 (cat. 111)

290. Trinity. Ginge Manor, Oxon., Viscount Astor, f. 140ᵛ (cat. 111)

291. David playing the harp, David and Goliath below. Cambridge, St. John's College, D. 30 (103**), f. 7 (cat. 112)

292. David pointing to his eyes. Cambridge, St. John's College, D. 30 (103**), f. 25ᵛ (cat. 112)

293. David and a fool. Cambridge, St. John's College, D. 30 (103**) f. 50 (cat. 112)

294. Plaintiffs in court. London, B.L., Royal 10.E.VII, f. 186ᵛ (cat. 114)

295. Marriage scene. Cambridge, St. John's College, A.4 (4) Vol. I, f. 101 (cat. 113)

296. Priest at altar. Cambridge, St. John's College, A.4 (4) Vol. IV, f. 46ᵛ (cat. 113)

297. Nativity. London, B.L., Egerton 2781, f. 13 (cat. 115)

298. Annunciation. London, B.L., Egerton 2781, f. 53 (cat. 115)

299. Annunciation. London, B.L., Egerton 2781, f. 71 (cat. 115)

300. Miracle of the children in the oven. London, B.L., Egerton 2781, f. 88ᵛ (cat. 115)

301. Betrayal. London, B.L., Egerton 2781, f. 44 (cat. 115)

302. Miracle of the abbess delivered. London, B.L., Egerton 2781, f. 22ᵛ (cat. 115)

303. Betrayal. Rome, Vatican, Bibl. Apostolica, Pal. lat. 537, f. 32 (cat. 116)

304. The damned cast into hell. Rome, Vatican, Bibl. Apostolica, Pal. lat. 537, f. 139ᵛ (cat. 116)

305. Annunciation. Baltimore, Walters Art Gallery, 105, f. 7ᵛ (cat. 117)

306. Virgin and Child. Baltimore, Walters Art Gallery, 105, f. 17 (cat. 117)

307. Betrayal. Dublin, Trinity College, 94 (F.5.21), f. 47 (cat. 118)

308. Christ before Pilate. Dublin, Trinity College, 94 (F.5.21), f. 55ᵛ (cat. 118)

309. Annunciation. Oxford, Bodl. Lib., Lat. liturg. e. 41, f. 7 (cat. 119)

310. Betrayal. Oxford, Bodl. Lib., Lat. liturg. e. 41, f. 35ᵛ (cat. 119)

311. Entombment. Oxford, Bodl. Lib., Lat. liturg. e. 41, f. 57 (cat. 119)

312. Christ bearing the Cross. Dublin, Trinity College, 94 (F.5.21), f. 61ᵛ (cat. 118)

313. Presentation of the Virgin. Dublin, Trinity College, 94 (F.5.21), f. 109ᵛ (cat. 118)

314. Descent into Limbo. Paris, Bibl. Nat., lat. 765, f. 15 (cat. 120)

315. Christ in Majesty. Paris, Bibl. Nat., lat. 765, f. 21ᵛ (cat. 120)

316. Crucifixion. Paris, Bibl. Nat., lat. 765, f. 22 (cat. 120)

317. David playing the harp. Paris, Bibl. Nat., lat. 765, f. 23 (cat. 120)

318. Clerics chanting. Oxford, Bodl. Lib., Liturg. 198, f. 91ᵛ (cat. 121)

319. David and Goliath. Oxford, Bodl. Lib., Liturg. 198, f. 46 (cat. 121)

320. Jonah and the whale. Oxford, Bodl. Lib., Liturg. 198, f. 60 (cat. 121)

321. Circumcision. Cambridge, Fitzwilliam Museum, 259, f. 3ᵛ (cat. 122)

322. Judas and the silver. Cambridge, Fitzwilliam Museum, 259, f. 10ᵛ (cat. 122)

323. Circumcision. Cambridge, Trinity College, B.10.15, f. 7ᵛ (cat. 123)

324. The damned in Hell. Cambridge, Trinity College, B.10.15, f. 32ᵛ (cat. 123)

325. Vision of St. Benedict and St. Paul. London, B.L., Royal 6.E.VI, f. 16 (cat. 124)

326. Monks kneeling before their superior. London, B.L., Royal 6.E.VII, f. 490 (cat. 124)

327. Dentist with teeth. London, B.L., Royal 6.E.VI, f. 503ᵛ (cat 124)

328. Adolescence. London, B.L., Royal 6.E.VI, f. 58ᵛ (cat. 124)

329. Arsonist. London, B.L., Royal 6.E.VII, f. 257 (cat. 124)

330. Christ teaching. Oxford, Bodl. Lib., Laud Misc. 165, f. 155 (cat. 125)

331. Christ teaching. Oxford, Bodl. Lib., Laud Misc. 165, f. 241 (cat. 125)

332. Christ and disciples in Galilee. Oxford, Bodl. Lib., Laud Misc. 165, f. 283ᵛ (cat. 125)

333. Clerics destroying a church. Hatfield House, Marquess of Salisbury, CP 290, f. 13 (cat. 126)

334. Scholar lecturing. Hatfield House, Marquess of Salisbury, CP 290, f. 145ᵛ (cat. 126)

335. Decorated initial. London, B.L., Add. 44949, f. 74 (cat. 127)

336. David playing the harp. London, B.L., Add. 44949, f. 39 (cat. 127)

337. Crucifixion and Ascension. London, B.L., Add. 44949, f. 5ᵛ (cat. 127)

338. Clerics chanting. Oxford, Bodl. Lib., Rawlinson G. 185, f. 81ᵛ (cat. 128)

339. God-Father holding the Crucified Son. Oxford, Bodl. Lib., Rawlinson G. 185, f. 97 (cat. 128)

340. Leaving the Ark. London, B.L., Egerton 1894, f. 4 (cat. 129)

341. Lot, Abraham and Sarah. London, B.L., Egerton 1894, f. 8 (cat. 129)

342. St. Andrew; below, Samson and Delilah. Cambridge, Fitzwilliam Museum, 48, f. 47 (cat. 130)

343. St. George. Cambridge, Fitzwilliam Museum, 48, f. 85 (cat. 130)

344. Creation of Adam. Cambridge, Fitzwilliam Museum, 48, f. 12 (cat. 130)

345. Fall of Man. Cambridge, Fitzwilliam Museum, 48, f. 14 (cat. 130)

346. Baruch writing. Bloomington, Indiana University, Lilly Lib., Ricketts 15, f. 261 (cat. 132)

347. Daniel in the lion's den. Bloomington, Indiana University, Lilly Lib., Ricketts 15, f. 339 (cat. 132)

348. Micah writing. New York, Pierpont Morgan Lib., M. 741, f. 1ᵛ (388ᵛ) (cat. 132)

349. Habakkuk writing. New York, Pierpont Morgan Lib., M. 741, f. 2 (395) (cat. 132)

350. Nativity. London, B.L., Royal 13.D.1*, f. 9 (cat. 131)

351. David pointing to his mouth; border, saints and prophets. London, B.L., Royal 13.D.1*, f. 16ᵛ (cat. 131)

352. David praying in the water; the Lord above. London, B.L., Royal 13.D.1*, f. 20ᵛ (cat. 131)

353. Border decoration. London, B.L., Royal 13.D.1*, f. 42, (cat. 131)

354. David enthroned; below, impious man falling. Vienna, Österreichische Nationalbibl., 1826*, f. 7 (cat. 133)

355. Moses at the Red Sea. Vienna, Österreichische Nationalbibl., 1826*, f. 85ᵛ (cat. 133)

356. Initials and border decoration. Oxford, Exeter College, 47, f. 53 (cat. 134)

357. Initials and border decoration. Oxford, Exeter College, 47, f. 84ᵛ (cat. 134)

358. Initials and border decoration. Oxford, Exeter College, 47, f. 121ᵛ (cat. 134)

359. Initials and border decoration. London, B.L., Egerton 3277, f. 141 (cat. 135)

360. Woman clothed in arms of England and Bohun. London, B.L., Egerton 3277, f. 131ᵛ (cat. 135)

361. David at Altar. London, B.L., Egerton 3277, f. 42 (cat. 135)

362. Scenes from life of David; in margin, King of England receives sword from King of France. London, B.L., Egerton 3277, f. 68ᵛ (cat. 135)

363. Arthur, Lancelot and Guinevere. London, B.L., Royal 20.D.IV, f. 1 (cat. 136)

364. St. Thomas the Apostle; death of St. Philip. Pommersfelden, Gräflich Schönbornische Bibl., 2934, f. 3ᵛ (cat. 137)

## Colour Plates

## Text Figures

# ILLUSTRATIONS

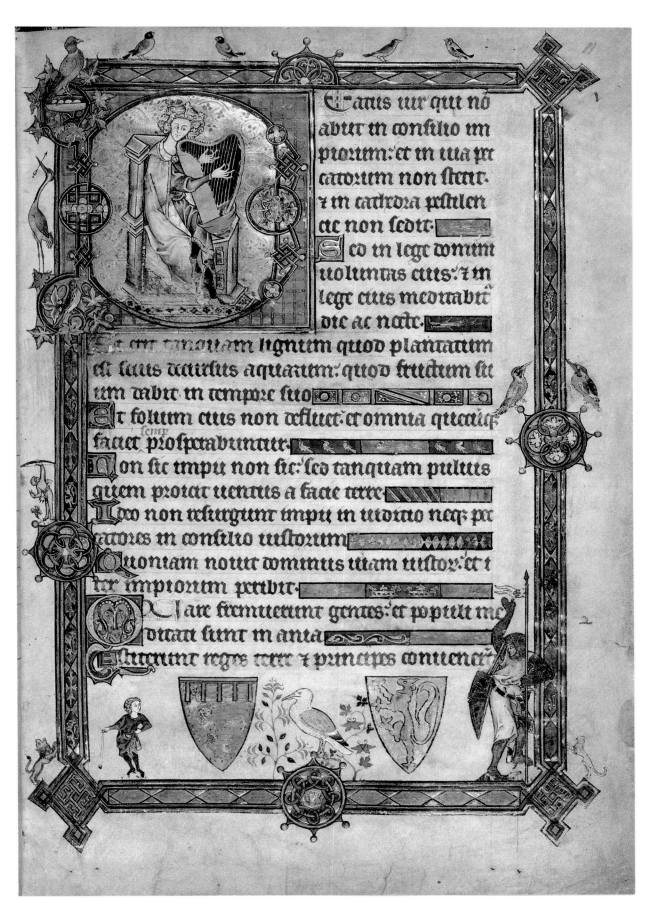

1. David playing the harp. London, B.L., Add. 24686, f.11 (cat.1)

2. St. Anne and the Virgin, Saints Catherine, Margaret and Barbara. London, B.L., Add. 24686, f.2ᵛ (cat.1)

3. Ascension. London, B.L., Royal 3.D.VI, f.283ᵛ (cat.2)

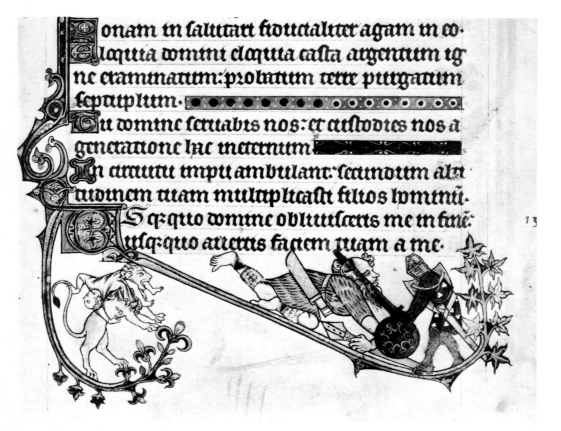

4. Lion attacking man, warrior slaying giant. London, B.L., Add. 24686, f.17 (cat.1)

5. Pharoah with Jews building. London, B.L., Royal 3.D.VI, f.46 (cat.2)

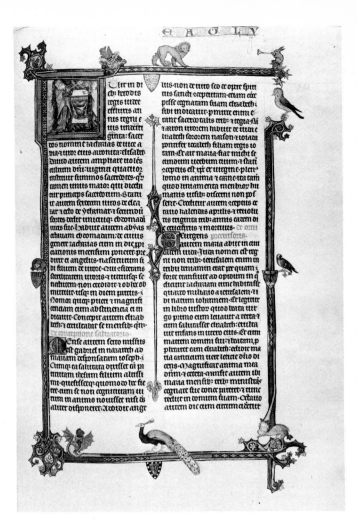

6. Zacharias censing altar. London, B.L., Royal 3.D.VI, f.234 (cat.2)

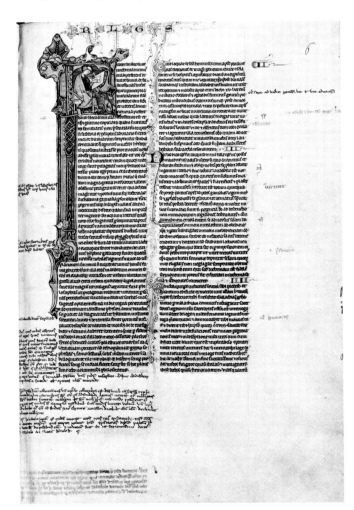

7. Jerome writing. Paris, Bibl. Nat., lat. 15472, f.6 (cat.6)

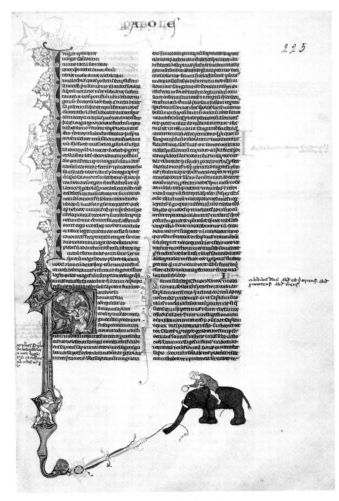

8. Solomon teaching. Paris, Bibl. Nat., lat. 15472, f.225 (cat.6)

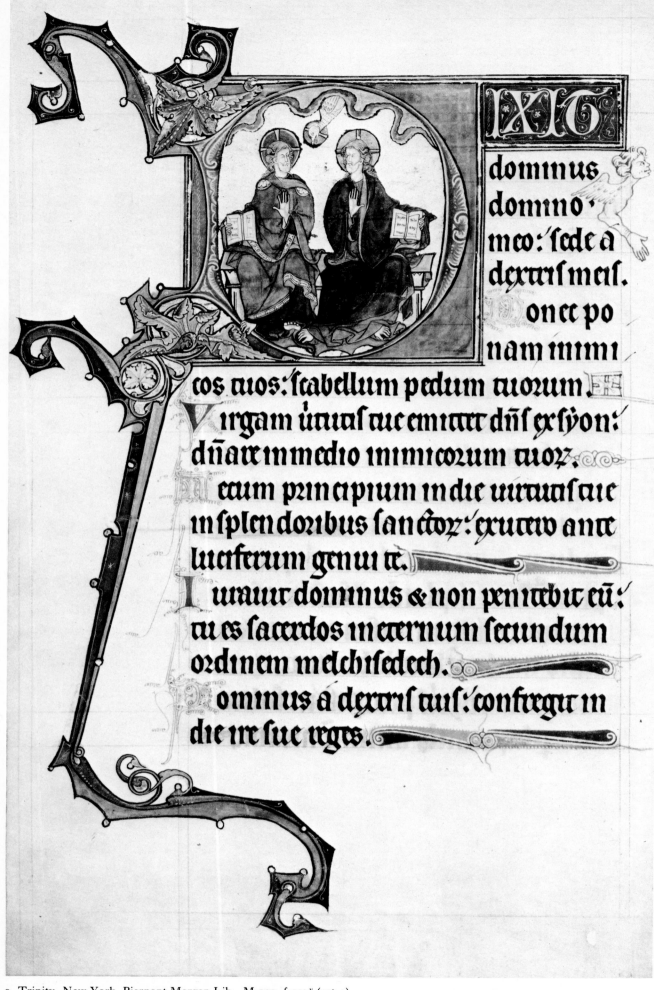

dominus
domino
meo: sede a
dextris meis.
onec po
nam inimi
cos tuos: scabellum pedum tuorum.
Virgam virtutis tue emittet dñs ex syon:
dñare in medio inimicorum tuorum.
tecum principium in die virtutis tue
in splendoribus sanctorum: ex utero ante
luciferum genui te.
Iurauit dominus & non penitebit eū:
tu es sacerdos in eternum secundum
ordinem melchisedech.
Dominus á dextris tuis: confregit in
die ire sue reges.

9. Trinity. New York, Pierpont Morgan Lib., M.102, f.117ᵛ (cat.4)

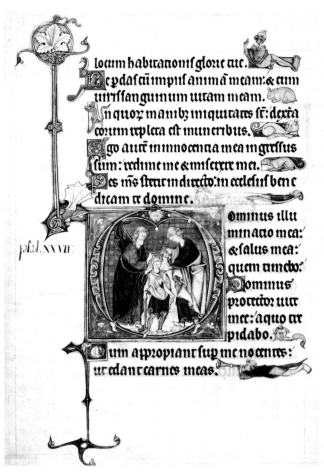

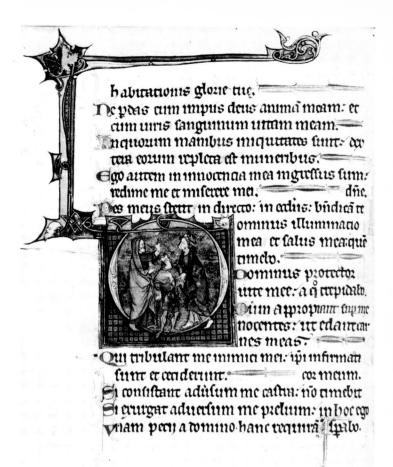

10. Anointing of David. New York, Pierpont Morgan Lib., M.102, f.24ᵛ (cat.4)

11. Anointing of David. London, Private Collection, Mostyn Psalter, f.30ᵛ (cat.5)

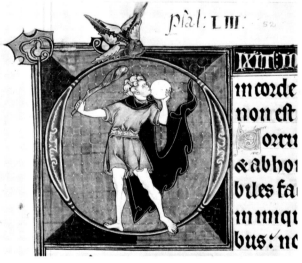

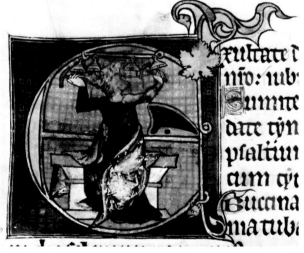

12. Standing fool. New York, Pierpont Morgan Lib., M.102, f.53ᵛ (cat.4)

13. David playing bells. London, Private Collection, Mostyn Psalter, f.76ᵛ (cat.5)

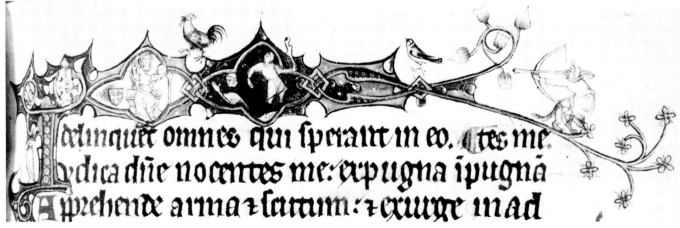

14. Dominican before the Lord. London, Private Collection, Mostyn Psalter, f.37 (cat.5)

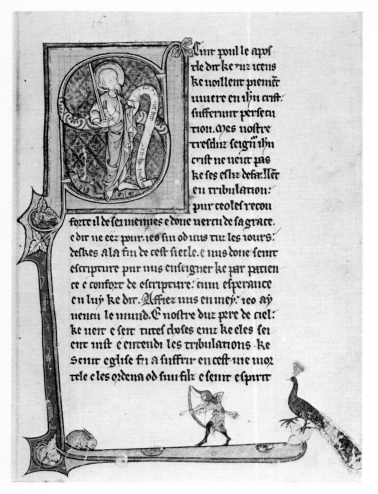

15. St. Paul. Oxford, New College, 65, f.1 (cat.7)

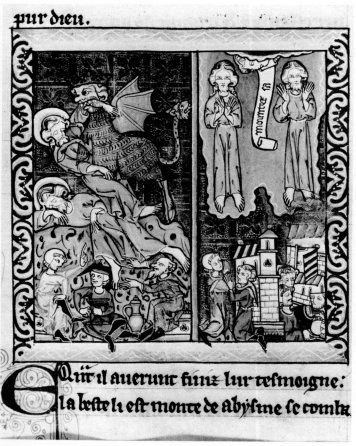

16. Death and Ascension of the Witnesses.
Oxford, New College, 65, f.36ᵛ (cat.7)

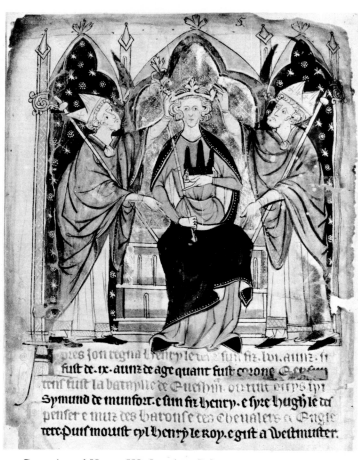

17. Crowning of Henry III. London, B.L.,
Cotton Vitellius A.XIII, f.6 (cat.9)

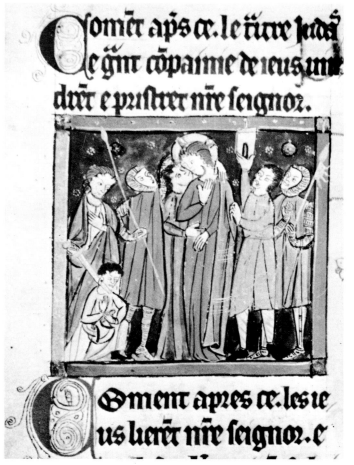

18. Betrayal. Cambridge, St. John's College, 262 (K.21), f.49ᵛ (cat.8)

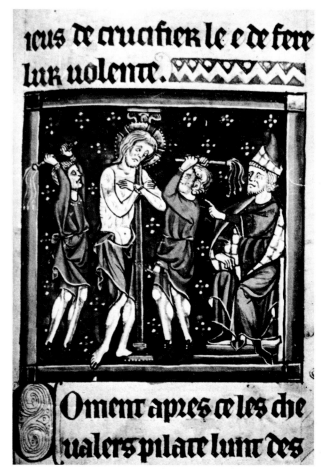

19. Flagellation. Cambridge, St. John's College, 262 (K.21), f.51 (cat.8)

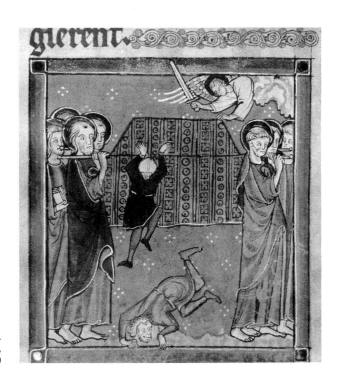

20. Funeral of the Virgin. Cambridge, St. John's College, 262 (K.21), f.64 (cat.8)

21. Anointing of David. Cambridge,
Fitzwilliam Museum 2-1954, f.23ᵛ (cat.10)

22. Crucifixion. London, Private Collection,
York Hours, f.76 (cat.11b)

23. Annunciation. London, Private Collection,
York Hours, f.26 (cat.11b)

24. Beatus initial. New York, Pierpont Morgan Lib.,
M.100, f.7 (cat.12)

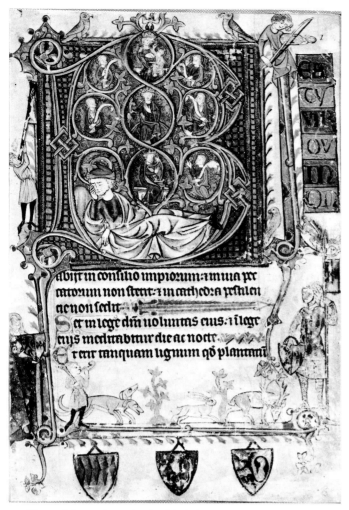

25. Tree of Jesse. New York, Clark Stillman,
unfoliated (cat.11a)

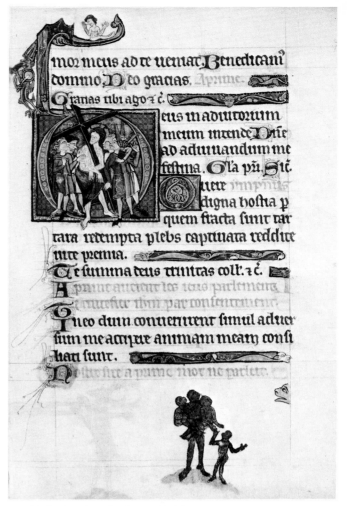

26. Christ bearing the Cross. Baltimore,
Walters Art Gallery, W.102, f.76 (cat.15)

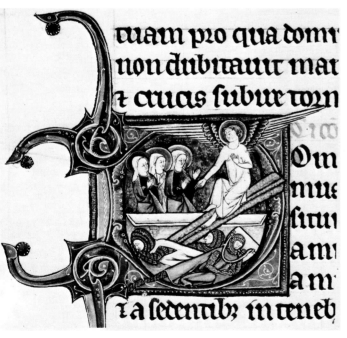

27. Marys at the Tomb. Baltimore,
Walters Art Gallery, W.102, f.7ᵛ (cat.15)

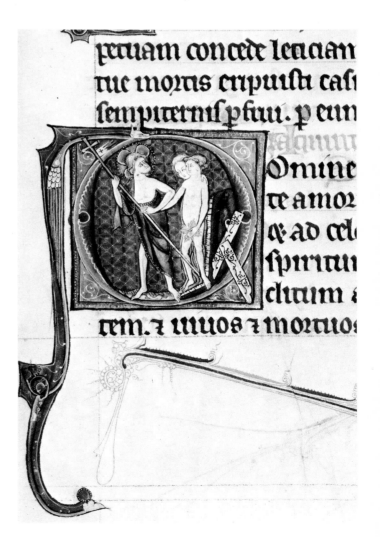

28. Descent into Limbo. Baltimore,
Walters Art Gallery, W.102, f.8 (cat.15)

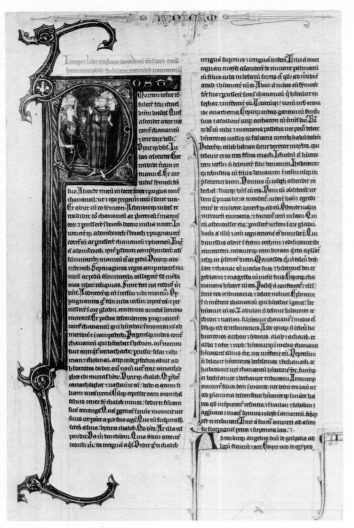

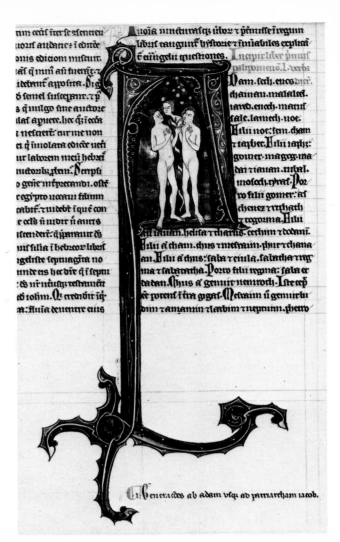

29. Judge with an audience. Oxford, Bodl. Lib., Auct. D.3.2, f.77 (cat.13)

30. Fall of Man. Oxford, Bodl. Lib., Auct. D.3.2, f.133 (cat.13)

31. Border decoration, hybrids. Baltimore, Walters Art Gallery, W.102, f.51 (cat.15)

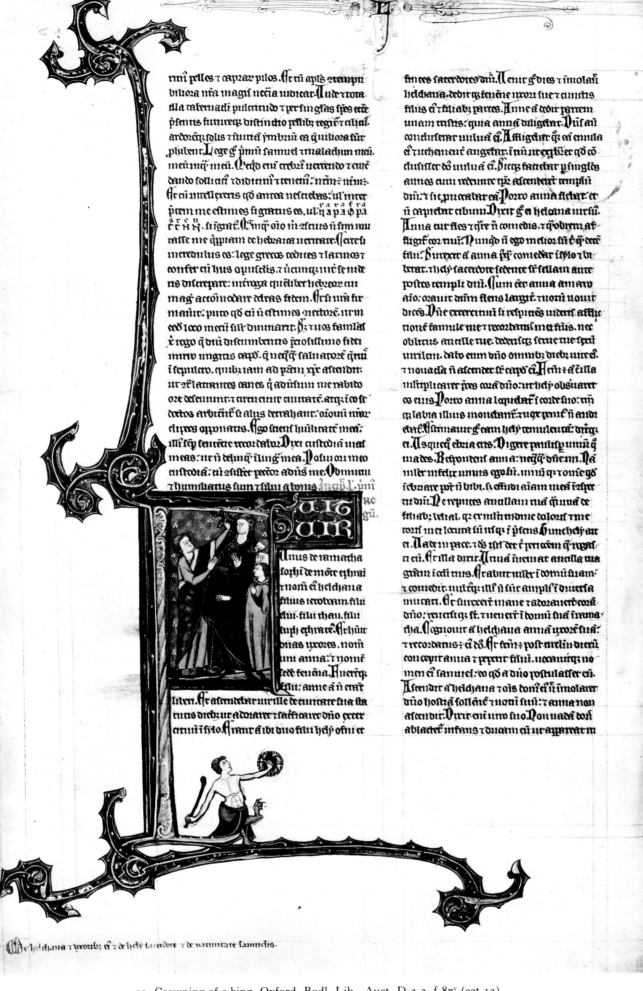

32. Crowning of a king. Oxford, Bodl. Lib., Auct. D.3.2, f.87ᵛ (cat.13)

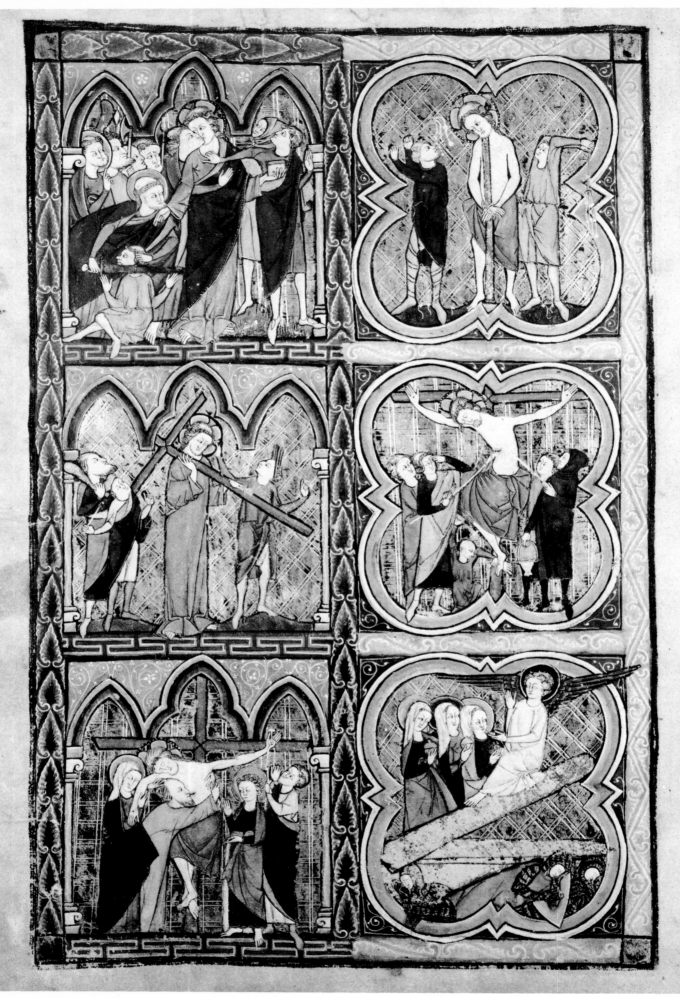

33. Passion Scenes. Cambridge, Trinity College,
O.4.16, f.113ᵛ (cat.14)

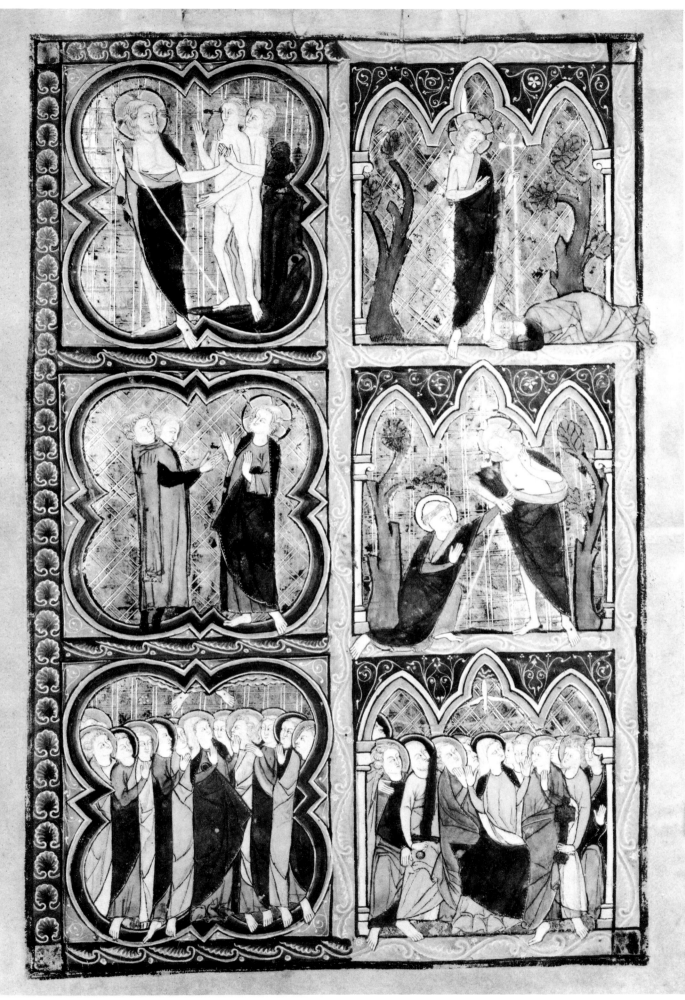

34. Descent into Limbo; Appearances of Christ; Ascension, Pentecost.
Cambridge, Trinity College, O.4.16, f.114 (cat.14)

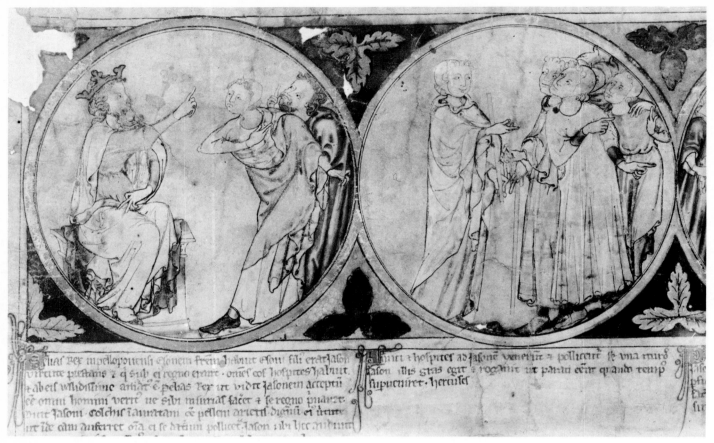

35. King Pelias and Jason; Jason and the Argonauts.
Oxford, Bodl. Lib., Bodley Rolls 3, Row I: 1,2 (cat.16a)

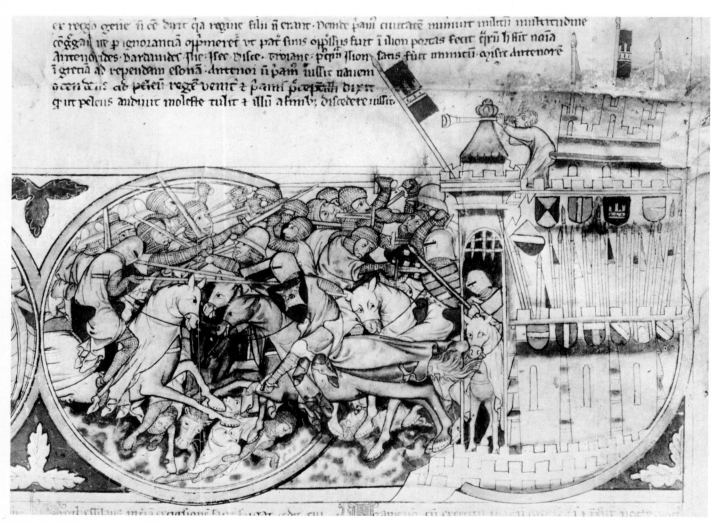

36. Sack of Troy. Oxford, Bodl. Lib., Bodley
Rolls 3, Row IV: 15,16 (cat.16a)

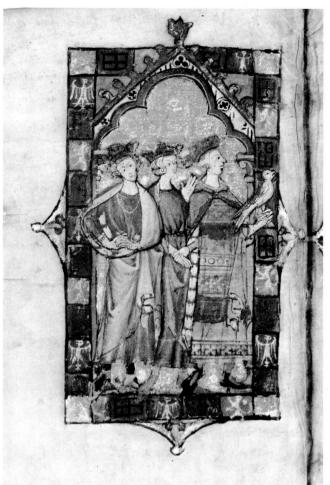

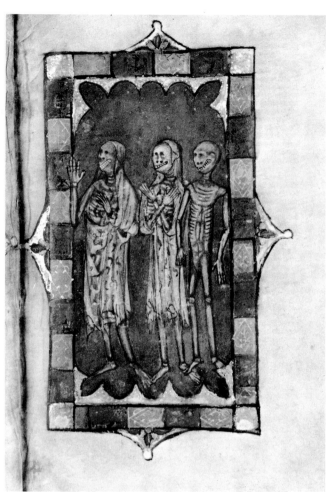

37. The Three Living. Baltimore, Walters Art Gallery,
W.51, f.1ᵛ (cat.18)

38. The Three Dead. Baltimore, Walters Art Gallery,
W.51, f.2 (cat.18)

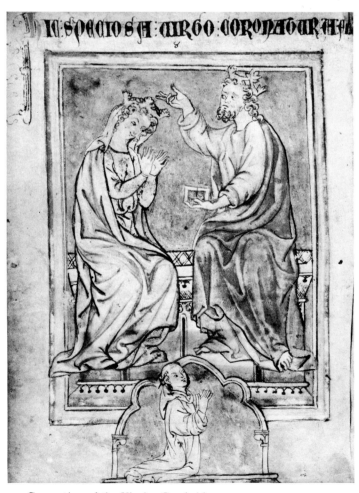

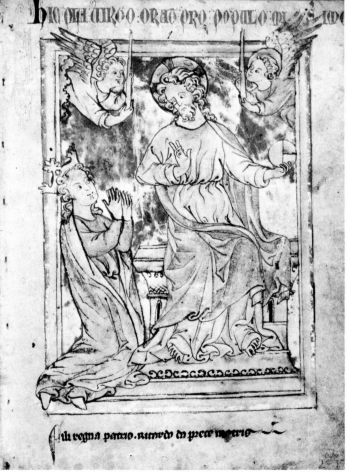

39. Coronation of the Virgin. Cambridge,
Fitzwilliam Museum, 370, f.1ᵛ (cat.17)

40. Virgin interceding with Christ. Cambridge,
Fitzwilliam Museum, 370, f.2 (cat.17)

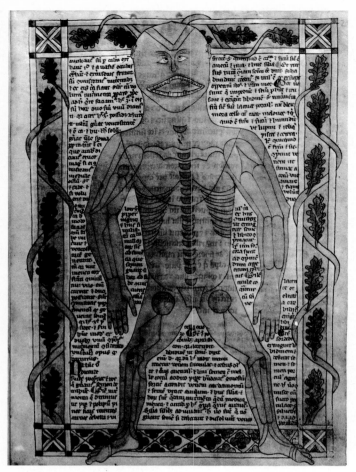

41. Figure demonstrating bones. Oxford, Bodl. Lib., Ashmole 399, f.20 (cat.19)

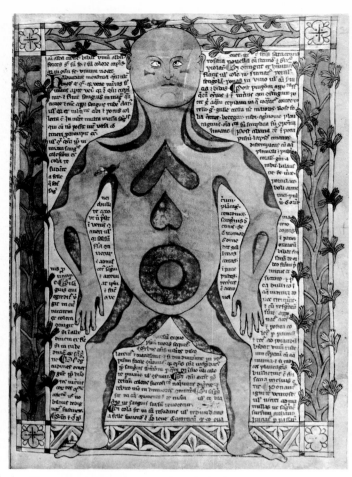

42. Figure demonstrating muscles. Oxford, Bodl. Lib., Ashmole 399, f.22 (cat.19)

43. Pilkington Charter. Cambridge, Fitzwilliam Museum, BL 51 (cat.3)

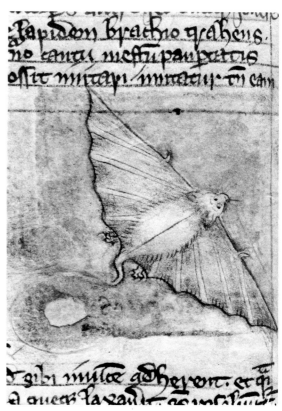

44. Goat eating leaves. Canterbury, Cathedral Lib.,
lit. D.10, f.1ᵛ (cat.20)

45. Nocturnal bat. Canterbury,
Cathedral Lib., lit. D.10, f.19ᵛ (cat.20)

46. Justice with petitioners; knightly combat.
Oxford, Bodl. Lib., Rawlinson C.160, f.1 (cat.21)

47. Goat; unicorn; bear. Cambridge,
Corpus Christi College, 53, f.193 (cat.23)

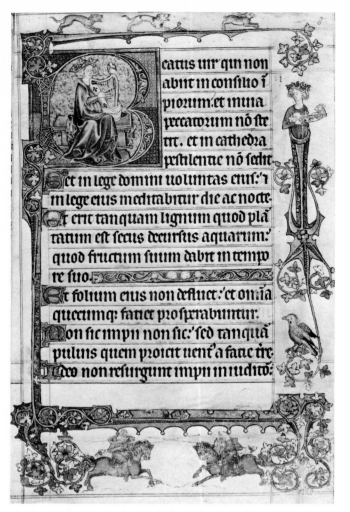

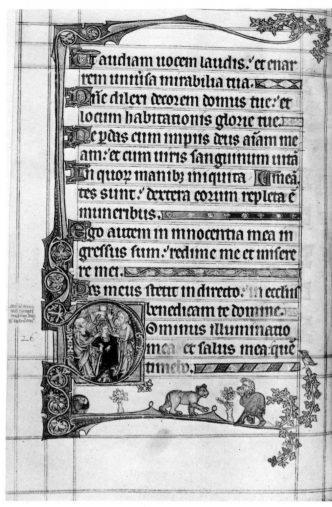

48. David playing the harp. Oxford, Jesus College, D.40, f.8 (cat.24)

49. Anointing of David. Oxford, Jesus College, D.40, f.35ᵛ (cat.24)

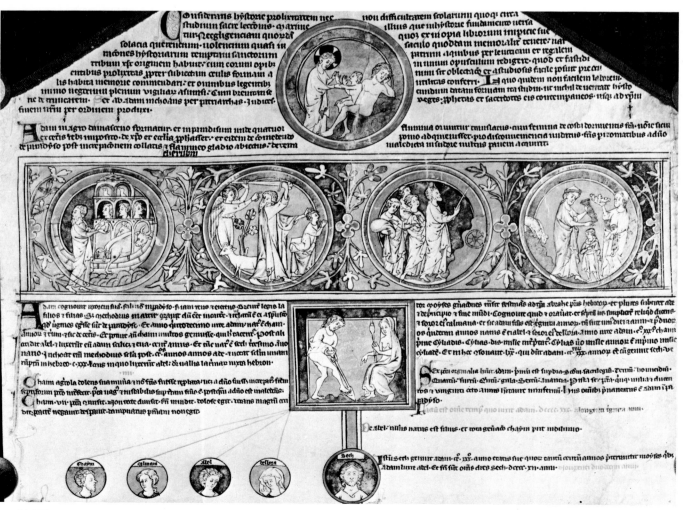

50. Old Testament Scenes. London, B.L., Add. 14819, Roll (cat.22)

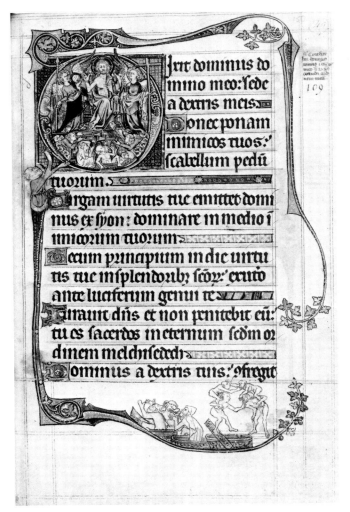

51. Last Judgement. Oxford, Jesus College, D.40, f.150 (cat.24)

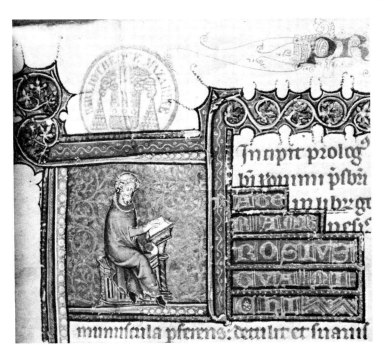

52-53. Jerome writing; Jews carrying the Ark.
Paris, Bibl. Mazarine, 34,
ff.1 and 50 (cat.25)

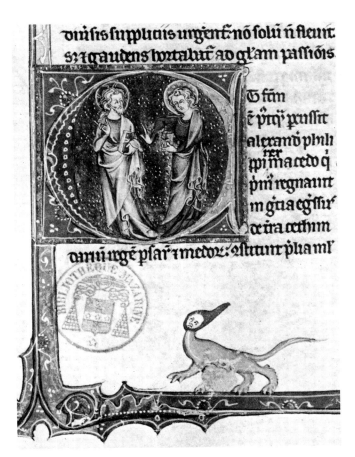

54. Christ with an apostle. Paris,
Bibl. Mazarine, 34, f.289 (cat.25)

55. Jonah and the whale. Paris,
Bibl. Mazarine, 34, f.203ᵛ (cat.25)

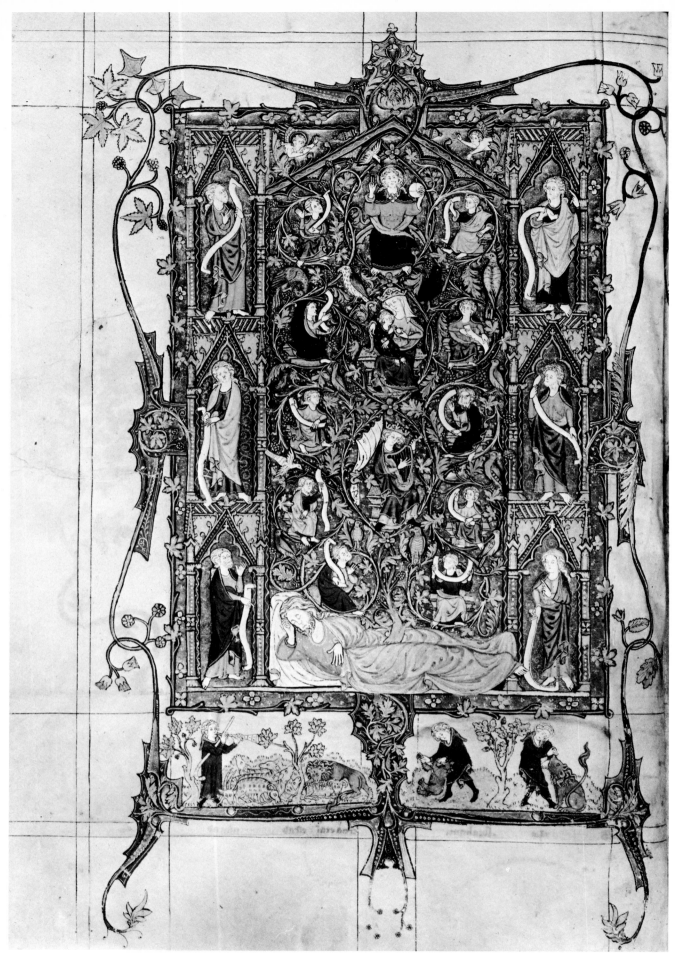

56. Tree of Jesse. New York Public Lib., Spencer 26, f.5ᵛ (cat.26)

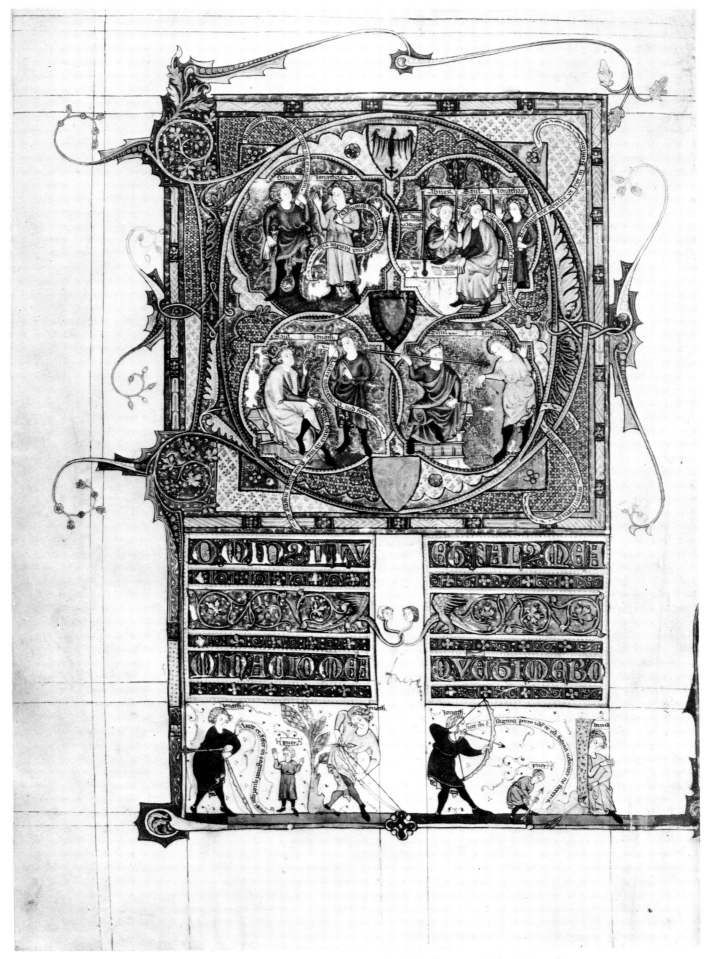

57. Scenes from life of David. New York Public Lib., Spencer 26, f.26ᵛ (cat.26)

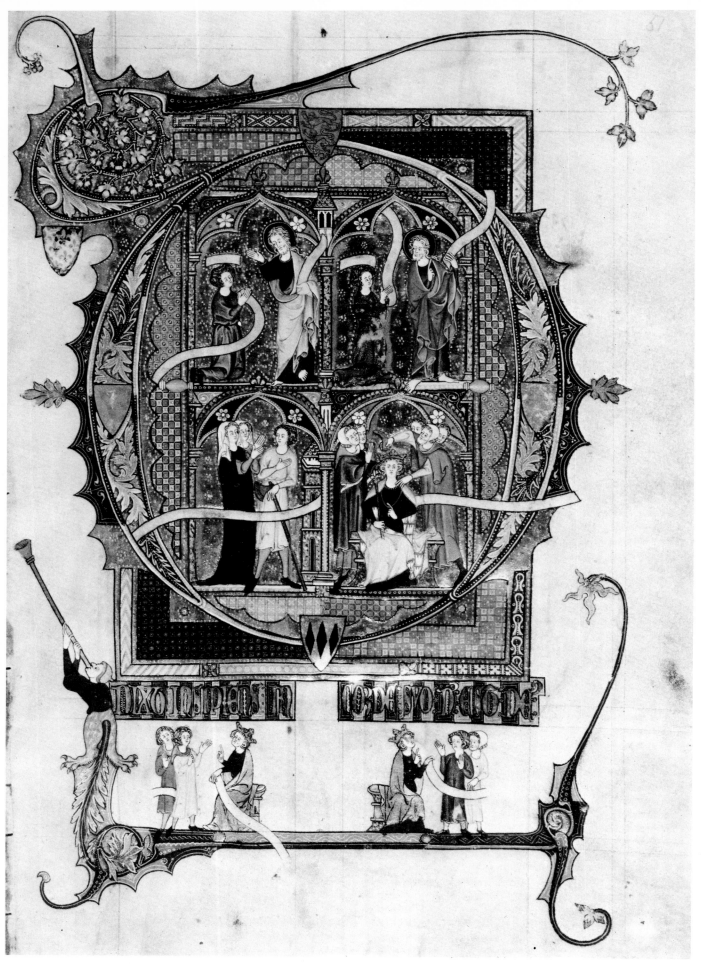

58. Scenes from life of David. New York Public Lib., Spencer 26, f.51 (cat.26)

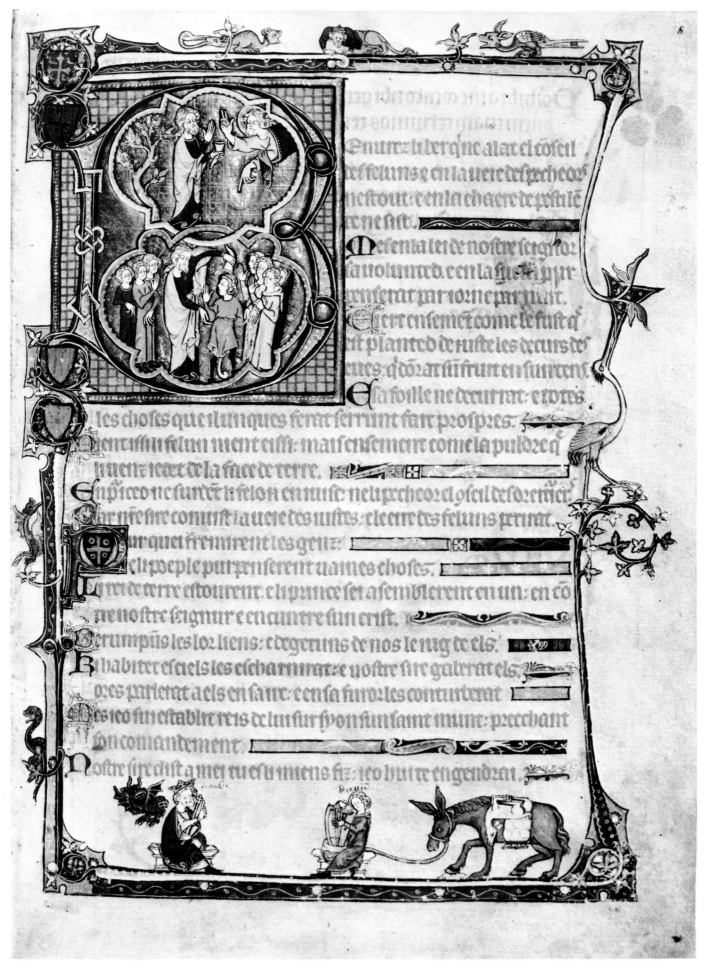

59. Anointing of David. Munich, Bayerische Staatsbibl., gall.16, f.8 (cat.27)

60. Healing of the blind man.
Oxford, Bodl. Lib., Lat. liturg. D.40 (cat.28)

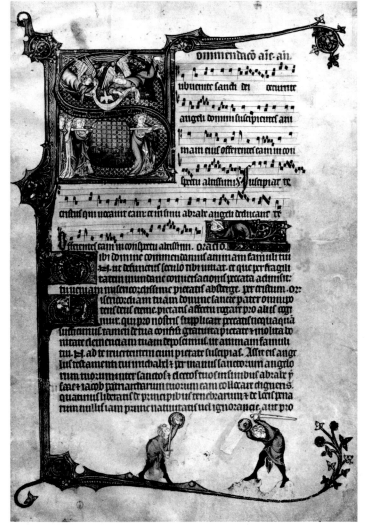

61. Funeral procession. Initial S.
Cambridge, University Lib.,
Dd.8.2, f.21 (cat.29)

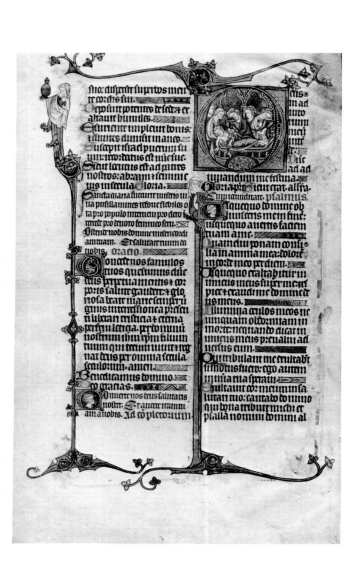

62. Entombment. Cambridge, University Lib.,
Dd.8.2, f.37ᵛ (cat.29)

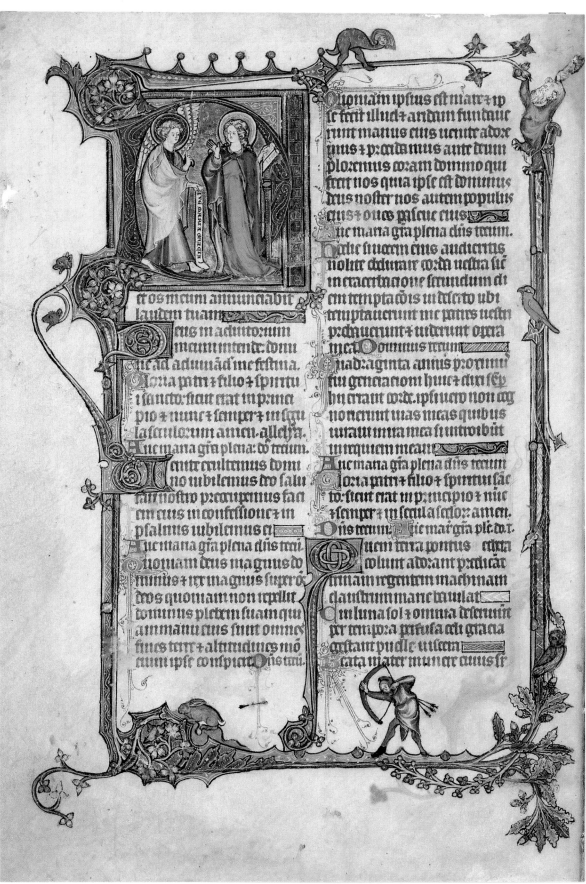

63. Annunciation. Cambridge, University Lib., Dd.8.2, f.27ᵛ (cat.29)

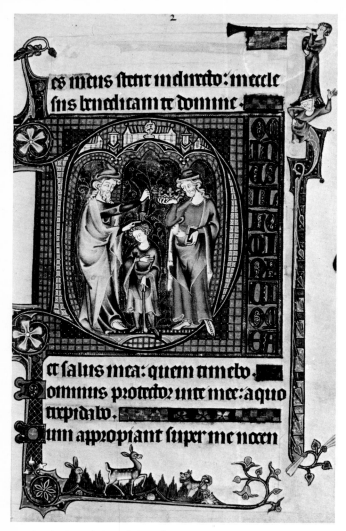

65. Samson fighting the lion. Cambridge,
Fitzwilliam Museum, McClean 15, f.62 (cat.32)

64. Anointing of David. London,
Lambeth Palace Lib.,233, f.44 (cat.30)

66. Esdras with Christ. Cambridge,
Fitzwilliam Museum, McClean 15, f.149ᵛ (cat.32)

67. David playing the harp. Cambridge,
Fitzwilliam Museum, McClean 15, f.176ᵛ (cat.32)

68. Jonah saved from the whale, the Lord above.
Princeton, University Lib., Garrett 35, f.67ᵛ (cat.35)

69. Aristotle. Paris, Bibl. Nat., lat. 6299,
f.2 (cat.33)

70. Aristotle. Paris, Bibl. Nat., lat. 6299,
f.14 (cat.33)

71. Aristotle. Paris, Bibl. Nat., lat. 6299,
f.23ᵛ (cat.33)

72. Aristotle. Paris, Bibl. Nat., lat. 6299,
f.66 (cat.33)

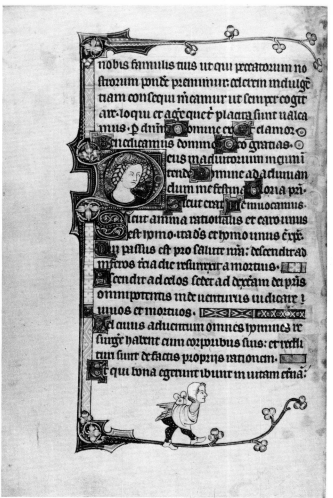

73. Decorative head. Cambridge, Fitzwilliam
Museum 242, f.40ᵛ (cat.31)

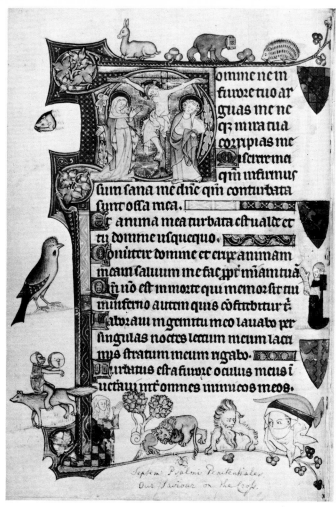

74. Crucifixion. Cambridge, Fitzwilliam
Museum 242, f.55ᵛ (cat.31)

75. Vision of Christ and the Book. London, B.L.,
Royal 15.D.II, f.122ᵛ (cat.34)

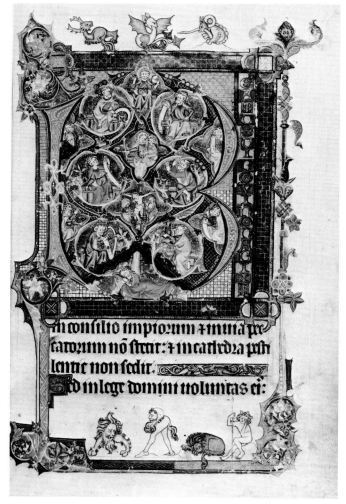

76. Psalm 1, Tree of Jesse. London,
Lambeth Palace Lib., 233, f.15 (cat.30)

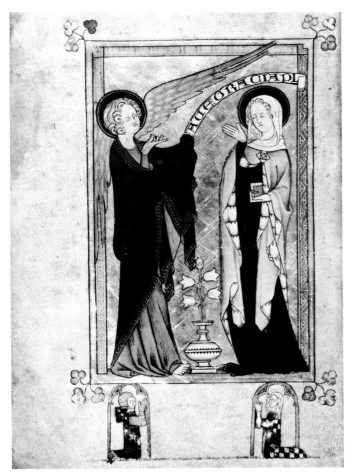

77. Annunciation. Cambridge, Fitzwilliam Museum 242, f.2ᵛ (cat.31)

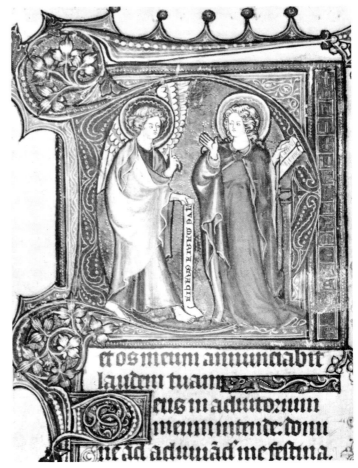

78. Annunciation. Cambridge, University Lib., Dd.8.2, detail of f.27ᵛ (cat.29)

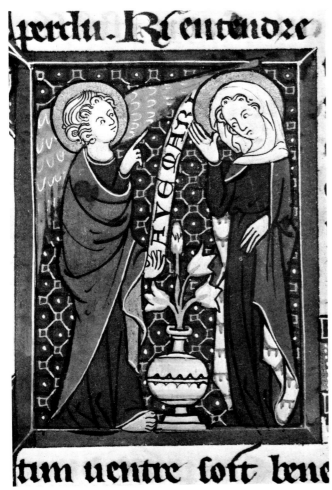

79. Annunciation. London, B.L., Royal 15.D.II, f.3 (cat.34)

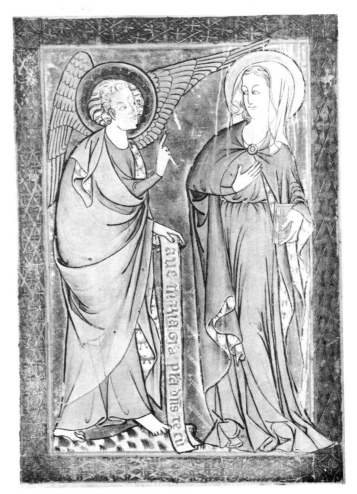

80. Annunciation. Princeton, University Lib., Garrett 35, f.1ᵛ (cat.35)

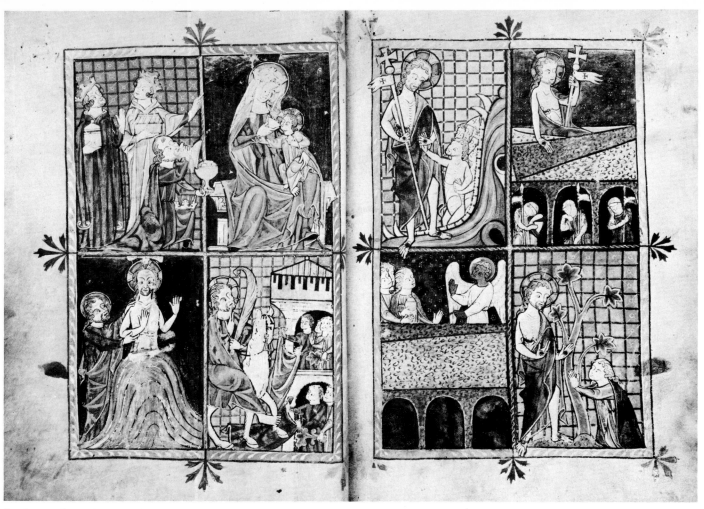

81. Scenes from the Life of Christ. New York Public Lib., Spencer 2, f.7ᵛ-8 (cat.36)

82. Nativity, Martyrdom of St. Anastasia;
Annunciation to the Shepherds. New York Public Lib.,
Spencer 2, f.161ᵛ (cat.36)

83. Border decoration.
Madresfield Court, Earl Beauchamp M,
f.42ᵛ (cat.37)

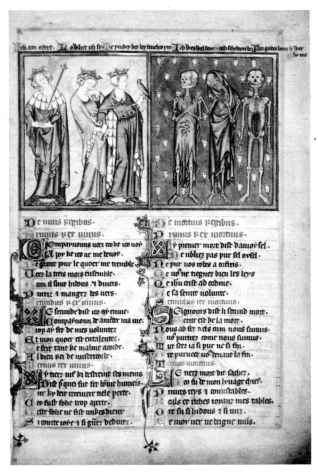

84. Three Living and Three Dead. London,
B.L., Arundel 83 II, f.127 (cat.38)

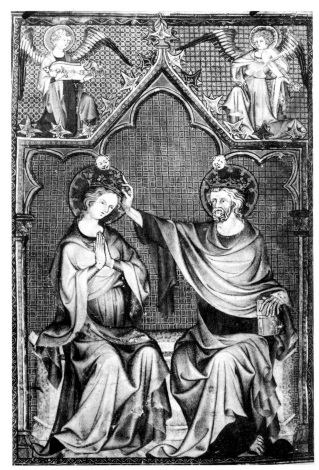

85. Coronation of the Virgin. London,
B.L., Arundel 83 II, f.134ᵛ (cat.38)

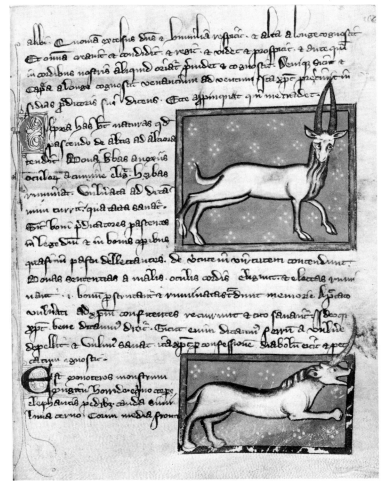

86. Goat; unicorn. Oxford, St. John's College, 178,
f.166 (cat.39)

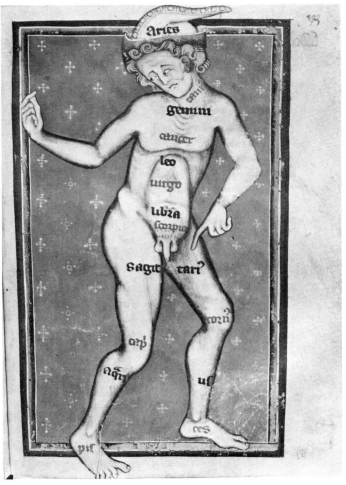

87. Zodiacal Man. Oxford, St. John's College, 178,
f.143 (cat.39)

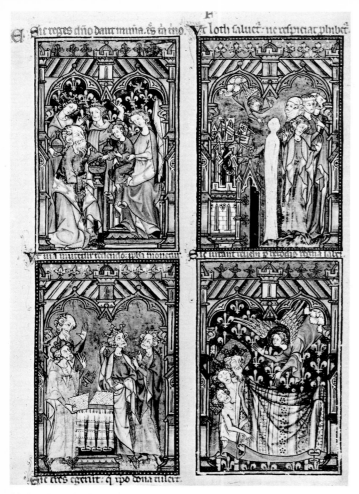

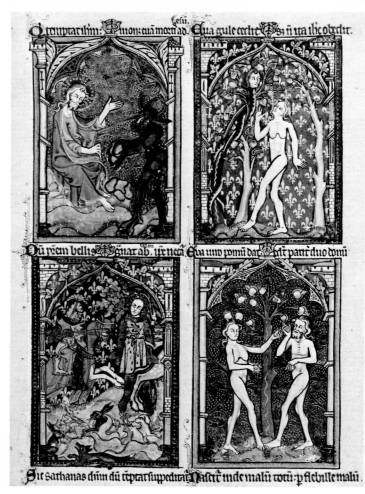

88-89. Typological scenes. Brussels, Bibl. Royale 9961-62, ff.12 and 25 (cat.40)

90. Abbot praying. Brussels, Bibl. Royale 9961-62, f.65 (cat.40)

91. David rising from his Throne. St. Paul in Lavantthal, Stiftsbibl. Cod. XXV/2, 19, f.121 (cat.41)

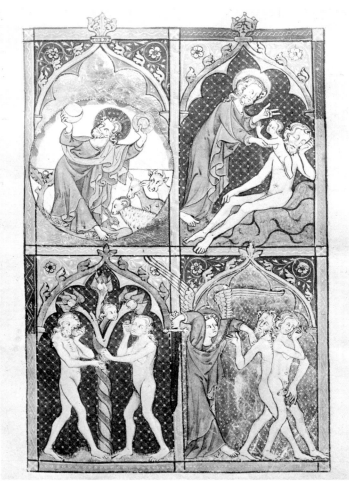

92. Genesis Scenes . New York, Pierpont Morgan Lib.,
M.302, f.1 (cat.41)

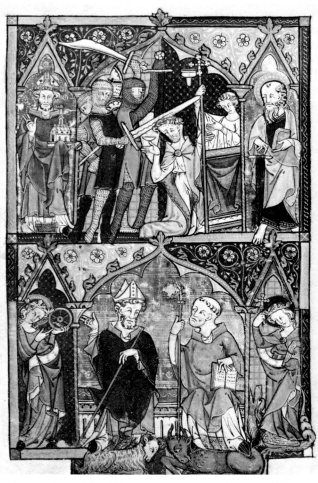

93. Martyrdom of St. Thomas; Founders of Ramsey Abbey.
Pierpont Morgan Lib., M.302, f.4ᵛ (cat.41)

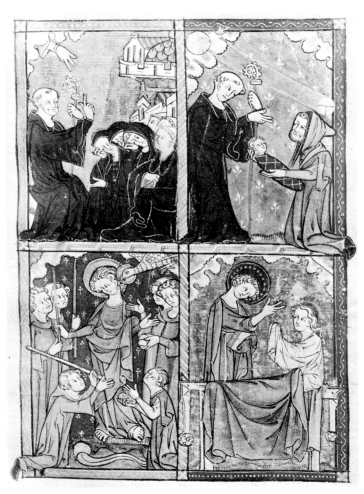

94. St. Benedict; St. John the Evangelist. New York,
Pierpont Morgan Lib., M.302, f.5 (cat.41)

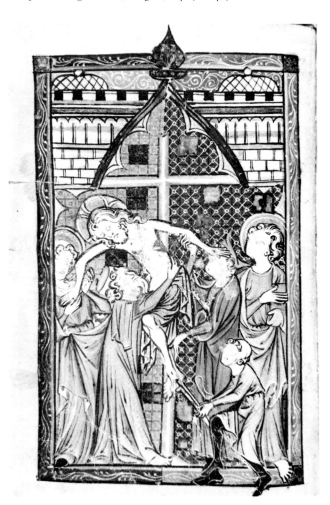

95. Deposition. Oxford, Bodl. Lib.,
Gough liturg. 8, f.61ᵛ (cat.42)

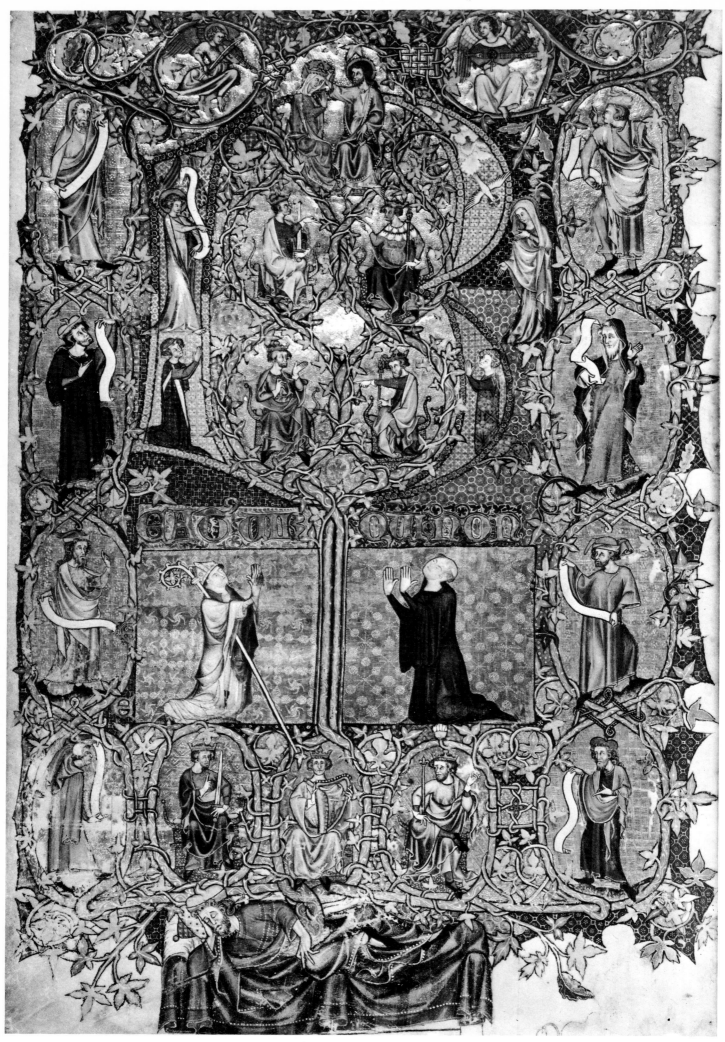

96. Tree of Jesse. Oxford, Bodl. Lib., Douce 366, f.9ᵛ (cat.43)

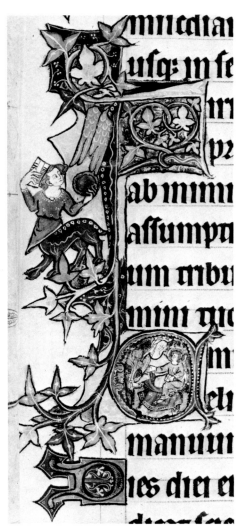

97-98. Initials and borders. Oxford, Bodl. Lib., Douce 366, ff.29 and 63 (cat.43)

99. A murder. Oxford, Bodl. Lib., Ashmole 1523, f.65 (cat.44)

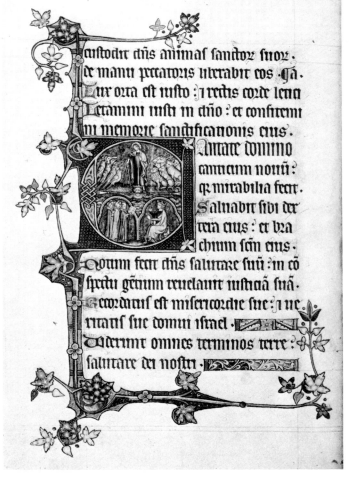

100. Decorated initial. Oxford, Bodl. Lib., Ashmole 1523, f.127ᵛ (cat.44)

101. The Creator with adoring animals; David and clerics chanting, Lord above. Oxford, Bodl. Lib., Ashmole 1523, f.116ᵛ (cat. 44)

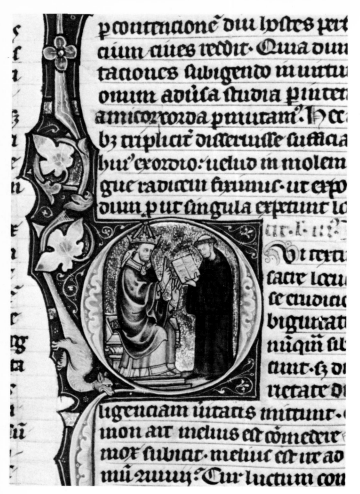

102. Gregory and a Benedictine. Cambridge,
Emmanuel College, 112, Book IV (cat.45)

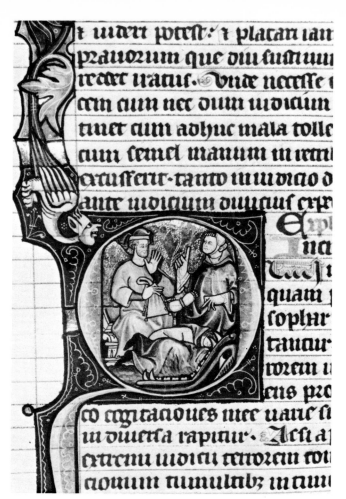

103. Two seated misers. Cambridge,
Emmanuel College, 112, Book XV (cat.45)

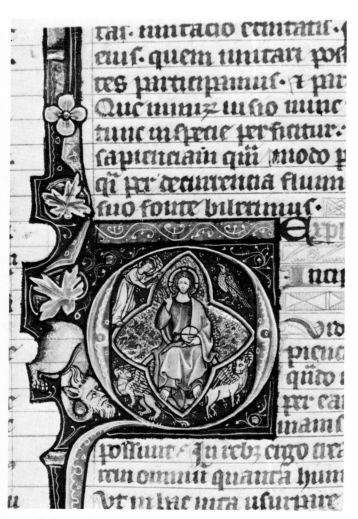

104. Christ in Majesty. Cambridge,
Emmanuel College, 112, Book XIX (cat.45)

105. Christ washing the disciples' feet. Cambridge,
Emmanuel College, 112, Book XXII (cat.45)

106. Fall of Man.
Cambridge, Emmanuel College, 112,
Book XXXI (cat.45)

107. The Voice of the Eagle and the Fifth Trumpet.
Dublin, Trinity College, 64 (K.4.31), p.XXII (cat.46)

108. Angel and the Book; John takes the Book. Dublin,
Trinity College Lib., 64 (K.4.31), p.XXVI (cat.46)

109. Presentation of Christ. Norwich,
Castle Museum, 158.926.4f, f.53ᵛ (cat.47)

110. Virgin and Child. Norwich,
Castle Museum, 158.926.4f, f.27 (cat.47)

111. Coronation of the Virgin. Norwich,
Castle Museum, 158.926.4f, f.76 (cat.47)

112. Resurrected Christ blessing. Norwich,
Castle Museum, 158.926.4f, f.95 (cat.47)

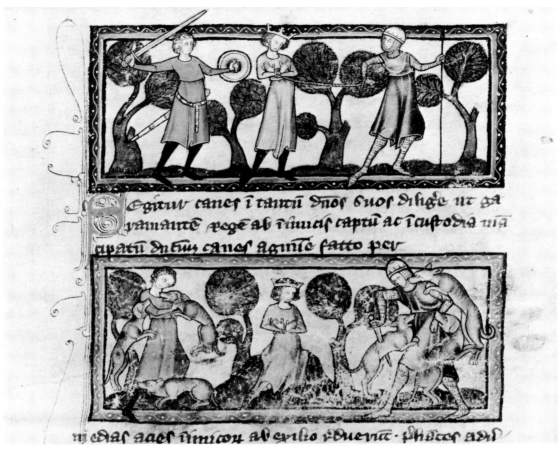

113. King saved by dogs. Cambridge, Fitzwilliam Museum, 379, f.10ᵛ (cat.49)

114. Border decoration. London, B.L.,
Royal 14.C.I, f.20 (cat.48)

115-116. Border decoration; Grotesque swallowing human head.
London, B.L., Add. 49622, ff.7ᵛ, 198ᵛ (cat.50)

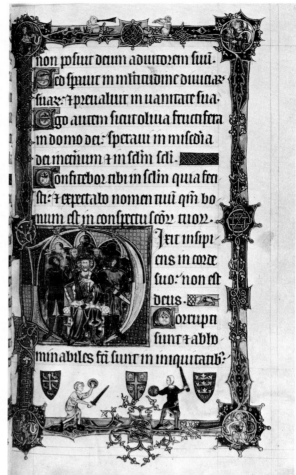

117-118. Doeg and the priests; King with knights. London, B.L., Add. 49622, ff.68ᵛ, 69 (cat.50)

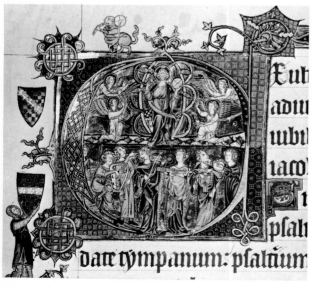
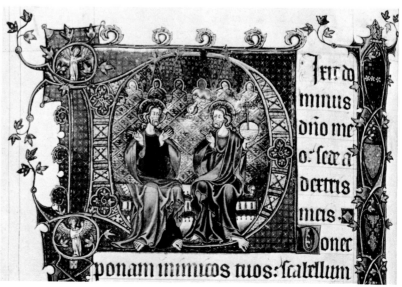

119-121. Border decoration with heads and foliage; Musicians playing, Lord enthroned above; Trinity. London, B.L., Add. 49622, ff.12ᵛ, 107ᵛ, 146ᵛ (cat.50)

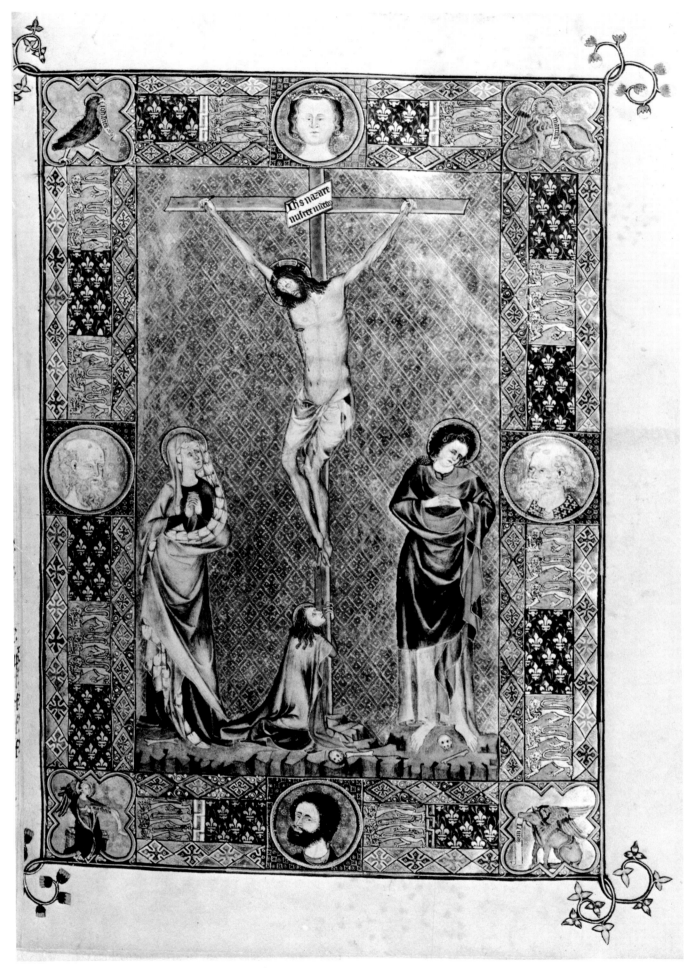

122. Crucifixion. London, B.L., Add. 49622, f.7 (cat.50)

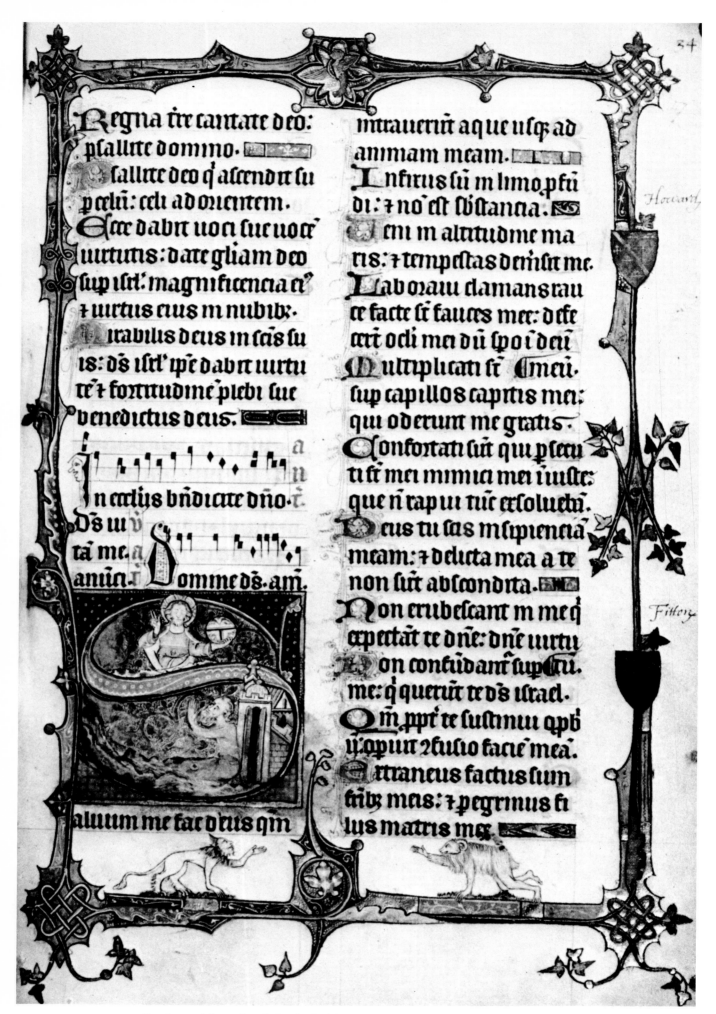

123. Jonah saved from the whale, the Lord above. London, B.L., Arundel 83 I, f.47 (cat.51)

124. Christ bearing the Cross. London, B.L.,
Arundel 83 I, f.115ᵛ (cat.51)

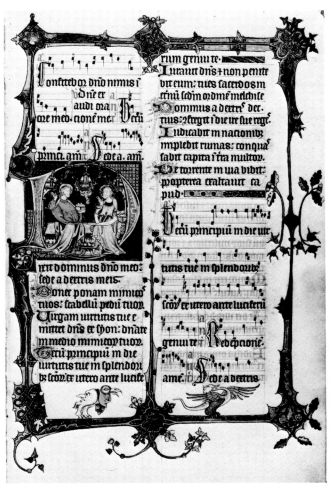

125. Trinity. London, B.L.,
Arundel 83 I, f.72 (cat.51)

126. Border decoration. Longleat,
Marquess of Bath, 10, f.1 (cat. 52)

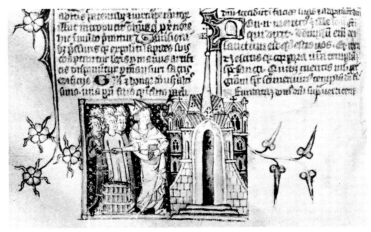

127. Dedication of a church. Longleat,
Marquess of Bath, 10, f.105ᵛ (cat.52)

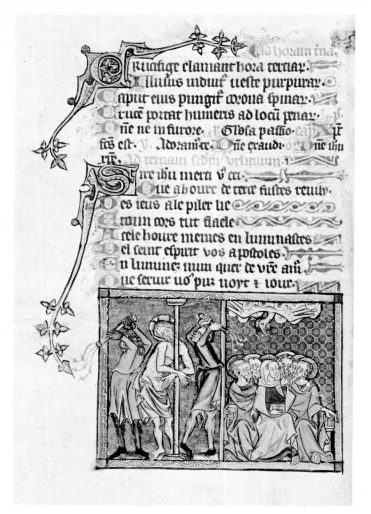

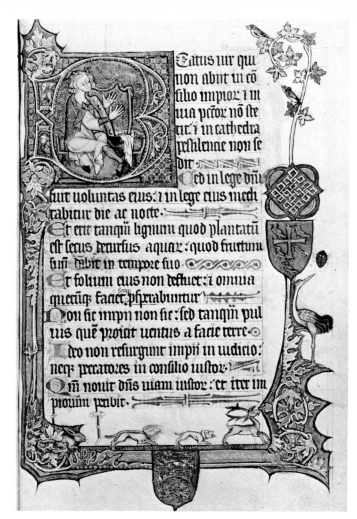

128. Flagellation and Pentecost. San Marino,
Huntington Lib., EL 9.H.17, f.15ᵛ (cat.53)

129. David playing the harp. San Marino,
Huntington Lib., EL 9.H.17, f.42 (cat.53)

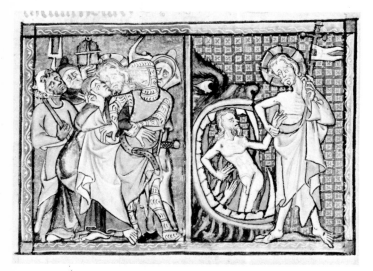

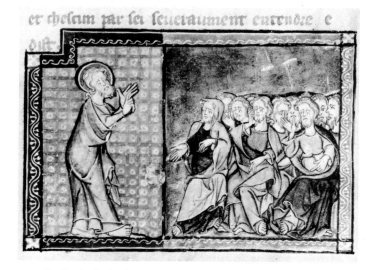

130. Betrayal and Descent into Limbo. San Marino,
Huntington Lib., EL 9.H.17, f.14ᵛ (cat.53)

131. St. Paul. Oxford, Bodl. Lib.,
Selden Supra 38, f.39 (cat.54)

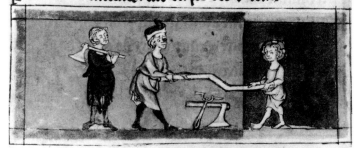

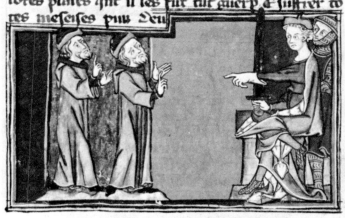

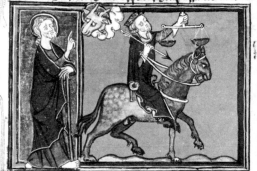

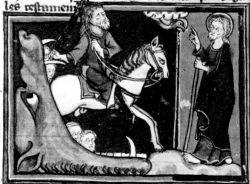

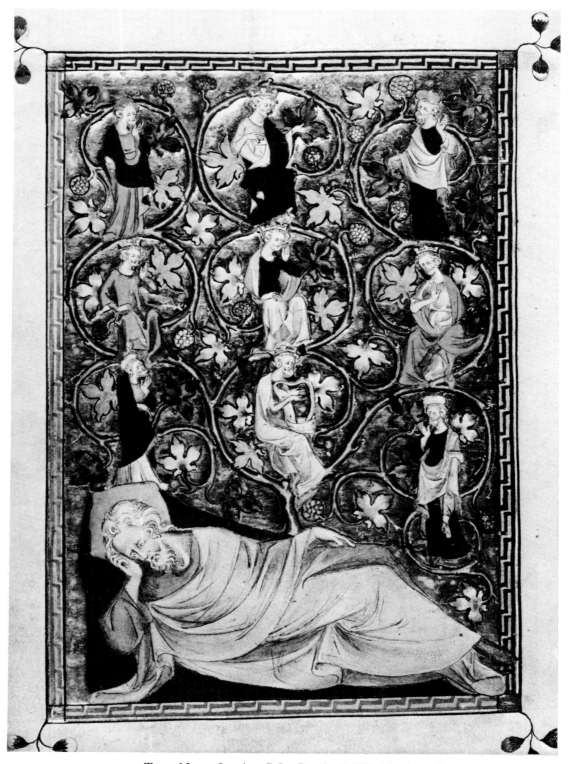

137. Tree of Jesse. London, B.L., Royal 2.B.VII, f.67ᵛ (cat.56)

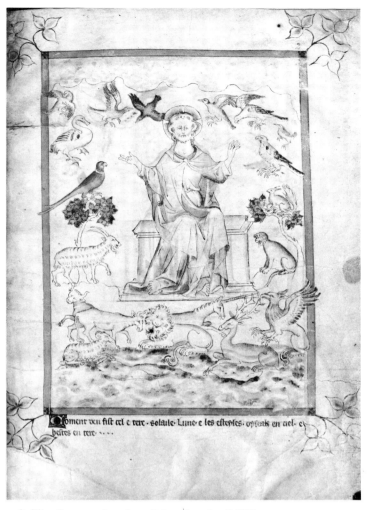

138. The Creator. London, B.L., Royal 2.B.VII,
f.2 (cat.56)

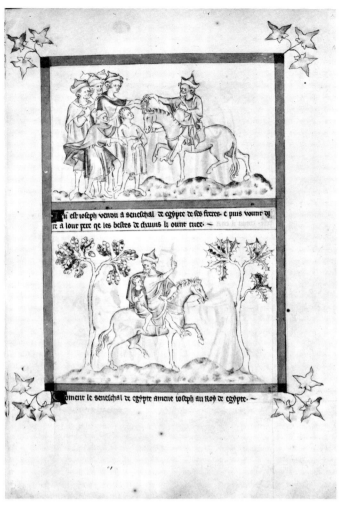

139. Scenes from the life of Joseph. London,
B.L., Royal 2.B.VII, f.15 (cat.56)

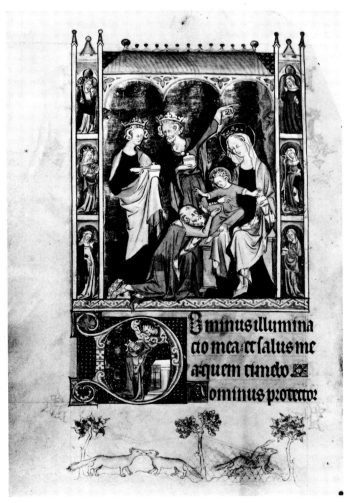

140. Adoration of the Magi. London, B.L.,
Royal 2.B.VII, f.112ᵛ (cat.56)

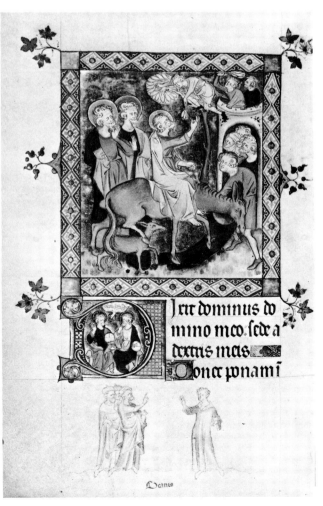

141. Entry into Jerusalem. London, B.L.,
Royal 2.B.VII, f.233ᵛ (cat.56)

142. David and a fool. New York, Pierpont
Morgan Lib., G.53, f.47ᵛ (cat.57)

143. Trinity. New York, Pierpont
Morgan Lib., G.53, f.102 (cat.57)

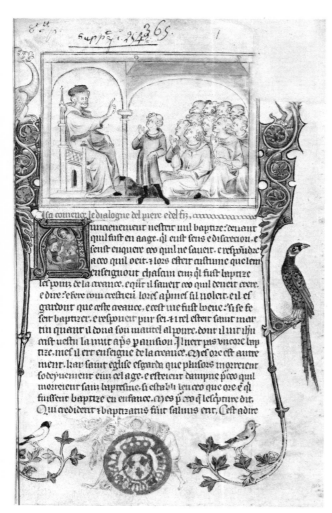

144. Scholar addressing audience. Paris,
Bibl. Nat., fr. 13342, f.1 (cat.58)

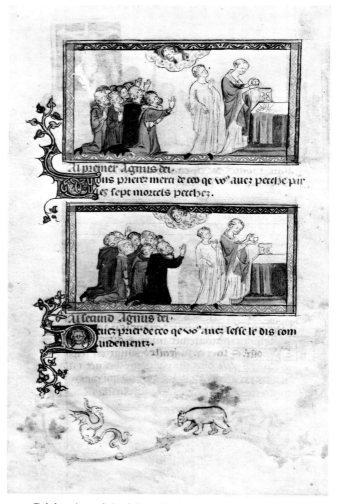

145. Celebration of the Mass. Paris,
Bibl. Nat., fr. 13342, f.47ᵛ (cat.58)

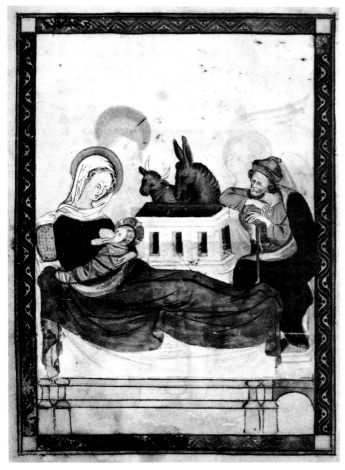

146. Nativity. Oxford, Bodl. Lib.,
Douce 79, f.2ᵛ (cat.59)

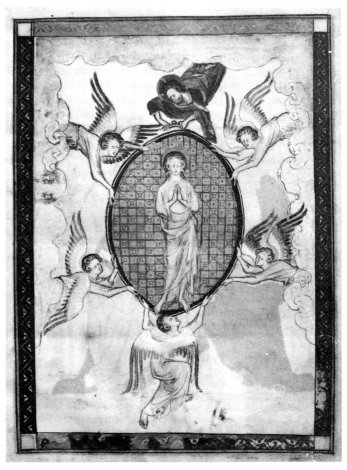

147. Assumption of the Virgin. Oxford, Bodl. Lib.,
Douce 79, f.3 (cat.59)

148. Ten Commandments. Cambridge, St. John's College,
S.30 (256), p.1 (cat.60)

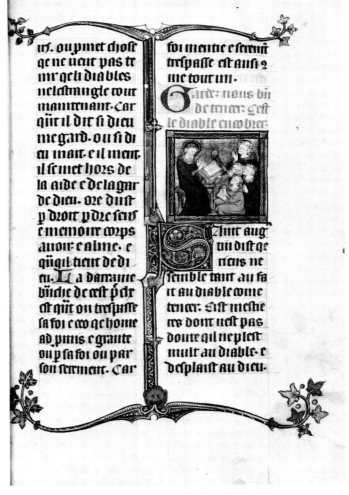

149. St. Augustine lecturing. Cambridge, St. John's
College, S.30 (256), p.117 (cat.60)

150-151. Pentecost; Jonah and the whale.
Oxford, Bodl. Lib., Lat. liturg. d.42,
ff.12, 23 (cat.62a)

152-153. St. Edmund; Bishop preaching.
Oxford, Bodl. Lib., Lat. liturg. d.42,
ff.36, 46 (cat.62a)

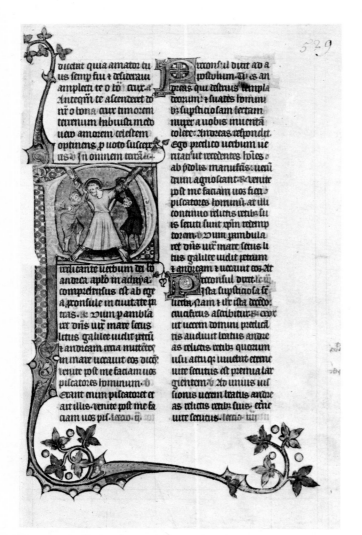

154. St. Andrew. Oxford, Bodl. Lib.,
Lat. liturg. d.42, f.38 (cat.62a)

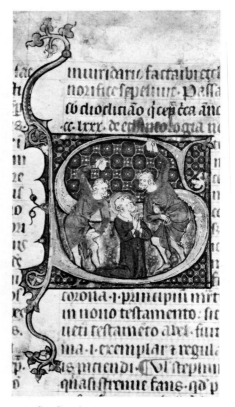

155. St. Stephen.
Oxford, Bodl. Lib.,
Lat. theol. c.30, f.2ᵛ (cat.63)

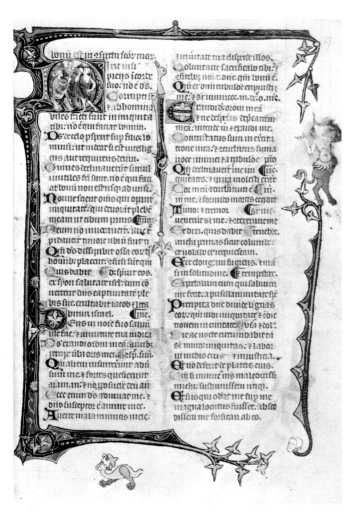
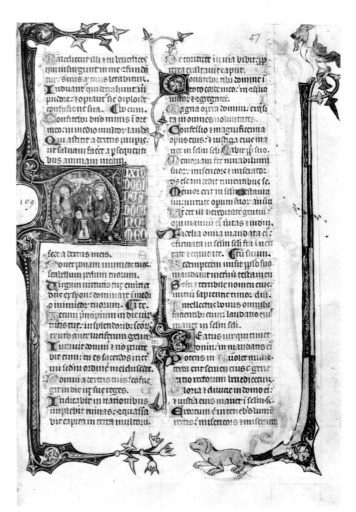

156. David and a fool. Oxford, Bodl. Lib.,
Gough liturg. 8, f.27 (cat.64a)

157. Trinity. Oxford, Bodl. Lib.,
Gough liturg. 8, f.47 (cat.64a)

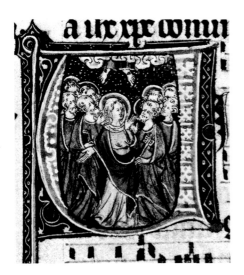
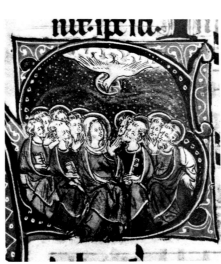

158-159. Ascension; Pentecost.
Aberystwyth, National Lib.,
15536 E, ff.164, 169ᵛ (cat.65)

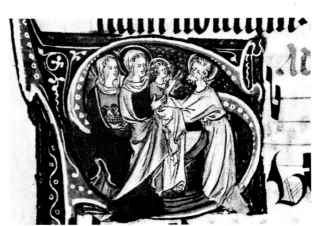

160. Presentation in the Temple.
Aberystwyth, National Lib.,
15536 E, f.246 (cat.65)

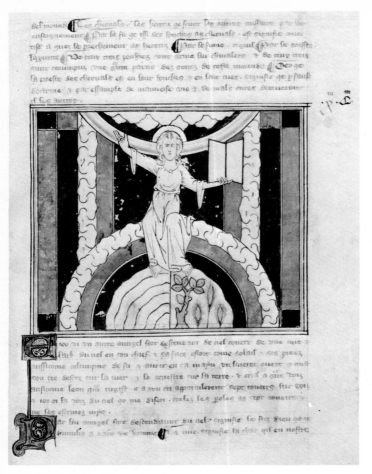

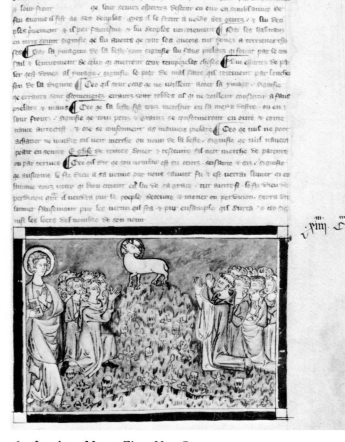

161. Angel and the Book. London, B.L.,
Royal 19.B.XV, f.17 (cat.61)

162. Lamb on Mount Zion. New Song.
London, B.L., Royal 19.B.XV, f.25 (cat.61)

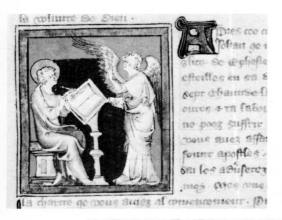

163. Angel ordering Letters to Seven Churches.
London, B.L., Royal 19.B.XV, f.3 (cat.61)

164 (below). John takes the Book. London, B.L.,
Royal 19.B.XV, f.17ᵛ (cat.61)

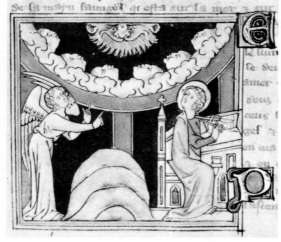

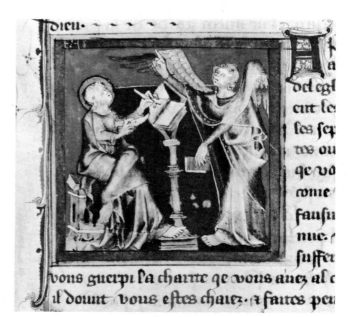

165. Angel ordering letters to Seven Churches.
Oxford, Lincoln College, 16, f.141 (cat.72)

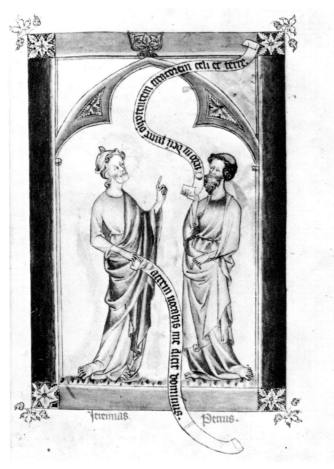

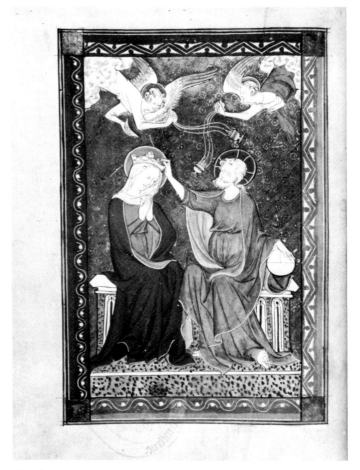

166. Prophet Jeremiah and St. Peter. Cambridge,
Corpus Christi College, 53, f.7 (cat.66)

167. Coronation of the Virgin. Cambridge,
Corpus Christi College, 53, f.11ᵛ (cat.66)

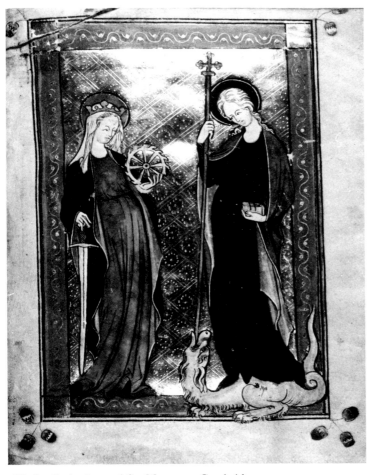

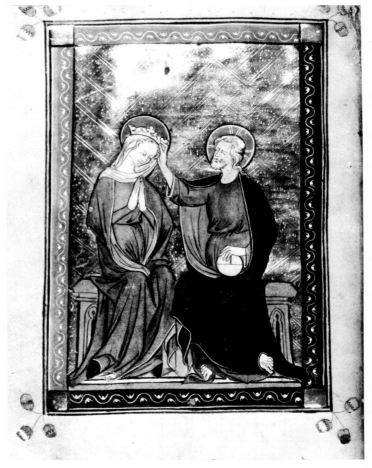

168. St. Catherine and St. Margaret. Cambridge,
University Lib., Dd.4.17, f.2 (cat.67)

169. Coronation of the Virgin. Cambridge,
University Lib., Dd.4.17, f.9ᵛ (cat.67)

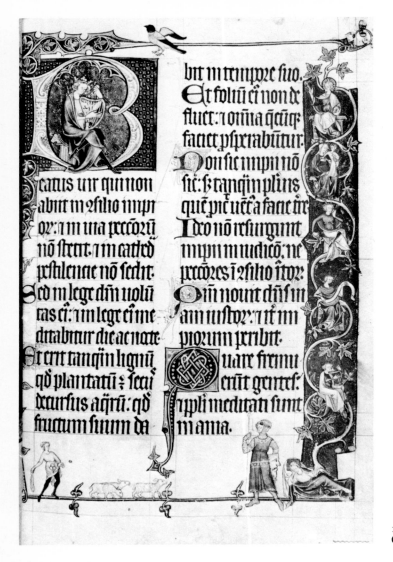

170. David playing the harp and Tree of Jesse.
Cambridge, Corpus Christi College, 53, f.19 (cat.66)

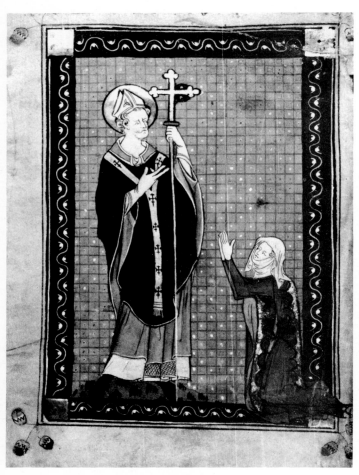

171. Praying woman before an archbishop-saint.
Cambridge, University Lib., Dd.4.17, f.1ᵛ (cat.67)

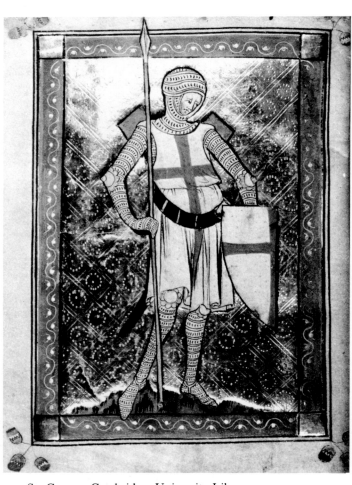

172. St. George. Cambridge, University Lib.,
Dd.4.17, f.3ᵛ (cat.67)

173. Henry II and Thomas, Archbishop of Canterbury.
London, B.L., Cotton Claudius D.II, f.73 (cat.68 MS 'C')

174. Giles de Rome presenting book to Philip the Fair.
Baltimore, Walters Art Gallery, W.144, f.2 (cat.71)

175. Seated scholar. Oxford, Oriel College,
46, f.187 (cat.68 MS 'O')

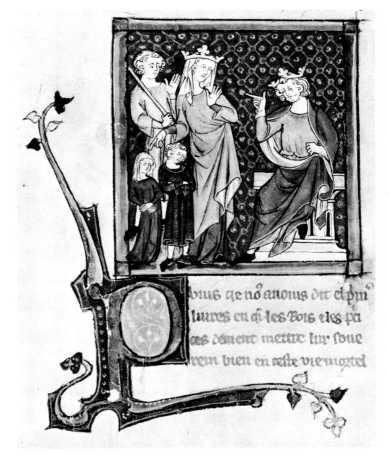

176. Queen with two children before king. Baltimore,
Walters Art Gallery, W.144, f.41ᵛ (cat.71)

177. Penwork initials. Bangor Cathedral,
Pontifical, f.69ᵛ (cat. 69)

178. Decorated initial. Bangor Cathedral,
Pontifical, f.100ᵛ (cat. 69)

179. Penwork flourishing. Paris, Bibl. Nat.,
lat. 17155, f.160ᵛ (cat. 70)

180. Michael Scotus and Stephen of Provins.
Paris, Bibl. Nat., lat. 17155, f.225 (cat. 70)

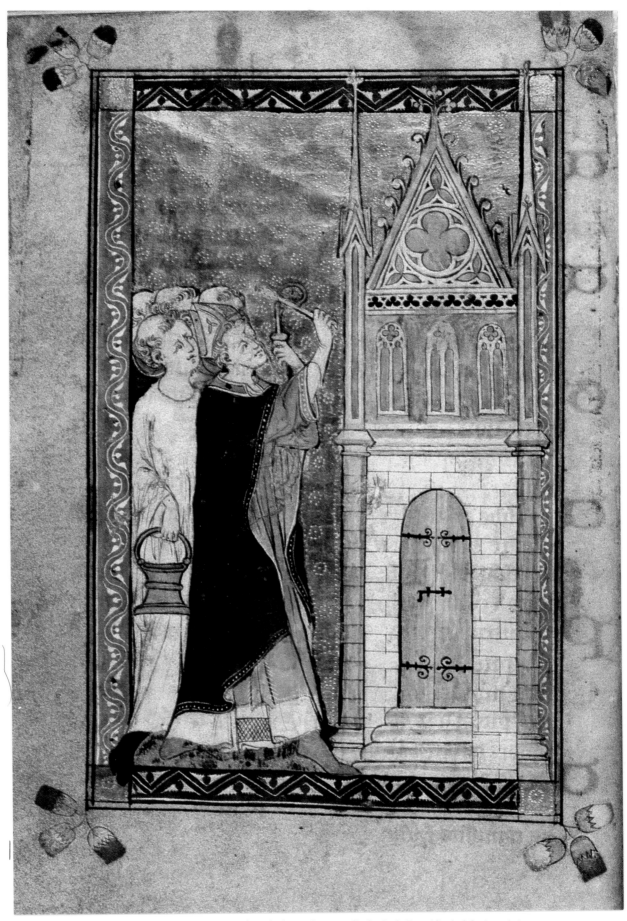

181. Bishop and attendants at church door. Bangor Cathedral, Pontifical, f.8ᵛ (cat.69)

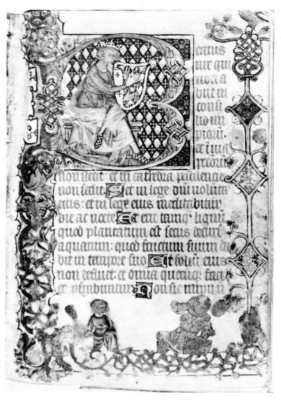

183. David playing the harp,
David slaying Goliath (*below*). London,
Dr. Williams, Anc.6, f.20 (cat.74)

182. Initial and border decoration. London,
Corporation Record Office, Liber Custumarum, f.6 (cat.68 MS 'G')

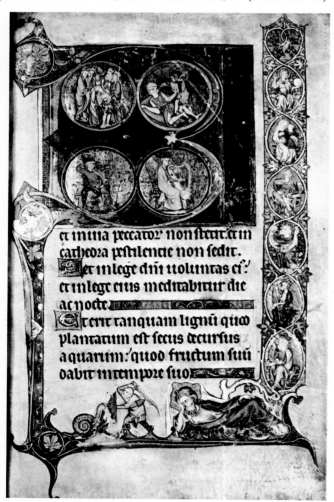

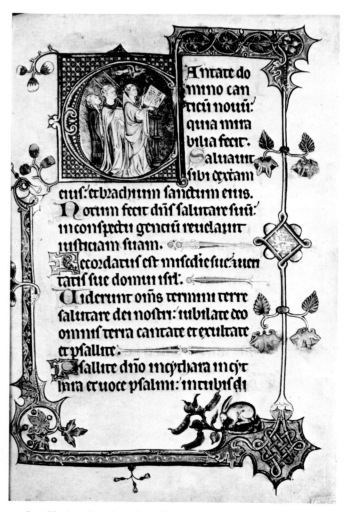

184. Scenes from life of David and Tree of Jesse.
Longleat, Marquess of Bath, 11, f.7 (cat. 73)

185. Clerics chanting. Longleat,
Marquess of Bath, 11, f.126 (cat.73)

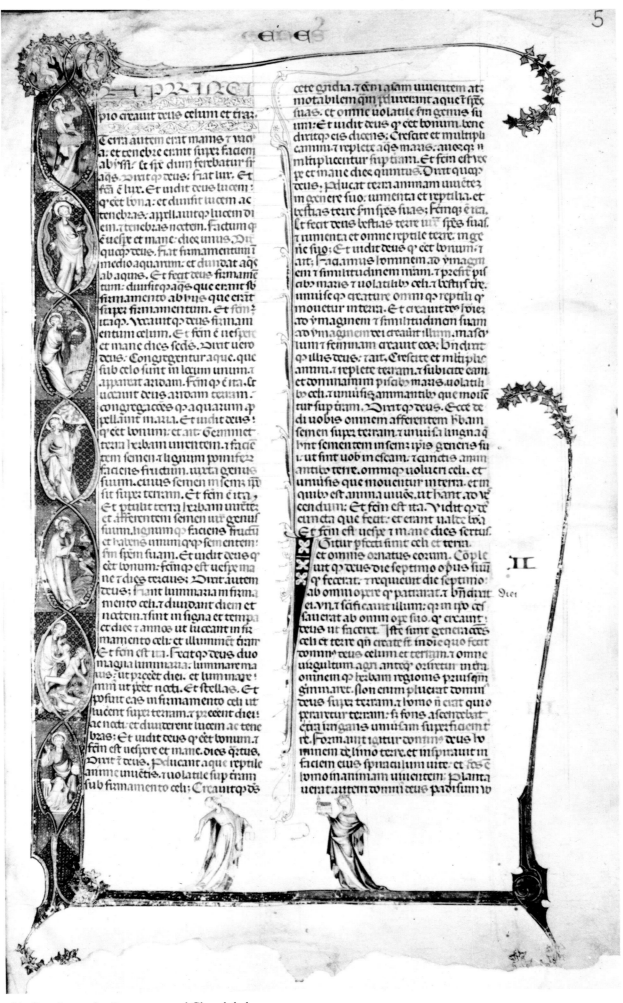

186. Creation cycle. Synagogue and Church below.
Cambridge, University Lib., Dd.1.14, f.5 (cat.75)

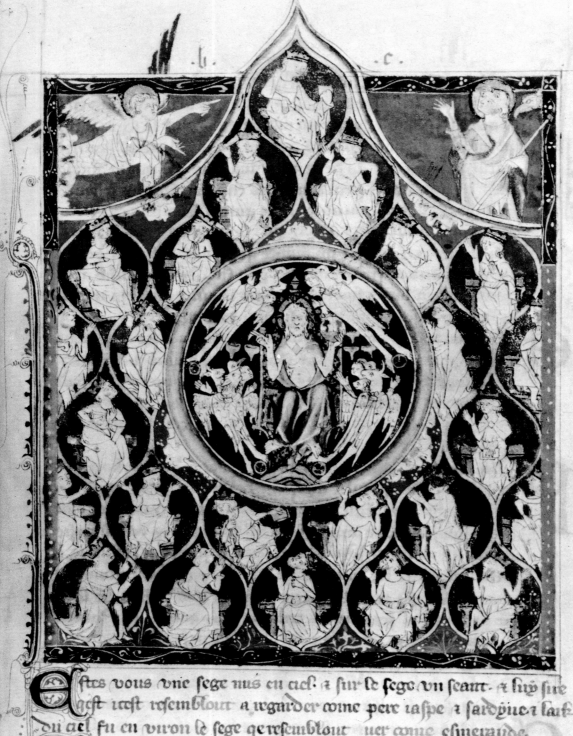

Estres vous vne sege nus en ciel. z sur le sege vn seaunt. z luy sur
qest irest resemblout a wgarder come pere iaspe z sardyne z laik
du ciel fu en viron le sege qeresemblout uer come esmeraude.
Ceo qe seint iohan vit le vs ouert du ciel. signisie qe luy bon
prelat a entendement de seinte escripture zentent qe luy venz
testament le somount abataille en countre vices. z ceo est la prime
re voiz come de busine. Ly mounter signesie hautesce de boue vie
solom la doctrine del euugeile. Ly mounter des choses qe a ven
dronit tost. signesie qe il odire la suauiir de vie pardurable.

187. Vision of Christ and the Twenty-four Elders. Oxford, Lincoln College, 16, f.144 (cat.72)

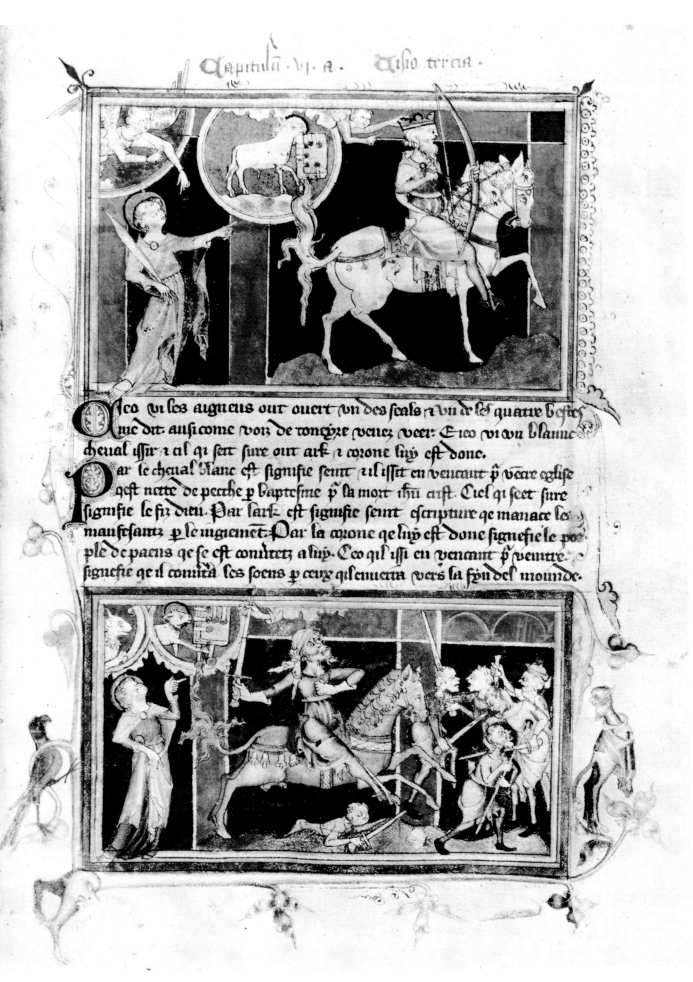

Aco vi les aigneus out ouert un des scals a un de ses quatre bestes
Ame dit ausi come voiz de toneyre venez veer. E ico vi un blanc
cheual issir a al qi sett sure out ark a corone luy est done.
Par le cheual blanc est signifie seint aul issit en venent p̃ veer eglise
q̃ est nette de pecche p̃ baptesme p̃ sa mort ihũ crist. Ciel qi seet sure
signifie le fiz dieu. Par lark est signifie seint escripture qe manace les
maufesauntz p̃ le iugement. Par la corone qe luy est done signefie le po-
ple de paeus qe se est couitetz a luy. Eco qil issit en venent p̃ veintre
signefie qe il couitra ses soens p̃ ceux qi senuertu vers sa fin des mounde.

188. First and Second Seals. Oxford, Lincoln College, 16, f.148 (cat.72)

189. Zodiacal Man. Oxford, Bodl. Lib.,
Canonici Misc. 248, f.42 (cat.76)

190. Scenes from life of St. Denis.
Oxford, Bodl. Lib.,
Canonici Misc. 248, f.45ᵛ (cat.76)

191. Christ bearing the Cross. New York,
Pierpont Morgan Lib., G.50, f.63ᵛ (cat.77)

192. Female questioner and male respondent.
New York, Pierpont Morgan Lib., G.50, f.64 (cat.77)

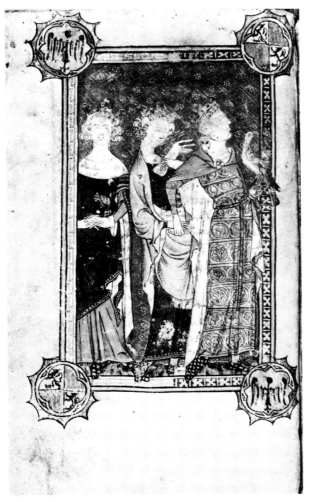

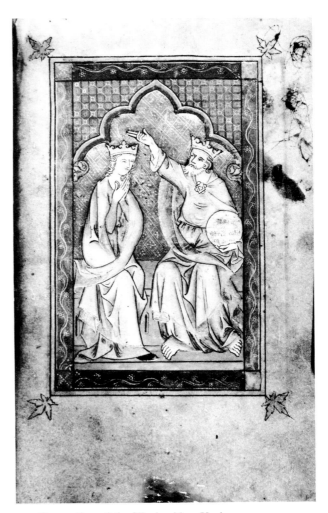

193. The Three Living (kings). New York,
Pierpont Morgan Lib., G.50, f.6ᵛ (cat.77)

194. Coronation of the Virgin. New York,
Pierpont Morgan Lib., G.50, f.163 (cat.77)

195. Border decoration. New York,
Pierpont Morgan Lib., M.107, f.48ᵛ (cat.78)

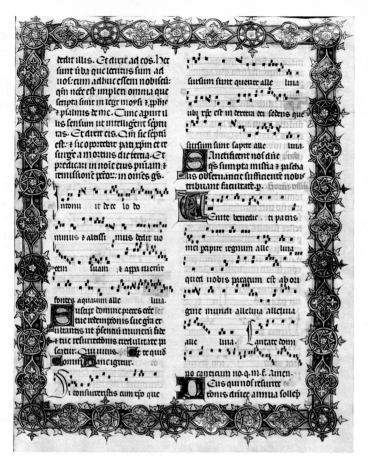

196. Border decoration. New York,
Pierpont Morgan Lib., M.107, f.147 (cat.78)

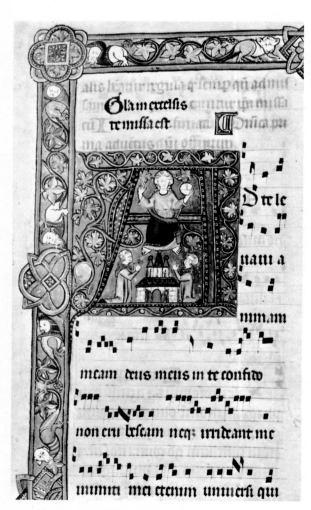

197. Two men praying, the Lord above.
New York, Pierpont Morgan Lib.,
M. 107, f.8 (cat. 78)

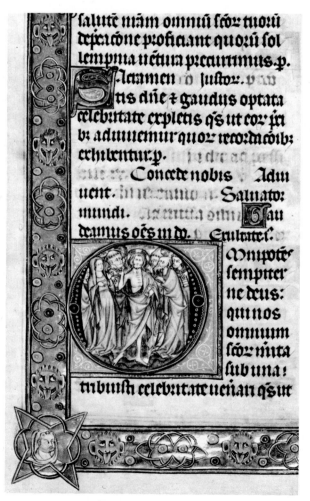

198. Christ with the Virgin, Saints Peter,
Paul and Lawrence. New York, Pierpont
Morgan Lib., M.107, f.267 (cat.78)

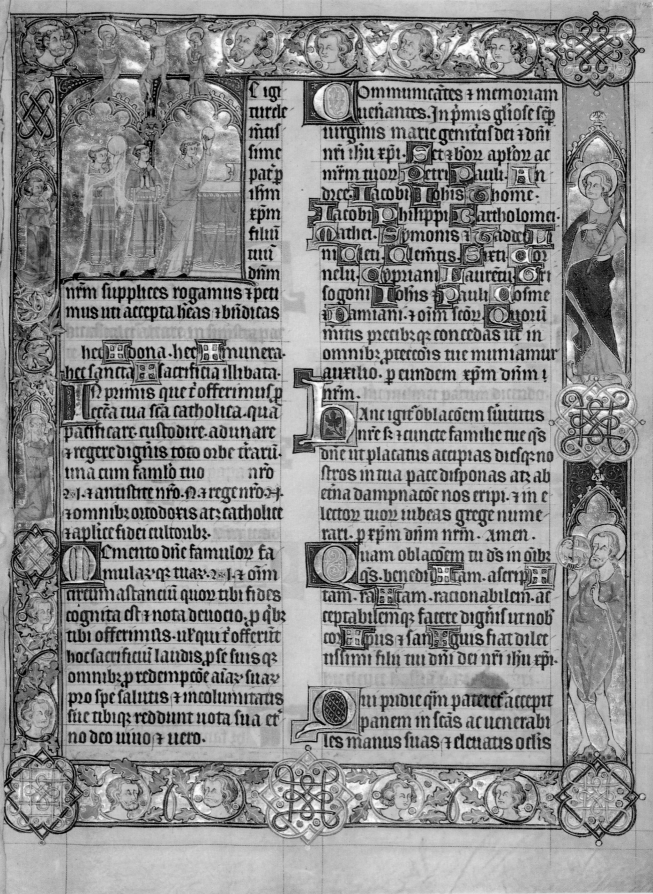

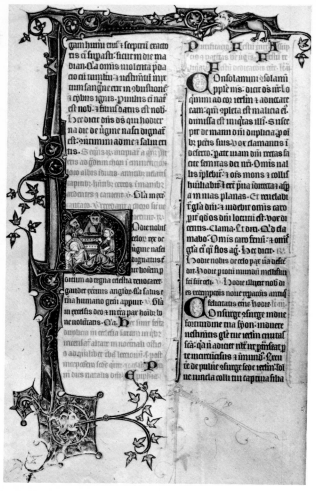

200. Nativity. London, B.L., Stowe 12,
f.16ᵛ (cat.79)

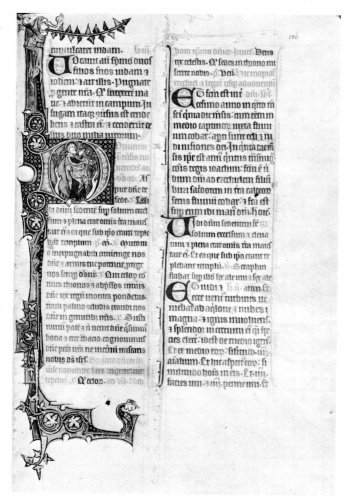

201. Ezechiel. London, B.L., Stowe 12,
f.136 (cat.79)

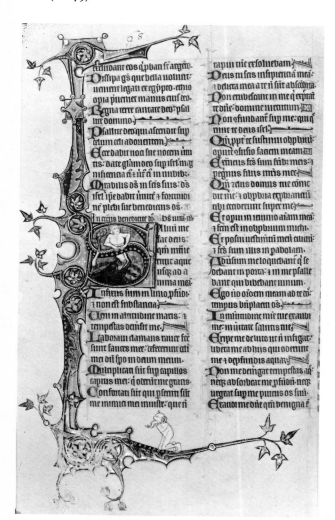

202. Jonah saved from the whale. London,
B.L., Stowe 12, f.184ᵛ (cat.79)

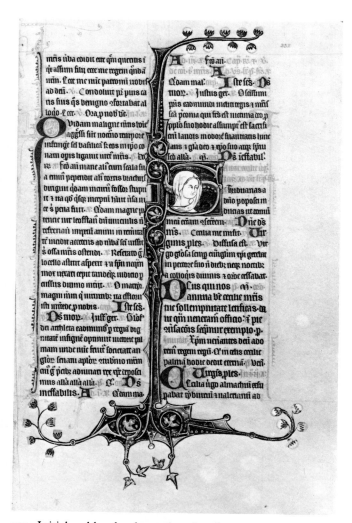

203. Initial and border decoration. London,
B.L., Stowe 12, f.332 (cat.79)

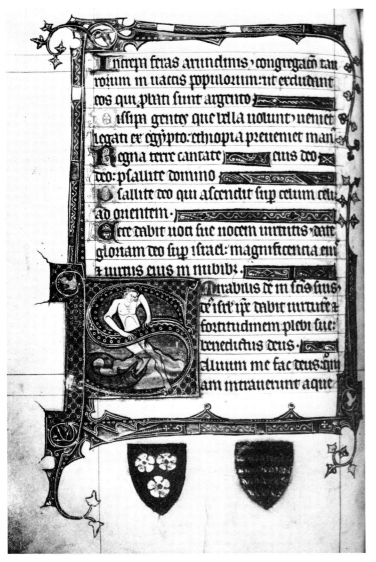

205. David pointing to his eyes.
Escorial Lib., Q II 6, f.36 (cat.80)

204. Jonah saved from the whale. Escorial Lib.,
Q II 6, f.75ᵛ (cat.80)

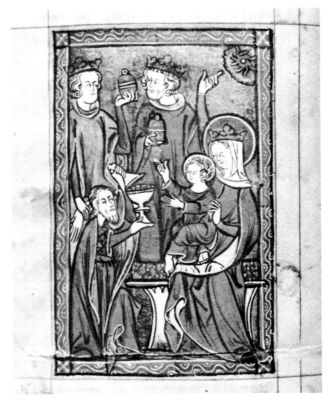

206. Adoration of the Magi. Escorial Lib.,
Q II 6, f.4ᵛ (cat.80)

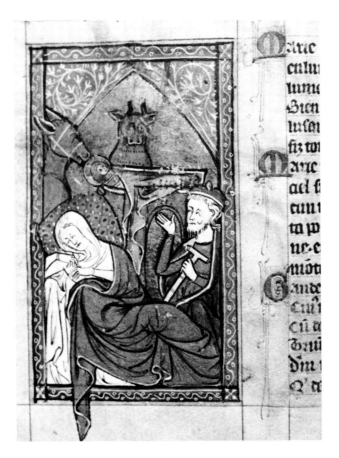

207. Nativity. Escorial Lib., Q II 6, f.4ᵛ (cat.80)

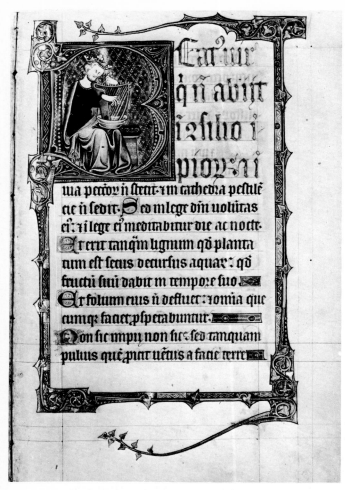

208. David playing the harp. Herdringen,
Fürstenbergische Bibl., 8, f.7 (cat.81)

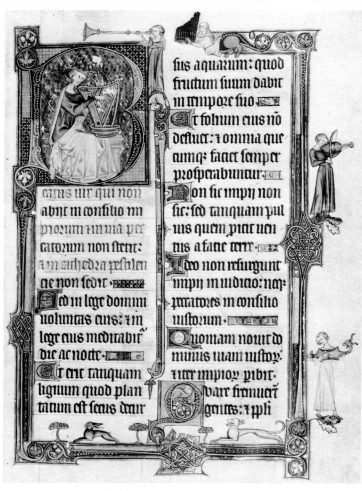

209. David playing the harp. Oxford,
All Souls College, 7, f.7 (cat.82)

210. David pointing to his eyes. Oxford,
All Souls College, 7, f.26 (cat.82)

211. King addressing audience. Dublin,
Trinity College, 35 (A.1.2), f.180ᵛ (cat.83)

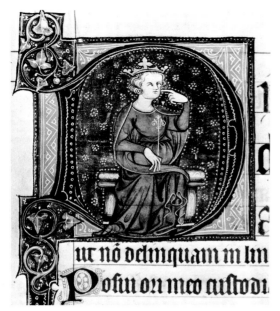

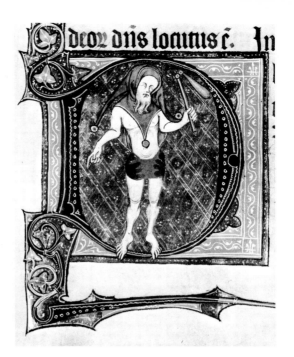

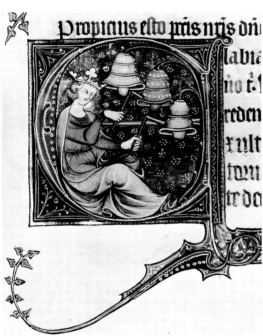

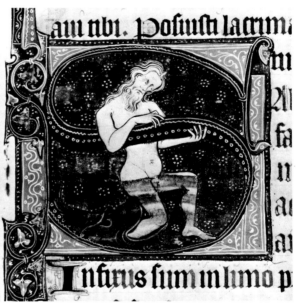

212-213. David pointing to his mouth;
David playing bells. Herdringen,
Fürstenbergische Bibl., 8, ff.50ᵛ, 99 (cat.81)

214-215. Standing fool;
Jonah saved from the whale. Herdringen,
Fürstenbergische Bibl., 8, ff.66, 80ᵛ (cat.81)

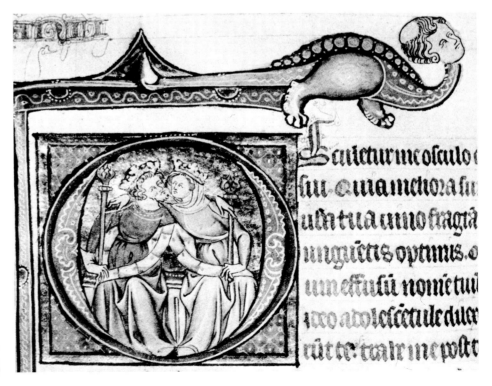

216. King and queen kissing.
Dublin, Trinity College,
35 (A.1.2), f.182ᵛ (cat.83)

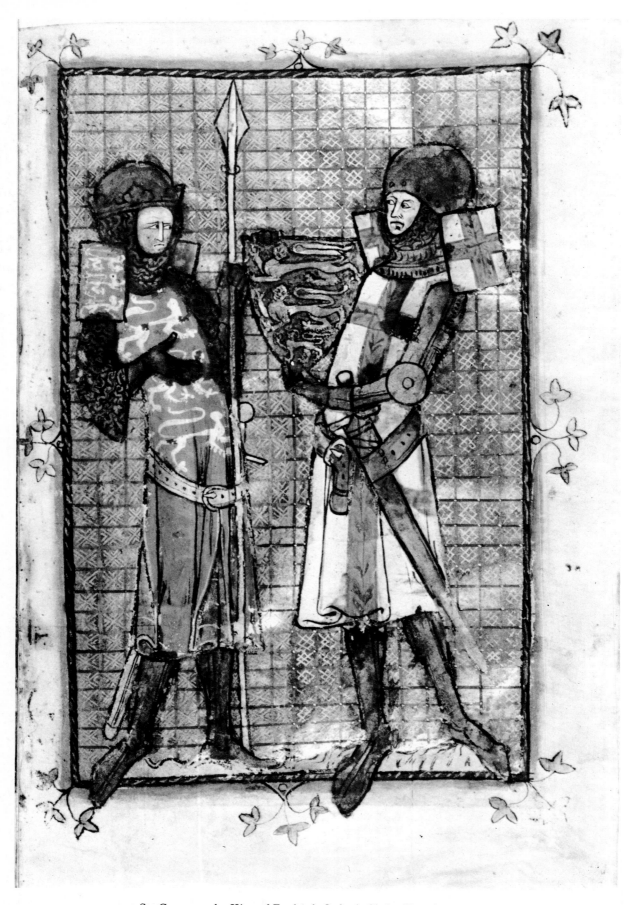

217. St. George and a King of England. Oxford, Christ Church, 92, f.3 (cat.84)

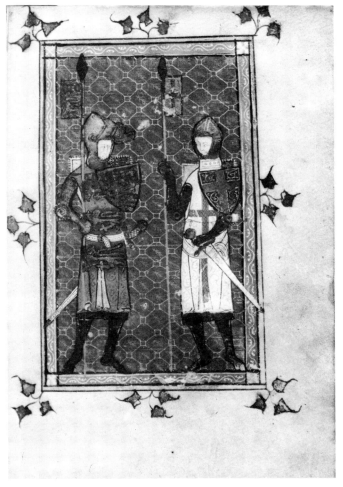

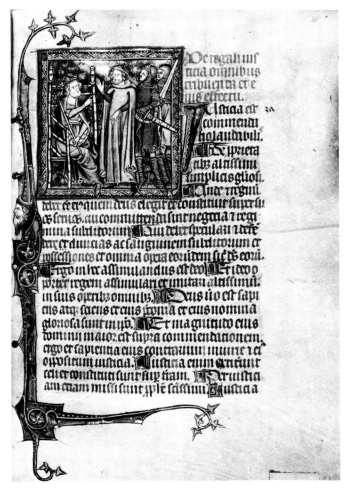

218. St. George and Thomas, Earl of Lancaster.
Oxford, Bodl. Lib., Douce 231, f.1 (cat.87)

219. Aristotle advising Alexander. London,
B.L., Add. 47680, f.28 (cat.85)

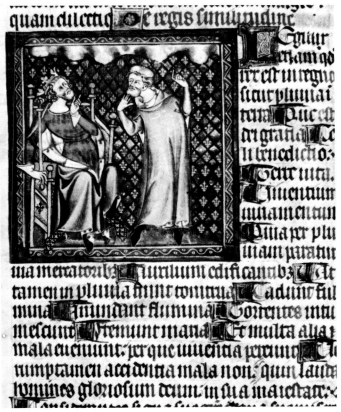

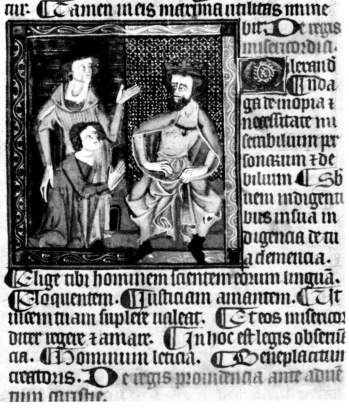

220. Aristotle advising Alexander. London,
B.L., Add. 47680, f.20ᵛ (cat.85)

221. Aristotle advising Alexander. London,
B.L., Add. 47680, f.21ᵛ (cat.85)

222. Border decoration. Oxford, Christ Church, 92, f. 68 (cat.84)

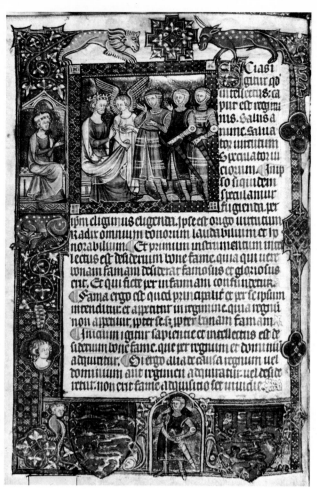

223. Decorated border; Aristotle advising Alexander. London, B.L., Add. 47680, f.14ᵛ (cat.85)

224. Border decoration. Cambridge, Sidney Sussex College, 76, unfoliated (cat.86)

225. Jonah saved from the whale. Cambridge, Sidney Sussex College, 76, unfoliated (cat.86)

226. Resurrection. Oxford, Bodl. Lib.,
Douce 231, f.58 (cat.87)

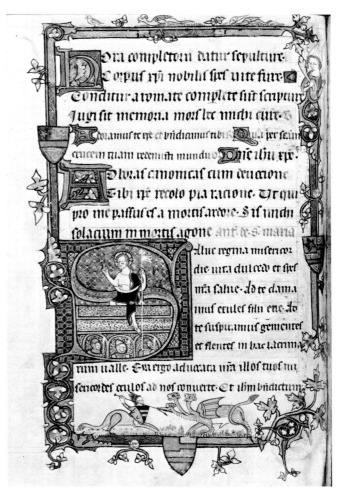

227. Resurrection. New York, Pierpont
Morgan Lib., M.700, f.48ᵛ (cat.88)

228. John Duns Scotus receiving book from an angel.
Paris, Bibl. Nat., lat. 3114¹, f.1 (cat.90)

229. Nativity. Paris, Bibl. Nat., lat. 3114¹,
f.149ᵛ (cat.90)

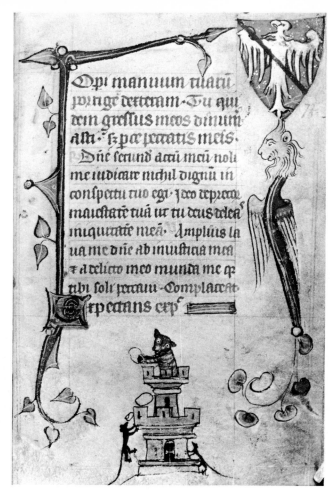

230-231. Border decoration. London, B.L., Harley 6563, ff.74ᵛ-75 (cat.89)

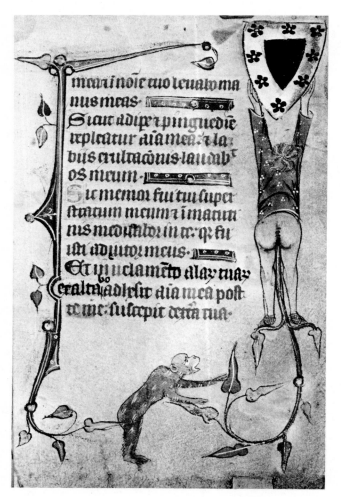

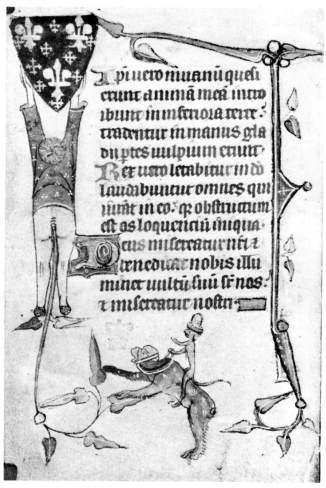

232-233. Border decoration. London, B.L., Harley 6563, ff.6-6ᵛ (cat.89)

234. David playing bells.
Oxford, Bodl. Lib.,
Douce, d.19, f.3 (cat.94)

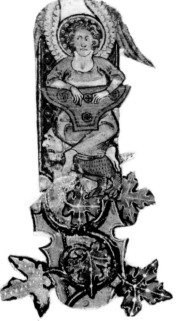

235. Angel playing psaltery.
Oxford, Bodl. Lib.,
Douce, d. 19, f.3 (cat. 94).

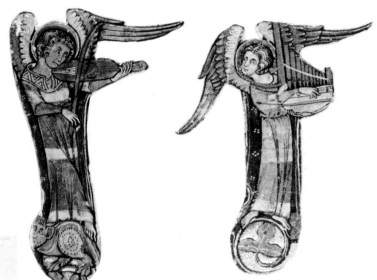

236-237. Angel playing viol;
Angel playing portable organ.
Bodl. Lib., Douce, d.19, f.3 (cat. 94)

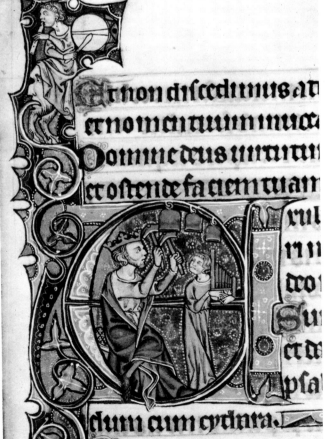

238. David playing bells. Oxford, Bodl. Lib.,
Barlow 22, f.99 (cat.91)

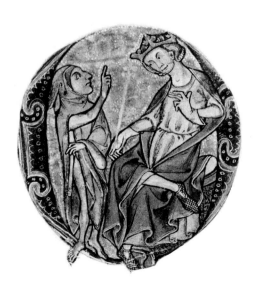

239. David and a fool. Oxford, Bodl. Lib., Douce, b.4, f.4 (cat.94)

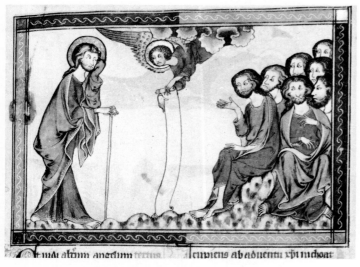

240. Angel and the Everlasting Gospel. Oxford,
Bodl. Lib., Canonici Bibl. 62, f.22 (cat.92)

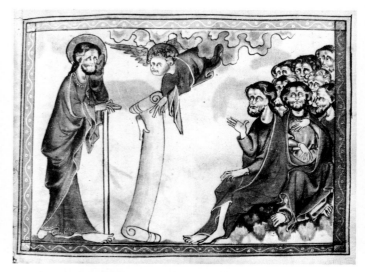

241. Angel and the Everlasting Gospel. Cambridge,
Magdalene College, 5, f.22 (cat.93)

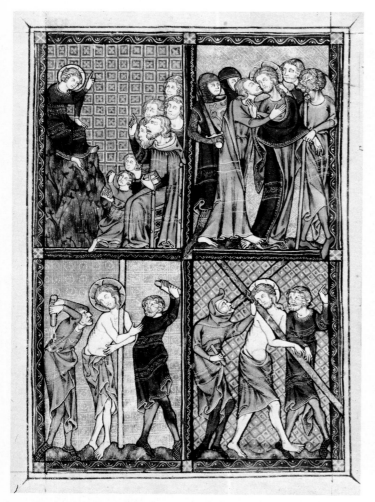

242. Scenes from the life of Christ. Oxford,
Bodl. Lib., Barlow 22, f.13 (cat.91)

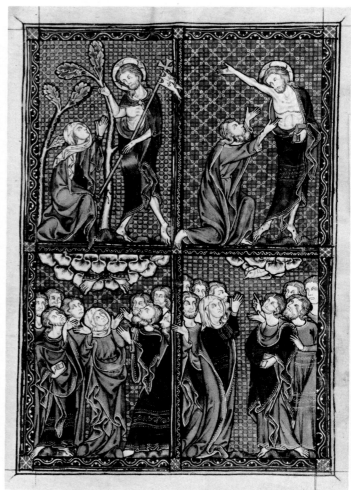

243. Scenes from the life of Christ. Oxford,
Bodl. Lib., Barlow 22, f.14 (cat.91)

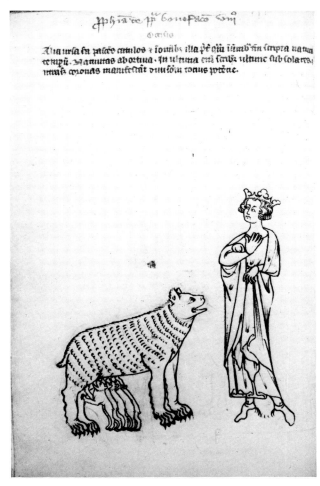

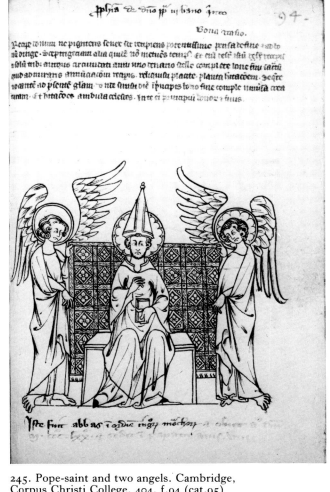

244. King menaced by a bear. Cambridge,
Corpus Christi College, 404, f.90ᵛ (cat.95)

245. Pope-saint and two angels. Cambridge,
Corpus Christi College, 404, f.94 (cat.95)

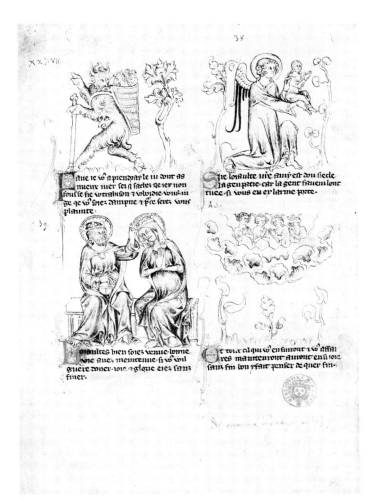

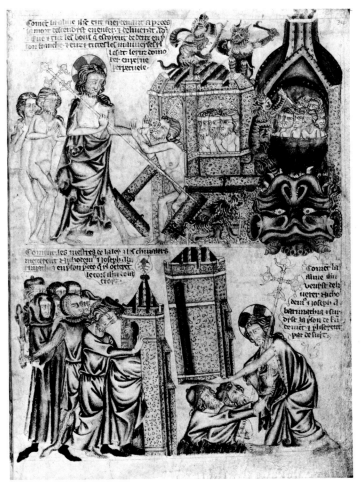

246. Scenes from Fauveyn. Paris, Bibl. Nat.,
fr. 571, f.150ᵛ (cat.96)

247. Descent into Limbo; Christ saving Nicodemus and
Joseph of Arimathaea. London, B.L., Add. 47682, f.34 (cat.97)

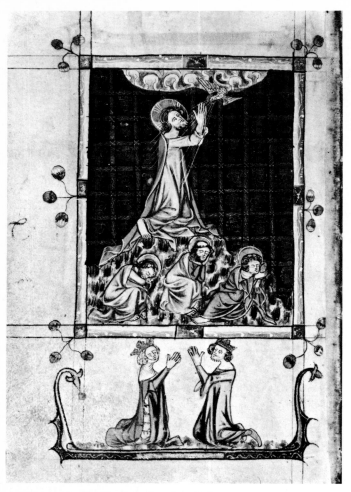

248. Agony in the Garden. London, B.L.,
Yates Thompson 13, f.118ᵛ (cat.98)

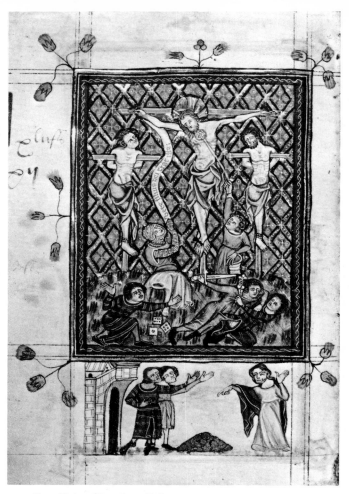

249. Crucifixion. London, B.L.,
Yates Thompson 13, f.121ᵛ (cat.98)

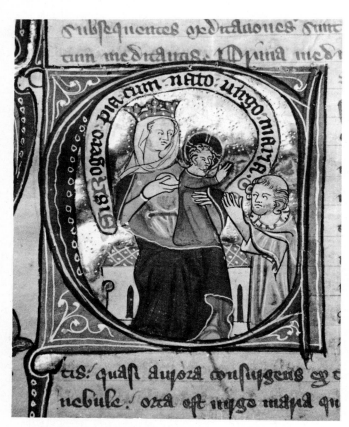

250. Roger adoring the Virgin and Child.
Glasgow, University Lib.,
Hunter 231, p.62 (cat.99)

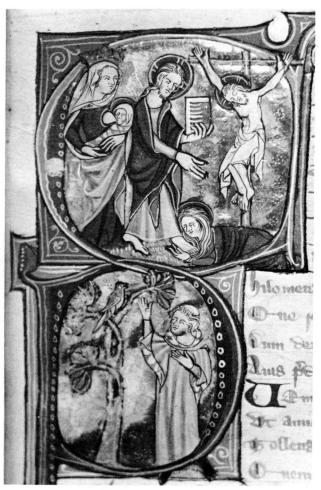

251. Virgin lactans, Mary Magdalene at the feet of
Christ, Crucifixion; author addressing a bird.
Glasgow, University Lib., Hunter 231, p.89 (cat.99)

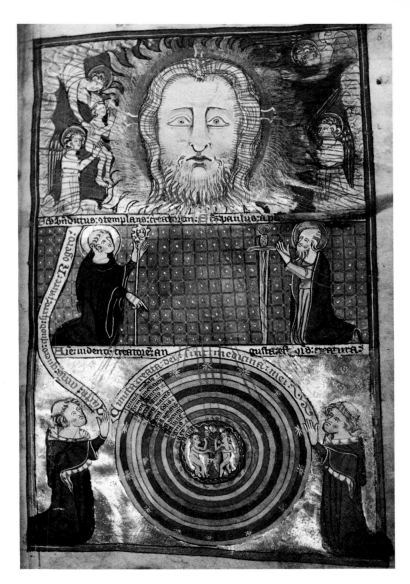

252. Visions of St. Benedict
and St. Paul. Glasgow, University Lib.,
Hunter 231, p.85 (cat.99)

253. Assumption with Roger adoring. Glasgow,
University Lib., Hunter 231, p.36 (cat.99)

254. Crucifixion with Roger adoring. Glasgow,
University Lib., Hunter 231, p.53 (cat.99)

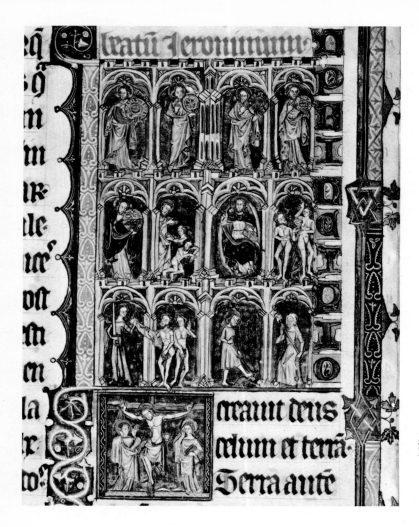

255. Genesis Scenes and Crucifixion.
London, B.L., Royal 1.E.IV, f.12ᵛ (cat.100)

256-257. Border scenes: playing figures, bird, castle. London, B.L., Royal 10.E.IV, ff.94ᵛ, 95 (cat.101)

258. Initials and border decoration. London, B.L., Royal 10.E.IV, f.3 (cat.101)

259. Doeg slaying a priest. Oxford, Exeter College, 46, f.54ᵛ (cat.102)

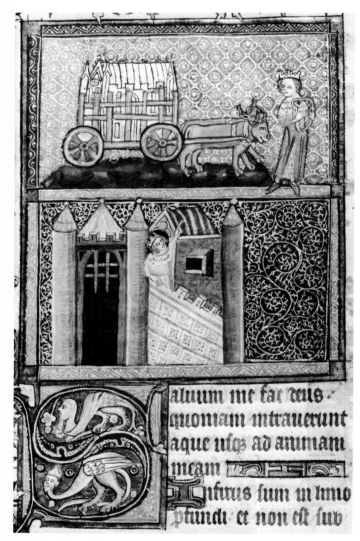

260. David and the Ark, Michal on the Ramparts. Oxford, Exeter College, 46, f.68 (cat.102)

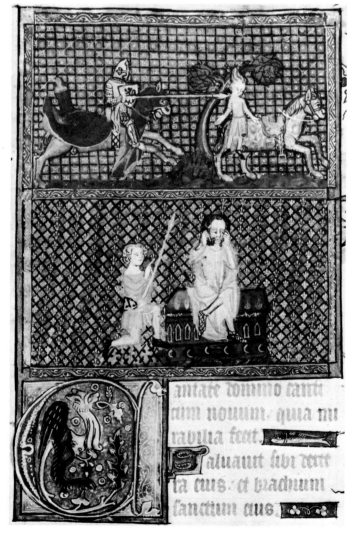

261. Death of Absalom. Oxford, Exeter College, 46, f.99ᵛ (cat.102)

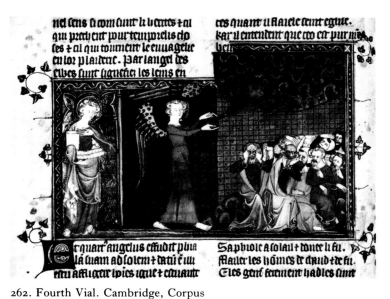

262. Fourth Vial. Cambridge, Corpus
Christi College, 20, f.40ᵛ (cat.103)

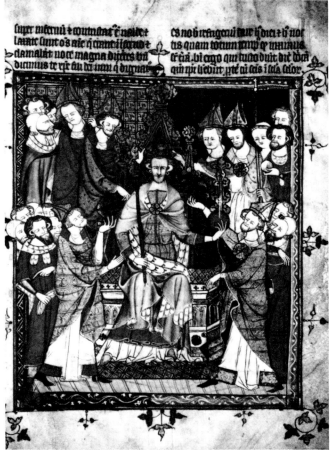

263. Coronation of a king of England. Cambridge,
Corpus Christi College, 20, f.68 (cat.103)

264-265. Border decoration. London, B.L., Yates Thompson 14 (Add.39810), ff.7ᵛ - 8 (cat. 104)

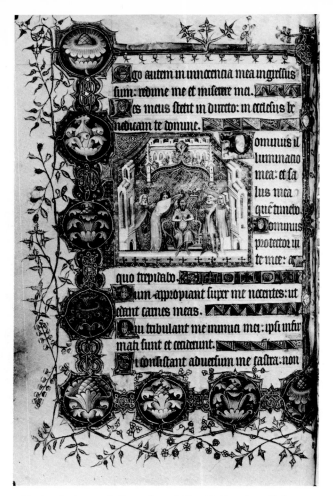

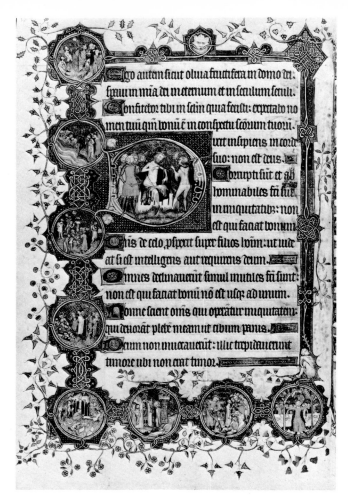

266. Anointing and Crowning of David. London, B.L., Yates Thompson 14 (Add. 39810), f.29ᵛ (cat.104)

267. David and a fool; scenes from the lives of Moses and Samson. London, B.L., Yates Thompson 14 (Add. 39810), f.57ᵛ (cat.104)

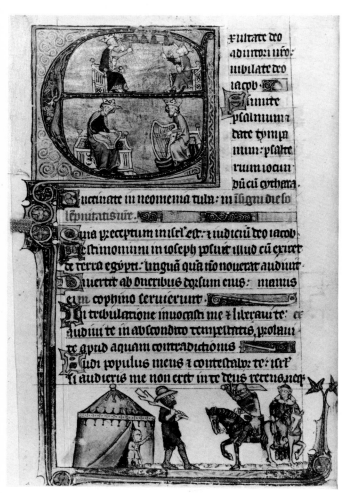

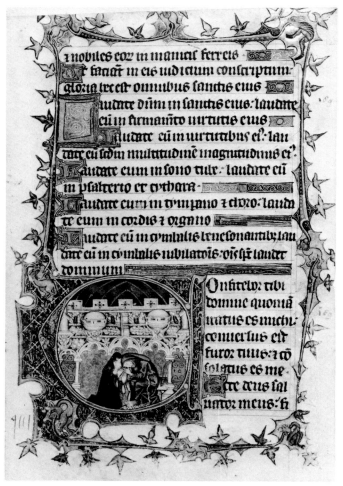

268. King-musicians; dwarf, giant, knight and lady. Oxford, Bodl. Lib., Douce 131, f.68ᵛ (cat.106)

269. Franciscan hearing confession of a nun. Oxford, Bodl. Lib., Douce 131, f.126 (cat.106)

270. Psalm 104, original surface details revealed by show-through from offset on f.132ᵛ. Douai, Bibl. Mun., 171, f.132 (cat.105)

271. Psalm 104, original underdrawing. Douai, Bibl. Mun., 171, f.133 (cat.105)

272. David praying (Psalm 119). Douai, Bibl. Mun., 171, f.163ᵛ (cat.105)

273. Marcolf and Solomon; Samson and the lion. Douai, Bibl. Mun., 171, f.124ᵛ (cat.105)

Domine eduxisti ab inferno animam meam: saluasti me a descendentibus in lacum.

Psallite domino sancti eius: et confitemini memorie sanctitatis eius.

Quoniam ira in indignacione eius: et uita in uoluntate eius.

Ad uesperum demorabitur fletus: et ad matutinum leticia.

Ego autem dixi in habundancia mea: non mouebor in eternum.

Domine in uoluntate tua prestitisti: decori meo uirtutem.

274. Border decoration. London, B.L., Add. 42130, f.55ᵛ (cat.107)

Et tradidit eos in manus gentium: et dominati sunt eorum qui oderunt eos.

Et tribulauerunt eos inimici eorum: et humiliati sunt sub manibus eorum sepe liberauit eos.

Ipsi autem exacerbauerunt eum in consilio suo: et humiliati sunt in iniquitatibus suis.

Et uidit cum tribularentur: et audiuit oracionem eorum.

Et memor fuit testamenti sui et penituit eum secundum multitudinem misericordie sue.

275. Border decoration. London, B.L., Add. 42130, f.193ᵛ (cat.107)

inimici de regionibus congregauit eos.

A solis ortu et occasu: ab aquilone et mari.

Errauerunt in solitudine in inaquoso: uiam ciuitatis habitaculi non inuenerunt.

Esurientes et sicientes: anima eorum in ipsis defecit.

Et clamauerunt ad dominum cum tribularentur: et de necessitatibus eorum eripuit eos.

Et eduxit eos in uiam rectam: ut irent in ciuitatem habitacionis.

276. Border decoration. London, B.L., Add. 42130, f.194ᵛ (cat.107)

Confiteantur domino misericordie eius: et mirabilia eius filiis hominum.

Quia saciauit animam inanem: et animam esurientem saciauit bonis.

Sedentes in tenebris et in umbra mortis: uinctos in mendicitate et ferro.

Quia exacerbauerunt eloquia dei: et consilium altissimi irritauerunt.

Et humiliatum est in laboribus cor eorum: et infirmati sunt nec fuit qui adiuuaret.

277. Border decoration. London, B.L., Add. 42130, f.195 (cat.107)

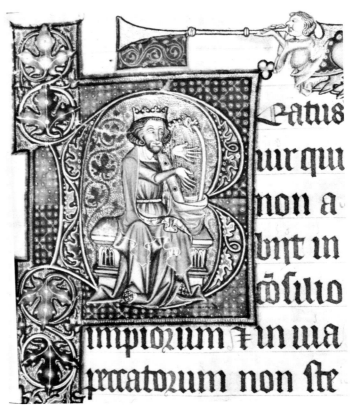

278. David playing a psaltery. London, B.L.,
Add. 42130, f.149 (cat.107)

279. David playing the harp. New Haven,
Yale University, Beinecke Lib., 417, f.7 (cat.108)

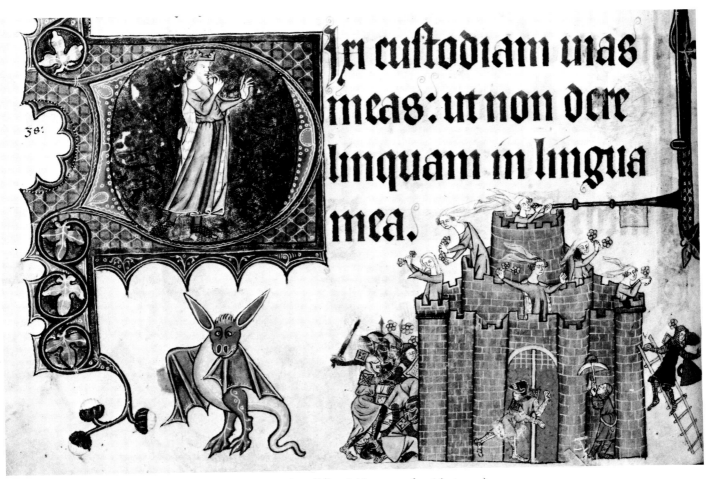

280. David pointing to his mouth. Castle of Love. London, B.L., Add. 42130, f.75ᵛ (cat. 107)

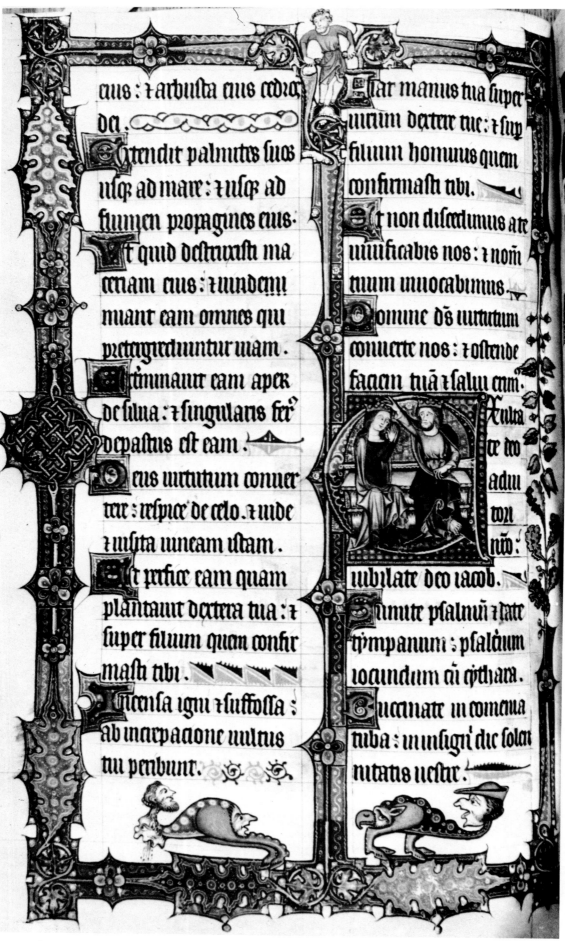

cius : ⁊ arbusta cius cedzos
dei .

Extendit palmitres suos
usq; ad mare : ⁊ usq; ad
flumen propagines cius.
Ut quid destruxisti ma
cceriam cius : ⁊ uindem
miant cam omnes qui
pretergrediuntur uiam .
Extirminauit cam aper
de silua : ⁊ singularis fer⁹
depastus est cam .

Deus uirtutum conuer
tere : respice de celo . ⁊ unde
⁊ uisita uineam istam .

Et perfice cam quam
plantauit dextera tua : ⁊
super filium quem confir
masti tibi .

Incensa igni ⁊ suffossa :
ab increpacione uultus
tui peribunt .

Et fiat manus tua super
uirum dextere tue : ⁊ sup
filium hominis quem
confirmasti tibi .

Et non discedimus ate
uiuificabis nos : ⁊ nom
tuum innocabimus .

Domine deus uirtutum
conuerte nos : ⁊ ostende
faciem tuā ⁊ salui erim .

Exulta
te deo
adiu
tori
nro :

iubilate deo iacob .

Sumite psalmū ⁊ date
tympanum : psalterium
iocundum cū cythara .

Buccinate in neomenia
tuba : in insigni die solen
nitatis uestre .

281. Coronation of the Virgin. New Haven, Yale University, Beinecke Lib., 417, f.64ᵛ (cat.108)

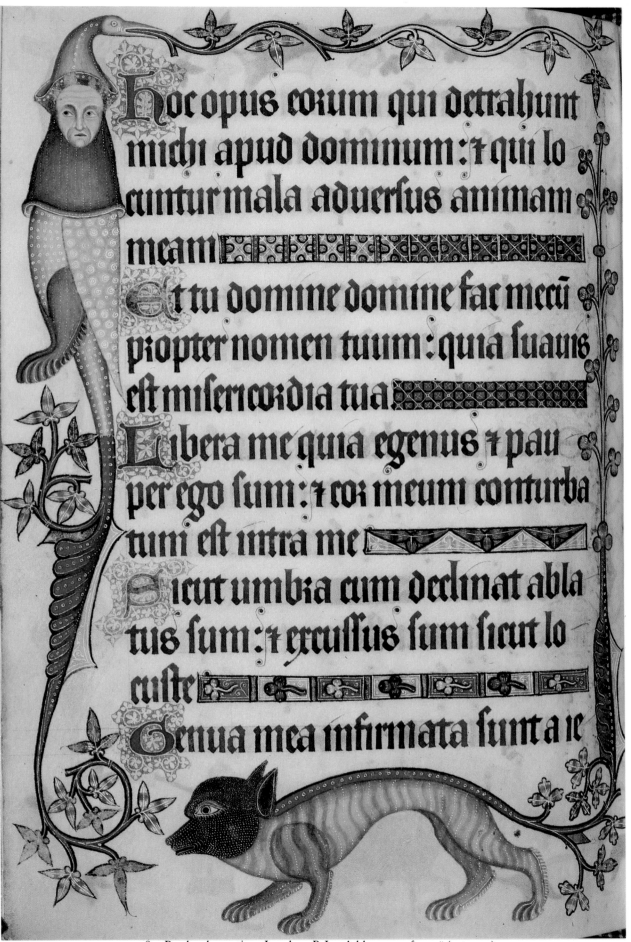

Hoc opus eorum qui detrahunt
michi apud dominum : ꝛ qui lo
cuntur mala aduersus animam
meam

Et tu domine domine fac mecū
propter nomen tuum : quia suauis
est misericordia tua

Libera me quia egenus ꝛ pau
per ego sum : ꝛ cor meum conturba
tum est intra me

Sicut umbra cum declinat abla
tus sum : ꝛ excussus sum sicut lo
custe

Genua mea infirmata sunt a ie

282. Border decoration. London, B.L., Add. 42130, f. 201ᵛ (cat. 107)

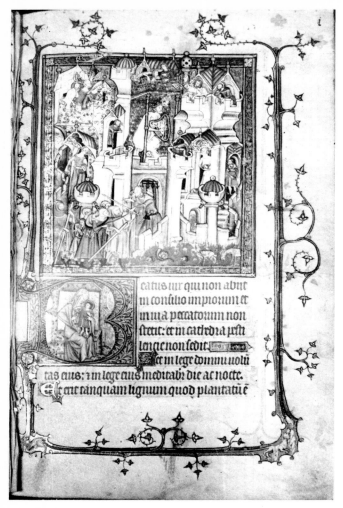

283. David playing the harp in his palace, Virgin and Child. Brescia, Bibl. Queriniana, A.V.17, f.7 (cat.109)

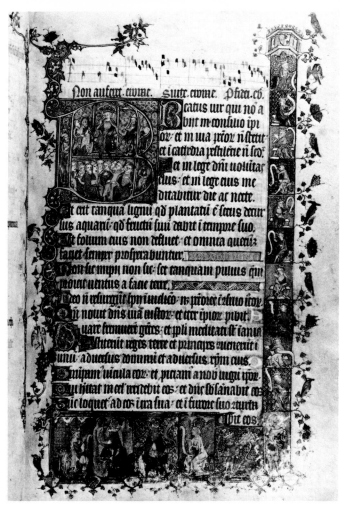

284. David and prophets, kings in the border. London, B.L., Harley 2899, f.8 (cat.110)

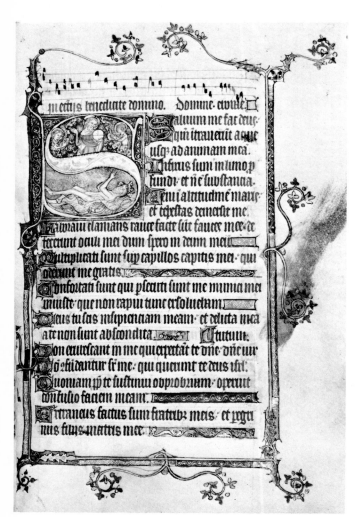

285. David in the water praying, the Lord above. London, B.L., Harley 2899, f.53 (cat.110)

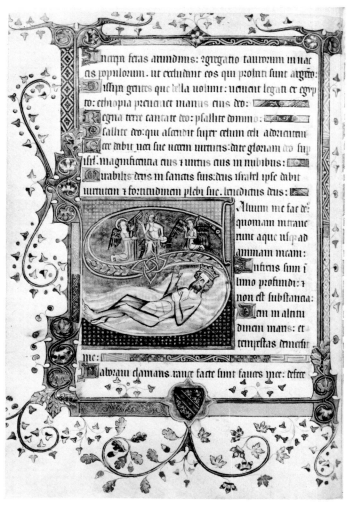

286. David in the water praying. Ginge Manor, Oxon., Viscount Astor, f. 101ᵛ (cat.111)

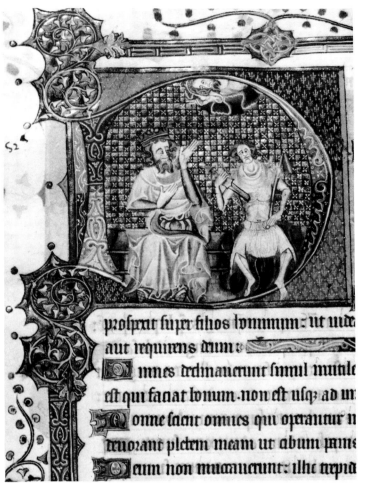

287. David and a fool committing suicide.
Ginge Manor, Oxon., Viscount Astor, f.91ᵛ (cat.111)

288. Clerics chanting. Ginge Manor, Oxon.,
Viscount Astor, f.127ᵛ (cat.111)

289. David playing bells. Ginge Manor, Oxon.,
Viscount Astor, f.115 (cat.111)

290. Trinity. Ginge Manor, Oxon., Viscount Astor,
f.140ᵛ (cat.111)

291. David playing the harp, David and Goliath below. Cambridge, St. John's College, D.30 (103**), f.7 (cat.112)

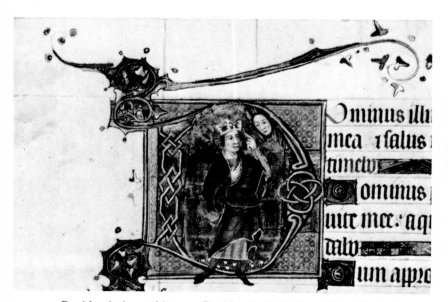

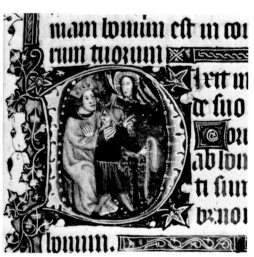

292-293. David pointing to his eyes. David and a fool. Cambridge, St. John's College, D.30 (103**) ff.25ᵛ, 50 (cat.112)

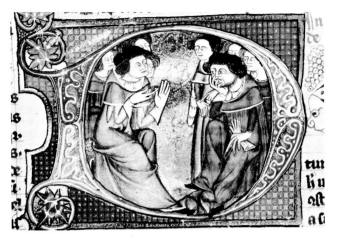

294. Plaintiffs in court. London, B.L.,
Royal 10.E.VII, f.186ᵛ (cat.114)

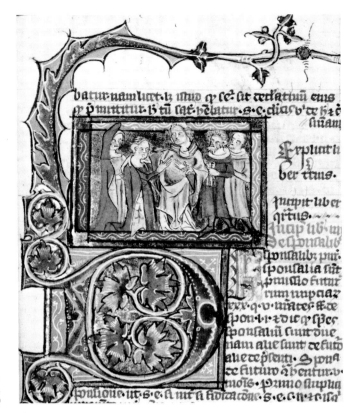

295. Marriage scene.
Cambridge, St. John's College,
A.4 (4) Vol.I, f.101 (cat.113)

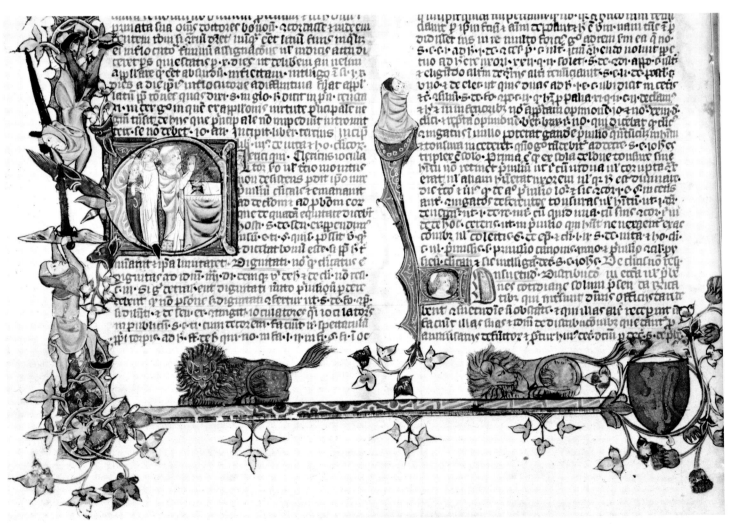

296. Priest at altar. Cambridge, St. John's College, A.4 (4) Vol.IV, f.46ᵛ (cat.113)

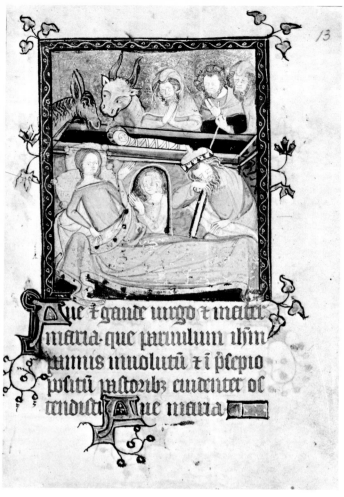

297. Nativity. London, B.L., Egerton 2781,
f.13 (cat.115)

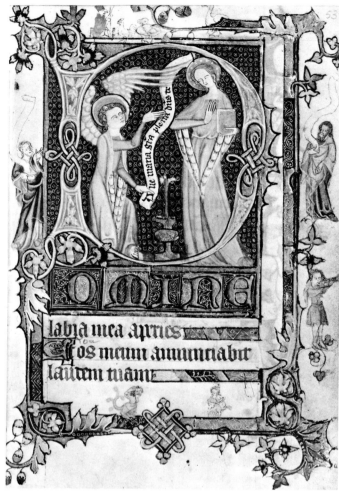

298. Annunciation. London, B.L., Egerton 2781,
f.53 (cat.115)

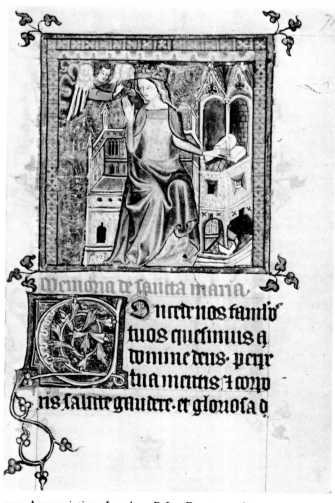

299. Annunciation. London, B.L., Egerton 2781,
f.71 (cat.115)

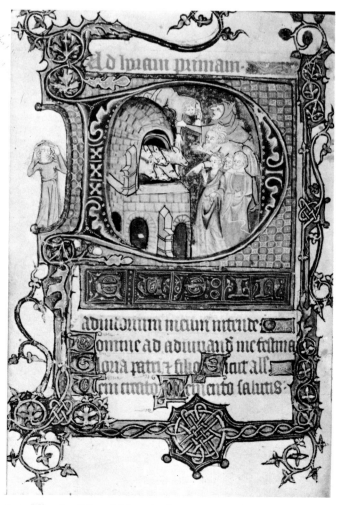

300. Miracle of the children in the oven.
London, B.L., Egerton 2781, f.88ᵛ (cat.115)

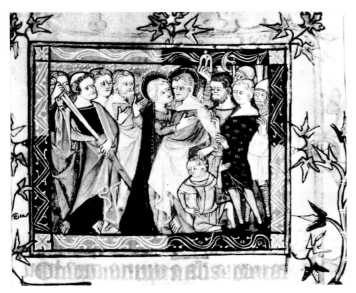

301. Betrayal. London, B.L., Egerton 2781,
f.44 (cat.115)

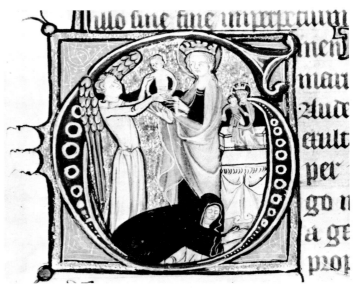

302. Miracle of the abbess delivered. London,
B.L., Egerton 2781, f.22ᵛ (cat.115)

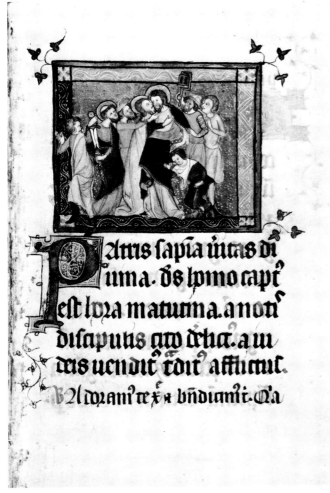

303. Betrayal. Rome, Vatican, Bibl. Apostolica,
Pal. lat. 537, f.32 (cat.116)

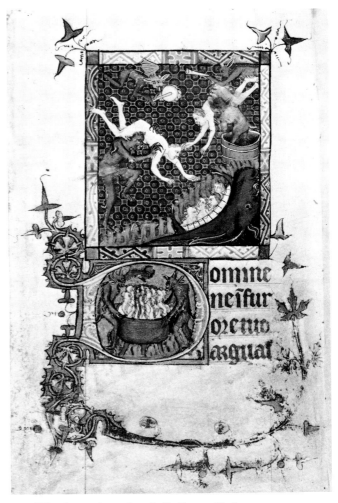

304. The damned cast into hell. Rome, Vatican,
Bibl. Apostolica, Pal. lat. 537, f.139ᵛ (cat.116)

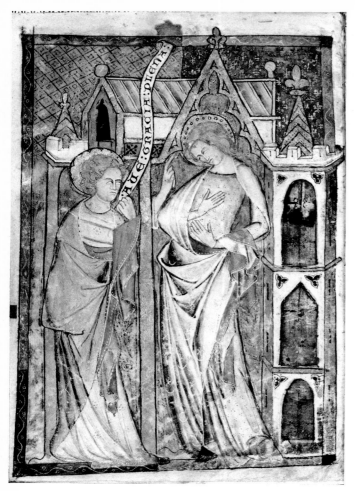

305. Annunciation. Baltimore, Walters Art Gallery, 105, f.7ᵛ (cat.117)

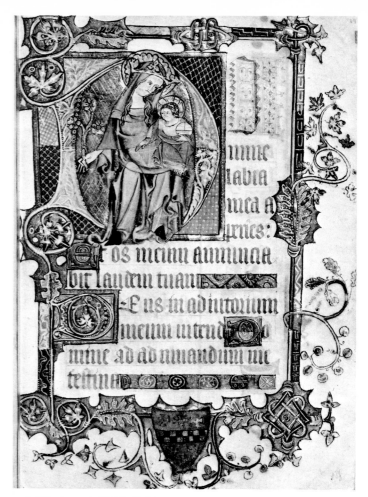

306. Virgin and Child. Baltimore, Walters Art Gallery, 105, f.17 (cat.117)

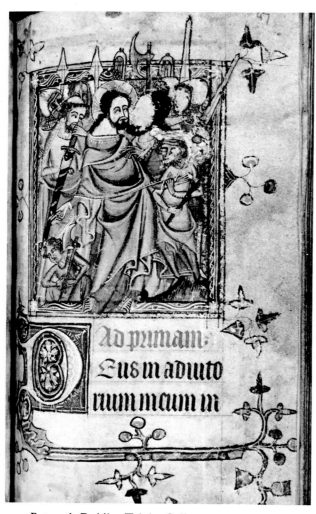

307. Betrayal. Dublin, Trinity College, 94 (F.5.21), f.47 (cat.118)

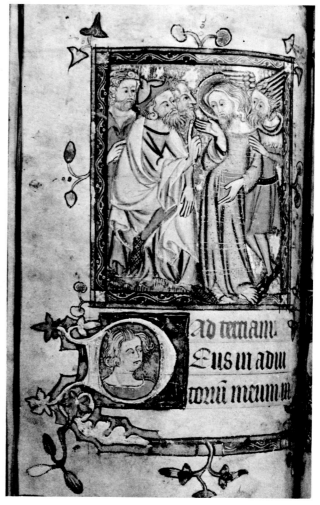

308. Christ before Pilate. Dublin, Trinity College, 94 (F.5.21), f.55ᵛ (cat.118)

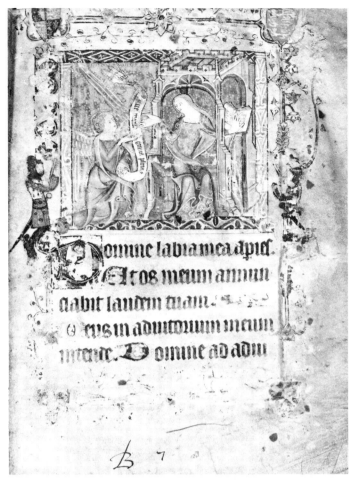

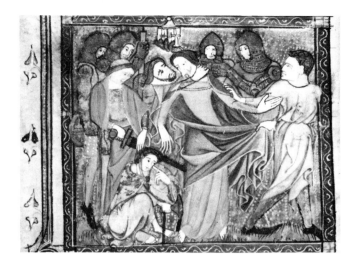

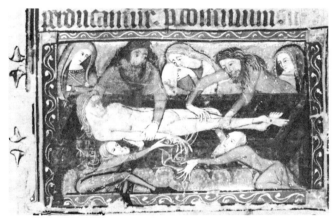

309. Annunciation. Oxford, Bodl. Lib.,
Lat. liturg. e.41, f.7 (cat.119)

310-311. Betrayal; Entombment. Oxford, Bodl. Lib.,
Lat. liturg. e.41, ff.35ᵛ, 57 (cat.119)

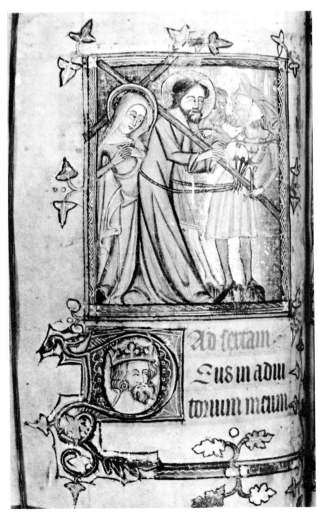

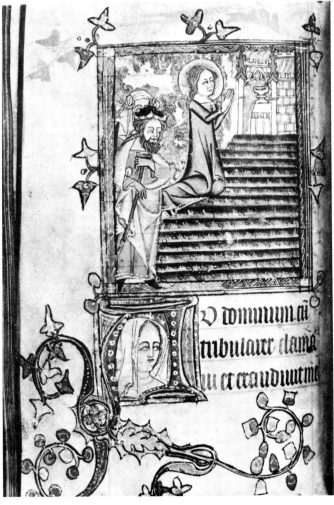

312. Christ bearing the Cross. Dublin,
Trinity College, 94 (F.5.21), f.61ᵛ (cat.118)

313. Presentation of the Virgin. Dublin,
Trinity College, 94 (F.5.21), f.109ᵛ (cat.118)

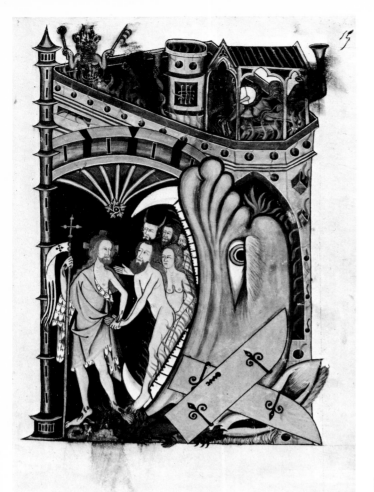

314. Descent into Limbo.
Paris, Bibl. Nat.,
lat. 765, f.15 (cat.120)

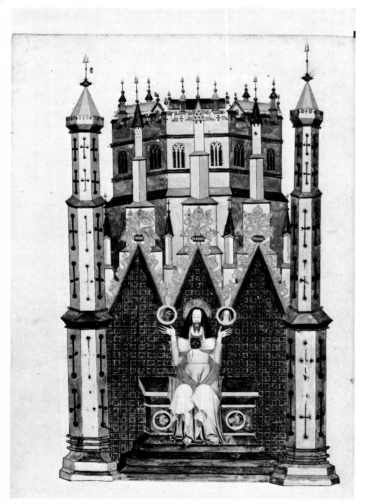

315. Christ in Majesty. Paris, Bibl. Nat.,
lat. 765, f.21ᵛ (cat.120)

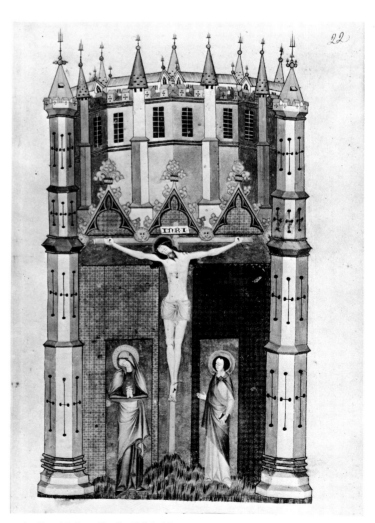

316. Crucifixion. Paris, Bibl. Nat.,
lat. 765, f.22 (cat.120)

317. David playing the harp. Paris,
Bibl. Nat., lat. 765, f.23 (cat.120)

318. Clerics chanting. Oxford, Bodl. Lib.,
Liturg. 198, f.91ᵛ (cat.121)

319. David and Goliath. Oxford, Bodl. Lib.,
Liturg. 198, f.46 (cat.121)

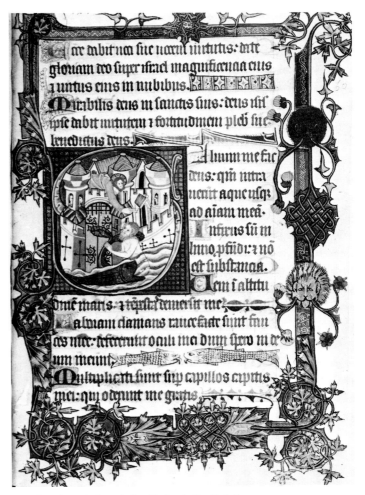

320. Jonah and the whale. Oxford, Bodl. Lib.,
Liturg. 198, f.60 (cat.121)

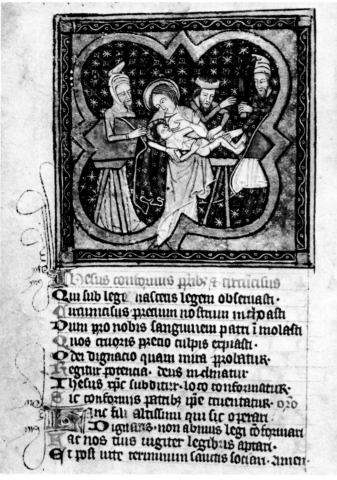

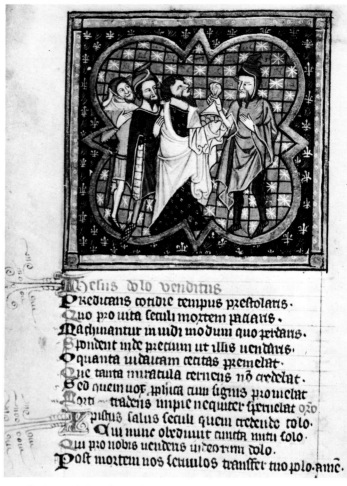

321. Circumcision. Cambridge, Fitzwilliam Museum,
259, f.3ᵛ (cat.122)

322. Judas and the silver. Cambridge,
Fitzwilliam Museum, 259, f.10ᵛ (cat.122)

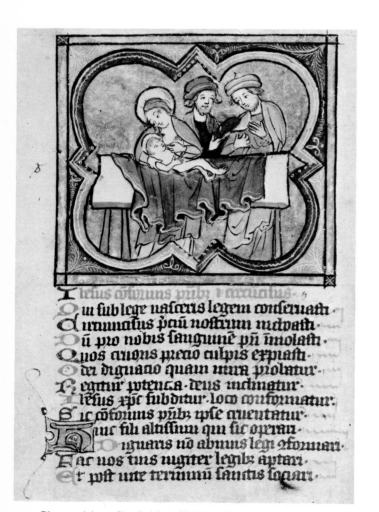

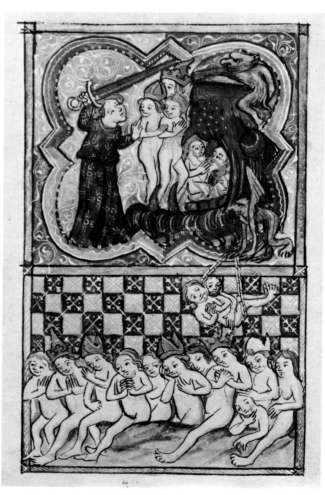

323. Circumcision. Cambridge, Trinity College,
B.10.15, f.7ᵛ (cat.123)

324. The damned in Hell. Cambridge,
Trinity College, B.10.15, f.32ᵛ (cat.123)

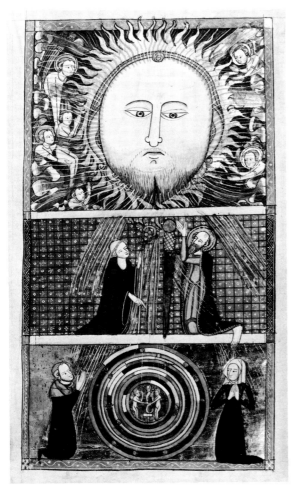

325. Vision of St. Benedict
and St. Paul. London, B.L.,
Royal 6.E.VI, f.16 (cat.124)

326–327. Monks kneeling before their superior;
Dentist with teeth. London B.L., Royal 6.E.VII,
f.490 and Royal 6.E.VI, f.503ᵛ (cat. 124)

328–329. Adolescence; Arsonist.
London, B.L., Royal 6.E.VI, f.58ᵛ and
Royal 6.E.VII, f.257 (cat. 124)

330-332. Christ teaching; Christ teaching; Christ and disciples in Galilee. Oxford, Bodl. Lib., Laud Misc. 165, ff.155, 241, 283ᵛ (cat.125)

333. Clerics destroying a church. Hatfield House,
Marquess of Salisbury, CP 290, f.13 (cat.126)

334. Scholar lecturing. Hatfield House,
Marquess of Salisbury, CP 290, f.145ᵛ (cat.126)

335. Decorated initial. London, B.L.,
Add. 44949, f.74 (cat.127)

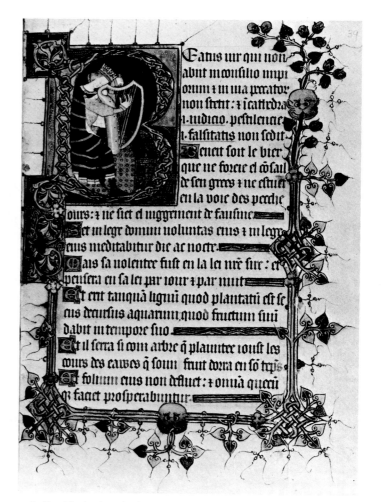

336. David playing the harp. London, B.L.,
Add. 44949, f.39 (cat.127)

337. Crucifixion and Ascension. London, B.L., Add. 44949, f.5ᵛ (cat.127)

338. Clerics chanting. Oxford, Bodl. Lib.,
Rawlinson G.185, f.81ᵛ (cat.128)

339. God-Father holding the Crucified Son. Oxford,
Bodl. Lib., Rawlinson G.185, f.97 (cat.128)

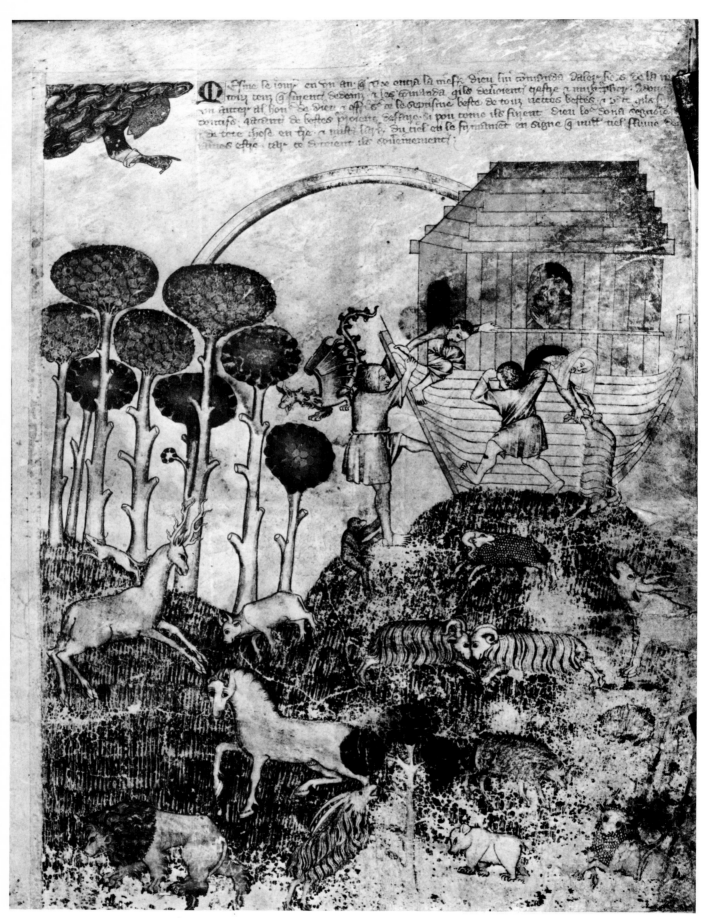

340. Leaving the Ark. London, B.L., Egerton 1894, f.4 (cat.129)

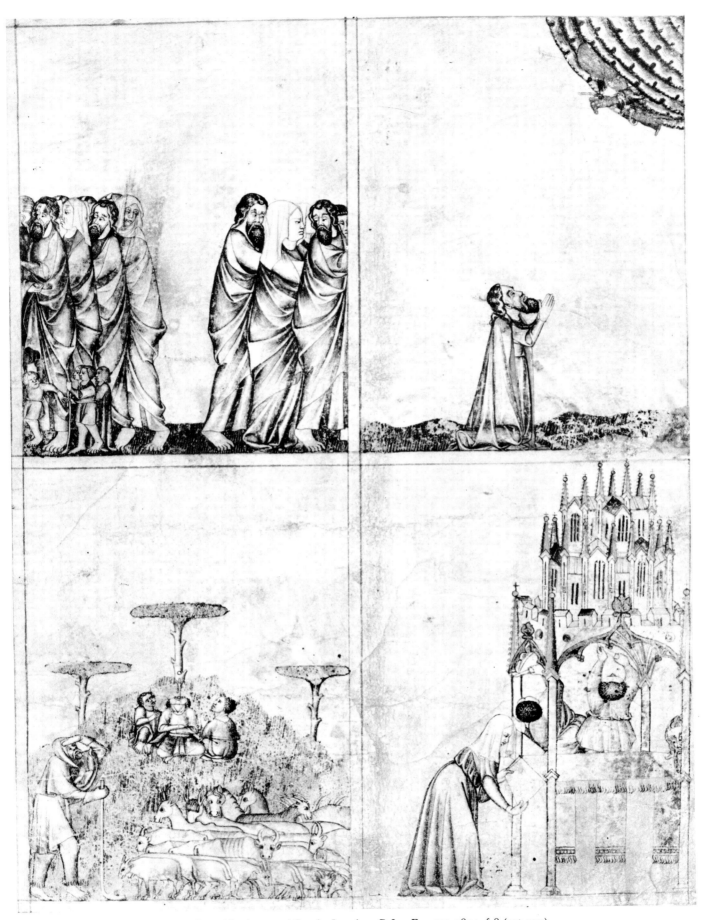

341. Lot, Abraham and Sarah. London, B.L., Egerton 1894, f.8 (cat.129)

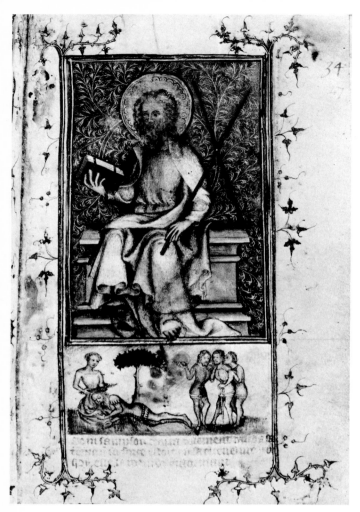

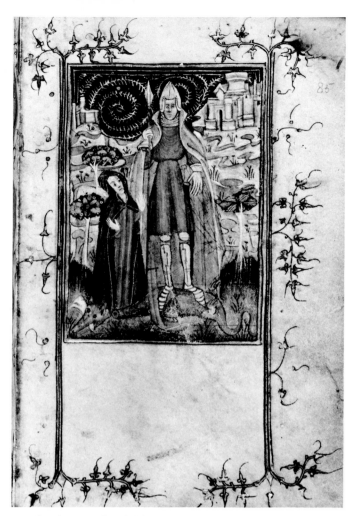

342. St. Andrew; below, Samson and Delilah.
Cambridge, Fitzwilliam Museum, 48, f.47 (cat.130)

343. St. George. Cambridge, Fitzwilliam
Museum, 48, f.85 (cat.130)

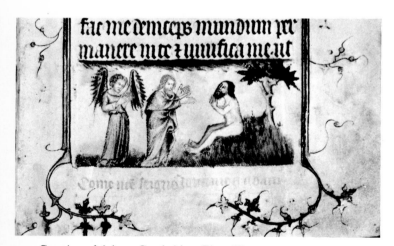

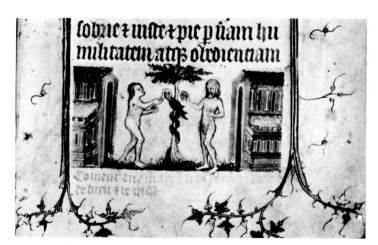

344. Creation of Adam. Cambridge, Fitzwilliam
Museum, 48, f.12 (cat.130)

345. Fall of Man. Cambridge, Fitzwilliam
Museum, 48, f.14 (cat.130)

346. Baruch writing. Bloomington, Indiana University, Lilly Lib., Ricketts 15, f.261 (cat.132)

347. Daniel in the lion's den. Bloomington, Indiana University, Lilly Lib., Ricketts 15, f.339 (cat.132)

348. Micah writing. New York, Pierpont Morgan Lib., M.741, f.1ᵛ (388ᵛ) (cat.132)

349. Habakkuk writing. New York, Pierpont Morgan Lib., M.741, f.2 (395) (cat.132)

350. Nativity. London, B.L., Royal 13.D.1*, f.9 (cat.131)

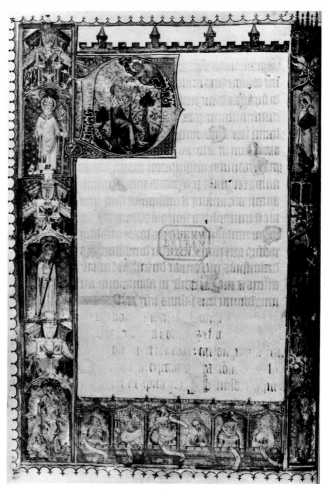

351. David pointing to his mouth; border, saints and prophets. London, B.L., Royal 13.D.1*, f.16ᵛ (cat.131)

352. David praying in the water; the Lord above. London, B.L., Royal 13.D.1*, f.20ᵛ (cat.131)

353. Border decoration. London, B.L., Royal 13.D.1*, f.42, (cat.131)

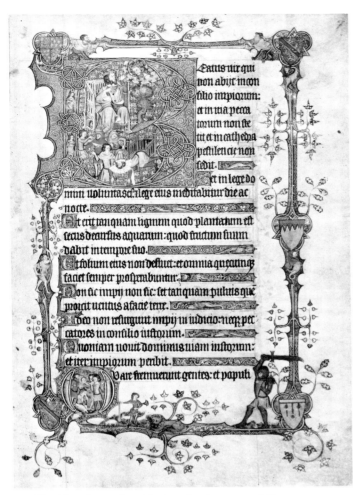

354. David enthroned and below, impious man falling.
Vienna, Österreichische Nationalbibl.,
1826*, f.7 (cat.133)

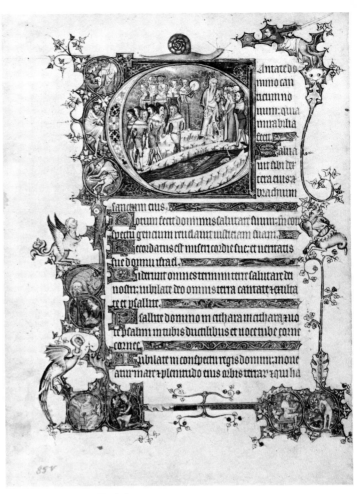

355. Moses at the Red Sea.
Vienna, Österreichische Nationalbibl.,
1826*, f.85ᵛ (cat.133)

356. Initials and border decoration. Oxford,
Exeter College, 47, f.53 (cat.134)

357. Initials and border decoration. Oxford,
Exeter College, 47, f.84ᵛ (cat.134)

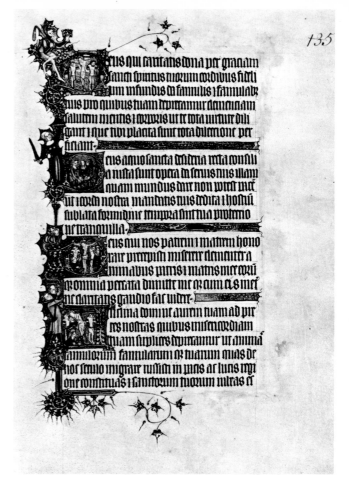

358. Initials and border decoration. Oxford,
Exeter College, 47, f.121ᵛ (cat.134)

359. Initials and border decoration.
London, B.L., Egerton 3277, f.141 (cat.135)

360-361. Woman clothed in arms of England and Bohun;
David at Altar. London, B.L.,
Egerton 3277, ff.131ᵛ, 42 (cat.135)

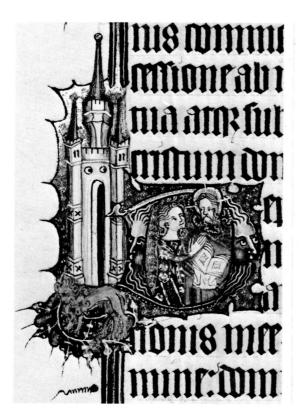

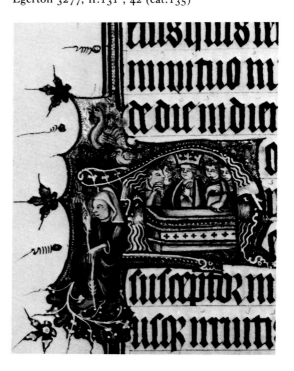

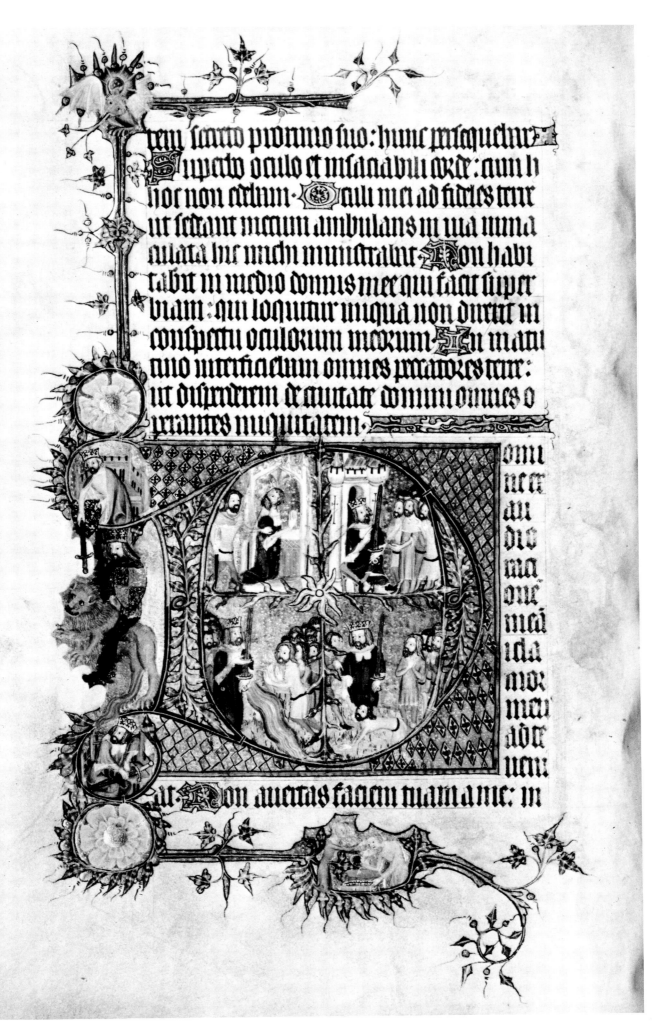

362. Scenes from life of David; in margin, King of England receives sword from King of France.
London, B.L., Egerton 3277, f.68ᵛ (cat.135)

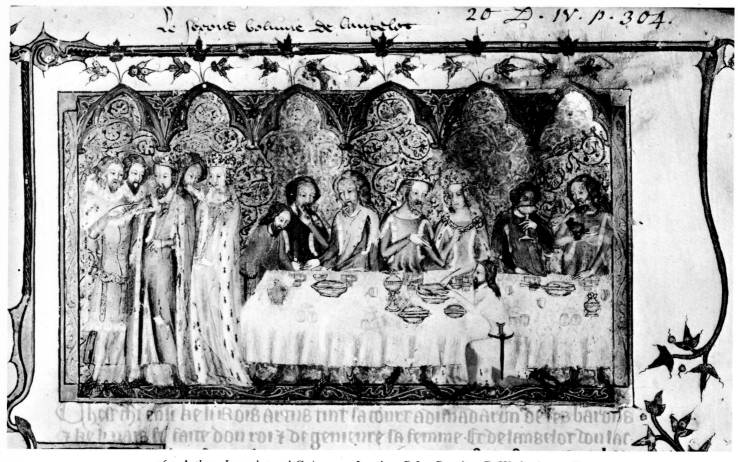

363. Arthur, Lancelot and Guinevere. London, B.L., Royal 20.D.IV, f.1 (cat.136)

364. St. Thomas the Apostle; death of St. Philip.
Pommersfelden, Gräflich Schönbornische Bibl.,
2934, f.3ᵛ (cat.137)

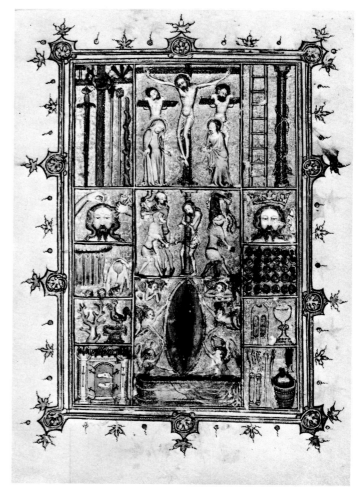

365. Crucifixion and *Arma Christi*. Pommersfelden,
Gräflich Schönbornische Bibl., 2934, f.9ᵛ
(cat.137)

366. Last Judgement. Copenhagen, Kongelige Bibl., Thott 547.4°, f.32ᵛ (cat. 140)

367. Creation. Oxford, Bodl. Lib., Auct. D.4.4,
f.1 (cat.138)

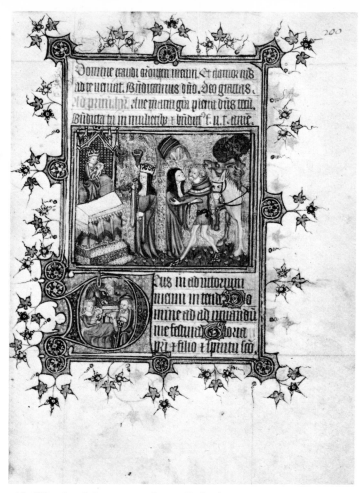

368. Miracle of the nun-sacristan. Oxford,
Bodl. Lib., Auct. D.4.4, f.200 (cat.138)

369. Initial and border decoration. Cambridge,
Fitzwilliam Museum, 38-1950, f.25ᵛ (cat.139)

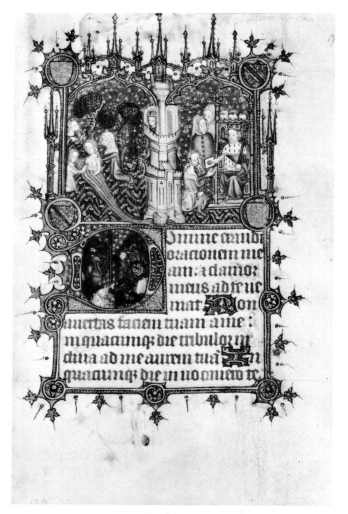

370. Scenes from the life of David. Cambridge,
Fitzwilliam Museum, 38-1950, f.123 (cat.139)

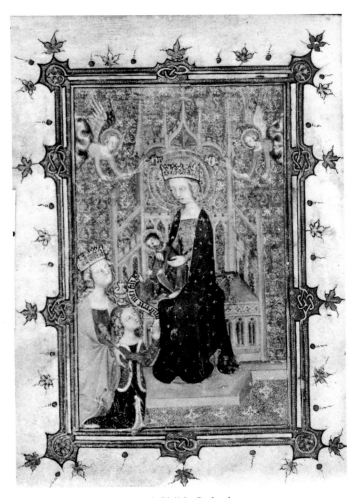

371. Enthroned Virgin and Child. Oxford,
Bodl. Lib., Auct. D.4.4, f.181ᵛ (cat.138)

372. Assumption of the Virgin. Copenhagen,
Kongelige Bibl., Thott. 517.4°, f.1 (cat.141)

373-374. St. Margaret; St. Mary Magdalene. Copenhagen,
Kongelige Bibl., Thott. 517.4°, ff.10ᵛ, 22ᵛ (cat.141)

375. Annunciation. Copenhagen, Kongelige Bibl.,
Thott. 547.4°, f.1 (cat.140)

376. Two prophets. Edinburgh, National Lib.,
Adv. 18.6.5, f.9 (cat.142)

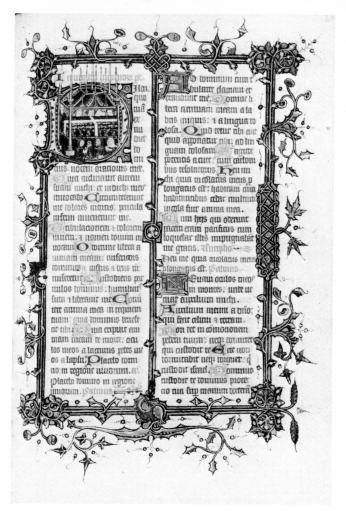

377. Funeral service. Edinburgh,
National Lib., Adv. 18.6.5, f.48 (cat.142)

378. St. Jerome. Edinburgh, National Lib.,
Adv. 18.6.5, f.60ᵛ (cat.142)

379. David in the water, praying. Edinburgh,
National Lib., Adv. 18.6.5, f.95 (cat.142)

380. David pointing to his mouth. Holkham Hall,
Earl of Leicester, 26, f.22 (cat.143)

381. Resurrection. Oxford, Trinity College, 8,
f.131ᵛ (cat.144)

382. David in the water, praying.
Holkham Hall, Earl of Leicester, 26,
f.34 (cat.143)

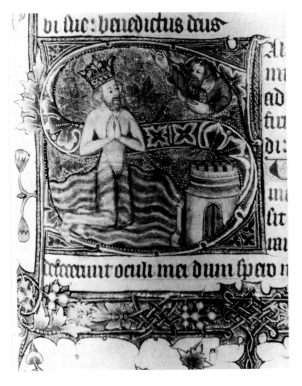

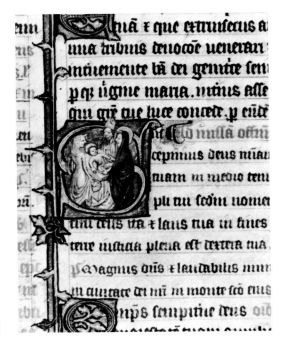

383. Presentation of Christ. Oxford,
Trinity College, 8, f.198ᵛ (cat.144)

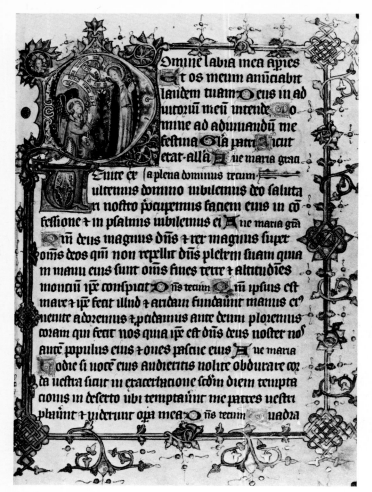

384. Annunciation. London, B.L., Add. 16968,
f.10 (cat.145)

385. Visitation. London, B.L., Add. 16968,
f.13 (cat.145)

386. David playing the harp. Hatfield, Marquess of
Salisbury, CP 292, f.21 (cat.147)

387. Enthroned Virgin and Child. Oxford,
Keble College, 47, f.9 (cat.146)

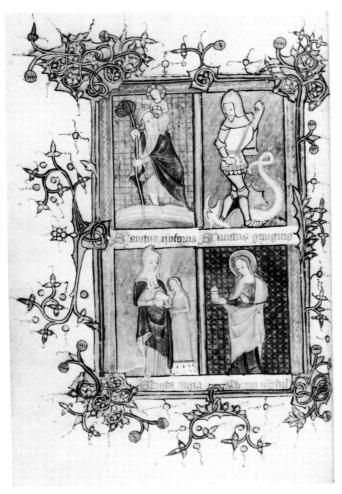

388. Saints Christopher, George, Anne and
the Virgin, Mary Magdalene. Oxford,
Keble College, 47, f.7ᵛ (cat.146)

389. Resurrection.
Oxford, Keble College, 47,
f.57ᵛ (cat.146)

390-391. Standing fool; David in the water, praying.
Hatfield, Marquess of Salisbury,
CP 292, ff.57ᵛ, 68 (cat.147)

392. Christ bearing the Cross,
Adoration of the Magi. London, B.L.,
Add. 16968, f.20 (cat.145)

393. Ascension. London, Westminster Abbey, 37,
f.106ᵛ (cat.150)

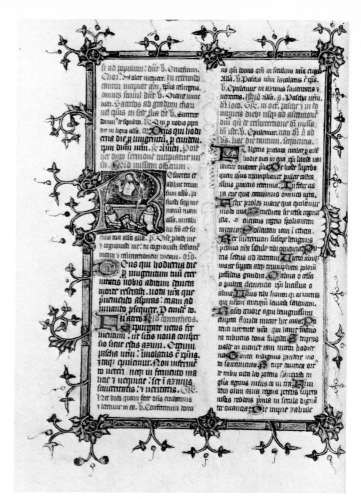

394. Resurrection. Cambridge, Trinity College,
B.11.3, f.131ᵛ (cat.148)

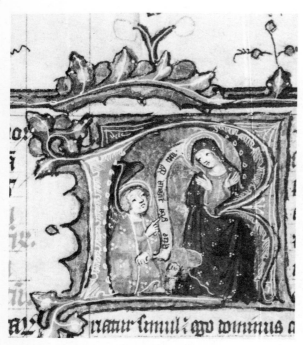

395. Annunciation. Cambridge, Trinity College,
B.11.3, f.261 (cat.148)

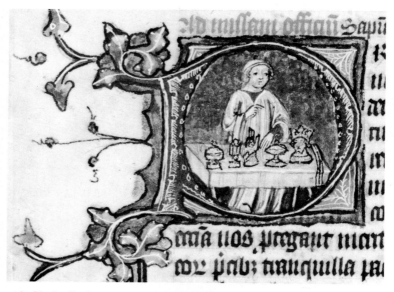

396. Cleric displaying Relics. Cambridge,
Trinity College, B.11.3, f.218ᵛ (cat.148)

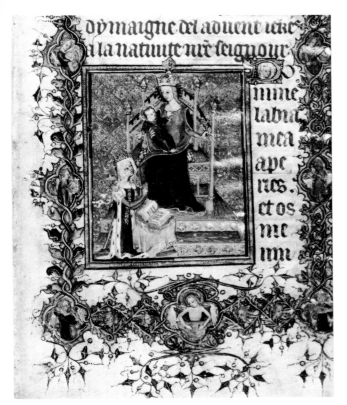

397. Enthroned Virgin and Child. Oxford,
Bodl. Lib., Laud Misc. 188, f.1 (cat.149)

398. Annunciation. Oxford, Bodl. Lib.,
Laud Misc. 188, f.21 (cat.149)

401. Presentation of Christ. Oxford, Bodl. Lib.,
Laud Misc. 188, f.143ᵛ (cat.149)

399-400. Nativity; Presentation of Christ. Oxford,
Bodl. Lib., Laud Misc. 188, ff.35, 41 (cat.149)

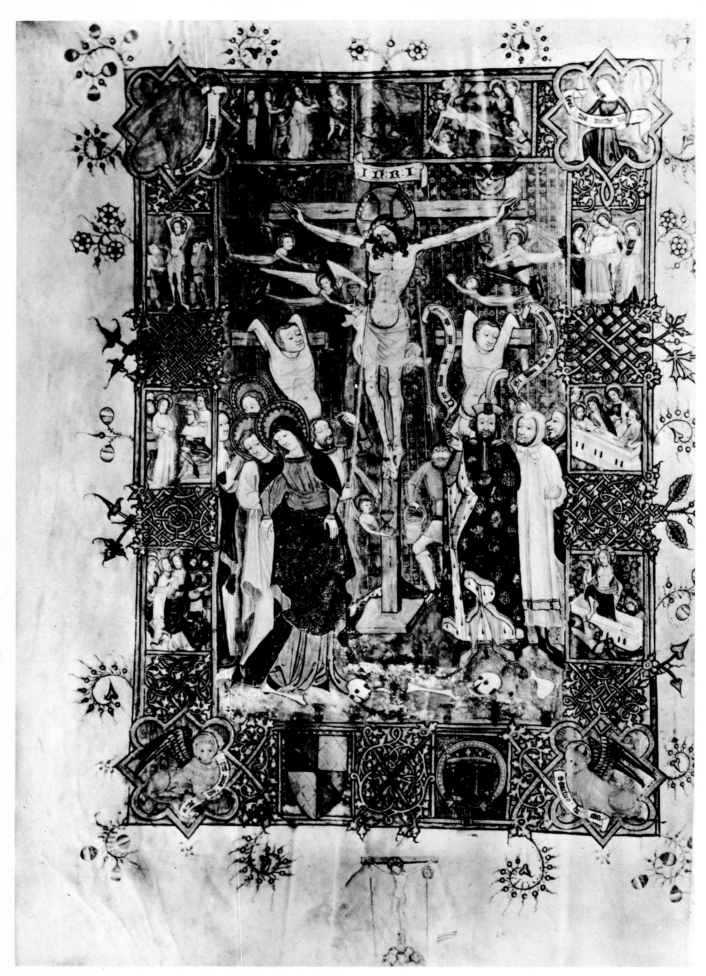

402. Crucifixion. London, Westminster Abbey, 37, f.157ᵛ (cat.150)

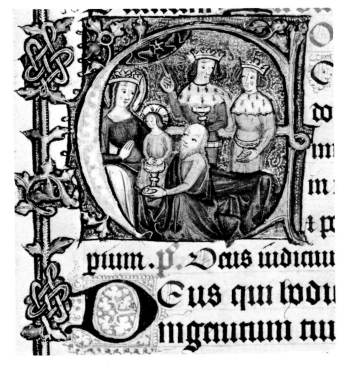

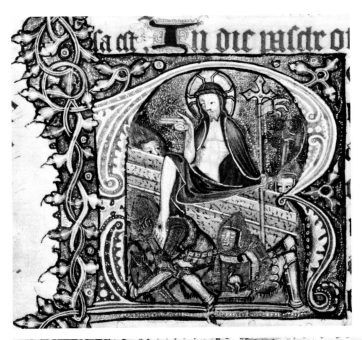

403. Adoration of the Magi. London,
Westminster Abbey, 37, f.26 (cat.150)

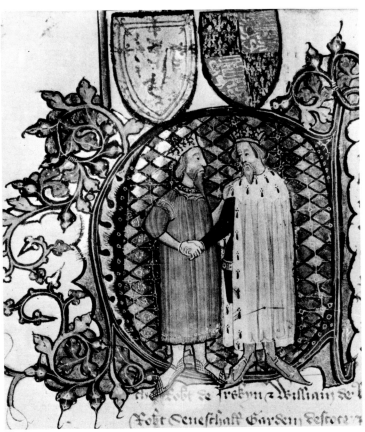

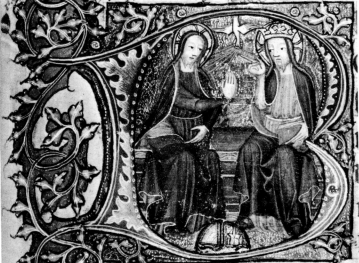

404-405. Resurrection; Trinity. London,
Westminster Abbey, 37, ff.95ᵛ, 120 (cat.150)

406. Truce between the Kings of England and Scotland.
London, B.L., Cotton Nero D.VI, f.61ᵛ (cat.151)

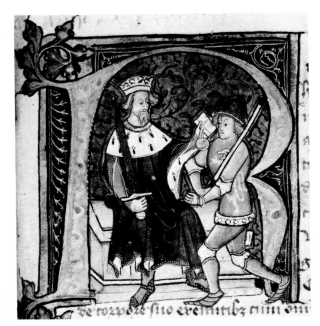

407. Richard II and Thomas of Mowbray.
London, B.L., Cotton Nero D.VI,
f.85 (cat.151)

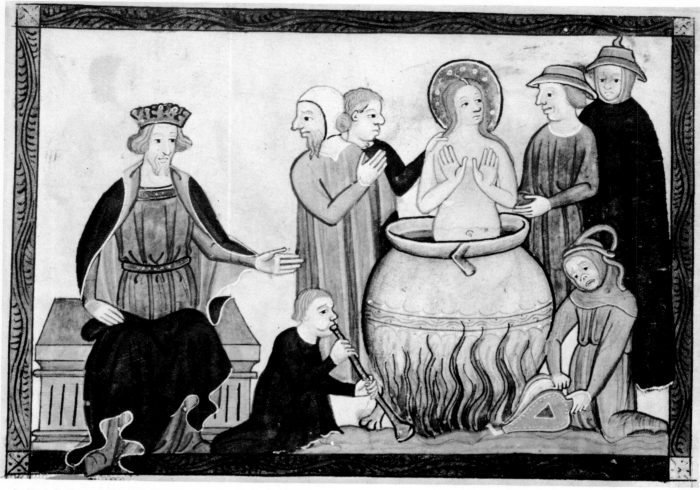

408. St. John in a cauldron of boiling oil. Cambridge, Trinity College, B.10.2, f.1ᵛ (cat.153)

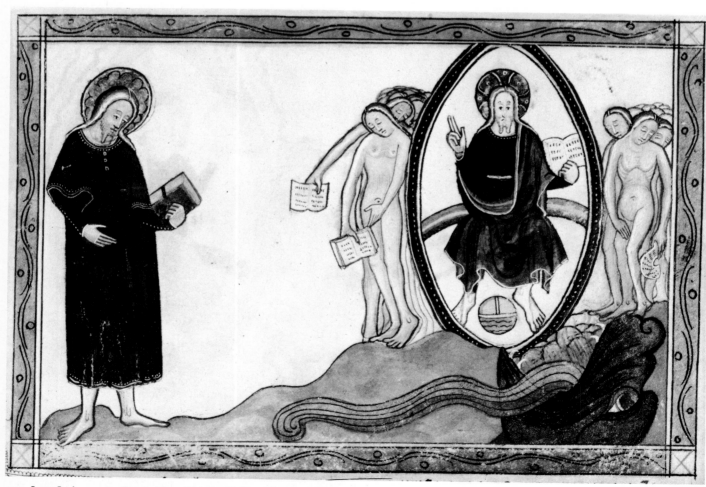

409. Last Judgement. Cambridge, Trinity College, B.10.2, f.36 (cat.153)

410. Geomancy figures.
Oxford, Bodl. Lib.,
Bodley 581, f.15ᵛ (cat.152)

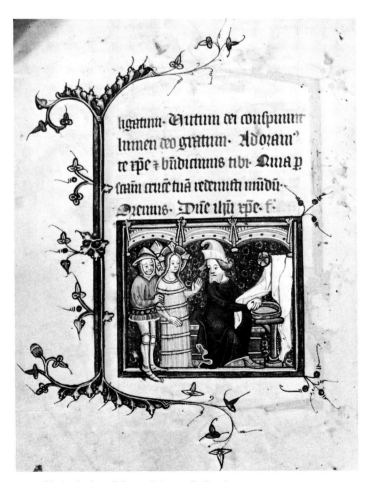

411. Christ before Pilate. Private Collection,
Germany, Belknap Hours, f.51ᵛ (cat.154)

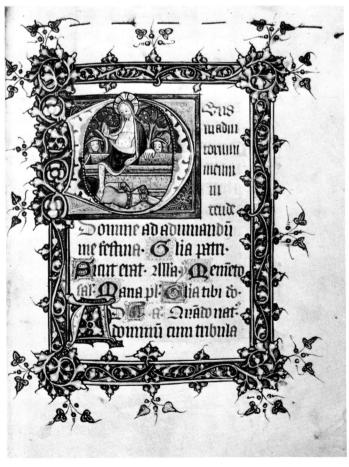

412. Resurrection. Private Collection,
Germany, Belknap Hours, f.52 (cat.154)

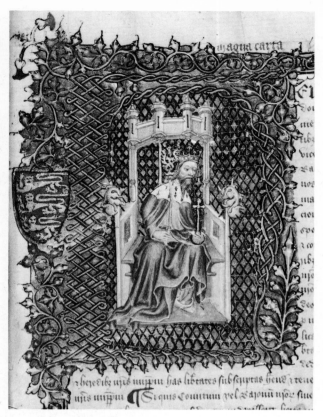

413. Henry III. Cambridge,
St. John's College, A.7, f.1 (cat.156)

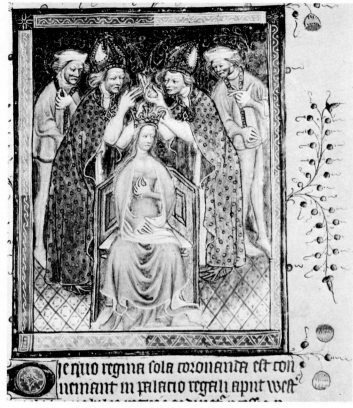

414. Coronation of a queen. London,
Westminster Abbey, 38, f.29 (cat. 155)

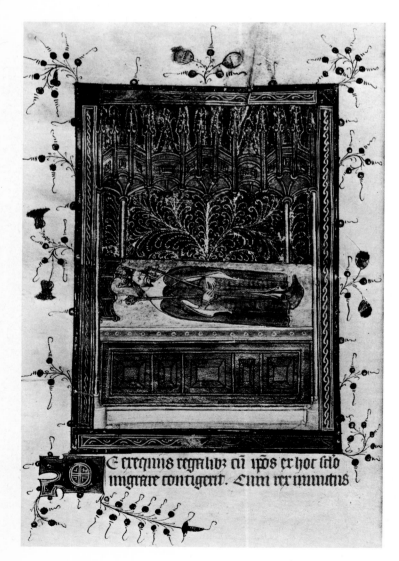

415. Funeral of a king.
London, Westminster Abbey, 38,
f.33ᵛ (cat.155)

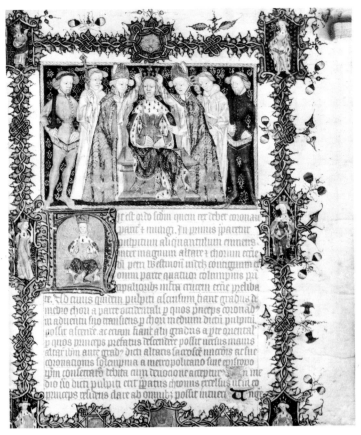

416. Coronation of a king. Pamplona,
Archivo de Navarra, 197, f.3 (cat.157)

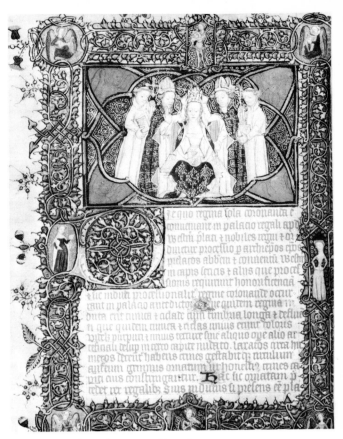

417. Coronation of a queen. Pamplona,
Archivo de Navarra, 197, f.19 (cat.157)

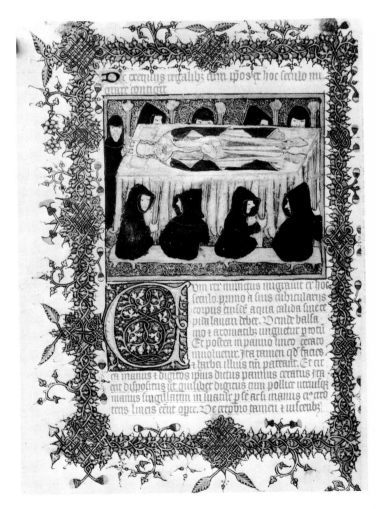

418. Funeral of a king.
Pamplona, Archivo de Navarra,
197, f.22ᵛ (cat.157)

419. Alanus Strayler, painter of miniatures. London,
B.L., Cotton Nero D.VII, f.108 (cat.158)